D0354095

The Little Big
ART BOOK

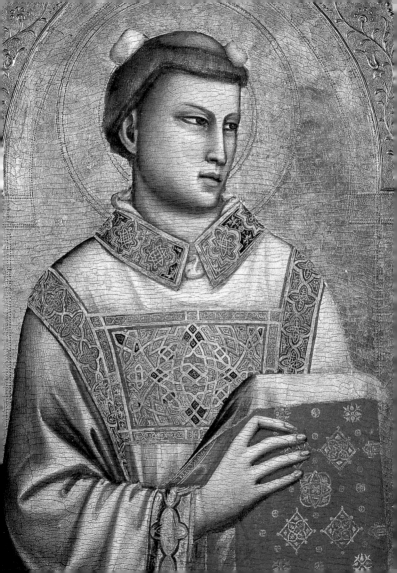

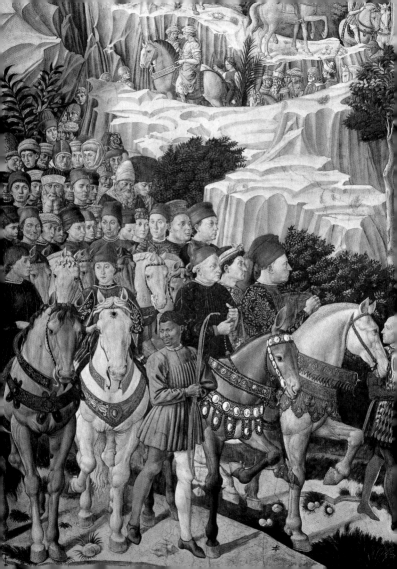

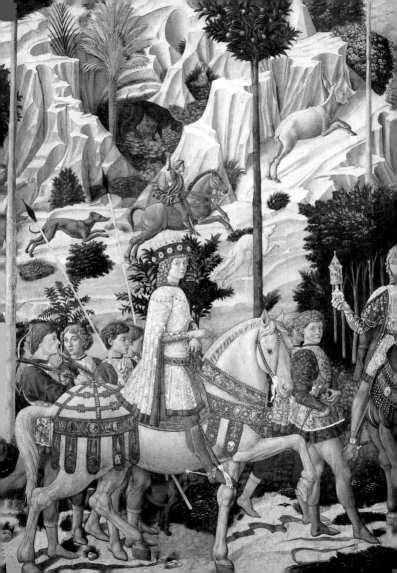

cover: CARLO CRIVELLI, *Annunciation with Saint Emygdius* (detail), National Gallery, London

spine: VINCENT VAN GOGH, *The Starry Night* (detail), Museum of Modern Art, New York

back cover: *Dionysiac Frieze* (detail), Villa of the Mysteries, Pompeii

p. 2: *Still Life with Peaches and Glass* (detail), Museo Archeologico Nazionale, Naples

p. 3: GIOTTO DI BONDONE, *St. Stephen* (detail), Horne Museum, Florence

pp. 4–5: BENOZZO GOZZOLI, *Procession of the Magi*, Palazzo Medici Riccardi, Florence

p. 7: VINCENT VAN GOGH, *Vase with Twelve Sunflowers*, Neue Pinakothek, Munich

p. 8: JAN VERMEER, *Head of a Girl with a Pearl Earring* (detail), Mauritshuis, The Hague

p. 11: RAPHAEL SANZIO, *School of Athens* (detail), Vatican Museums (Stanza della Segnatura), Vatican City

The Little Big Art Book
was created and produced by McRae Books Srl
Borgo Santa Croce, 8 – Florence (Italy)
info@mcraebooks.com
Publishers: Anne McRae and Marco Nardi

Text: Roberto Carvalho de Magalhaes
Translation: Anthony Shugaar
Graphic Design: Yotto Furuya
Editing: Loredana Agosta, Ellie Smith
Layout: Marco Nardi
Repro: Pica, Singapore

ISBN 88-89272-31-7
Printed and bound in China, by Tims Printing

The Little Big
ART BOOK

Western Painting from Prehistory to Post-Impressionism

Roberto Carvalho de Magalhães

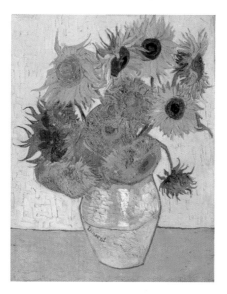

McRae Books

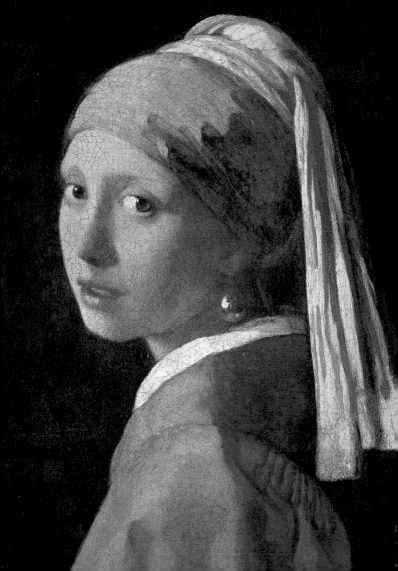

CONTENTS

Retelling several thousand years of art history within the confines of a single volume is no easy task. Inevitably, many things have been left out, while others have been simplified. General trends aside, the history of painting is the story of individual vision and creativity. These shape the thoughts of other artists and of humanity as a whole, stimulating new ideas and forming, in the end, a complex cultural fabric. Every original artist deserves special attention, because he or she is not merely the expression of a general trend, but the bearer of a new vision of the world. No one has described this proliferation of ideas, visions, and knowledge better than Marcel Proust in Time Regained: "*Thanks to art, instead of seeing one world, our own, we see it multiplied and as many original artists as there are, so many worlds are at our disposal, differing more widely from each other than those which roll round the infinite...*". And so, there will never be a definitive history of painting; instead, there can only be more or less inclusive histories of painting. And yet those histories are necessary because they offer a first approach, or a way in, for anyone who wishes to enter the infinite world of human creativity.

"A way in": perhaps that is the best way to describe this book. Setting aside reserves about the limitations and arbitrary nature of splitting art history up into periods or styles, we have divided Western painting into thirteen chronologically ordered chapters, beginning in prehistoric times and ending in the early twentieth century. Each chapter begins with a short essay with a brief overview of the period. It is not intended as an exhaustive treatment of the style or artists of the time. Instead, it provides a few key concepts and definitions to help the reader understand the paintings reproduced. More than anything else *The Little Big Art Book* is intended as a visual introduction to art. With more than 450 reproductions of the works of the most influential painters—artists whose original visions helped to expand the boundaries of painting as a medium—this book sets out to provide a sense of the variety,

richness, and character, not only of art periods and styles, but also of individual artists. Each short essay is like a door that opens onto a time period, in which it is possible to identify one or several overriding themes, but where the profusion of ideas and forms found in the works reproduced is so vast that any general description comes to seem inadequate. Our hope is that the reader will be struck by the richness of Western painting and stimulated to learn more.

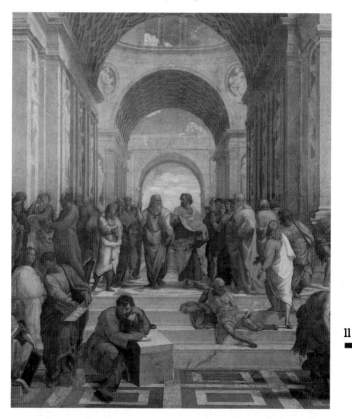

PREHISTORY

The desire to create images manifested itself very early in humans. Indeed, the earliest known drawings date back about 40,000 years. Dating from this same remote era is a small stick of ocher uncovered in Pech de l'Aze, France, and probably used to draw figures, on hide or bark, as well as on the walls of caves. From that date up to about 10,000 BC a few, truly pioneering artists worked busily to develop techniques and materials to give form to their visions. They used three main types of pigment: yellow ocher and red ocher, made from colored clay, and black, obtained from manganese. Their creations, executed, as far as we know, in caves, occasionally rise to the level of genuine cycles of paintings, as at Lascaux (France) and Altamira (Spain). These are the early forerunners of Egyptian, Greek, and Roman wall paintings and the frescoes of the modern era.

Despite attempts to categorize these ancient works of art, our still-fragmentary knowledge and the discovery of new cycles of cave art—such as at Gasquet and Chauvet, in southern France, found respectively in 1991 and 1994—undermine any ideas we may express about the development of styles. However, we do know what subjects these artists from the dawn of humanity preferred. Throughout the period of the Upper Paleolithic, i.e., from about 40,000 years ago until 10,000 BC, animals were the chosen subject, at least in Europe. Whatever function may have been attributed to these drawings—propitiatory rite for hunting or fertility, inventory of animals caught, simple worship—it was with the depiction of bison, mammoths, reindeer, stags, bulls, ibexes, and so on, that they developed their skills at composition, their ability to express themselves through images, to render the idea of motion, space, and rhythm, as well as a narrative sense.

From around 10,000 BC, these pioneers of painting seem to leave the safe, protected settings of the caves, and begin to work on the rock walls of canyons. At the same time, humans join animals as the subjects of the scenes

depicted. We begin to see, in Spain, for instance, agitated scenes of battle and hunting, in which legions of men, drawn in a style that is graphic, linear, and astonishingly well suited to the portrayal of movement, fight one another (rock shelter of Los Dogues) or hunt (Cueva Remigia, Cueva Vieja de Alpera).

Notwithstanding the difficulties of interpretation, it is possible to distinguish a number of styles in the art of this long period. Many French and Spanish caves near the Pyrenees, where humans lived between 30,000 and 17,000 years ago, feature depictions of animals that employ the techniques of punctation (a series of colored dots to make an outline), blurred punctation (when the color runs from one point to the next, creating a continuity similar to a line), and pure linearity (a continuous outline enclosing the silhouette of a simple figure, usually abbreviated). This style is known as Perigordian art, because of the great concentration of examples in the caves found in the French department of Périgord. It should not be considered primitive and uncontrolled, but rather as an important step in the quest for a visual language that was the product of enormous efforts on the part of the artists, who had no history of techniques and methods on which to rely. At the end of this period, we find a number of examples of painting in the most famous painted cave on earth: in Lascaux (France). Carbon 14 testing has shown that the wall paintings in there date to at least 17,000 years ago. Given the variety of styles seen in the drawings, however, we may guess that they were not all the work of one artist or even from the same period. They were probably done in successive periods by different artists or groups of artists, probably under the supervision of teachers. In the latest drawings, we can see a greater profusion of detail, a surprising sense of articulation among the numerous figures, and even the notion of volume, three-dimensional space, and foreshortening (see back-to-back Bison on pp. 20–21). This is the beginning of the Magdalenian period, which produced another great cycle of prehistoric painting, in the cave of Altamira (Spain).

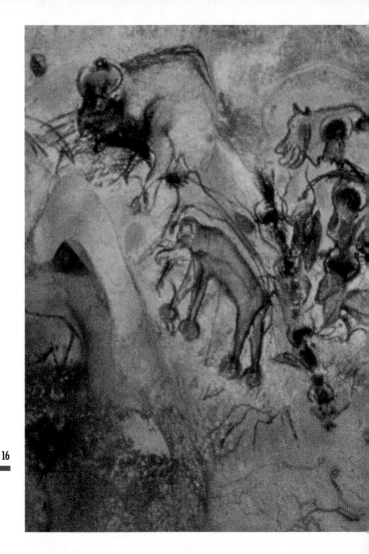

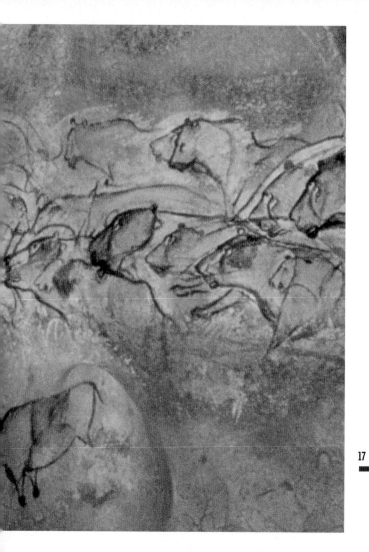

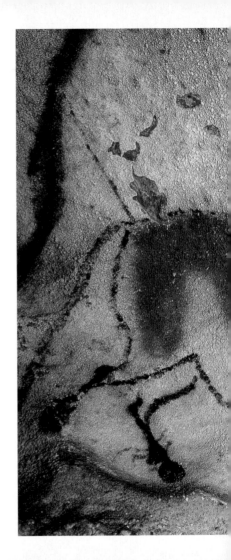

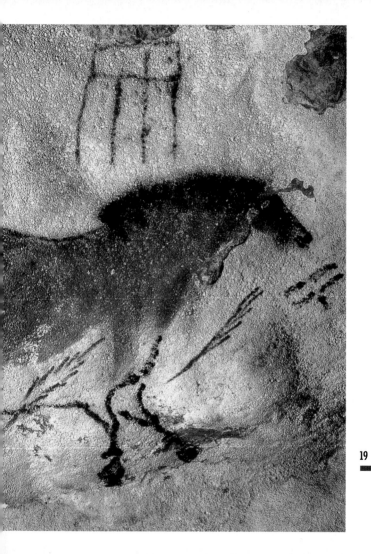

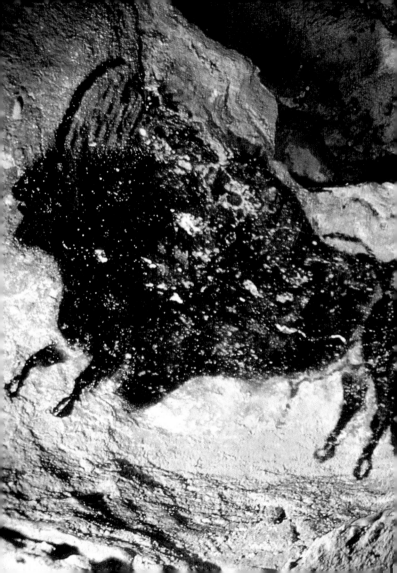

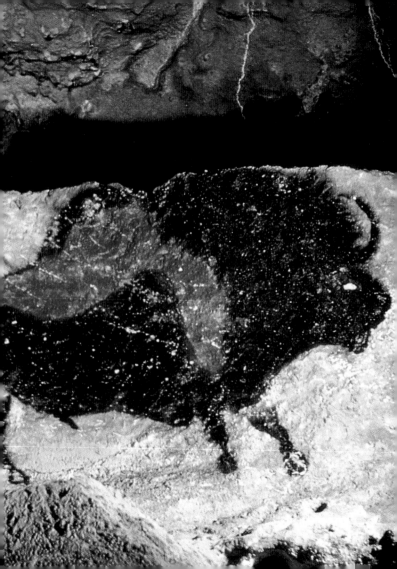

ANCIENT EGYPT

n ancient Egypt relief carving and painting often mingled. Whether we are talking about art from the Old Kingdom (4000–2050 BC), the Middle Kingdom (2050–1550 BC), or the New Kingdom (1550–1075 BC), painting was almost always part of the low reliefs that covered walls intended for public use or else walls inside tombs, with scenes and stories meant for the glorification of a pharaoh or a god.

Egyptian civilization codified strict canons for the rendering in two dimensions of human figures and space, canons that varied only slightly over the course of the nearly three thousand years of artistic activity prior to the decline of the civilization and the subsequent invasion of other styles. Thus, we can say that, in general, the Egyptian artist complied with established canons and primarily expressed the sensibility of an era, rather than a particular, individual vision of the world. In fact, the frescoes or painted reliefs were collective works, executed by workshops, that required everyone working on them to employ the same style.

What was the Egyptian figurative canon? First of all, an Egyptian artist broke down the visible world into two-dimensional forms, which were then put together in such a way as to render the subject clearly recognizable. The human figure, for instance, was the product of two different points of view, the frontal view and the side view. Eyes, ears, and upper body were depicted frontally, while head, hips, and limbs were portrayed in profile. Figures were generally arranged symmetrically, and one group of figures was often counterbalanced by another group, arranged as a mirror image. As was later the case with Byzantine mosaics and European frescoes in the fourteenth and fifteenth centuries, Egyptian artists divided their work surfaces into strips, and then deployed the scenes along them. In Egyptian art, the bottom line of each strip acted as a baseline upon which the figures rested. If the figures' feet, for instance, are placed above the line, this means that they are further

in the background. This is how an Egyptian artist expressed spatial depth. There were other rules too, such as making male complexions darker and female complexions lighter. This distinction probably referred to the fact that men worked outdoors and women spent more of their lives indoors, tending to household matters. A similar correlation can be found in the tendency to depict women with their legs together and men with their legs apart: this was meant to indicate that men were more active while women played a more passive role in Egyptian society.

These rules, and the frequent placement of hieroglyphics amidst the figures depicted, helped not only to describe the religious practices and the glories of the pharaohs, but also to create a complex visual world of rhythms and balances.

Despite the strict rules governing art in ancient Egypt, a few examples of independent personal expression have survived. These are to be found among objects of daily use, in the more modest tombs of private individuals, or on "ostraka," or shards of pottery or limestone, upon which artists sketched freely. No longer restricted to the official style and themes imposed upon public works, the artist could indulge in other forms of depiction, more personal notations, and the free expression of movement.

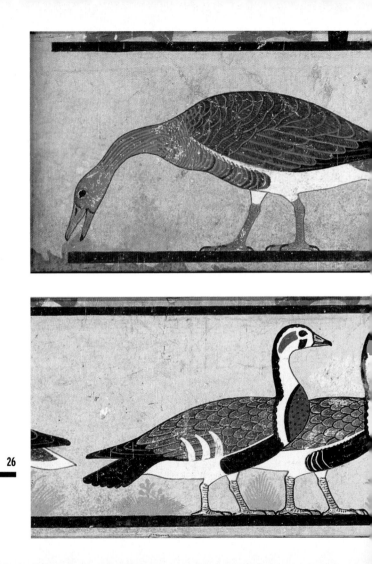

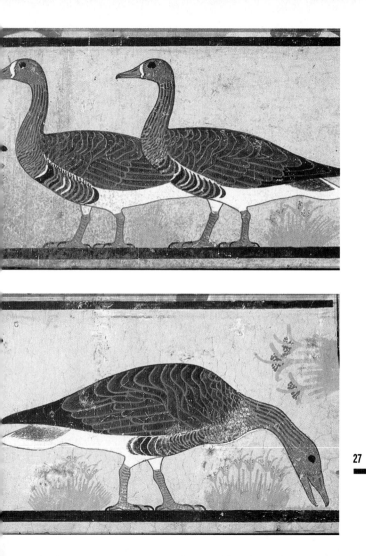

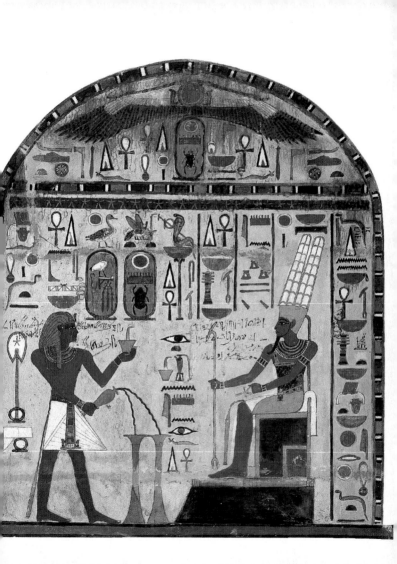

Fowling in the Marshes
from the Funerary Chapel
of Nebamun, Thebes
(fragment)

c. 1350 BC

Painting on dry plaster
h. 32 in (81 cm)
British Museum
London

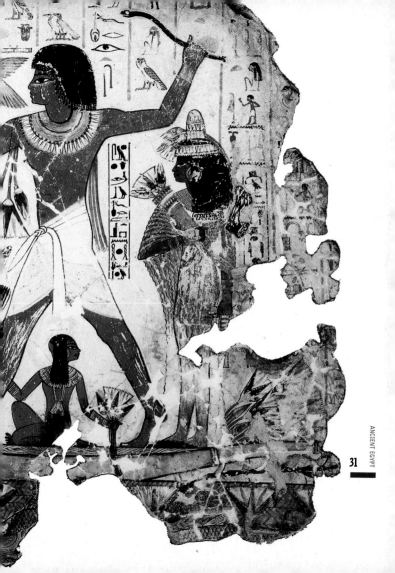

32

Cattle Brought for Inspection
from the Tomb of Nebamun, Thebes
(Fragment)

c. 1350 BC

Painting on dry plaster
h. 23 in (58.5 cm)
British Museum
London

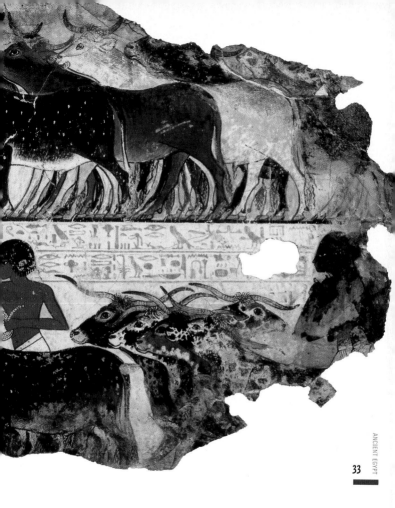

34

The Goddess Maat
from the Tomb of Seti I, Valley of the Kings,
Thebes

c. 1295 BC

Polychrome relief on limestone
29 x 18 ½ in (74 x 47 cm)
Archeological Museum
Florence

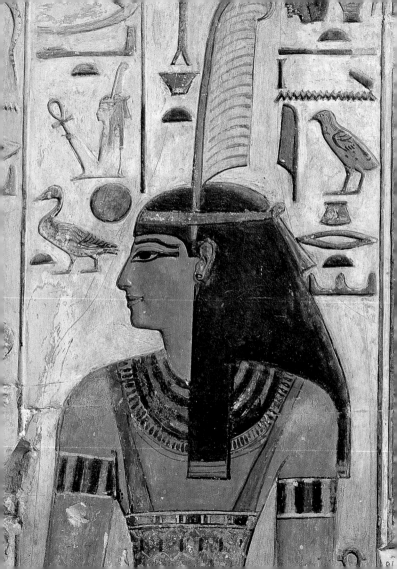

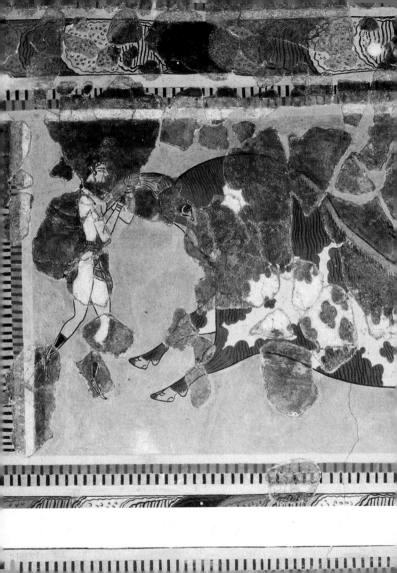

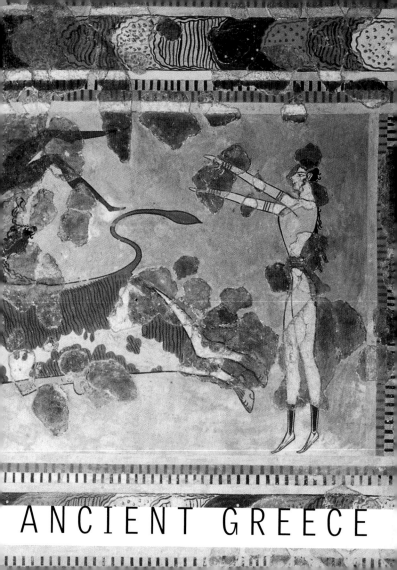

ANCIENT GREECE

Ancient writers, including Pliny the Elder (AD 23–79), describe Greek painting as a glorious period in art history. They record the names of such painters as Apelles (active fourth century BC), Parrhasius (active latter fifth century BC), and Polygnotus of Thasos (active mid-fifth century BC). Apelles, official portraitist to Alexander the Great, was renowned for his use of perspective and chiaroscuro. Parrhasius was famous for his depictions of the Centauromachia on the bronze shield of the statue of Athena Promachos, the work of the sculptor Phidias. Polygnotus worked at Delphi and Athens. He apparently had a special gift for endowing his figures with psychological depth through their facial expressions. Unfortunately, neither the panel paintings nor the frescoes executed by these great artists have survived the ravages of time. Indeed, there are very few surviving works of ancient Greek painting, and they do not represent the great artistic period described by literary sources. Among the exceedingly rare examples that are still extant, are the frescoes of the Palace of Knossos, on Crete, dating from the sixteenth to the thirteenth century BC, and the frescoes of the Tomb of the Diver, at Paestum, Italy, dating back to 480–470 BC.

Glimpses of that great period of Greek painting can be found, however, in the wall paintings of Etruscan tombs, in the painting of ancient Rome, and in the floor mosaics of the time. Vase painting was also certainly linked to the painting of frescoes and panels, and the huge number of vases that have survived has made it possible to trace each stage in the development of this art.

As early as the ninth century BC, the so-called "geometric" style began to develop in vase painting. Throughout the ninth century, vase painting was basically abstract, revealing a rigorous and rhythmic sense of composition. At the beginning of the eighth century BC, figures first appear. They were initially quite schematic, following the laws of geometry. There are many examples of painted vases from this period that were unearthed in the Athenian necropolis of Dipylon.

The decoration of these large vases, made for use in tombs, was intended, among other things, as a celebration of the life of the deceased, through the depiction of battle scenes or even the funeral ceremony itself.

With the passage of time, human and animal figures became the most important elements in the decoration of vases, together with plant motifs of Eastern origin. By the seventh century BC, black-figure vase painting had evolved. These vases showed mythological episodes, with gods, goddesses, and heroes, almost certainly based upon paintings, executed in black figures with etched silhouettes standing out sharply against a yellow-reddish clay background. Important examples of this technique are the amphora by the Painter of Amasis, showing Dionysus and the Maenads, and a kylix (a shallow bowl with two horizontal handles) depicting Dionysus sailing in a boat, by Exekias (active c. 550–525 BC), both dating from around 530 BC.

The first red-figure vases appeared in the second half of the sixth century BC. Virtual negatives of the black-figure vases, now the figures are red, with black outlines, standing out against a black background. Vase painters used this technique to transfer the ideas of the great school of painting onto their creations for about a century. Not only did they achieve foreshortening of the figures, but could also render spatial depth and psychological insight into their subjects. Among the most important examples of this style are the calyx krater (a large vase in which water and wine were mixed before being served at banquets) showing Herakles Wrestling Antaeus, by Euphronius (active c. 520–500 BC), dating back to about 510 BC.

ANCIENT GREECE

Ironically, during fourth century BC—the height of Greek painting, according to literary sources, when Apelles, Zeuxis (active latter fifth century BC), and Parrhasius were all working—Attic vase painting went into a period of decline. In contrast, vase painting flourished in southern Italy, then part of Magna Graecia.

Fisherman
from Thera

c. 1550 BC

Fresco
h. 53 ¼ in (135 cm)
National Archaeological Museum
Athens

pp. 36–37

The Toreador Fresco
from the Palace of Knossos, Crete

c. 1500 BC

Fresco
h. 34 in (86 cm)
Iraklion Museum
Crete

42

Boxers
from Thera

c. 1550 BC

Fresco
National Archeological Museum
Athens

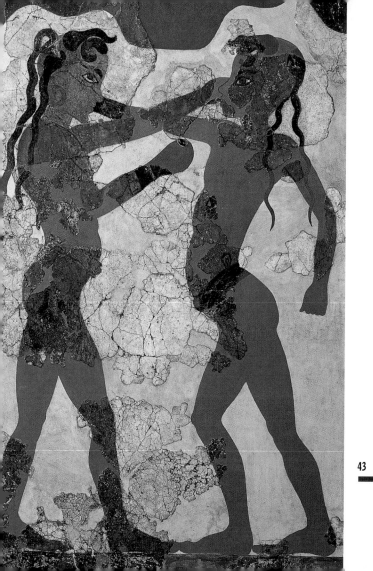

44

Dipylon Vase

c. 750 BC

Ceramic
h. 61 in (155 cm)
National Archeological Museum
Athens

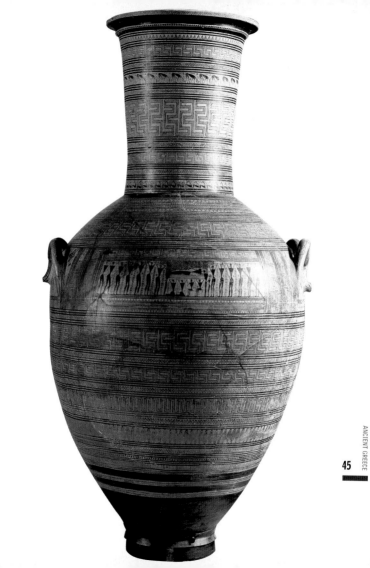

46

Exekias
active c. 550–525 BC

The Departure of the Dioskouroi
Amphora

c. 540–530 BC

Ceramic
h. 24 in (61 cm)
Gregorian Museum of Etruscan Art
Vatican City

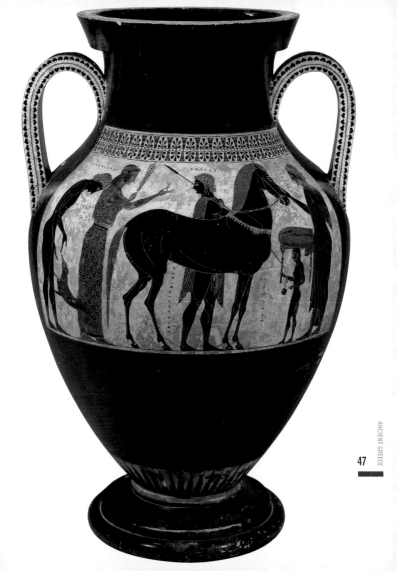

Exekias
active c. 550–525 BC

Dionysus in a Boat with a Vine
Kylix

c. 530 BC

Ceramic
h. 5 ¹/₄ in (13.6 cm) diam. 12 in (30.5 cm)
Staatliche Antikensammlung und Glyptothek
Munich

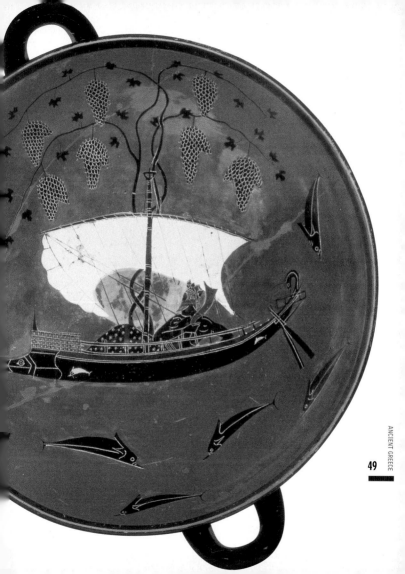

ANCIENT GREECE

Exekias
active c. 550–525 BC

Achillies and Ajax Playing with Dice
Amphora

c. 540–530 BC

Ceramic
h. 23 ³/₄ in (61 cm)
Gregorian Museum of Etruscan Art
Vatican City

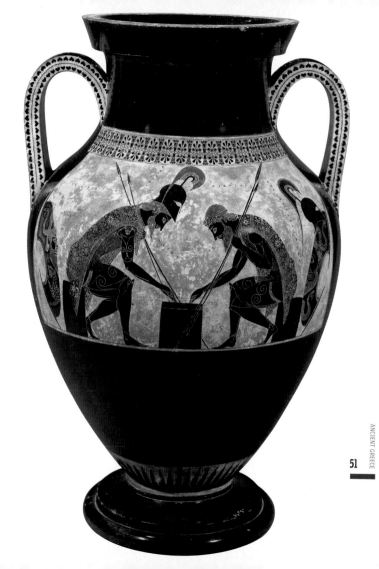

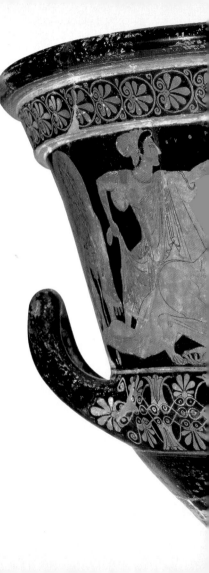

Euphronios
active c. 520–500 BC

Herakles Wrestling Antaeus
Calyx krater

c. 510 BC

Ceramic
h. 18 in (46 cm)
Louvre
Paris

Apollo Wreathed with Myrtle
Kylix

480–470 BC

Ceramic
Archeological Museum
Delphi

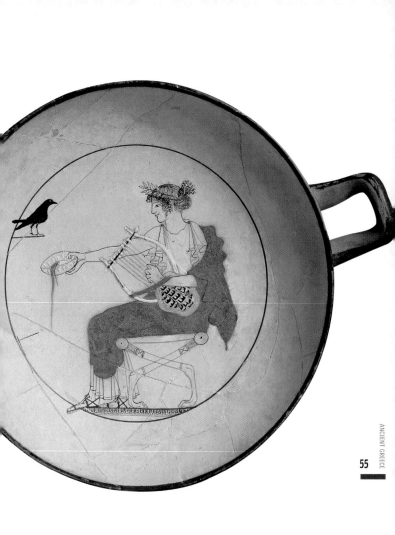

56

Pan and Maenads
Italiot krater
(detail)

C. 4ᵀᴴ CENTURY BC

Ceramic
Museo Eoliano
Lipari

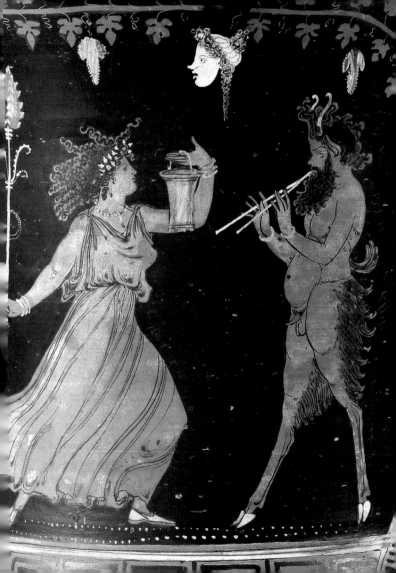

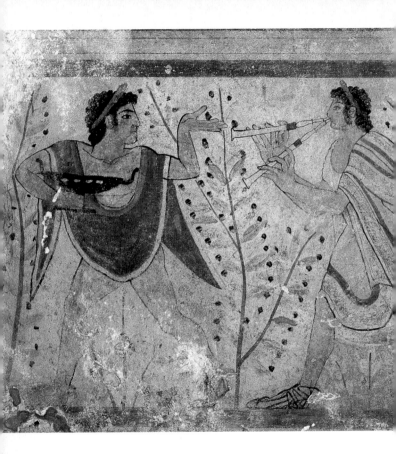

58

Revelers
from the Tomb of the Leopards (Etruscan)

c. 470 BC

Fresco
42 x 76 in (106.7 x 182.9 cm)
Tarquinia

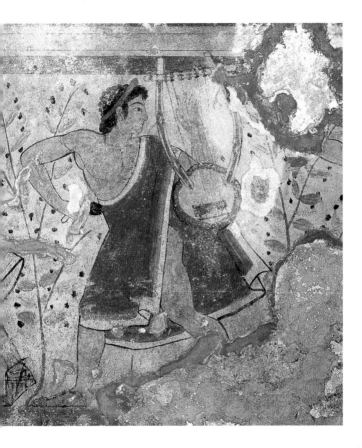

60

Pipe Player
from the Tomb of the Triclinium (Etruscan)

480–470 BC

Fresco
Archeological Museum
Tarquinia

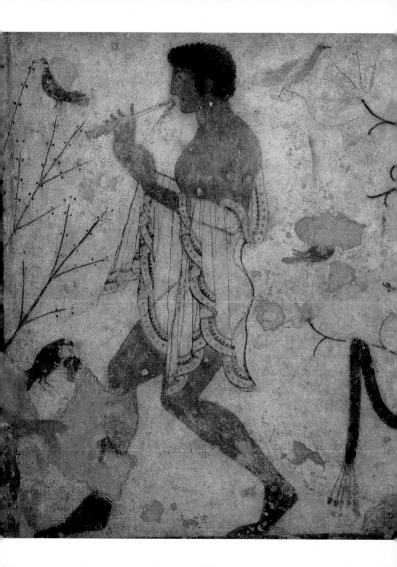

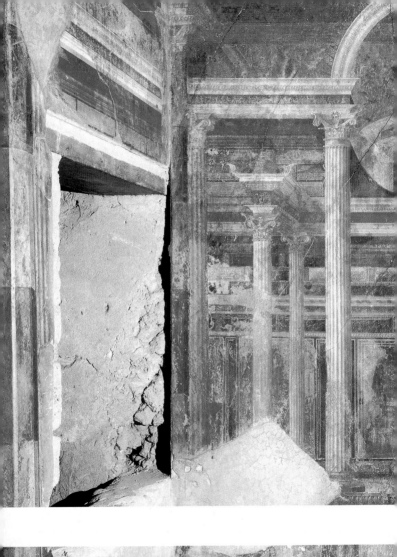

THE ROMAN ERA

Examples of painting from ancient Rome are far more plentiful than from Greece. Many come from the area around Vesuvius, especially from Pompeii and Herculaneum. Rome itself is also a good source, with the astonishing frescoes of a garden in the Villa of Livia or those in the home of Augustus, and in the Domus Aurea, built by the Emperor Nero. We have also included mosaics in this history of painting, of which there are many examples scattered across the Mediterranean basin, from Syria and North Africa to the Iberian Peninsula.

Painting of the Roman period is traditionally divided into four successive styles. They are known as the "Pompeiian styles," because they have been chiefly documented in Pompeii, up until AD 79, the year the eruption of Vesuvius destroyed the city. The first style (2nd century-early 1st century BC), involved painted imitations of colored marble wall facings. Often embellished with painted plaster reliefs, or stuccoes, it was closely linked to architecture. This style may also have been typical of the painting of the Greek world as well.

The second style (1st century BC), progressed to the depiction of full-fledged architectural structures, using perspective and *trompe l'oeil*, opening out onto other spaces and landscapes. In these complex architectural interplays, fake statues and paintings were inserted, with scenes, objects, animals, and human figures. The Villa dei Misteri (Villa of Mysteries) in Pompeii and the House of Augustus, in Rome, are good examples of this style.

The third style (late 1st century BC–mid 1st century AD), was distinctly decorative. The painted architecture here becomes increasingly slender and ornamental rather than showing plausible buildings. There are fewer openings and landscapes and greater attention is paid to details. Examples of this style can be found in the pyramid of Gaius Cestius, in Rome, and in the houses of Marcus Lucretius Fronto and Cecilius Jocundus, in Pompeii.

The fourth style (circa AD 30–79), also known as the "fantastic" style, still features views of architecture but makes extensive use of bizarre and original decorative elements. The Roman architect Vitruvius (1st century BC), in his treatise *De Architectura*, had condemned a similar style for its scarce grip on reality. Uncovered in the sixteenth century, these decorations were called "grotesque," and were used extensively in Renaissance painting. The fourth style is widely documented in Pompeii, because it was fashionable during the final period of the tragic Vesuvian city.

Roman painting also included a compendiary, or "impressionistic" style. Probably originating in Greece, according to Pliny the Elder in his *Naturalis Historia*, around 300 BC, this style rendered figures with a few rapid strokes of color. The houses of Pompeii and Herculaneum, the frescoes of Roman houses, and catacomb walls were crowded with scenes, figures, masks, and animals executed in this technique. It was also the style in which many of the first artworks with Christian subjects were done.

The art of portrait painting was also highly developed in Roman times. There is reason to believe that it was in vogue just about everywhere in the Roman Empire during the first two centuries AD, although only about two hundred examples have come down to us, all from Roman settlements in Egypt and, especially, the oasis of el-Fayyum. The reason for this is that, since they were painted on wooden panels, and wood is highly perishable, the only portraits that survived were those that had been placed in tombs in the arid sands of the desert. These were not only funerary portraits, as one might think. Quite often, they were portraits done during the subjects' lives, from a sitting, and preserved in the home and, finally, used to cover the face of the deceased. The portraits of el-Fayyum are an exceedingly refined example of the compendiary style. Some of them show astonishing similarities to the style of nineteenth-century portraiture.

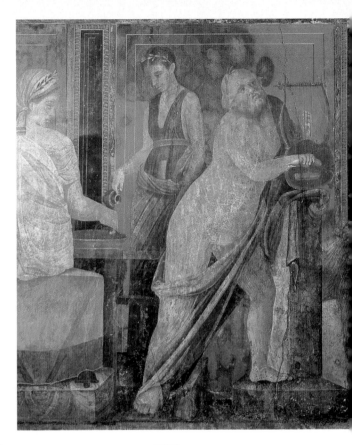

Dionysiac Frieze
detail
c. 60–50 BC

Fresco, h. 63 ³/₄ in (162 cm)
Villa of the Mysteries
Pompeii

pp. 62–63

Decoration with
***Trompe l'œil* Effect**

c. 60–50 BC

Fresco
Villa of the Mysteries
Pompeii

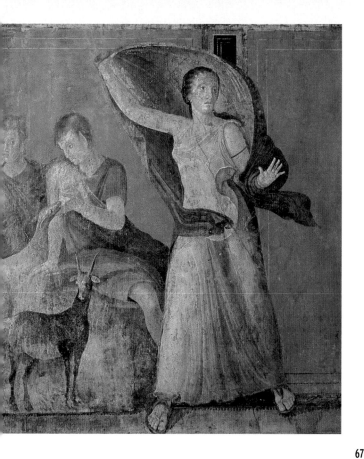

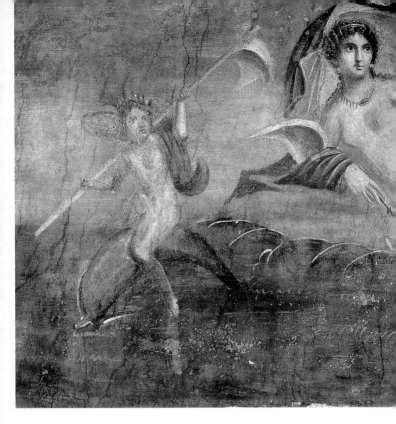

The Birth of Venus

1ˢᵀ CENTURY BC

Fresco
The House of Venus
Pompeii

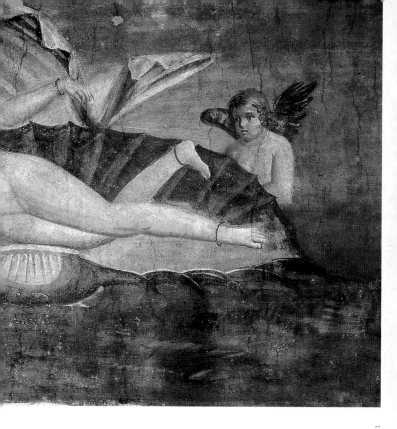

Bacchanalian Figure
fragment

1ˢᵗ CENTURY AD

Fresco
Antiquarium del Palatino
Rome

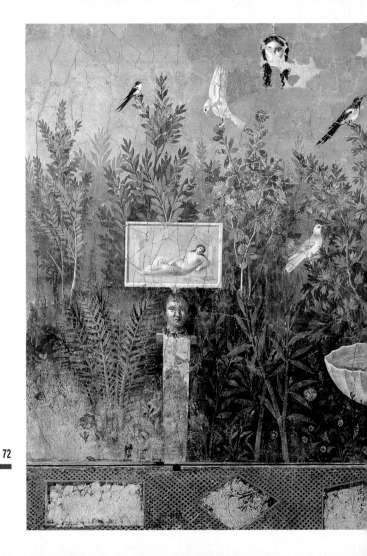

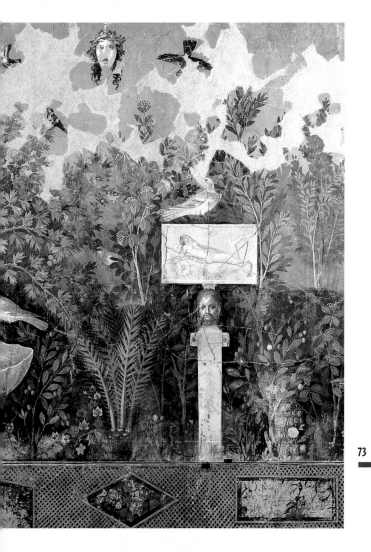

**Still Life with Peaches
and a Glass Vase**
from Herculaneum

1ˢᵗ CENTURY AD

Fresco
14 x 13 ½ in (35.6 x 34.3 cm)
National Archeological Museum
Naples

pp. 72-73

Garden with Hermes and Fountain
(left wall, central strip)

1ˢᵗ CENTURY AD

Fresco
Villa of the Golden Bracelet
Pompeii

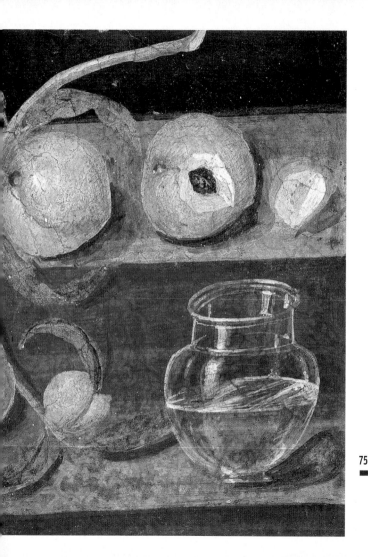

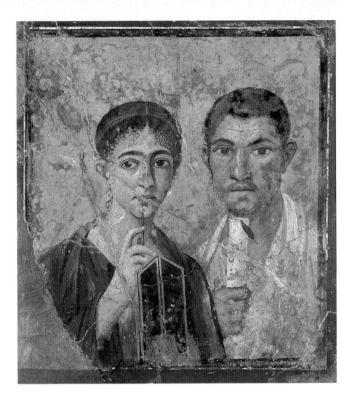

Paquio Procolo and his Wife
from House VII, Pompeii

1ˢᵗ CENTURY AD

Fresco
19 x 19 ¹/₄ in (48 x 49 cm)
National Archeological Museum
Naples

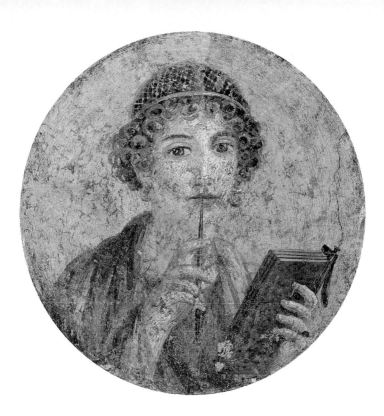

Sappho
(so-called)
from Pompeii

1^{ST} CENTURY AD

Fresco
National Archeological Museum
Naples

The Birth of Adonis
from the Domus Aurea, Rome

c. AD 64–68

Fresco
Ashmolean Museum
University of Oxford

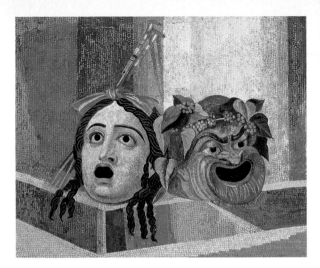

above

Tragic and Comic Masks
from the Baths of Decius, Rome

2ᴺᴰ CENTURY AD

Mosaic
h. 29 ¹/₄ in (74.6 cm)
Capitoline Museums
Rome

opposite

Underwater Scene
from Pompeii

2ᴺᴰ CENTURY AD

Floor mosaic
National Archeological Museum
Naples

p. 82

Mummy Portrait of a Woman
from Hawara, el-Fayyum

C. AD 55–70

Encaustic painting on wood panel
16 ¹/₂ x 8 ¹/₂ in (41.6 x 21.5 cm)
British Museum
London

p. 83

Mummy Portrait of a Man
from Hawara, el-Fayyum

C. AD 100–120

Encaustic painting on wood panel
15 ³/₄ x 8 ¹/₂ in (40.1 x 21.5 cm)
British Museum
London

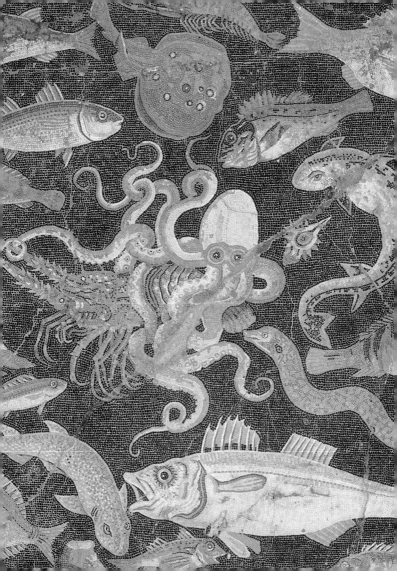

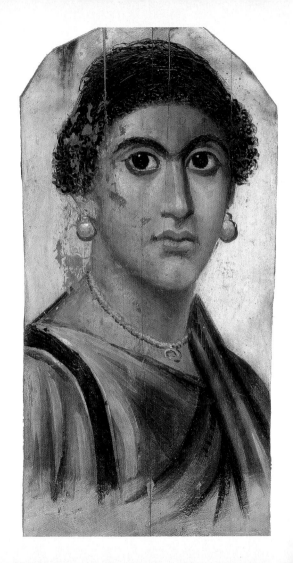

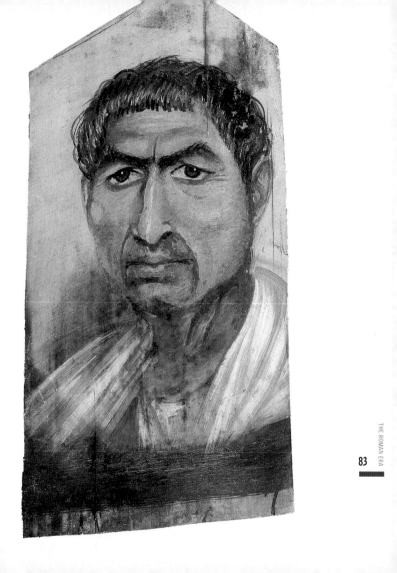

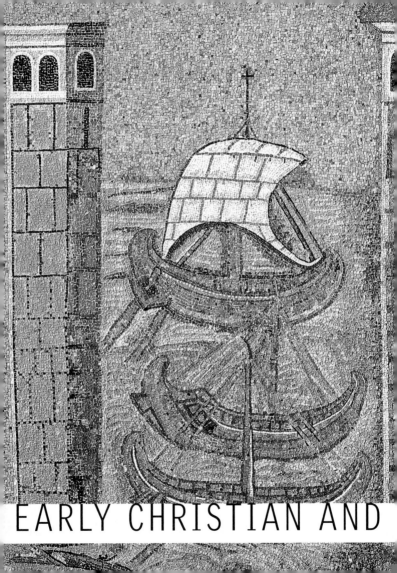

EARLY CHRISTIAN AND

BYZANTINE PAINTING

n AD 313, the Roman emperor Constantine promulgated the Edict of Milan, in favor of Christianity. From then onward Christians could freely profess their faith. In AD 380, Theodosius proclaimed Christianity to be the state religion, and later, in 391, went on to outlaw all forms of pagan worship. Under Constantine, in 320, work began on the Catacombs of the Via Latina, just outside of Rome. In 324, the foundation was laid for the first Basilica of Saint Peter, completed in 349. In 330, Constantine moved the capital of the Roman Empire to Byzantium, which became Constantinople (now Istanbul). In about 360, work began on the Basilica of Santa Maria Maggoire, in Rome, and in 386 construction was undertaken on the Basilica of Saint Ambrose, in Milan. At the end of what proved to be a turbulent century, the Roman empire was divided into the Western Roman Empire and the Eastern Roman Empire. In 404, Honorius moved the capital of the Western Empire from Rome to Ravenna. Between 532 and 537, the church of Hagia Sophia was built in Constantinople, to plans by the architects Anthemius of Tralles (active sixth century AD) and Isidore of Miletus (active sixth century AD). These are only a few of the many events that led to the progressive conversion of Europe to the Christian faith, a complex and troubled process, filled with war, schism, and reconciliation, which also had major consequences for the future of art.

In the first few centuries of the Christian era there were few references in painting to the new cult. In the Roman catacombs, frescoes dating back to the third and fourth centuries feature both pagan and biblical subjects, though the latter only in limited number. Many of these images were executed in the Roman compendiary style, with its short rapid brushstrokes. A good example is the depiction of the Virgin Mary and Christ Child in the Catacombs of Priscilla, in Rome.

Beginning with the proclamation of Christianity as the official state religion at the end of the fourth century, painting, which was to become practically the exclusive domain of the Church, underwent a slow process of detachment from Greek and

Roman models. From the fifth century on, mosaics became the preferred technique for decorating church walls with Christian stories. A new figurative idiom, based on lines and the absence of spatial depth, was developed and perfected in Byzantium, the capital of the Eastern Christian Empire. That style is reflected in the magnificent mosaics of the churches of San Vitale and Sant'Apollinare Nuovo, in Ravenna, as early as the sixth century. The figures are rigidly frontal, while the facial features are the product of an abstract codification, and are repeated from one personage to another. The use of chiaroscuro was phased out, and figures lost their volume. Anatomical details were rendered using lines and other graphic signs, as were the folds of clothing and drapery. Architectural backgrounds were also extremely simplified. Space, especially the space of the sky, was replaced with a golden surface which became the glittering symbol of divine light.

To express the quality of transcendence, alongside these stylistic rules, which intentionally distance an image from any correspondence with reality (be it anatomical, spatial, or natural), other rules were established: for instance, governing the location of Christian subjects within the physical church. The Christ Pantocrator (or Christ offering a benediction) was depicted in the domes or in the vaults of the apses, where you might also find the Virgin Mary and Christ Child.

Originating in the Eastern Roman Empire, between Constantinople and Greece, Byzantine art developed over a lengthy period of time, and spread from Italy and Germany to the southern Slavic countries (Bulgaria, Croatia, Serbia, etc.) and eastern Slavic countries (Russia, Byelorussia, and Ukraine). In Russia, Byzantine painting had as its principal center of diffusion, from the tenth century onward, the city of Kiev, in the wake of that country's conversion to Christianity. In its local versions, the Byzantine style would last in Russia up to the eighteenth century, in the production of religious icons. In the Balkans and on the island of Crete, as well, the production of religious icons was marked by the Byzantine style from the fifteenth to the eighteenth century.

Still Life with a Bird

2ND CENTURY

Fresco
Catacombs of Saint Sebastian
Rome

pp. 84–85

Classe Harbor

6TH CENTURY

Mosaic
Sant'Apollinare Nuovo
Ravenna

90

**Madonna and Child with Saints
Felix, Adauctus, and Luke**

6ᵀᴴ CENTURY

Fresco
Catacombs of Comodilla
Rome

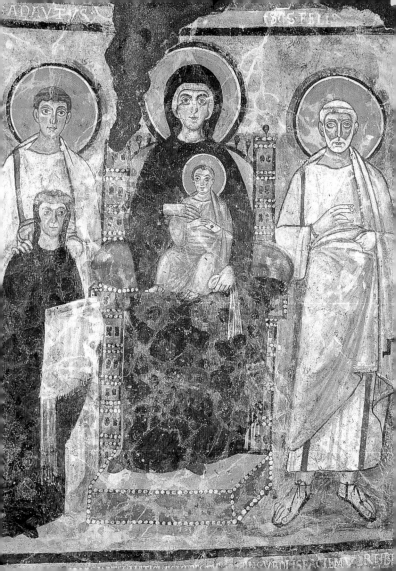

92

Crossing the Red Sea
Scenes from The Life of Moses

5TH CENTURY

Mosaic
Santa Maria Maggiore
Rome

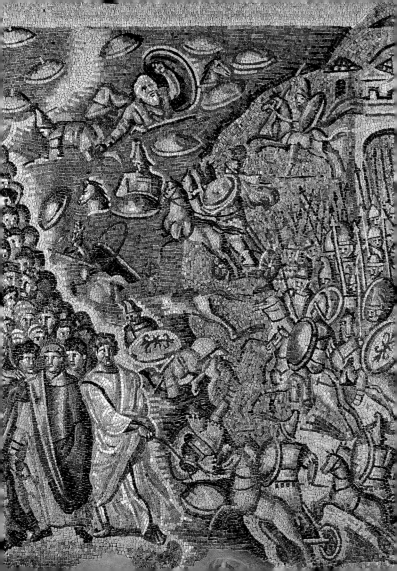

Saint Lawrence

5ᵀᴴ CENTURY

Mosaic
Mausoleum of Galla Placidia
Ravenna

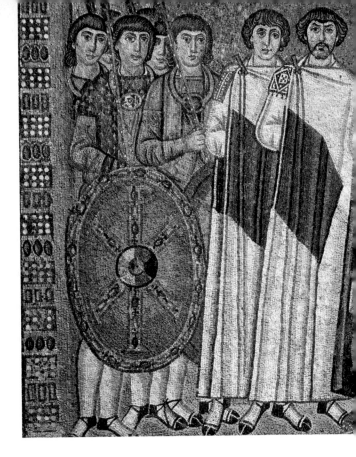

Justinian and Attendants

c. 547–548

Mosaic
San Vitale
Ravenna

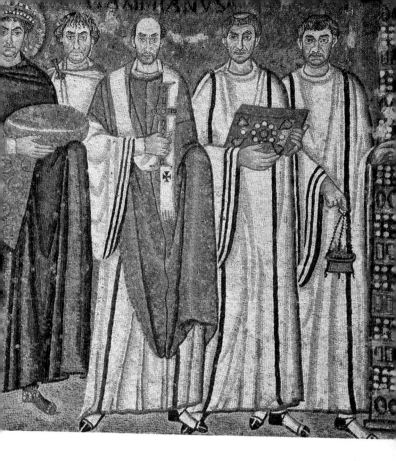

97

98

Moses on Mount Sinai

6TH CENTURY

Mosaic
San Vitale
Ravenna

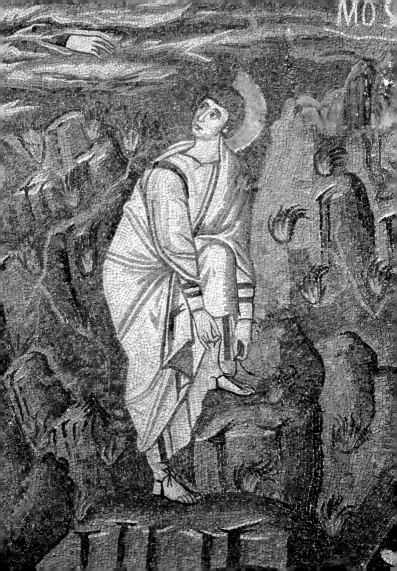

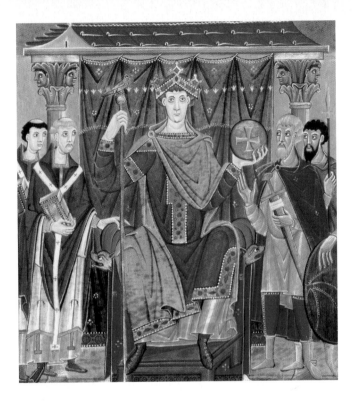

100

above

Master of the Registrum Gregorii
10ᵗʰ century

**The Coronation of the Holy Roman
Emperor Otto III**
from the Gospel of Otto III
Miniature on parchment
13 ¹/₄ x 9 ¹/₂ in (33.4 x 24.2 cm)
Bayerische Staatsbibliothek
Munich

opposite

Master of the Cividale Psalter
8ᵗʰ–9ᵗʰ century

King David Playing the Zither
from the Psalter of Egbert
(foglio 20, rect)
Miniature
National Archeological Museum
Cividale

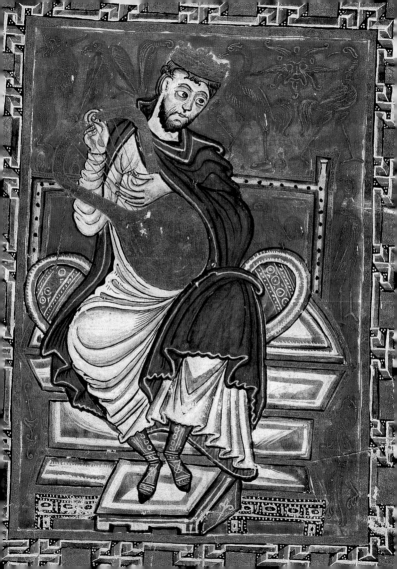

102

Christ the Pantocrator

12TH CENTURY

Mosaic
Cathedral of Monreale (apse)
Sicily

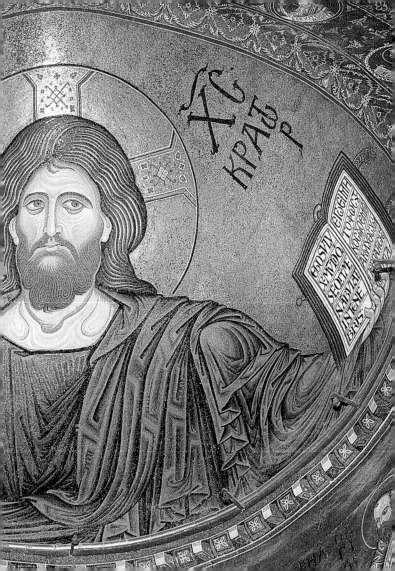

Master of the Bardi Saint Francis
Documented 1240-1280

104

Saint Francis

c. 1250

Tempera and gold on panel
89 $^1/_4$ x 79 $^1/_2$ in (227 x 202 cm)
Santa Croce (Bardi Chapel)
Florence

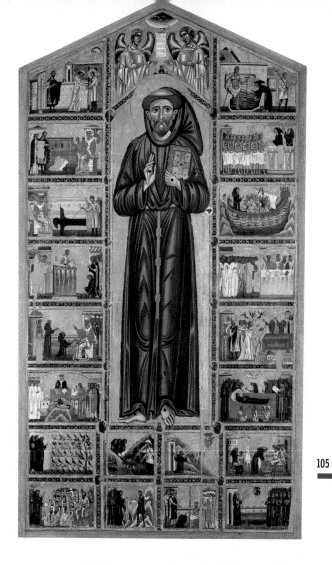

Andrei Rublev
c. 1370-1430

106

Vladimir Madonna
Icon

AFTER 1410

Tempera and gold on panel
11 $\frac{1}{2}$ x 6 $\frac{3}{4}$ in (29 x 17.5 cm)
Hermitage
Saint Petersburg

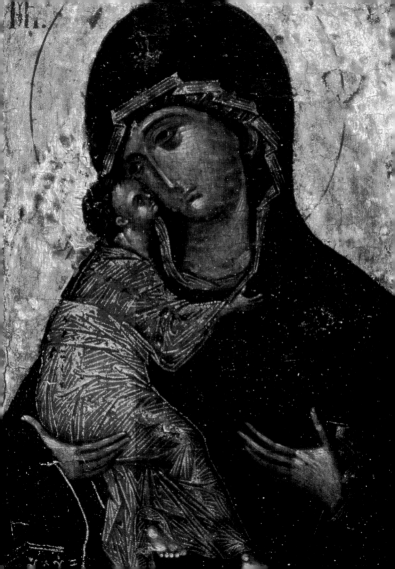

Andrei Rublev
c. 1370–1430

**The Old Testament Trinity
Prefiguring the Incarnation**
Icon

c. 1410

Tempera on panel
56 x 45 (142.2 x 116.8 cm)
Tretyakov Gallery
Moscow

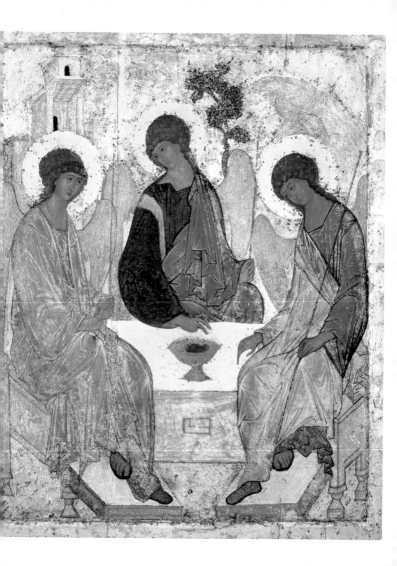

Andrei Rublev
c. 1370–1430

Saint Paul
Icon

c. 1410

Tempera and gold on panel
63 x 43 in (160 x 109 cm)
Tretyakov Gallery
Moscow

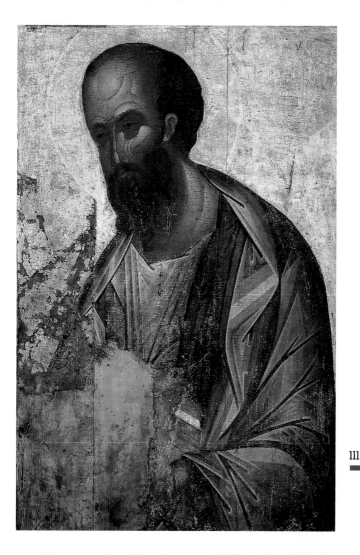

112

Emanuele Tzanes Bunialìs
Rethymno, Crete, 1610–Venice, 1690

Noli Me Tangere
Icon

1657

Tempera and gold on panel
47 ¹/₂ x 30 in (120 x 68.5 cm)
Icon Museum
Dubrovnik

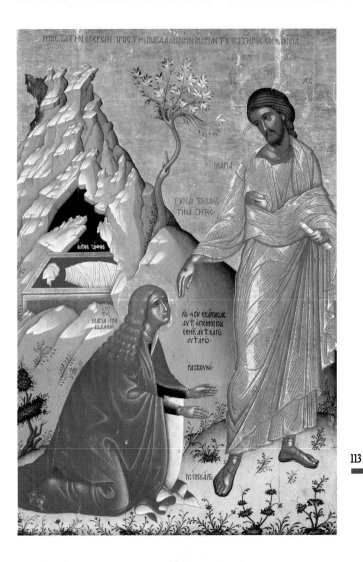

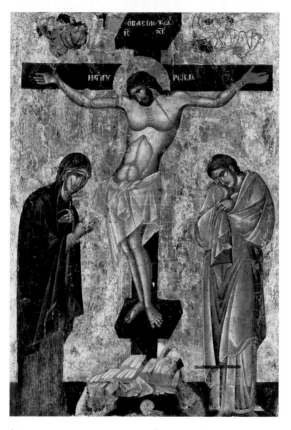

above
Crucifixion
Icon

13ᵀᴴ CENTURY

Tempera and gold on panel
38 x 26 ¹/₄ in (97 x 67 cm)
Icon Gallery
Ohrid

opposite
Annunciation
Icon

13ᵀᴴ CENTURY

Tempera and gold on panel
37 ¹/₂ x 31 ¹/₄ in (94.5 x 80.3 cm)
Icon Gallery
Ohrid

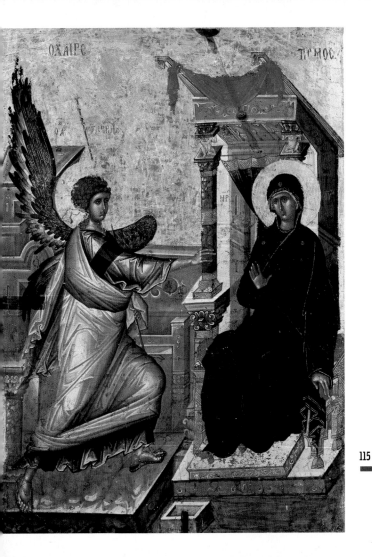

ΟΧΑΙΡΕ

ΤΙΣΜΟΣ

ΘΑ

ΓΑΒΡΙΗΛ

ΜΡ

116

The Chosen Saints
Icon

16ᵀᴴ CENTURY

Tempera and gold on panel
Museum of History and Architecture
Pskov

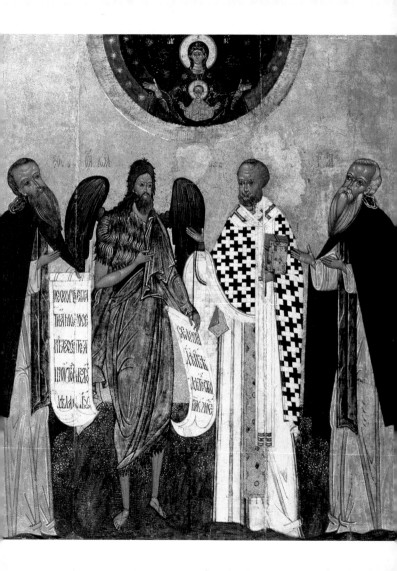

Emanuele Tzanes Bunialis
Rethymno, Crete, 1610–Venice, 1690

118

Saint Anne with the Virgin
Icon

1637

Tempera and gold on panel
41 ³/₄ x 30 in (106 x 76 cm)
Benaki Museum
Athens

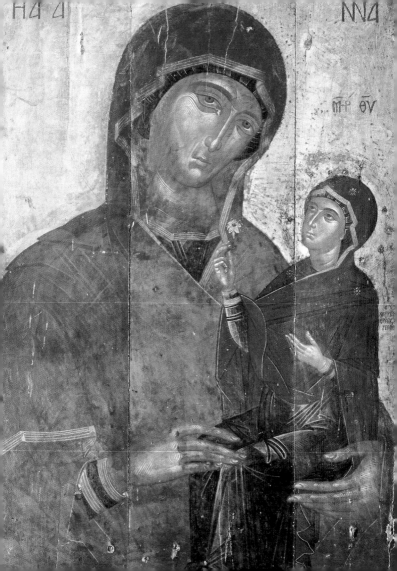

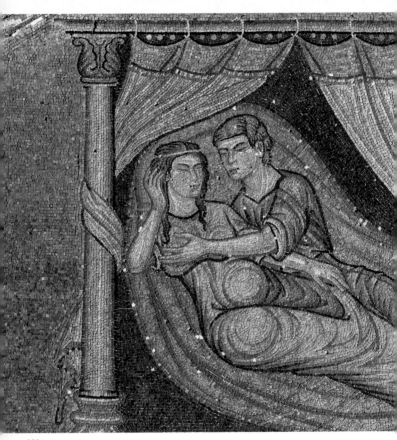

120

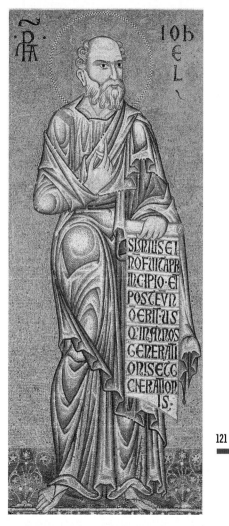

SI MULTI EL NO FUI CA PR INCIPIO · ET POST CVM O ERIT · US O IN MVNDS GENERATI ONIS ET O GNERATIO NIS;

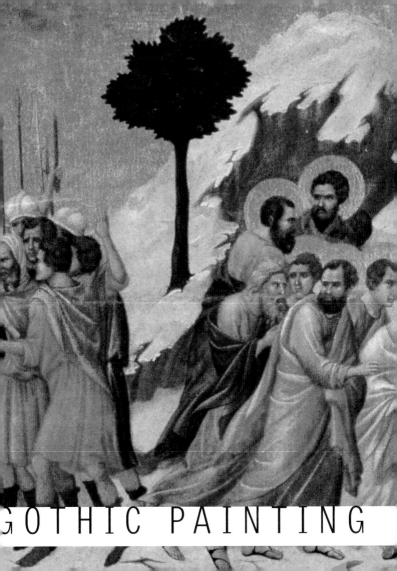

GOTHIC PAINTING

The origins of the Gothic style in painting can be traced to the stained glass windows of French cathedrals of the late twelfth and early thirteenth centuries. New technology in architecture (specifically, the use of the flying buttress, which freed exterior walls from their load-bearing function), made it possible to replace masonry with vast stained glass narrative cycles. These colorful depictions took their inspiration from the style of the sculpture of the period, based on sinuous lines and elongated figures. Among the most impressive examples of French Gothic stained glass windows are the ones in the Cathedral of Chartres and Sainte-Chapelle, in Paris.

Alongside the art of the stained glass window, especially in France, the Gothic style also developed in the decoration of illuminated manuscripts. A great many of the limners had their workshops in Paris. Toward the end of the thirteenth century, two names stand out: Honoré and Jean Pucelle (active c.1310–1334), who added a degree of plastic substantiality to the linear style of the figures. Much less is known about the development of mural painting, since the fresco cycles have either vanished or have been altered over time.

From France, the Gothic style spread to England, Germany, the Iberian peninsula, and Italy. It was in Italy, at the end of the thirteenth century and continuing throughout the fourteenth century, that Gothic panel and fresco painting reached some of its high points. In the second half of the thirteenth century, the Italian peninsula was still under the influence of Byzantine painting. The painter Cimabue (c. 1240–1302) began work in this context and became one of the first artists to free Italian painting of Byzantine graphism and geometric style. In his work, the figures take on a certain degree of plasticity, even though the sinuous line remains the chief stylistic element. There is also a greater perception of three-dimensional space. The two versions of the *Maestà* (Florence, Uffizi; Paris, Louvre) provide outstanding examples of this. The same can be said of the work

of the Sienese painter Duccio di Buoninsegna (c.1255–1318), whose figures and clothing are delineated in a flowing, melodious outline.

The Florentine painter and architect, Giotto (c.1267–1337), probably a pupil of Cimabue, was one of the most influential artists of the fourteenth century. We know that he worked as a painter as early as the last two decades of the thirteenth century in the newly built Upper Basilica of Assisi, which was a major point of reference for artists of the time. Among others, his supposed master, Cimabue, worked there, as did, later, the Sienese painters Simone Martini (c.1284–1344) and Ambrogio (1285–1348) and Pietro (1280–1348) Lorenzetti. Giotto painted scenes from the Old and New Testament and the *Stories of Saint Francis*. In contrast to their predecessors, Giotto and his assistants painted figures that were more fluid and rounded, giving great emphasis to three-dimensional space. With Giotto, the abstract rendering of figures and settings in Byzantine painting and French Gothic was replaced by more solid depictions. Where figures had once been quite stylized, they now took on a decidedly human aspect. This is why Giotto is considered to be a forerunner of Renaissance painting. His work would serve as a source of inspiration for artists such as Masaccio and Michelangelo.

Giotto worked at Assisi, Rome, Florence, and Naples, but also at Padua, where, in the first few years of the fourteenth century, he painted the *Stories of the Virgin Mary and Her Parents* and the *Stories of Christ* in the Arena Chapel. In these frescoes, more than ever before, the painter sought to give a solid aspect to his characters and to place them in an articulated, three-dimensional space. His new pictorial idiom could be seen in various parts of Italy, and its influence would be felt throughout the fourteenth century, in the painting of his pupils and followers, the painters known as "Giottesque" and including Taddeo Gaddi (c.1295–1366), Giovanni da Milano (c.1325–after 1369), and Altichiero da Zevio (documented 1369–1384).

Although strongly tied to the French linear tradition handed down to him by Duccio, the great Sienese painter Simone Martini (c.1284–1344) was also influenced by Giotto, especially in terms of the new conception of space. Simone, however, was a Gothic painter in the narrow sense of the word and he expressed himself chiefly through the line, which enclosed the figures in sinuous, musical outlines.

Even more open to Giotto's style were two other great painters from Siena: the brothers Pietro and Ambrogio Lorenzetti, who both died, probably of the plague, in 1348. Pietro executed some of the more dramatic frescoes in the Lower Basilica of Assisi, as well as paintings in which strongly plastic figures were set in an almost perfect three-dimensional space, such as the polyptych with the *Birth of the Virgin* (Siena, Museo dell'Opera del Duomo). Ambrogio's work is characterized by the number of new iconographic subjects and by his tireless work on style. He was responsible for the first series of paintings with a civic theme in the Christian era: the Allegories of Good and Bad Government frescoed in the Palazzo Pubblico, or Town Hall, of Siena. Ambrogio was also responsible for the first landscape views of the city and the countryside.

The late fourteenth century was marked by an artistic style known as the "International Gothic" or "fiorito" (flowery), which lasted nearly until the middle of the fifteenth century, coexisting with new, early Renaissance ideas about painting. This school is called "international" because it developed simultaneously in many parts of Europe. The term "fiorito" refers, on the other hand, to its clearly decorative aspect, its refinement, and its attention to the elements of nature. Moreover, the works of the International Gothic are full of elements taken from court life—clothing, hairstyles, and so on—even when dealing with religious subjects, which gives them a decidedly worldly aspect. For this reason this style is often described as "courtly painting." As well as French and Flemish miniatures, notable examples of this style can be found among the works of the

German painters Konrad von Soest (c.1370–after 1422), the Master Francke or the Master of the Garden of Eden of Frankfurt (1400–c.1435), the Italian painters Giovannino de' Grassi (active 1389–1398), Michelino da Besozzo (documented 1388–1445), Stefano da Verona (c.1379–after 1438), Gentile da Fabriano (c. 1370–1427), Pisanello (c.1395–1455), and Sassetta (c.1400–1450), and the Bohemian painter, the Master of Třeboň (active 1380–1390).

Window with Moses and Christ
detail

MID. 13ᵀᴴ CENTURY

Stained glass
Sainte-Chapelle
Paris

Pisanello
Verona, c. 1395–1455

**Saint George and
the Princess**
detail

1436–1438

Fresco
Sant'Anastasia
Verona

Duccio di Buoninsegna
Siena, c. 1255–c. 1318

The Betrayal of Christ
Maestà
(back, panel)

1308–1311

Tempera and gold on panel
133 ³/₄ x 88 in (212 x 425 cm)
Museo dell'Opera del Duomo
Siena

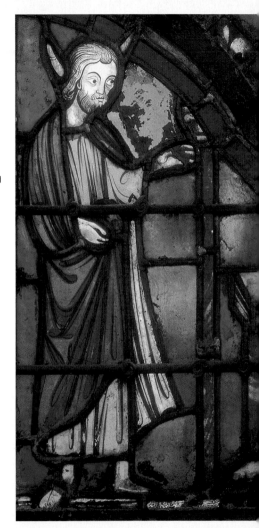

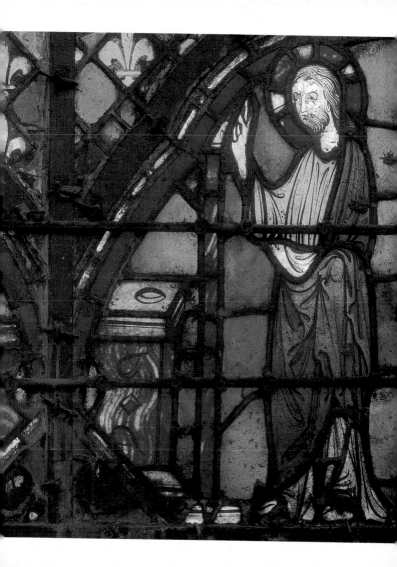

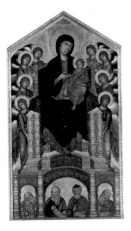

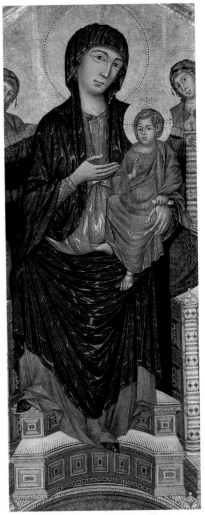

Cimabue (Cenni di Pepo)
Florence, c. 1240–Pisa, 1302

Maestà

c. 1285–1286

Tempera and gold on panel
133 $^1/_4$ x 88 in (338.5 x 223.5 cm)
Uffizi Gallery
Florence

opposite

Duccio di Buoninsegna
Siena, c. 1255–c. 1318

Maestà

c. 1285

Tempera and gold on panel
177 $^1/_4$ x 115 in (450 x 292 cm)
Uffizi Gallery
Florence

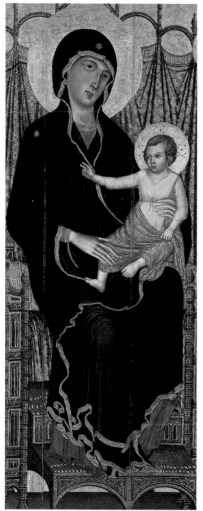

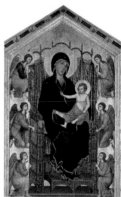

132

Cimabue (Cenni di Pepo)
Florence, c. 1240–Pisa, 1302

Crucifixion

c. 1288

Tempera and gold on panel
176 1/2 x 153 1/2 in (448 x 390 cm)
Santa Croce
Florence

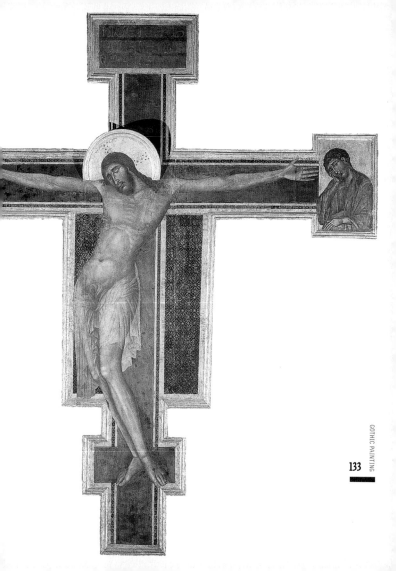

134

Giotto di Bondone
Colle di Vespignano, c. 1267–Florence, 1337

Preaching before Honorius III
Scenes from the Life of Saint Francis

c. 1288–1294

Fresco
San Francesco (upper church)
Assisi

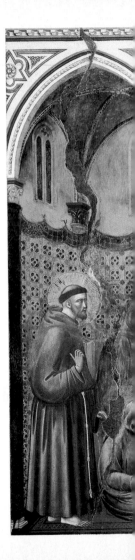

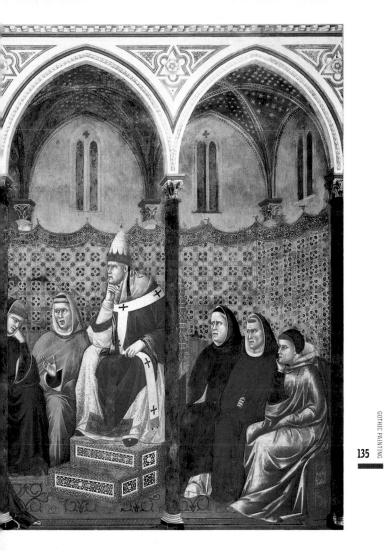

Giotto di Bondone

Colle di Vespignano, c. 1267–Florence, 1337

136 **The Expulsion of the Devils
from Arezzo**

Scenes from the Life of Saint Francis

c. 1288–1294

Fresco
San Francesco (upper church)
Assisi

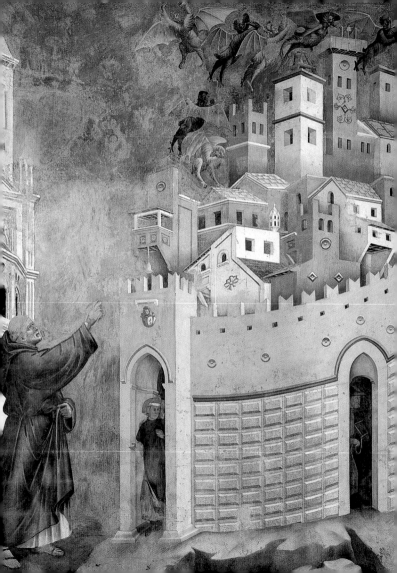

138

Giotto di Bondone
Colle di Vespignano, c. 1267–Florence, 1337

Crucifixion

c. 1290

Tempera on panel
227 $^1/_2$ x 159 $^3/_4$ in (578 x 406 cm)
Santa Maria Novella
Florence

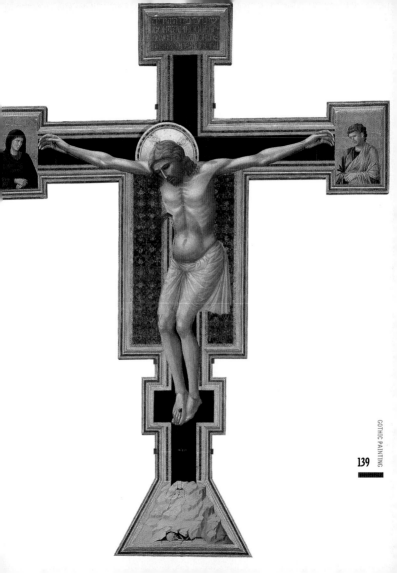

140

Giotto di Bondone
Colle di Vespignano, c. 1267–Florence, 1337

Meeting at the Golden Gate

c. 1305

Fresco
Arena Chapel
Padua

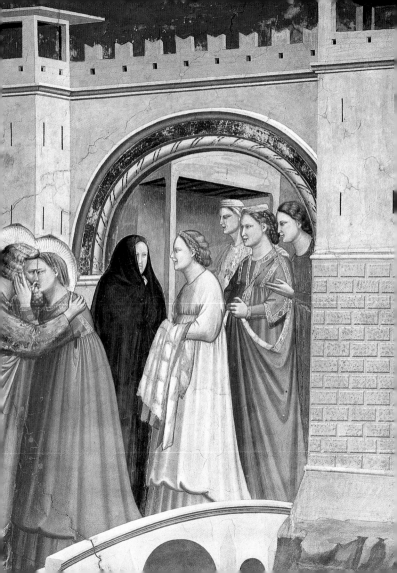

142

Giotto di Bondone

Colle di Vespignano, c. 1260–Florence, 1337

Ognissanti Madonna

c. 1310

Tempera and gold on panel
128 x 80 in (325.1 x 203.2 cm)
Uffizi Gallery
Florence

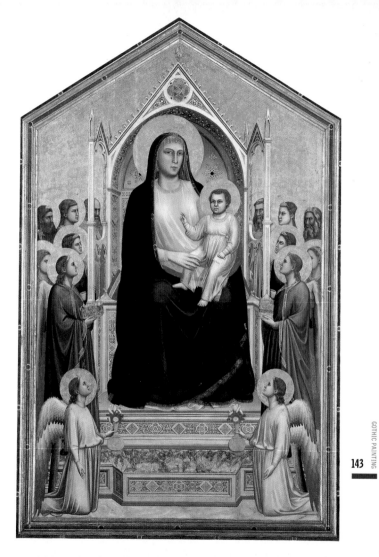

144

Giotto di Bondone

Colle di Vespignano, c. 1267–Florence, 1337

The Death of Saint Francis

Scenes from the Life of Saint Francis

c. 1317

Fresco
Santa Croce (Bardi Chapel)
Florence

146

Giotto di Bondone
Colle di Vespignano, c. 1267–Florence, 1337

Saint Stephen

c. 1330–1335

Tempera and gold on panel
33 x 21 ¹/₄ in (84 x 54 cm)
Horne Museum
Florence

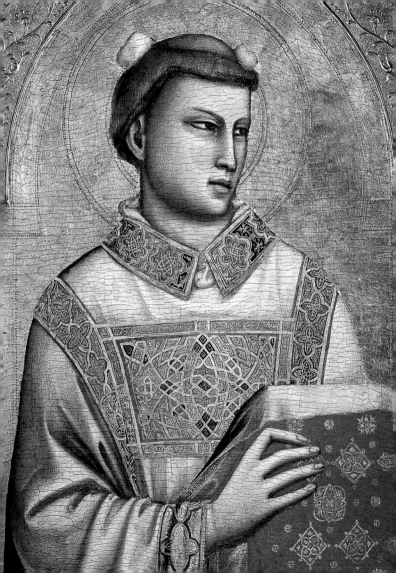

148

Simone Martini
Siena, c. 1284–Avignon, 1344

Saint Martin in Meditation

AFTER 1317

Fresco
San Francesco (lower church)
Assisi

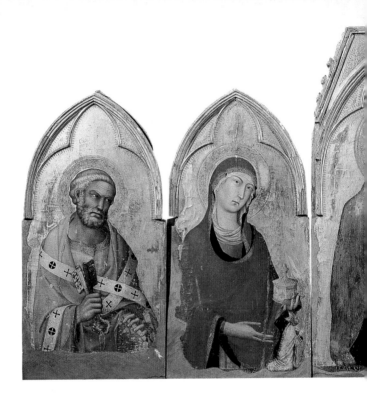

150

Simone Martini
Siena, c. 1284–Avignon, 1344

**Altarpiece with Madonna and Child
with Saints**

c. 1321

Tempera and gold on panel
44 ½ x 101 ¼ in (113 x 257 cm)
Museo dell'Opera del Duomo
Orvieto

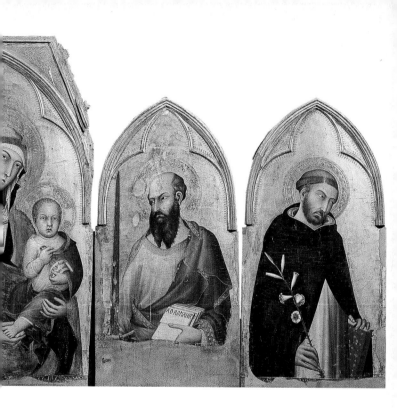

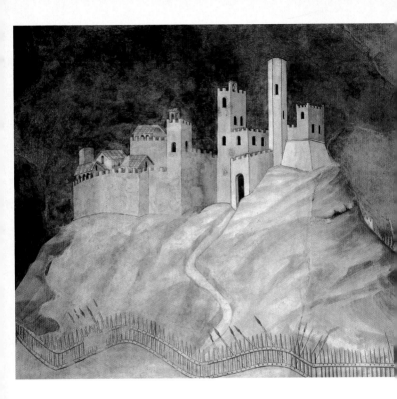

152

Simone Martini
Siena, c. 1284–Avignon, 1344

Guidoriccio da Fogliano Besieging Monte Massi

1330

Fresco
132 x 97 ¹/₂ in (335.3 x 975.4 cm)
Palazzo Pubblico
Siena

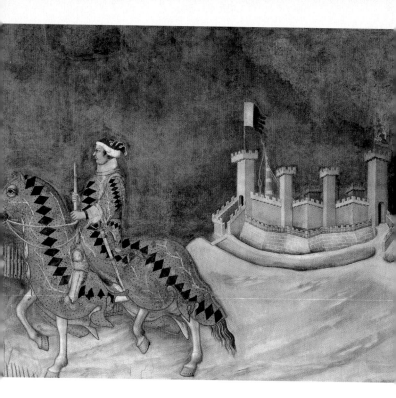

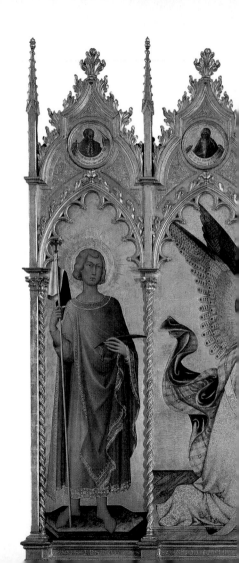

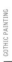

154

Simone Martini
Siena, c. 1284–Avignon, 1344

Annunciation

1333

Tempera and gold on panel
71 ³/₄ x 82 in (184 x 210 cm)
Uffizi Gallery
Florence

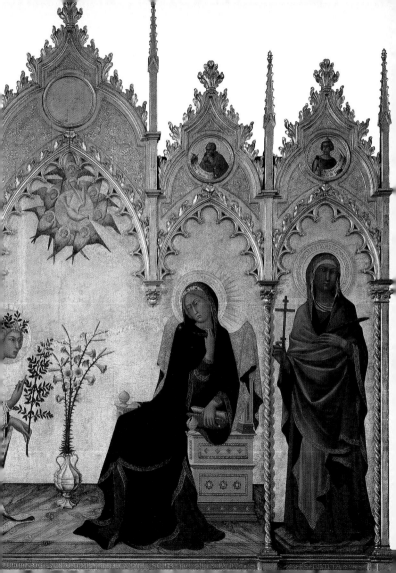

Simone Martini
Siena, c. 1284–Avignon, 1344

Road to Cavalry
Orsini Altarpiece (panel)

c. 1336

Tempera and gold on panel
11 3/$_4$ x 7 3/$_4$ in (30 x 20 cm)
Louvre
Paris

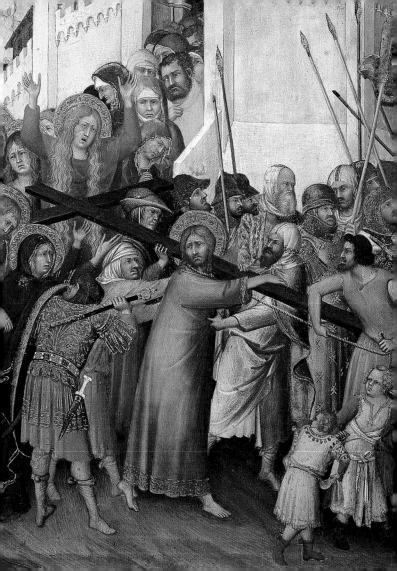

Pietro Lorenzetti
Siena, 1280-1348

**Madonna and Child,
Annunciation, Assumption, and Saints**
Polyptych

1320

Tempera and gold on panel
117 ¹/₄ x 121 ³/₄ in (298 x 309 cm)
Pieve di Santa Maria
Arezzo

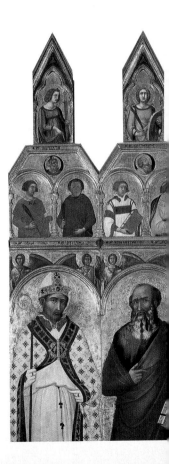

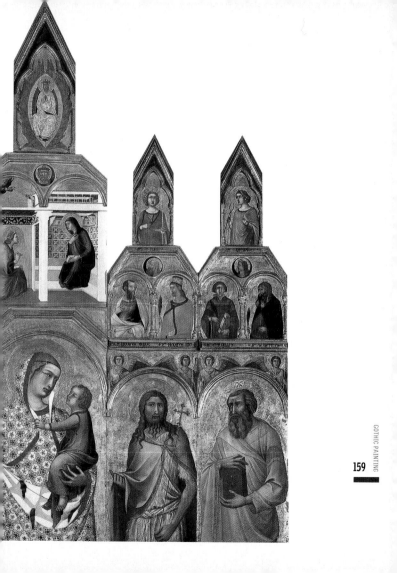

Pietro Lorenzetti
Siena, 1280–1348

Birth of the Virgin

1335–1342

Tempera on panel
73 x 71 in (187 x 182 cm)
Museo dell'Opera Metropolitana
Siena

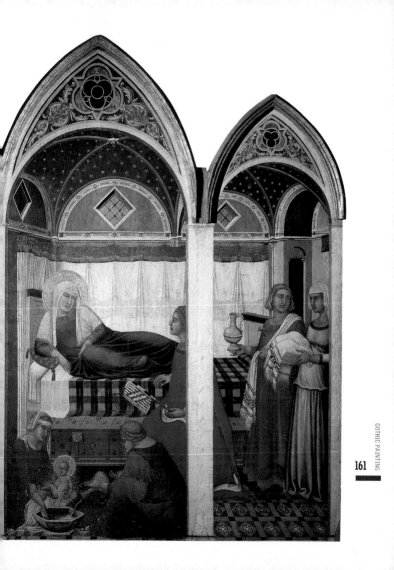

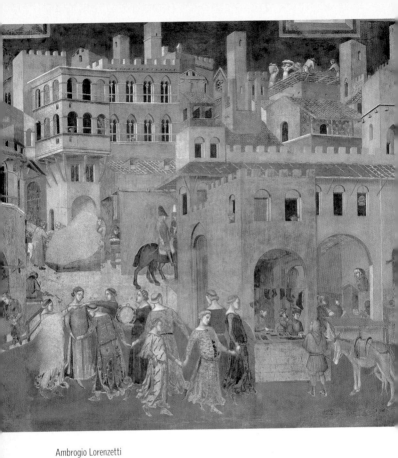

Ambrogio Lorenzetti

162

Siena, 1285-1348

The Effects of Good Government, The City

detail

1338-1340

Fresco
Palazzo Pubblico
Siena

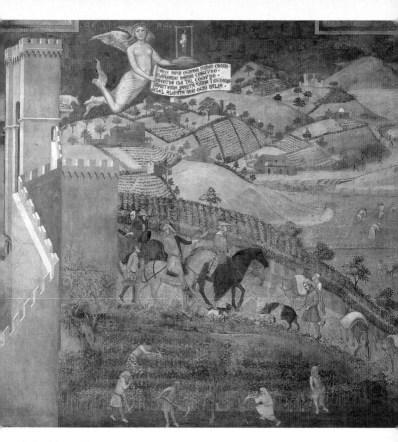

Ambrogio Lorenzetti
Siena, 1285–1348

The Effects of Good Government, The Country
detail

1338–1340

Fresco
Palazzo Pubblico
Siena

164

Ambrogio Lorenzetti
Siena, 1285–1348

Presentation in the Temple

1342

Tempera on panel
100 ½ x 65 ½ in (257 x 168 cm)
Uffizi Gallery
Florence

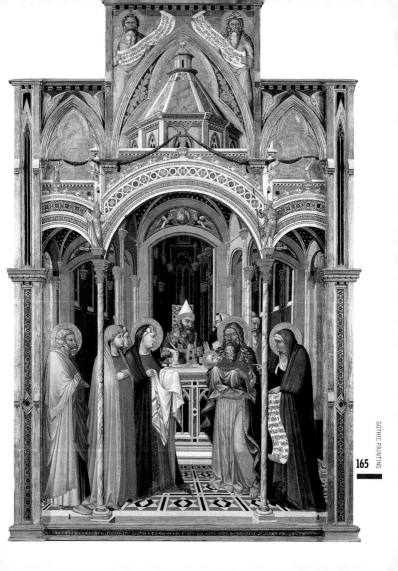

166

Taddeo Gaddi

Florence, c. 1295–1366

Annunciation to the Shepherds

1328–1332

Fresco
Santa Croce (Baroncelli Chapel)
Florence

168 Taddeo Gaddi
Florence, c. 1295-1366

Mary in the Temple
1328-1332

Fresco
Santa Croce (Baroncelli Chapel)
Florence

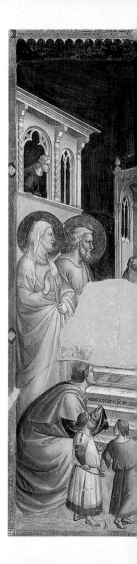

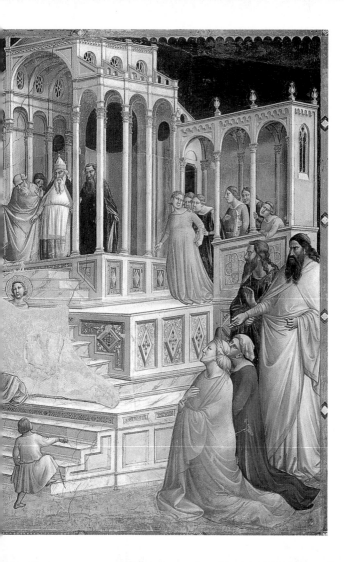

Orcagna (Andrea di Cione)
Florence, 1308-1368

Jacopo di Cione
Active in Florence, between 1343 and 1368

The Calling of Saint Matthew
Triptych depicting the Life of Saint Matthew
(panel)

1367
Tempera and gold on panel
Uffizi Gallery
Florence

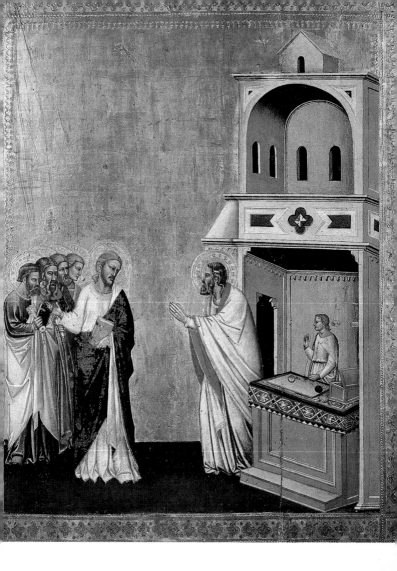

Orcagna (Andrea di Cione)
Florence, 1308-1368

172 **Beggars**
The Triumph of Death
(detail)

1348

Fresco
Camposanto
Pisa

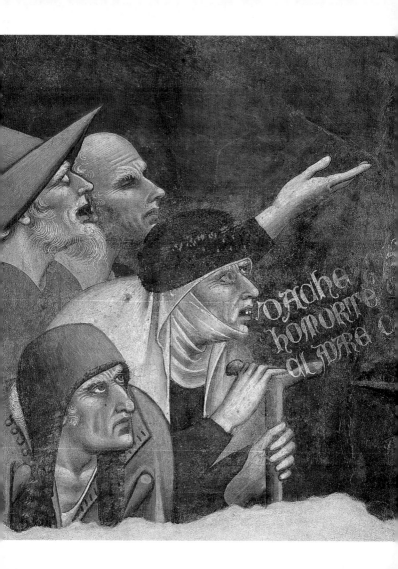

174

Orcagna (Andrea di Cione)
Florence, 1308–1368

The Damned and Demons
Hell
(fragment)

1348

Fresco
Museo dell' Opera di Santa Croce
Florence

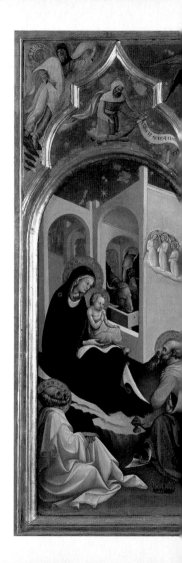

Lorenzo Monaco
Siena, c. 1370–Florence, c. 1425

Adoration of the Magi

c. 1422

Tempera on panel
Uffizi Gallery
Florence

pp. 176–177

Giovanni da Milano
Como, c. 1325–after 1369

Joachim Expelled from the Temple
Scenes from the Life of the Virgin

1365

Fresco
Santa Croce (sacristy)
Florence

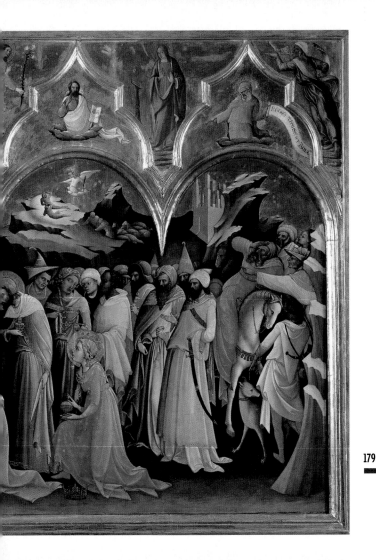

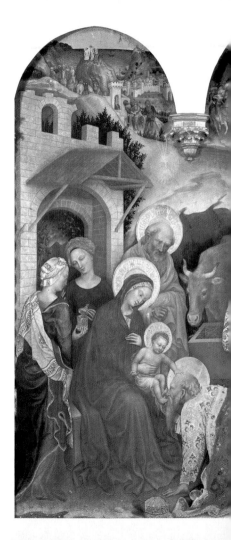

Gentile da Fabriano (Gentile di
Niccolò di Giovanni Massi)
Fabriano, c. 1370–Rome, 1427

Adoration of the Magi

1423

Tempera on panel
118 x 111 in (300 x 282 cm)
Uffizi Gallery
Florence

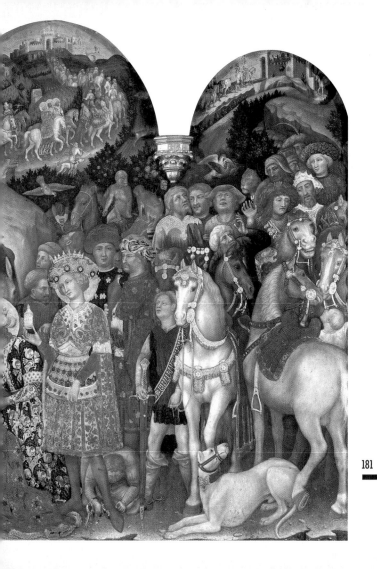

182

Bonifazio Bembo

active in Brescia, c.1420-1477

Tarot Card, The Page of Coins
7 x 3 ¹/₄ in (17.5 x 8.5 cm)
Accademia Carrara
Bergamo

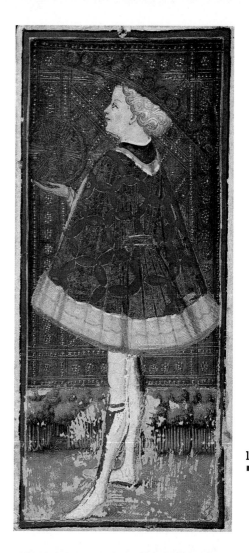

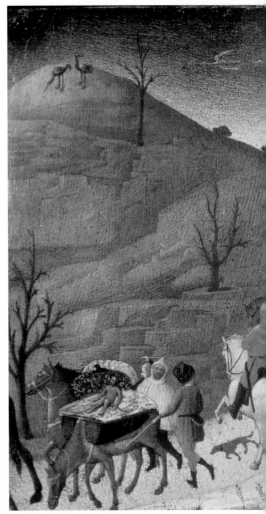

184

Sassetta
(Stefano di Giovanni)
Cortona?, c.1400–1450

Journey of the Magi

c. 1435

Tempera and gold on panel
8 ½ x 11 ¾ in (21.6 x 29.9 cm)
Metropolitan Museum of Art
New York

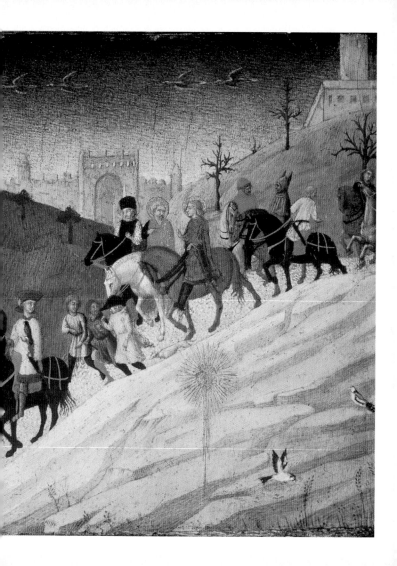

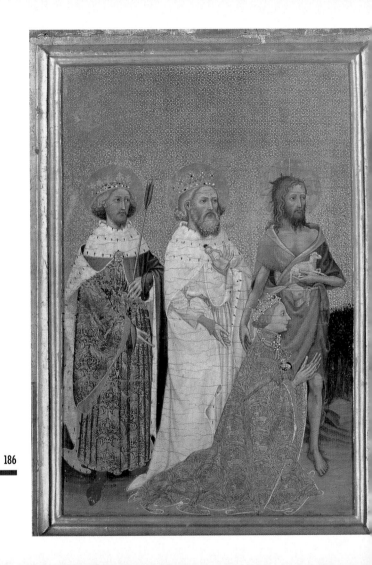

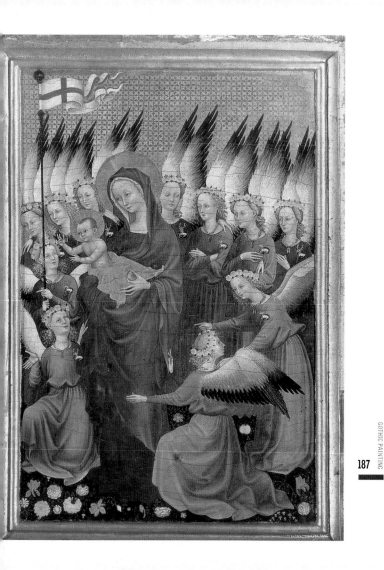

Henri Bellechose
First half of the 15ᵗʰ century

**Crucifixion with the Holy
Eucharist and the Martyrdom of
Saint Denis**
Saint Denis Altarpiece

1416

Oil on panel
63 ³/₄ x 83 in (162 x 211 cm)
Louvre
Paris

pp. 186–187

Master of the Wilton Diptych
Anonymous English or French artist

Wilton Diptych
Richard II presented to the Virgin and Child
by his Patron Saint John the Baptist and
Saints Edward and Edmund

c. 1395

Tempera and gold on panel
22 ¹/₄ x 11 ¹/₂ in (57 x 29.2 cm)
National Gallery
London

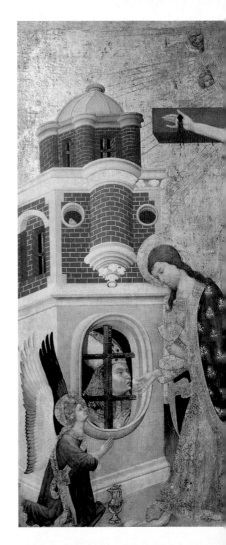

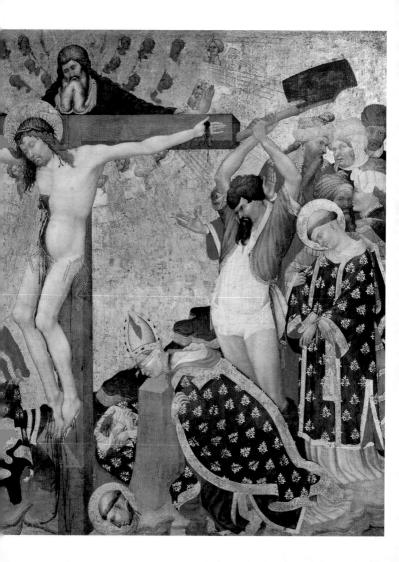

Stephan Lochner

Meersburg Lake Constance, c. 1400–
Cologne, 1451

Madonna in the Rose Garden

c. 1440

Oil and gold on panel
20 x 15 $^3/_4$ in (51 x 40 cm)
Verona Wallraf-Richartz Museum
Cologne

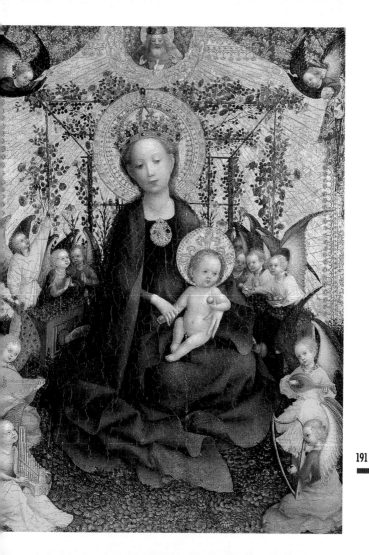

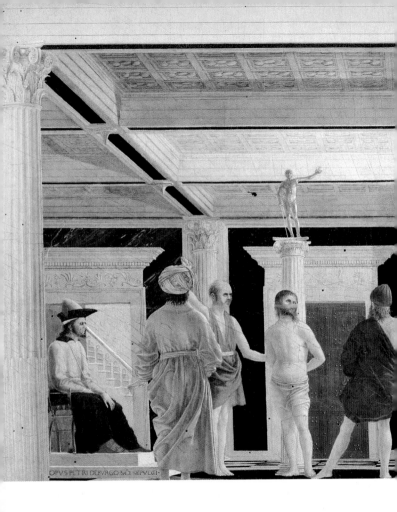

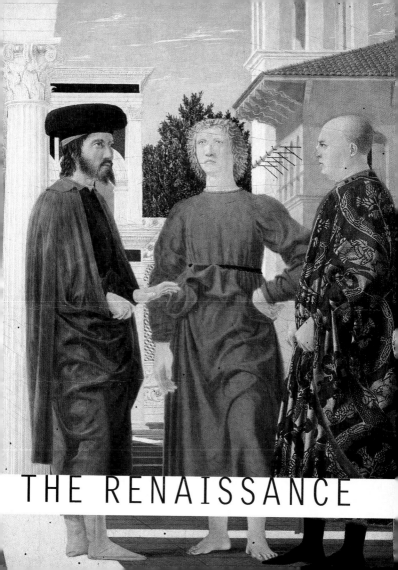

THE RENAISSANCE

The Renaissance can be described as a time when humanity developed self-awareness after many centuries (from the advent of Christianity to the fourteenth century) during which a mystical vision of the universe had prevailed. In the fields of painting, literature, and science, the fifteenth century seemed to waken the need in man to know himself, to explore his world, and to gain a rational understanding of the laws that govern the world. In painting, this led to the depiction of three-dimensional space according to the mathematical laws discovered at the beginning of the fifteenth century by the Florentine architect Filippo Brunelleschi (1377–1446). These laws are known today as "rational perspective."

At first there were two cradles of Renaissance painting: Florence and Flanders. In the Italian city, ruled by the Medici family, who became great patrons of art (previously art was commissioned almost exclusively by the Church), painters not only struggled to perfect the rational portrayal of three-dimensional space, they also attempted to unify their paintings by using the same source of light for all the various parts of each composition. In other words, all light was cast in a single direction, thus uniting all the figures in a single space and a single narrative time-frame. This appears in the work of Masaccio (1401–1428), especially in the frescoes in the Brancacci Chapel (Florence), the true birthplace of Renaissance painting. This magnificent example of rationalism was seen by many painters, from Filippo Lippi (1406–1469) to his son Filippino (c. 1457–1504), and from Fra' Angelico (c.1395–1455) and Piero della Francesca (c.1415/20–1492) to Michelangelo (1475–1564). In contrast to the golden backgrounds of the paintings of previous centuries, which gave the impression of an unreal space, perspective and the realistic use of light had the effect of bringing the scenes portrayed closer to the real world, irrespective of whether the subject was religious or profane. This approach to the real world is also known as "humanism," as distinguished from mysticism. The term signifies that man, as a rational being, had become the focus of the artist's

interest. It also meant that artists, within given limits, would also subordinate religious portrayals to the measure of man and the reality of life on earth.

Another fundamental aspect of early Italian Renaissance painting is the prevailing interest in classical culture—Greek and Roman literature, painting, and statuary. Evident at first in the sculpture of Brunelleschi, Lorenzo Ghiberti (1378-1455), and Donatello (1386-1466), it became a major point of reference for many leading painters, such as Andrea Mantegna (c.1450-1460) and Sandro Botticelli (1445-1510). Mantegna's love of archeology emerges continually in his work, both in his depictions of Roman ruins and classical architecture, and in the poses his characters assume. Botticelli's relationship with the classical world can be seen in his paintings on mythological subjects such as the *Primavera*, the *Birth of Venus*, *Pallas and the Centaur*, and *Mars and Venus*. These works were all linked to Neoplatonism, a philosophical school engaged in recovering and interpreting classical texts that re-emerged in Florence in the fifteenth century.

Flemish humanism differed from its Italian counterpart. At the turn of the fifteenth century, Flemish painters had not yet absorbed the techniques and ideas of Florentine rational perspective. Still, in an intuitive way, they began to focus their attention on nature and human beings, analyzing them in minute detail using a sophisticated set of techniques derived from the practice—common in northern Europe—of the miniature. They also employed oil paints, which allowed them to render detail and the infinite nuances of light in space and on the human figure. They painted the first true landscapes, albeit as backgrounds for biblical scenes or portraits. Among the pioneers of landscape painting, and of frontal and three-quarter-view portraits, were Jan van Eyck (c.1390-1441) and Rogier van der Weyden (c.1399-1464). Van Eyck, a painter from Bruges, worked for many years in the service of Duke Philip III of Burgundy. Van der Weyden was a painter from Brussels, but he also worked in

Ferrara, Italy, around 1450. The Flemish style spread through Europe, influencing many of the leading Dutch and German painters as well as painters on the Iberian peninsula.

Trade between Italy and Flanders thrived during the fifteenth century. The many Italian merchants and banking agents living in Flemish cities, including Giovanni Arnolfini and Tommaso Portinari, commissioned work from Flemish painters, especially portraits. Before long, paintings by Jan van Eyck, Rogier van der Weyden, and Hans Memling (c.1435–1494), to name a few, were to be found in Italy. In the second half of the fifteenth century, Italian painting incorporated many Flemish innovations. Alongside rationalism, and questions of space and proportion, there was intense interest in the natural world as a source of knowledge for painting itself. Leonardo da Vinci (1452–1519), who received his training in the Florentine workshop of Andrea del Verrocchio (c.1435–1488), was the epitome of the fusion of science and painting, blending rationalism, observation of the natural world, and artistic creativity.

During the sixteenth century, Rome and Venice became the great centers of art, though a few smaller towns offered extraordinary examples of innovation and expressive power. Parma, for instance, was home to Correggio (1489–1534), one of the greatest Renaissance painters. The large projects undertaken by the Church at this time attracted many architects and a small army of sculptors and painters to Rome, the capital of Christendom. Michelangelo and Raphael (1483–1520) both worked there, for the powerful pope Julius II. Michelangelo executed the frescoes in the vault of the Sistine Chapel between 1508 and 1512. Raphael frescoed the pope's new apartments with works that included the renowned *School of Athens*. Despite their many differences, these two geniuses of high Renaissance painting both rejected the rigid symmetry typical of fifteenth-century painting, replacing it with gesture and dynamism.

The only other school of painting that bears comparison with Rome at this time was in Venice. The Venetian artist Titian (1490-1576), a pupil of Giovanni Bellini (c.1432-1516) and a colleague of Giorgione (c.1477-1510), was destined to become the most famous painter of his time. He was admired and protected by Francis I, king of France, Charles V, the Hapsburg emperor, and by Charles's son, Philip II, king of Spain. Titian's paintings—including many portraits of his powerful patrons—made their way into the courts of Europe, setting a standard for future generations of artists. Titian was the leading figure of what would come to be known as "Venetian painting," a style in which the interplay of colors engenders a dominant tone that unites figures and landscape. The fluid brushstroke and the luminosity of many of his paintings would inspire, in Italy and elsewhere, many painters, such as Tintoretto (1518-1594), Veronese (c.1528-1588), PeterPaul Rubens (1577-1640), Diego Velázquez (1599-1660), and Rembrandt Harmenszoon van Rijn (1606-1669).

By this time, the greatest painters of Europe looked to Italy. One of them was Albrecht Dürer (1471-1528), master of the German Renaissance, who made two long visits to Venice and northern Italy, learning from the work of Mantegna and Bellini. Dürer brought back with him to Germany the rationalism that had developed in Italian painting. The influence of Classical art upon Italian art, in turn, affected the style of the German painter, especially in the rendering of the human figure.

In the second decade of the sixteenth century, however, a reaction began in Italy against rationalism. Known as Mannerism, it was distinguished, in painting, by a loss of equilibrium, fewer fixed points of spatial and architectural reference, and a different way of rendering the human figure. Compositions became extravagant and allegorical subjects became complex and often mysterious. The human figure was often elongated disproportionately, as in the works of Pontormo (1494-1555/7), Agnolo Bronzino (1503-1572),

Parmigianino (1503–1540), and the Venetian, Tintoretto (1518–1594). Moreover, the overt sensuality with which figures were often rendered clashed, in a clear and provocative way, with the religious subjects being portrayed. Examples of this are Jacopo Pontormo's *Deposition*, and Parmigianino's *Madonna of the Long Neck*. The term "Mannerism" derives from the word "*maniera*" ('manner'), used by Giorgio Vasari in his *Lives of the Most Eminent Painters, Sculptors, and Architects*, first published in 1550. He used it to refer to the fact that these painters took their inspiration from Michelangelo's energetic and "*avvitate*" ('twisted' or 'corkscrew') figures. Mannerism lived on through three full generations of artists, lasting right up until the turn of the seventeenth century.

Masaccio
(Tommaso di Ser Giovanni Cassai)
San Giovanni Valdarno, 1401–Rome, 1428

The Expulsion from Paradise

c. 1427

Fresco
81 ³/₄ x 34 ¹/₄ in (208 x 88 cm)
Santa Maria del Carmine (Brancacci Chapel)
Florence

pp. 192–193

Piero della Francesca
Borgo San Sepolcro, c. 1415/20–1492

The Flagellation of Christ

c. 1463–1464

Mixed technique on panel
23 x 31 ³/₄ in (59 x 81.3 cm)
Galleria Nazionale delle Marche
Urbino

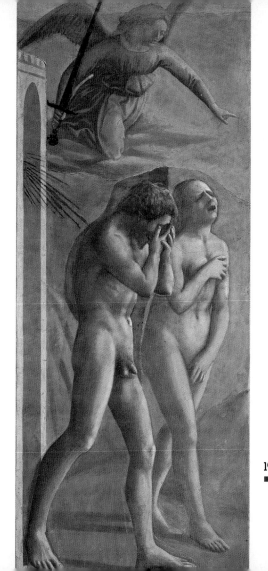

Masaccio
(Tommaso di Ser Giovanni Cassai)
San Giovanni Valdarno, 1401–Rome, 1428

The Tribute Money

1425–1427

Fresco
100 $^1/_4$ x 235 $^1/_2$ in (255 x 598 cm)
Santa Maria del Carmine (Brancacci Chapel)
Florence

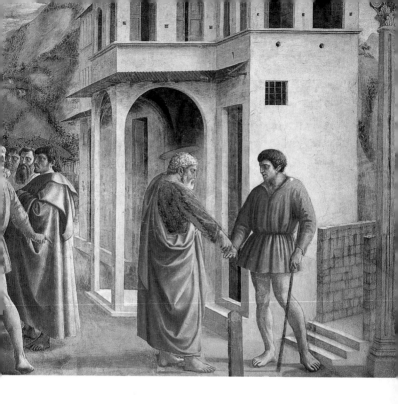

Masaccio
(Tommaso di Ser Giovanni Cassai)
San Giovanni Valdarno, 1401–Rome, 1428

The Holy Trinity

1428

Fresco
260 x 123 $^1/_2$ in (667 x 317 cm)
Santa Maria Novella
Florence

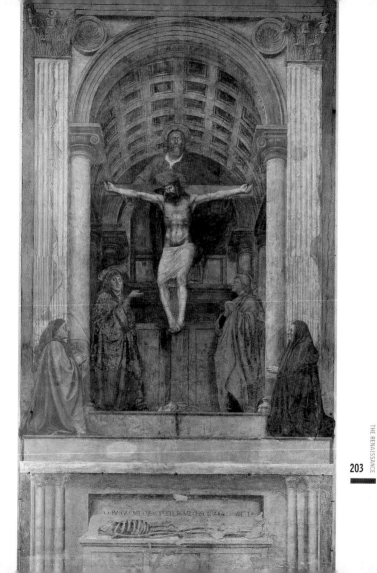

204

Masolino da Panicale

Panicale, Valdarno, 1383–Florence, c. 1440

The Temptation of Adam and Eve

1424–1425

Fresco
93 ¹/₂ x 35 in (214 x 90 cm)
Santa Maria del Carmine (Brancacci Chapel)
Florence

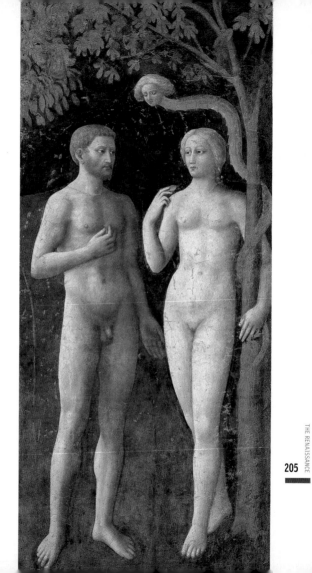

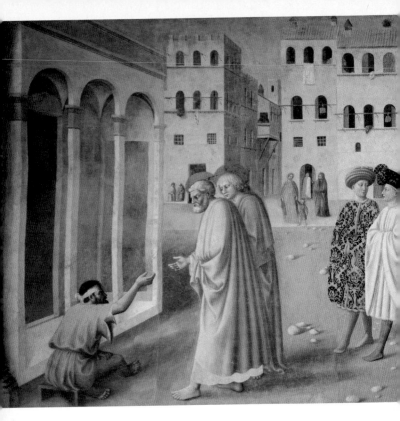

Masolino da Panicale

Panicale, Valdarno, 1383–Florence, c. 1440

Masaccio (Tommaso di Ser Giovanni Cassai)

San Giovanni Valdarno, 1401–Rome, 1428

Saint Peter Healing a Cripple and the Raising of Tabatha

c. 1425

Fresco
100 $\frac{1}{2}$ x 235 $\frac{1}{2}$ in (255 x 598 cm)
Santa Maria del Carmine (Brancacci Chapel)
Florence

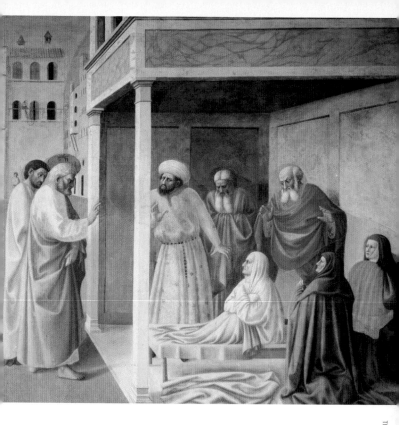

Fra' Angelico
(Fra' Giovanni da Fiesole)
Vicchio di Mugello, c.1395–Rome, 1455

Incoronation of the Virgin

BEFORE 1435

Tempera on panel
113 x 83 in (209 x 206 cm)
Louvre
Paris

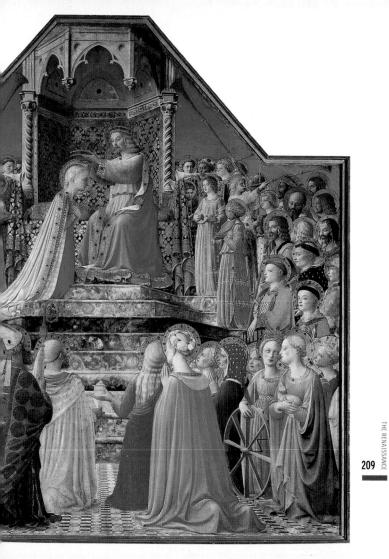

Fra' Angelico
(Fra' Giovanni da Fiesole)
Vicchio di Mugello, c.1395–Rome, 1455

Annunciation

BETWEEN 1438–1445

Fresco
90 ½ x 117 in (230 x 297 cm)
Museo di San Marco
Florence

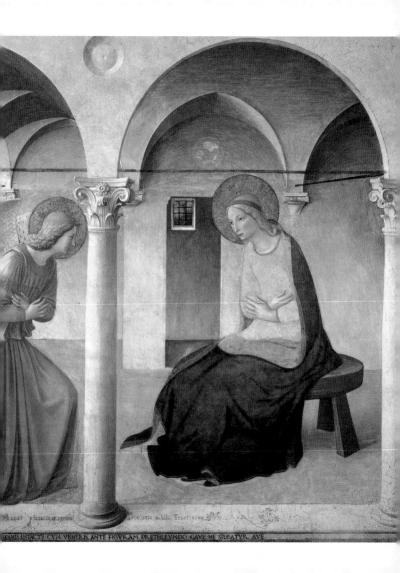

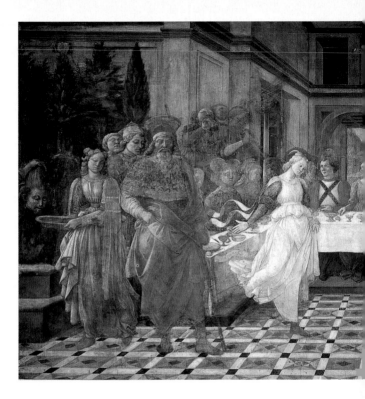

212

Fra' Filippo Lippi
Florence, 1406–Spoleto, 1469

The Feast of Herod

1452–1464

Fresco
Cathedral
Prato

214

Fra' Filippo Lippi
Florence, 1406–Spoleto, 1469

Madonna and Child with Angels

c. 1465

Oil on panel
25 x 36¹/₃ in (63,5 x 92 cm)
Uffizi Gallery
Florence

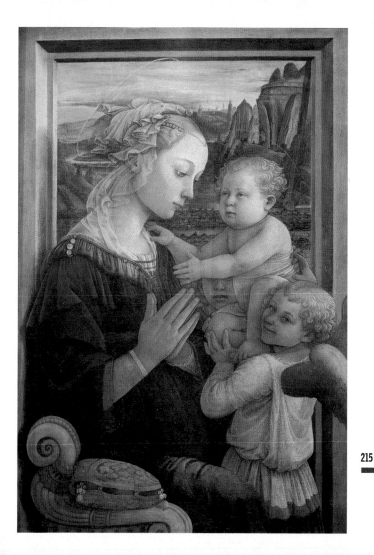

Paolo Uccello
Pratovecchio, Arezzo, 1397–Florence, 1475

Sir John Hawkwood

1436

Fresco transferred to canvas
319 $^3/_4$ x 201 in (820 x 515 cm)
Cathedral
Florence

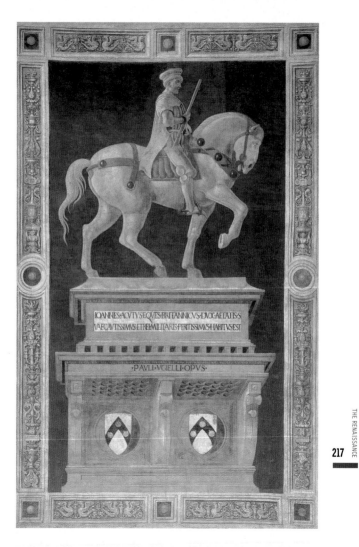

Paolo Uccello
Pratovecchio, Arezzo, 1397–Florence, 1475

Battle of San Romano

c. 1456

Tempera on panel, 71 x 126 in (182 x 323 cm)
Uffizi Gallery, Florence

220

Andrea del Castagno

Castagno, Florence, 1421?–
Florence, 1457

Pippo Spano

1450

Fresco transferred to canvas
97 $\frac{1}{2}$ x 60 in (250 x 154 cm)
Uffizi Gallery
Florence

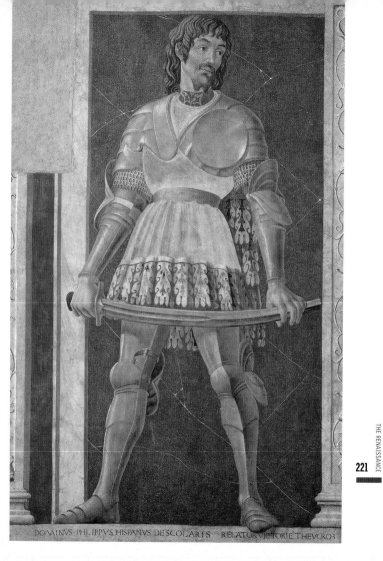

DOMINVS · PHILIPPVS · HISPANVS · DESCOLARIS RELATOR · VICTORIE · THEVCRO3

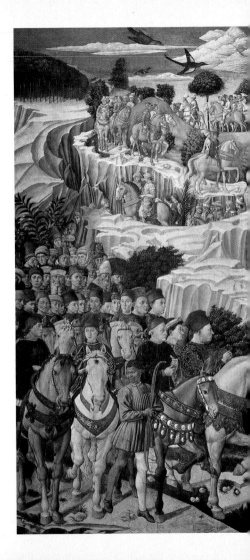

222

Benozzo Gozzoli
Florence, c. 1420–
Pistoia, 1497

Procession of the Magi

1459–60

Fresco
Palazzo Medici Riccardi
Florence

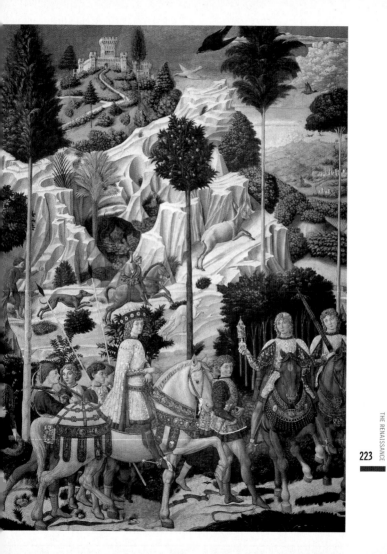

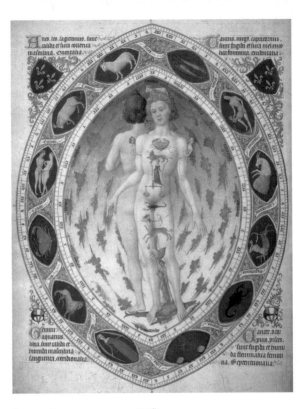

above

Limbourg Brothers

Nijmegen, end of the 14th century–
beginning of the 15th century

The Zodiac (The Anatomy of Man)

Les très riches heures du Duc de Berry

1413–1416

Miniature on vellum
22.2 x 14 cm (8 ³/₄ x 5 ¹/₂ in)
Musée Condé, Chantilly

opposite

Limbourg Brothers

Nijmegen, end of the 14th century–
beginning of the 15th century

April

Les très riches heures du Duc de Berry

1413–1416

Miniature on vellum
22.2 x 14 cm (8 ³/₄ x 5 ¹/₂ in)
Musée Condé, Chantilly

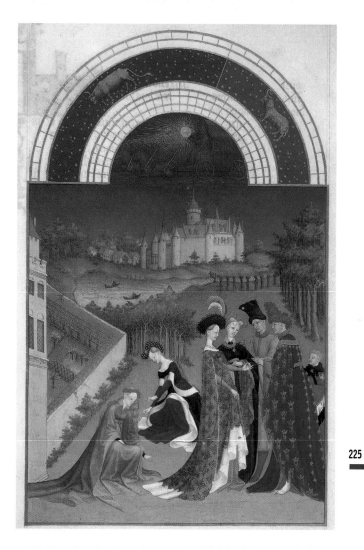

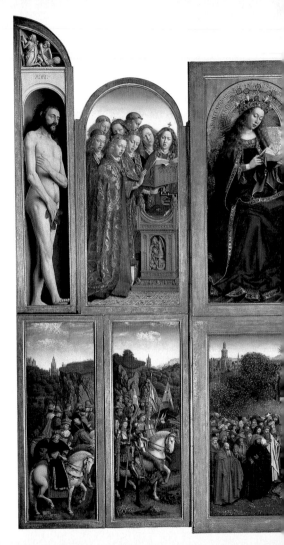

Jan van Eyck
Maaseik, c. 1390–
Bruges, 1441

Ghent Altarpiece
(open)

1432

Oil on panel
Saint-Bavone
Ghent

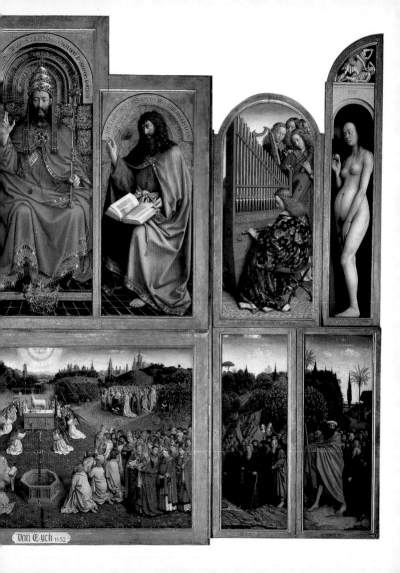

Van Eyck 1432

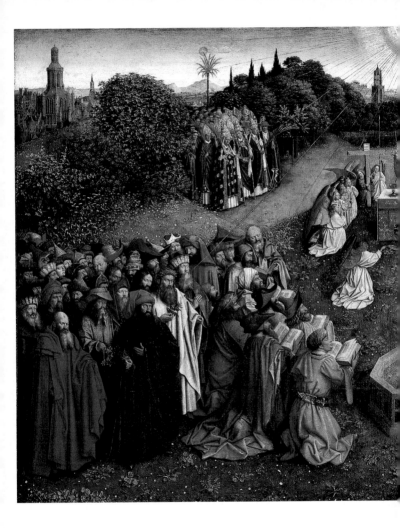

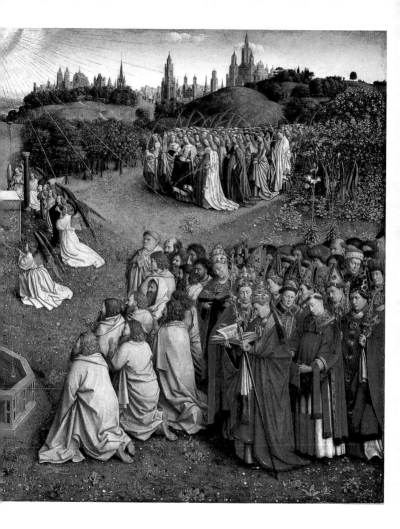

Jan van Eyck
Maaseik, c. 1390– Bruges, 1441

Man with a Red Turban

1433

Oil on panel
13 x 10 in (33.3 x 25.8 cm)
National Gallery
London

pp. 228–229

Jan van Eyck
Maaseik, c. 1390– Bruges, 1441

Ghent Altarpiece
(central panel, bottom register)

1432

Oil on panel
Saint Bavon
Ghent

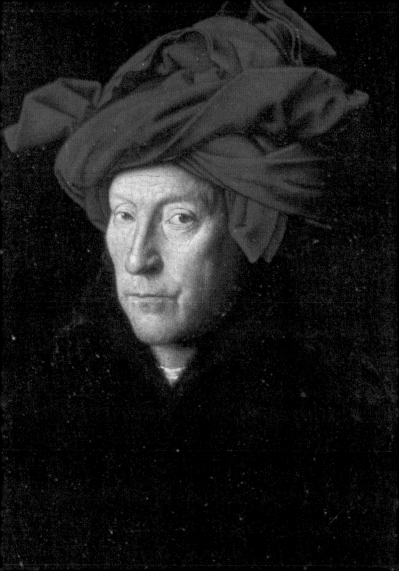

232

Jan van Eyck
Maaseik, c. 1390–Bruges, 1441

**Portrait of Giovanni Arnolfini
and his Wife**

1434

Oil on panel
13 x 10 in (81.8 x 59.7 cm)
National Gallery
London

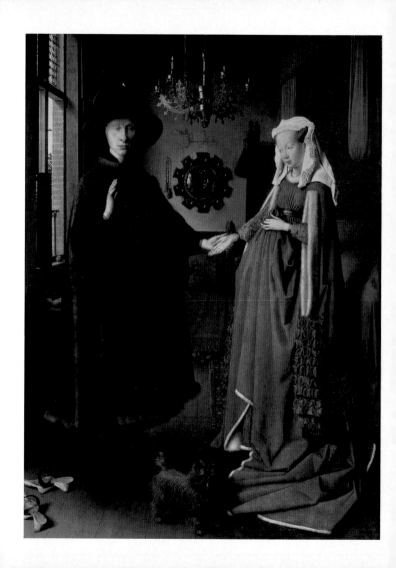

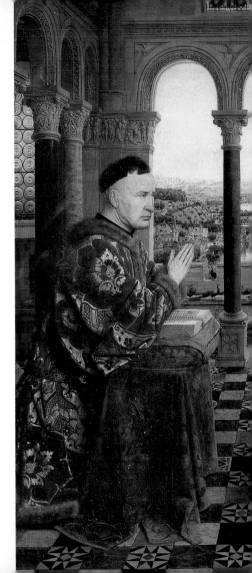

Jan van Eyck

Maaseik, c. 1390–
Bruges, 1441

**The Virgin of
Chancellor Rolin**

c. 1435

Oil on panel
26 x 24 ¹/₂ in (66 x 62 cm)
Louvre
Paris

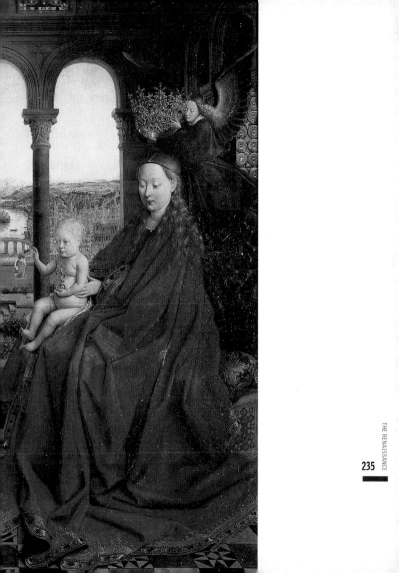

Rogier van der Weyden
Tournai, c. 1399–Brussels, 1464

Saint Luke Painting the Madonna

1435

Oil and tempera on panel
54 $\frac{1}{4}$ x 43 $\frac{1}{2}$ in (137.7 x 110.8 cm)
Alte Pinakothek
Munich

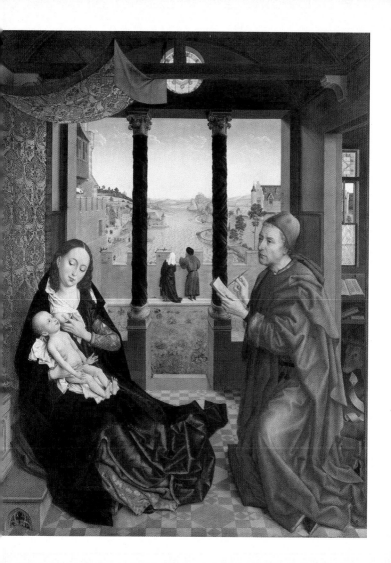

Rogier van der Weyden
Tournai, c. 1399–Brussels, 1464

Annunciation

c. 1435

Oil on panel
33 ¹/₂ x 32 ¹/₂ in (86 x 83 cm)
Louvre
Paris

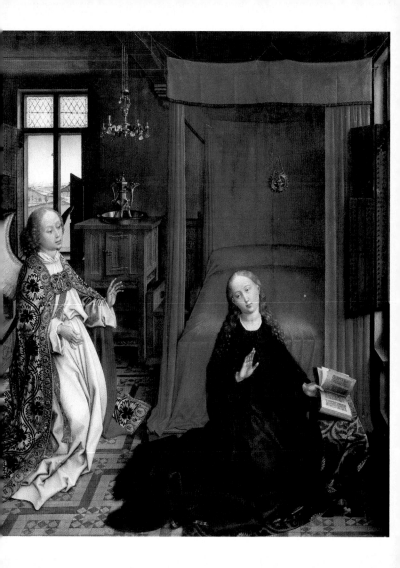

Rogier van der Weyden

Tournai, c. 1399–Brussels, 1464

240

**Portrait of a Young Woman
in a Pinned Hat**

c. 1435

Oil on panel
18 $^1/_4$ x 12 $^1/_2$ in (47 x 32 cm)
Gemäldegalerie
Berlin

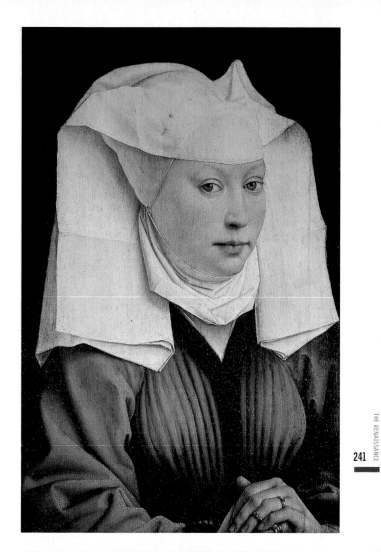

242

Rogier van der Weyden
Tournai, c. 1399–Brussels, 1464

Entombment of Christ

c. 1450

Oil on panel
43 ¹/₄ x 37 ³/₄ in (110 x 96 cm)
Uffizi Gallery
Florence

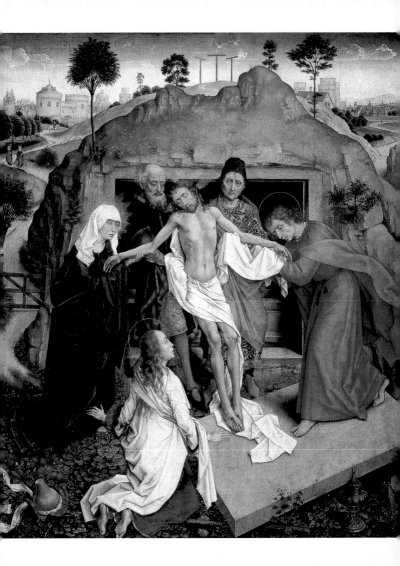

244

Petrus Christus
Baerle? c.1410–Bruges, 1475/76

The Lamentation over the Dead Christ

c. 1455–1460

Oil on panel
40 x 75 in (101 x 192 cm)
Musées Royaux des Beaux-Arts
Brussels

246

Domenico Veneziano
Venice?, c. 1405–Florence, 1461

Saint Lucy Altarpiece

1440–1450

Tempera on panel
113 x 83 in (290 x 213 cm)
Uffizi Gallery
Florence

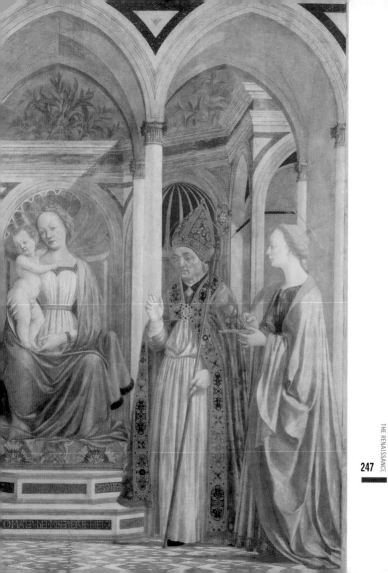

OMATER DEI MISERERE MEI

248

Piero della Francesca

Borgo San Sepolcro c. 1415/20-1492

Madonna of Mercy
Misericordia Altarpiece
(central panel)

1445

Tempera and gold on panel
57 $^3/_4$ x 35 $^3/_4$ in (134 x 91 cm)
Pinacoteca Comunale
Sansepolcro

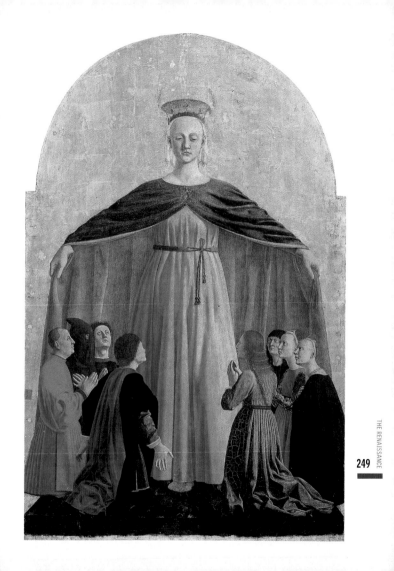

250

Piero della Francesca
Borgo San Sepolcro c. 1415/20–1492

Vision of Constantine
Legend of the True Cross

1459–1464

Fresco
San Francesco
Arezzo

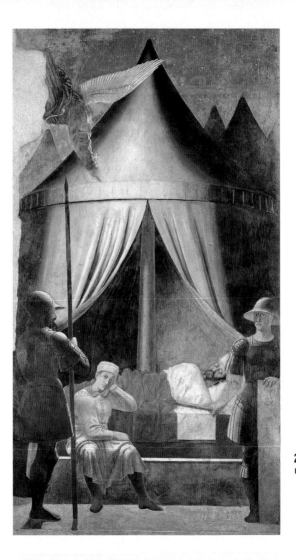

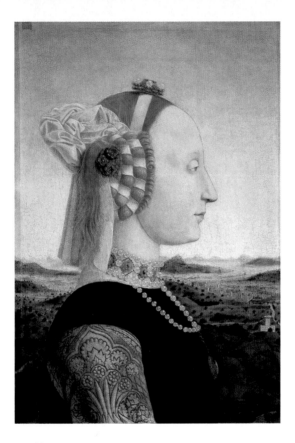

252 Piero della Francesca
Borgo San Sepolcro c. 1415/20–1492

Portrait of Battista Sforza

AFTER 1465

Oil on panel, 18 ½ x 13 in (47 x 33 cm)
Uffizi Gallery
Florence

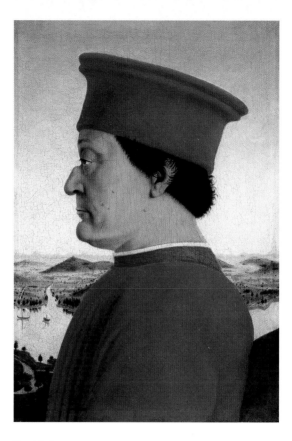

Piero della Francesca
Borgo San Sepolcro c. 1415/20-1492

Portrait of Federico da Montefeltro

AFTER 1465

Oil on panel, 18 ¹/₂ x 13 in (47 x 33 cm)
Uffizi Gallery
Florence

254

Piero della Francesca
Borgo San Sepolcro c. 1415/20–1492

Madonna and Child with Saints

c. 1475

Oil on panel
96 $^3/_4$ x 66 $^1/_4$ in (248 x 170 cm)
Pinacoteca di Brera
Milan

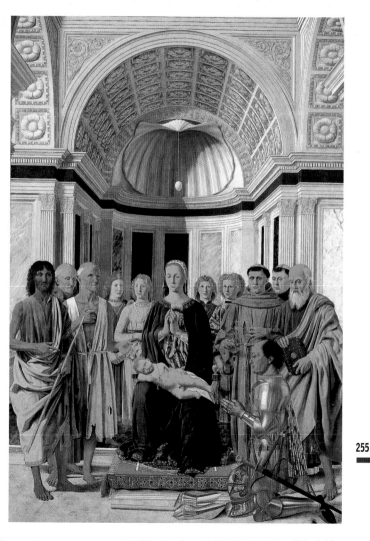

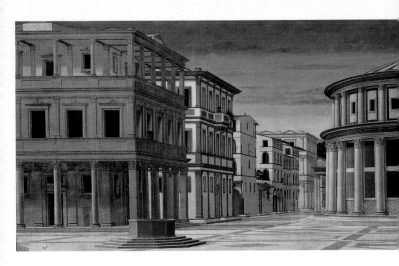

Piero della Francesca
(attributed to)
Borgo San Sepolcro c. 1415/20-1492

The Ideal City

1470-1480

Tempera on panel
26 ¹/₂ x94 ¹/₄ in (67.5 x 239.5 cm)
Palazzo Ducale
Urbino

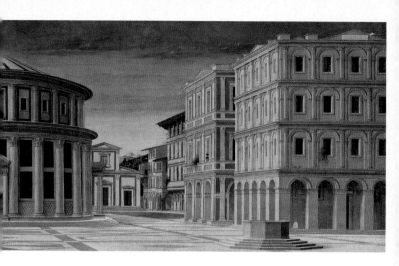

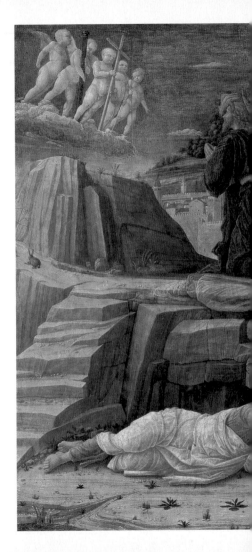

Andrea Mantegna

Island of Carturo, Padua, 1431-
Mantua, 1506

Agony in the Garden

c. 1450-1460

Tempera on panel
24 ³/₄ x 31 ¹/₂ in (62.9 x 80 cm)
National Gallery
London

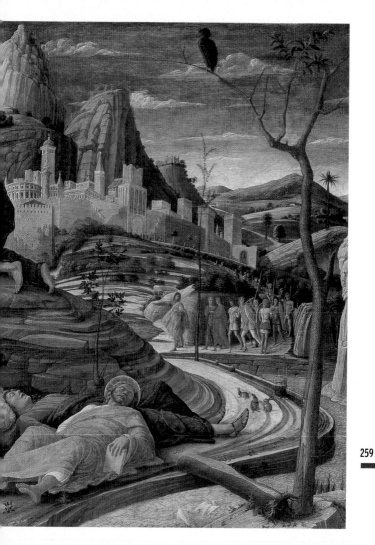

Andrea Mantegna

Island of Carturo, Padua, 1431–
Mantua, 1506

**Return of Cardinal Francesco
Gonzaga from Rome**

Camera degli Sposi

1472–1474

Fresco
Palazzo Ducale
Mantua

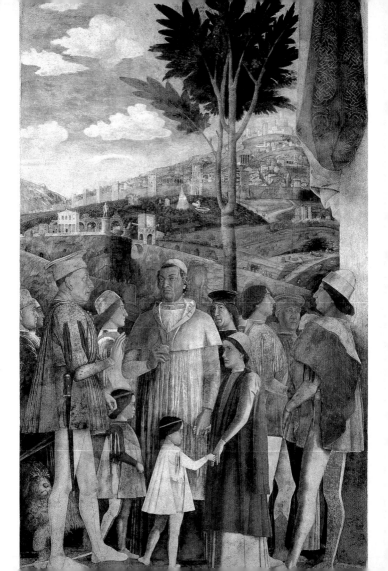

THE RENAISSANCE

262

Andrea Mantegna

Island of Carturo, Padua, 1431–
Mantua, 1506

Ceiling Fresco
Camera degli Sposi
(detail)

1472–1474

Fresco
Palazzo Ducale
Mantua

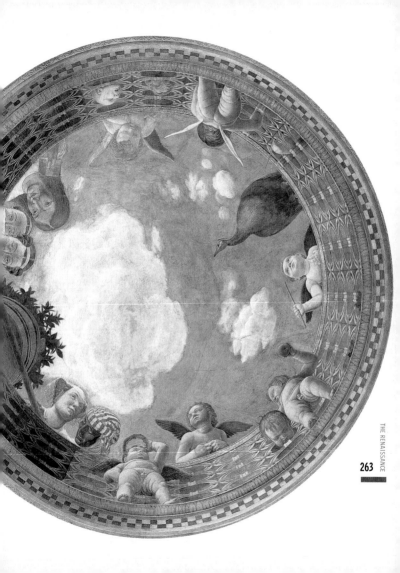

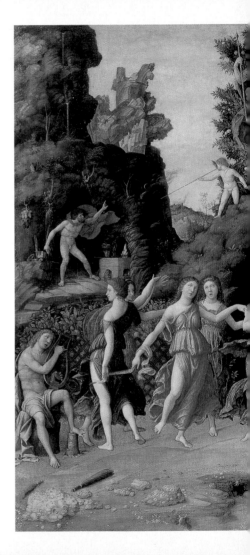

Andrea Mantegna
Island of Carturo, Padua, 1431–
Mantua, 1506

Parnassus

AFTER 1500

Tempera on canvas
63 ¹/₂ x 75 ³/₄ in (60 x 192 cm)
Louvre
Paris

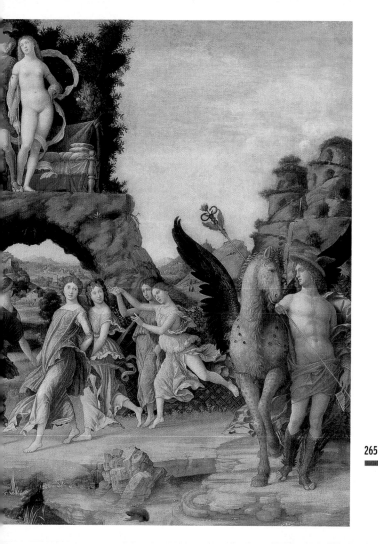

THE RENAISSANCE

Giovanni Bellini
Venice, c. 1430–1516

Pietà

c. 1460–1465

Oil on panel
33 ¹/₄ x 42 in (86 x 107 cm)
Pinacoteca di Brera
Milan

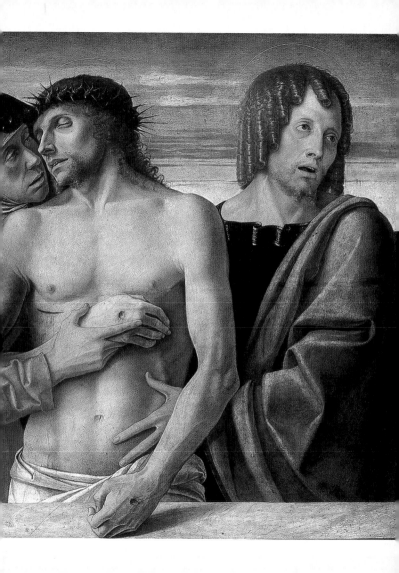

268

Giovanni Bellini
Venice, c. 1430–1516

Enthroned Madonna and Child
Saint Job Altarpiece

c. 1487

Oil on panel
185 $^1/_2$ x 101 $^1/_2$ in (471 x 258 cm)
Accademia
Venice

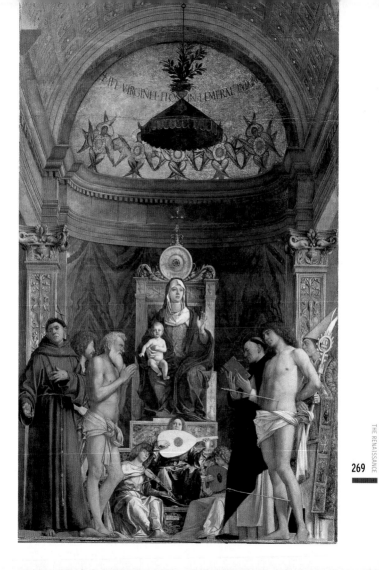

Carlo Crivelli
Venice, 1433–Ascoli?, 1495

Annunciation with Saint Emygdius

1486

Tempera and oil on canvas
(previously on panel)
81 1/2 x 57 3/4 in (207 x 146.7 cm)
National Gallery
London

pp. 270–271

Giovanni Bellini
Venice, c. 1430–1516

Sacred Allegory

c. 1487–1488

Tempera on panel
28 3/4 x 46 3/4 in (73 x 119 cm)
Uffizi Gallery
Florence

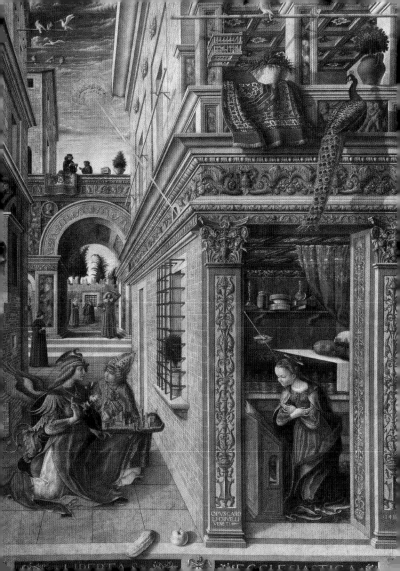

Cosmè Tura
Ferrara, 1430–1495

Pietà

1460

Oil on panel
19 x 13 in (48 x 33 cm)
Correr Museum
Venice

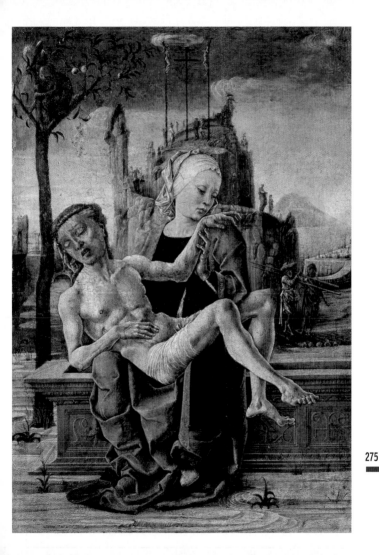

276

Ercole de' Roberti
Ferrara, c. 1450–1496

Madonna and Child with Saints

1481

Oil on panel
127 ¹/₄ x 95 in (323 x 240 cm)
Pinacoteca di Brera
Milan

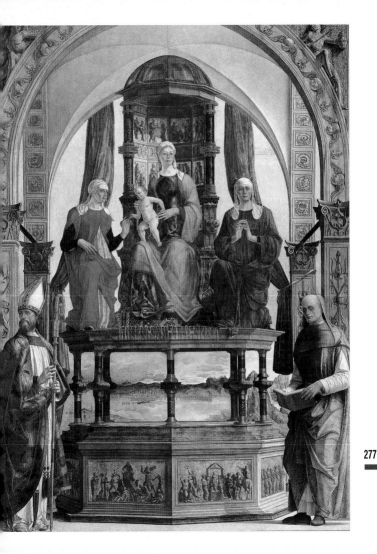

278

Antonello da Messina
Messina, c. 1430–1479

Portrait of a Man

c. 1473–1474

Oil on panel
18 x 14 $\frac{1}{4}$ in (35.6 x 36.2 cm)
National Gallery
London

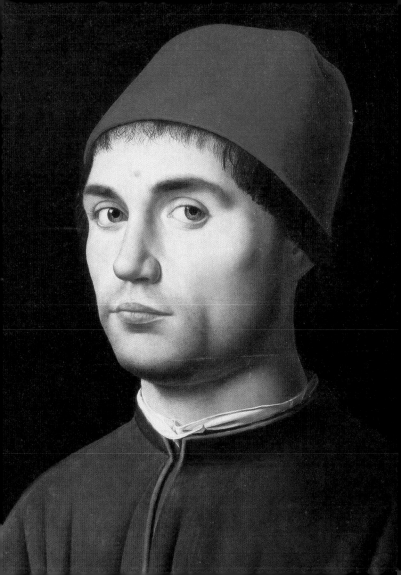

280

Antonello da Messina

Messina, c. 1430–1479

Saint Jerome in his Study

c. 1474–1475

Oil on panel
18 x 14 ¹/₄ in (45.7 x 36.2 cm)
National Gallery
London

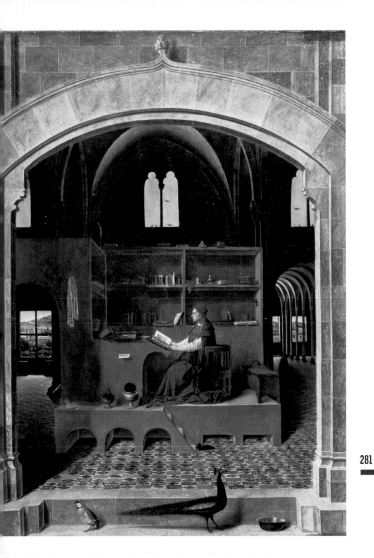

282

Antonello da Messina
Messina, c. 1430–1479

Virgin Annunciate

1475–1476

Oil on canvas
17 $^3/_4$ x 13 $^3/_4$ in (45 x 35 cm)
Galleria Nazionale della Sicilia
Palermo

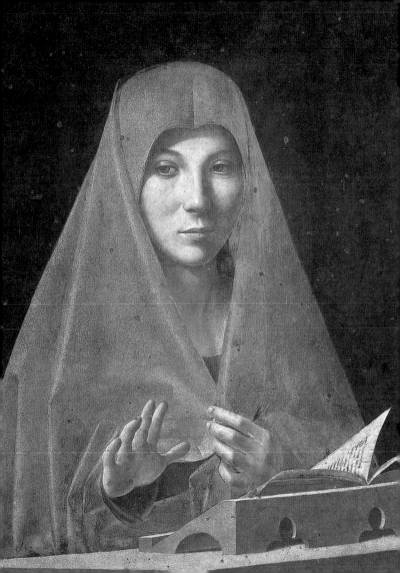

284

Jean Fouquet

Tours, c. 1420–1481

Charles VII of France

c. 1444–1449

Oil on panel
33 $^3/_4$ x 28 in (86 x 71 cm)
Louvre
Paris

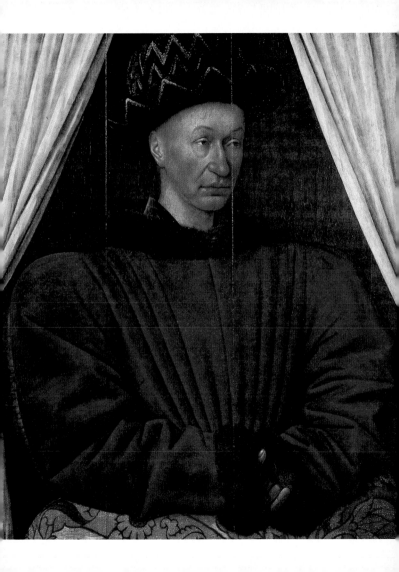

286

Jean Fouquet

Tours, c. 1420–1481

**Virgin and Child Surrounded
by Angels**
Diptych of Melun
(right panel)

c. 1450

Oil on panel
36 $^1/_4$ x 33 in (92 x 84 cm)
Musées Royaux des Beaux-arts
Antwerp

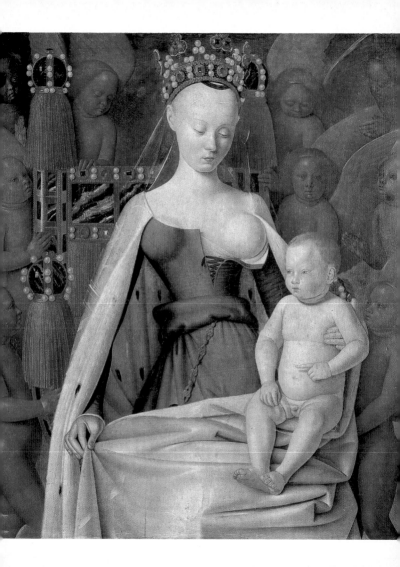

Jean Fouquet
Tours, c. 1420–1481

Portrait of Guillaume Juvénel des Ursins

c. 1460
Oil on panel
36 $\frac{1}{4}$ x 29 $\frac{1}{4}$ in (92 x 74 cm)
Louvre
Paris

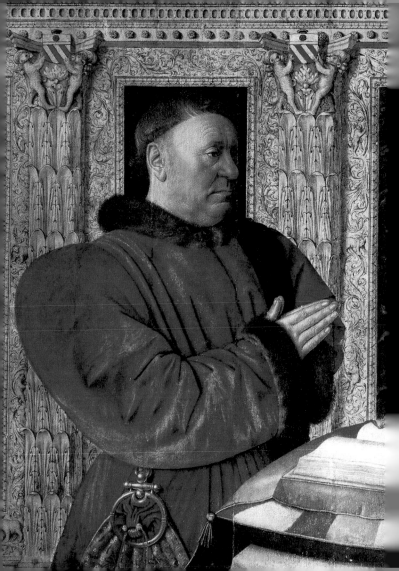

Dieric Bouts

Haarlem, c. 1415–Leuven, 1475

The Resurrection of Christ

c. 1450

Tempera on panel
41 $\frac{1}{2}$ x 26 $\frac{3}{4}$ in (105.3 x 68.2 cm)
Alte Pinakothek
Munich

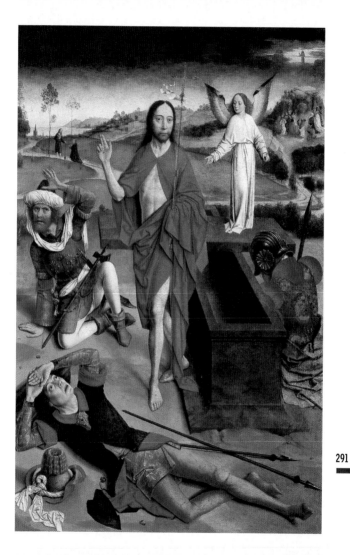

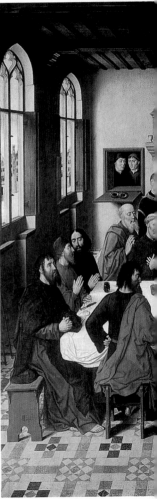

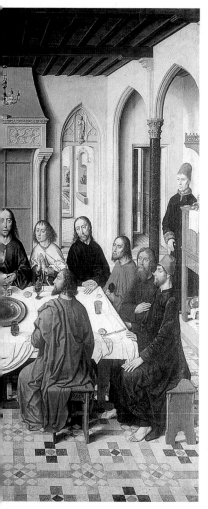

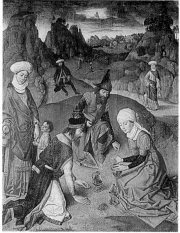

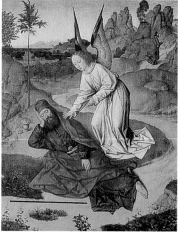

Hans Memling

Seligenstadt, c. 1435–Bruges, 1494

**The Mystic Marriage of
Saint Catherine**

Altarpiece of Saint John the Baptist and
Saint John the Evangelist
(central panel)

1479

Oil on panel
68 x 68 in (172 x 172 cm)
Hans Memling Museum
Bruges

pp. 292–293

Dieric Bouts

Haarlem, c. 1415–Leuven, 1475

Altarpiece of the Holy Sacrament

1464–1467

Oil on panel
59 x 127 ¹/₄ in (150 x 323 cm)
Saint Peter
Leuven

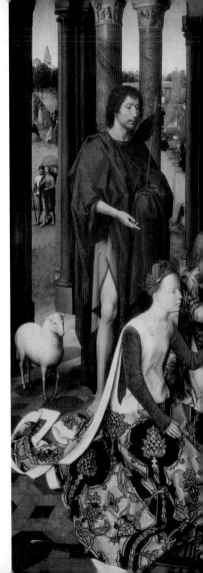

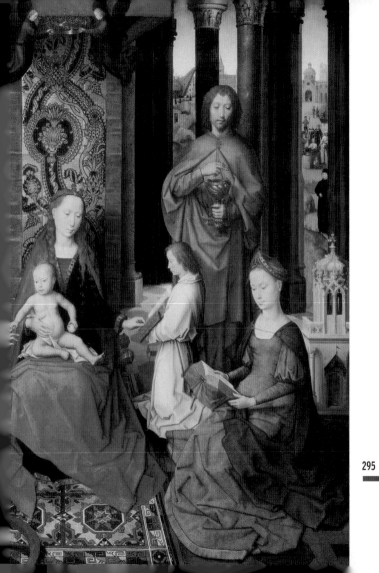

296

Hans Memling
Seligenstadt, c. 1435–Bruges, 1494

Portrait of a Man

1490

Oil on panel
13 $^3/_4$ x 9 $^1/_4$ in (35 x 25 cm)
Uffizi Gallery
Florence

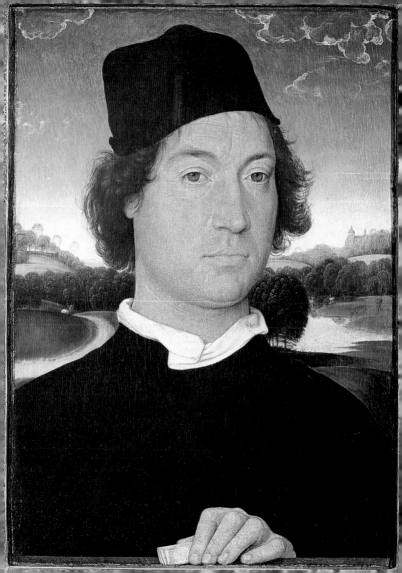

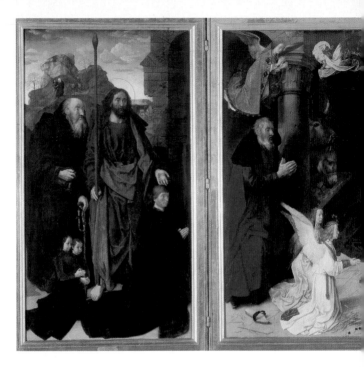

Hugo van der Goes

Ghent, c. 1440–Audergem, 1482

The Portinari Triptych

c. 1476

Oil on panel
99 ¹/₂ x 120 in (252.7 x 304.8 cm)
Uffizi Gallery
Florence

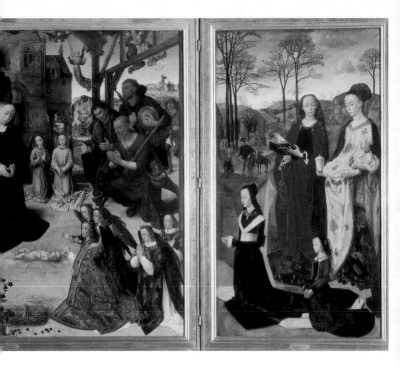

300

Albert van Ouwater

active in Haarlem 1440–1460

Saint John the Baptist

Oil on canvas
27 $^1/_2$ x 12 $^1/_4$ in (70 x 31 cm)
Capilla Real
Granada

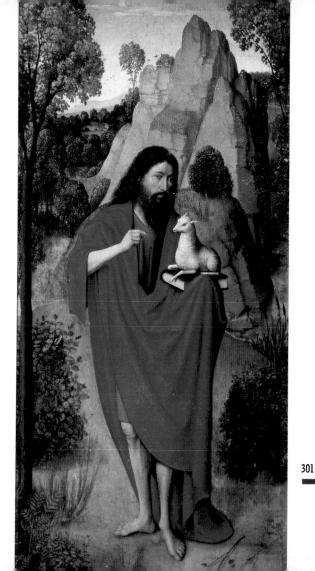

301

Geertgen tot Sint Jans

Haarlem, active in the second half of
the 15th century

The Resurrection of Lazarus

c. 1480

Oil on panel
49 ¹/₂ x 37 ³/₄ in (127 x 97 cm)
Louvre
Paris

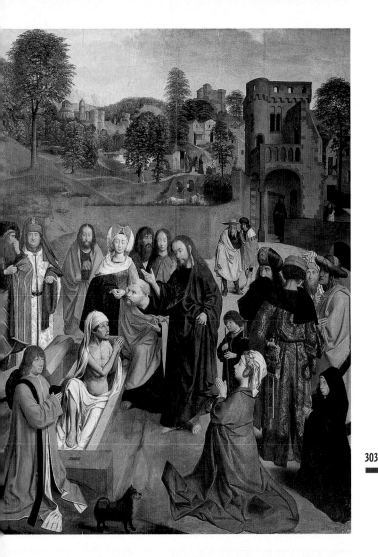

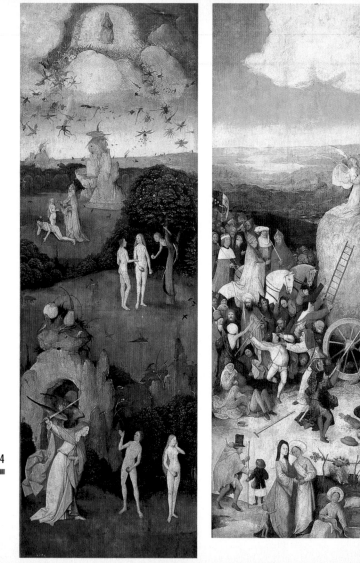

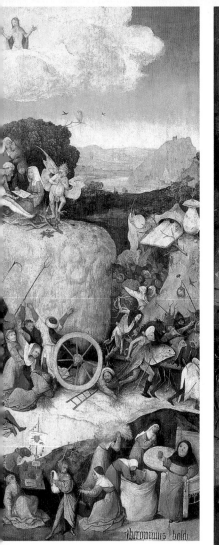

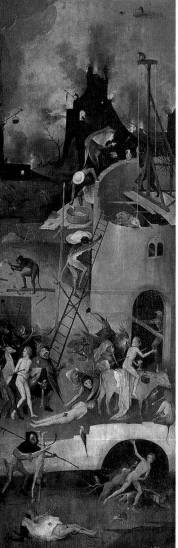

Jheronimus bosch

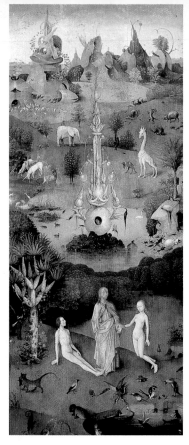

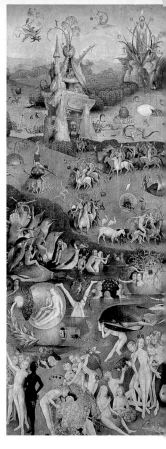

pp. 304–305

306

Hieronymus Bosch
s'Hertogenbosch, c. 1450–1516

The Garden of Earthly Delights
Triptych

c. 1510

Oil on panel, 86 ½ x 153 ¼ in (220 x 389 cm)
Prado, Madrid

Hieronymus Bosch
s'Hertogenbosch, c. 1450–1516

The Haywain
Triptych

c. 1500

Oil on panel, 53 ¼ x 74 ¾ in (135 x 190 cm)
Prado, Madrid

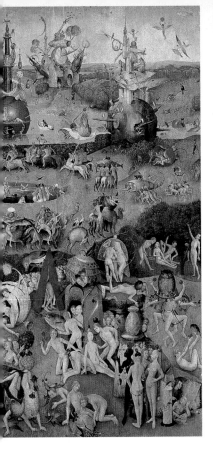
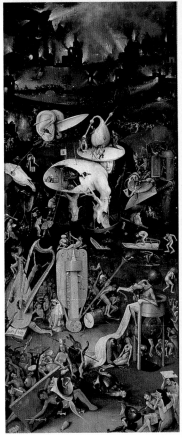

Nuno Gonçalves

Portugal, active in the second of the
15th century

Henry the Navigator
Saint Vincent Altarpiece
(detail)

c. 1470–1475

Oil on panel
Museu Nacional de Arte Antiga
Lisbon

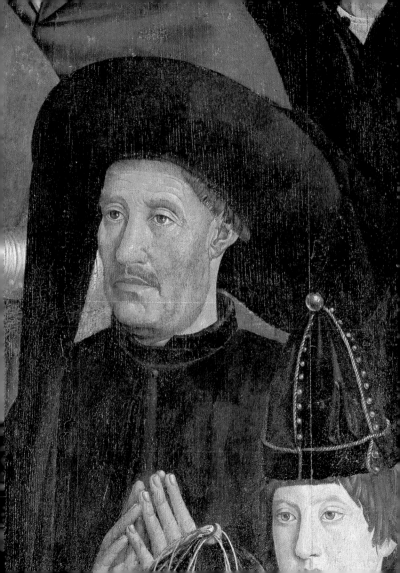

310

Antonio Pollaiolo
Florence, c. 1432–Rome, 1498

Hercules and the Hydra

c. 1460

Tempera on panel
6 $^3/_4$ x 4 $^3/_4$ in (17 x 12 cm)
Uffizi Gallery
Florence

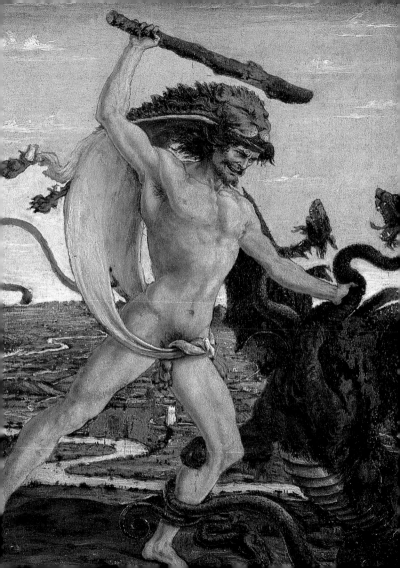

312

Antonio Pollaiolo
Florence, c. 1432–Rome, 1498

Portrait of a Young Woman

c. 1470

Tempera on panel
18 x 13 in (46 x 33 cm)
Museo Poldi Pezzoli
Milan

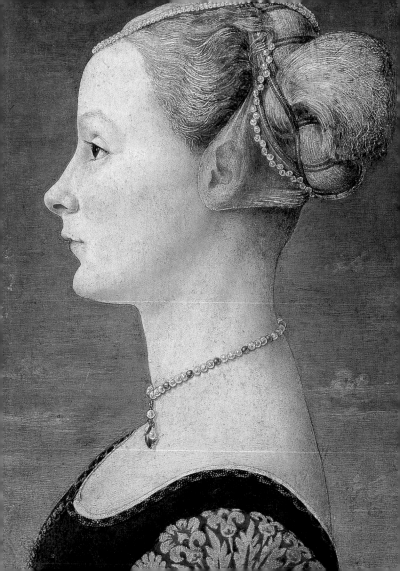

Andrea Verrocchio

Florence, c. 1435–Venice, 1488

with the collaboration of

Leonardo da Vinci and
Sandro Botticelli

Baptism of Christ

after 1470

Tempera on panel
69 ¹/₂ x 59 ¹/₂ in (176.5 x 151.1 cm)
Uffizi Gallery
Florence

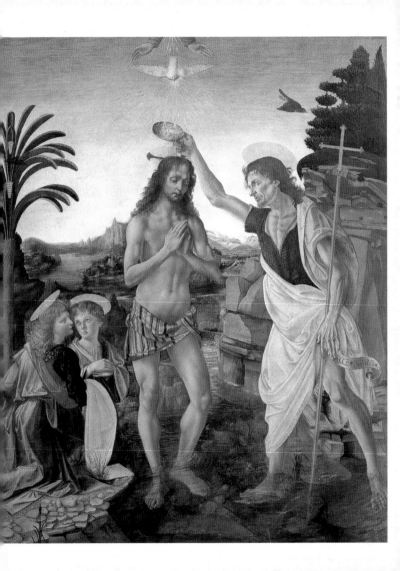

316

Sandro Botticelli

Florence, 1445–1510

**Portrait of a Man with a Medal
of Cosimo I**

c. 1474

Tempera on panel
22 ³/₄ x 17 ¹/₄ in (57.5 x 44 cm)
Uffizi Gallery
Florence

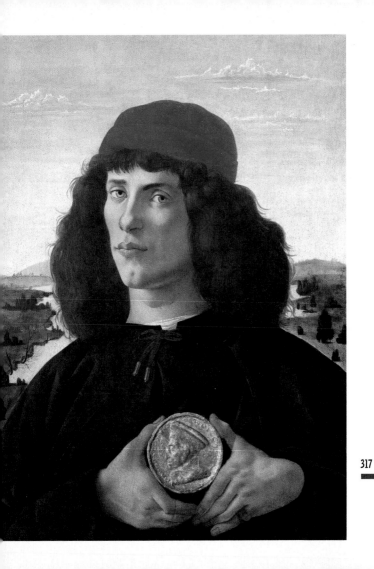

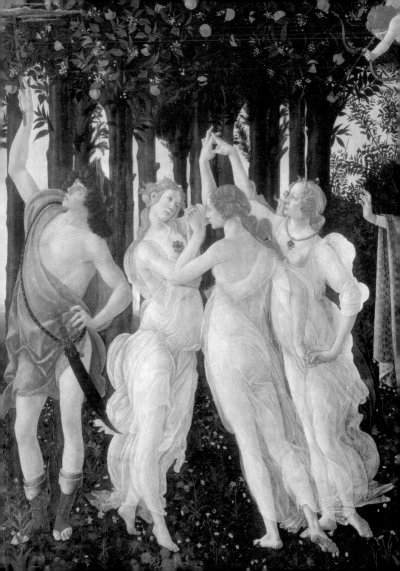

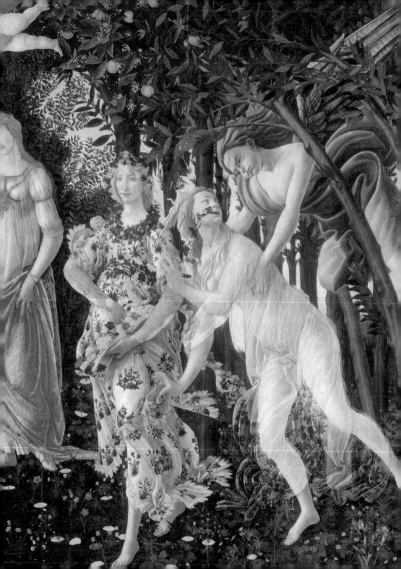

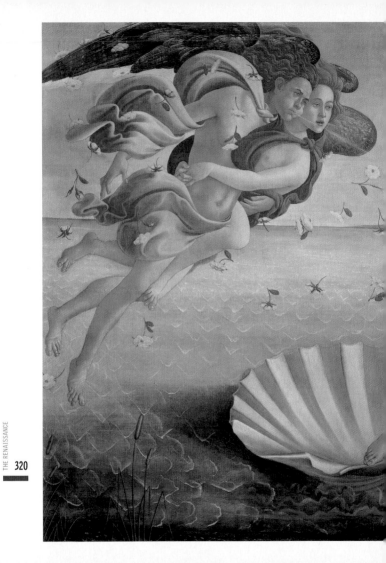

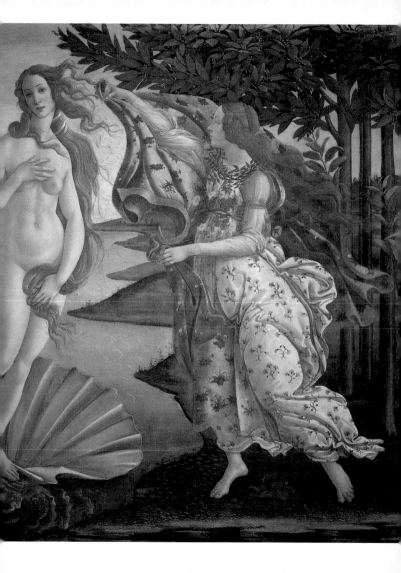

Sandro Botticelli
Florence, 1445–510

Pietà

c. 1495

Oil on panel
55 x 81 ½ in
(140 x 207 cm)
Alte Pinakothek
Munich

pp. 318-319

Sandro Botticelli
Florence, 1445-1510

Primavera

c. 1478–1482

Tempera on panel
80 x 123 ½ in
(203 x 314 cm)
Uffizi Gallery
Florence

pp. 320-321

Sandro Botticelli
Florence, 1445-1510

The Birth of Venus

c. 1482

Tempera on canvas
72 ¾ x 112 ½ in
(184.5 x 285.5 cm)
Uffizi Gallery
Florence

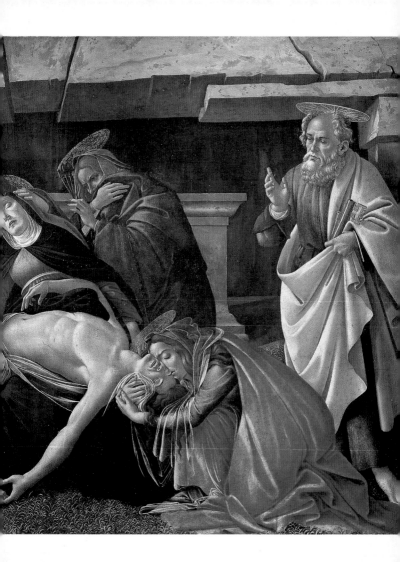

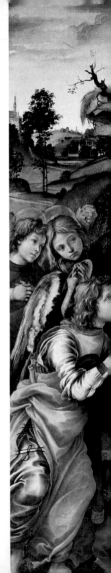

324

Filippino Lippi
Prato, c. 1457–Florence, 1504

Vision of Saint Bernard

1486

Oil on panel
82 x 77 in (210 x 195 cm)
Badia Fiorentina
Florence

Domenico Ghirlandaio

Florence, 1449–1494

Old Man with a Child

c. 1490

Tempera on panel
24 $^{3}/_{4}$ x 18 $^{1}/_{4}$ in (62.7 x 46.3 cm)
Louvre
Paris

pp. 326–327

Domenico Ghirlandaio

Florence, 1449–1494

**The Appearance of the Angel
to Zacharias**

1486–1490

Fresco
Santa Maria Novella (Tornabuoni Chapel)
Florence

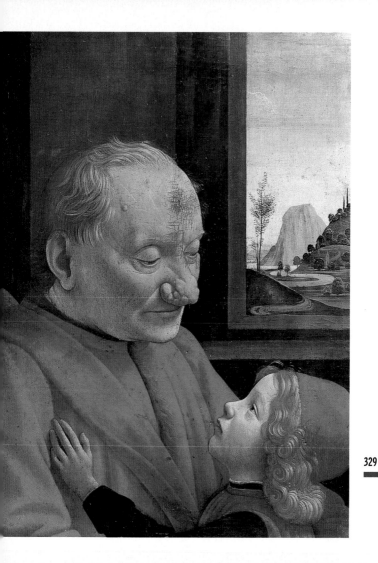

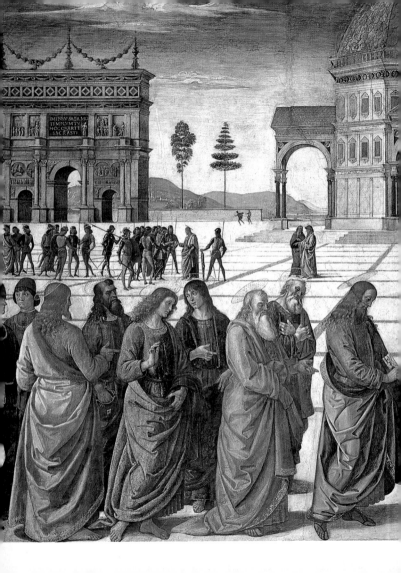

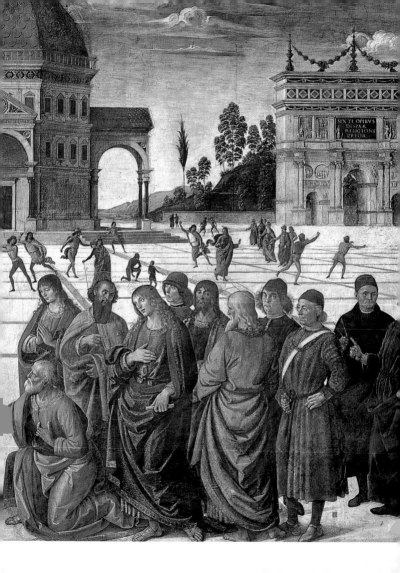

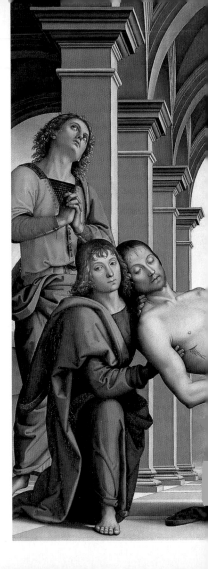

Pietro Perugino

Città della Pieve, Perugia,
1445/50-Fontignano, 1523

Pietà

1494-1495

Oil on panel
66 ¼ x 69 ¼ in (168 x 176 cm)
Uffizi Gallery
Florence

pp. 330-331

Pietro Perugino

Città della Pieve, Perugia,
1445/50-Fontignano, 1523

**The Handing of the Keys to
Saint Peter**

1482

Fresco
132 x 216 ½ in (335 x 550 cm)
Sistine Chapel
Vatican City

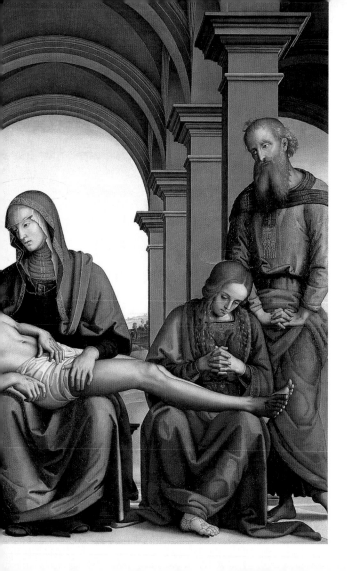

334

Pinturicchio (Bernardino di Betto)

Perugia, c. 1454–Siena, 1513

**Meeting between Frederick III
and Eleanor of Aragon**

Scenes from the Life of Pope Pius II

1502–1508

Fresco
Cathedral (Piccolomini Library)
Siena

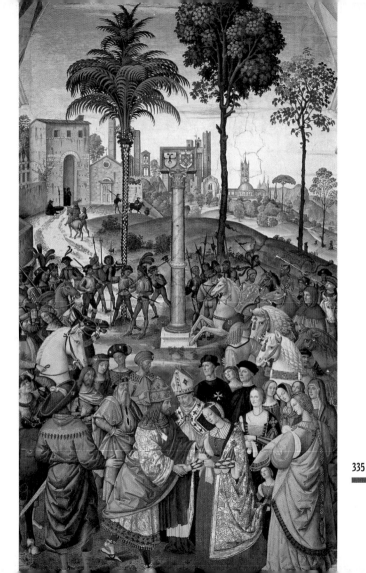

Vittore Carpaccio
Venice, c. 1460–1526

The Dream of Saint Ursula

1495

Tempera on canvas
108 x 105 in (274 x 267 cm)
Accademia
Venice

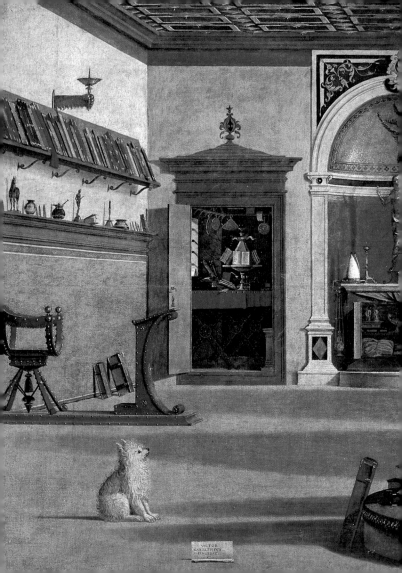

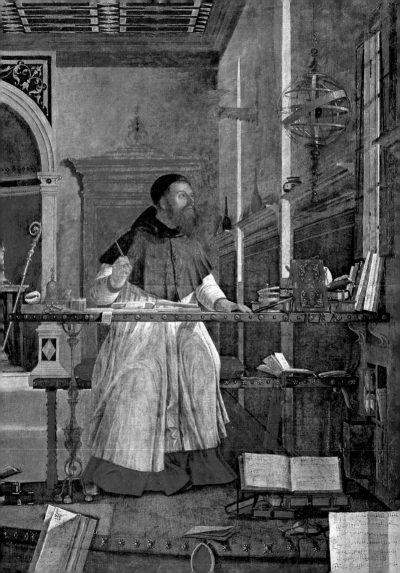

Luca Signorelli

Cortona, c. 1450–1523

Resurrection of the Dead

1499–1504

Fresco
Cathedral (Saint Brixio Chapel)
Orvieto

pp. 338–339

Vittore Carpaccio

Venice, c. 1460–1526

Saint Augustine in his Study

1502

Oil on canvas
55 ¹/₂ x 82 ³/₄ in (141 x 210 cm)
Scuola di San Giorgio degli Schiavoni
Venice

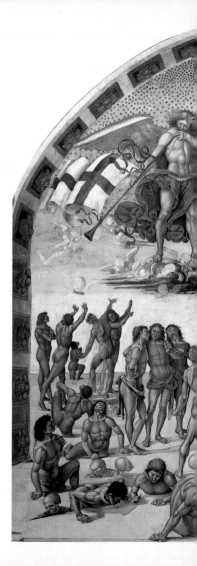

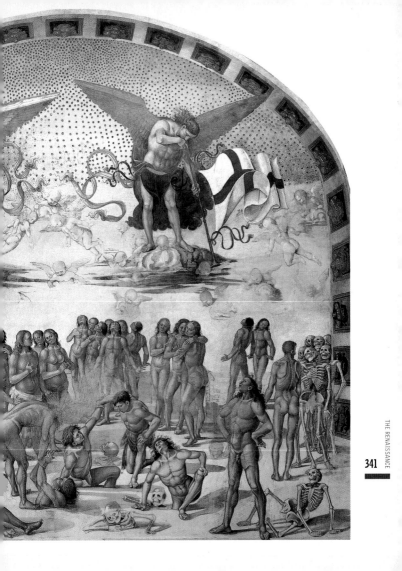

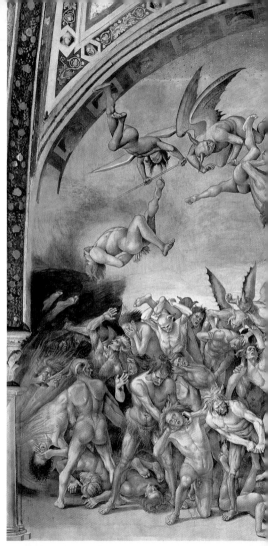

342

Luca Signorelli

Cortona, c. 1450–1523

**Damned Consigned
to Hell**

1499–1504

Fresco
Cathedral (Saint Brixio Chapel)
Orvieto

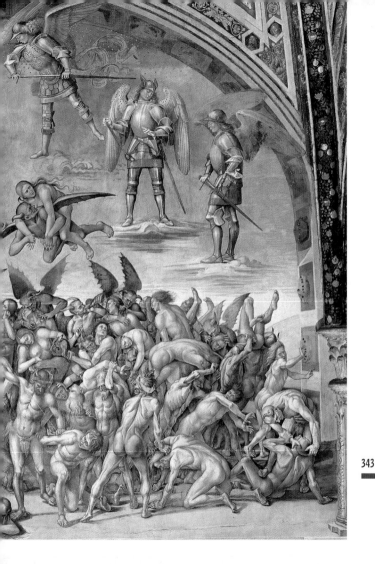

343

344

Leonardo da Vinci
Vinci, 1452–Amboise, 1519
Virgin of the Rocks
1483–1486

Oil on panel
74 $^1/_2$ x 47 $^1/_4$ in (189 x 120 cm)
Louvre
Paris

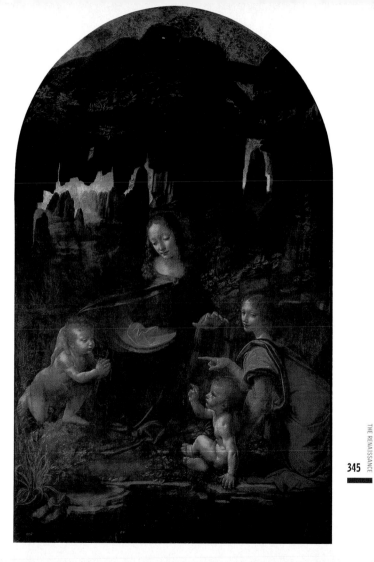

346

Leonardo da Vinci
Vinci, 1452-Amboise, 1519

La Belle Ferronière

c. 1490

Oil on canvas
21 $^1/_2$ x 17 $^1/_4$ in (62 x 44 cm)
Louvre
Paris

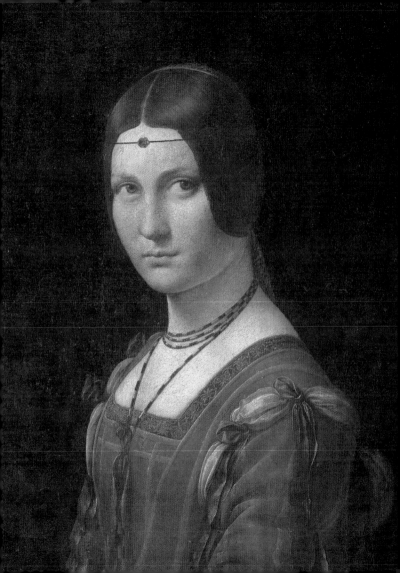

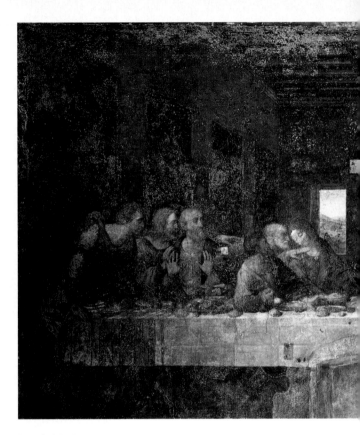

Leonardo da Vinci
Vinci, 1452–Amboise, 1519

The Last Supper

1495–1497

Fresco
181 x 346 ¹/₂ in (460 x 880 cm)
Santa Maria delle Grazie (refectory)
Milan

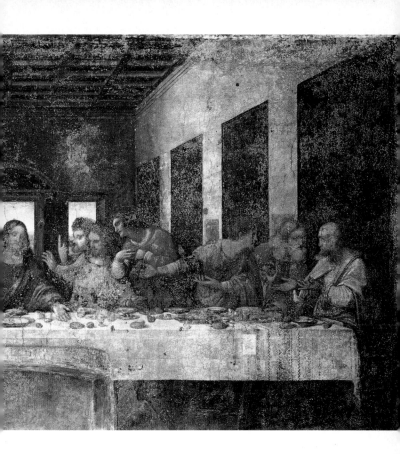

350

Leonardo da Vinci
Vinci, 1452–Amboise, 1519

Mona Lisa

1503–1504

Oil on panel
30 $^1/_4$ x 20 $^3/_4$ in (77 x 53 cm)
Louvre
Paris

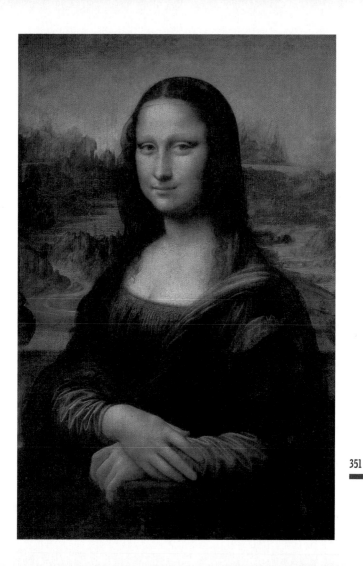

352

Leonardo da Vinci
Vinci, 1452–Amboise, 1519

Madonna and Child with Saint Anne

1510

Oil on panel
66 x 44 in (168 x 112 cm)
Louvre
Paris

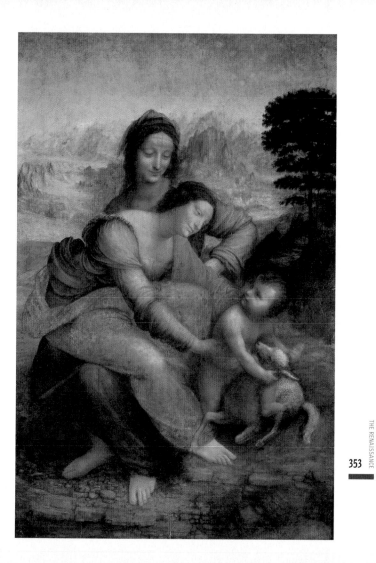

Piero di Cosimo

Florence, 1462–1521

Cleopatra
(so-called Portrait of Simonetta Vespucci)

c. 1488

Oil on panel
22 $\frac{1}{2}$ x 16 $\frac{1}{2}$ in (57.2 x 42 cm)
Musée Condé
Chantilly

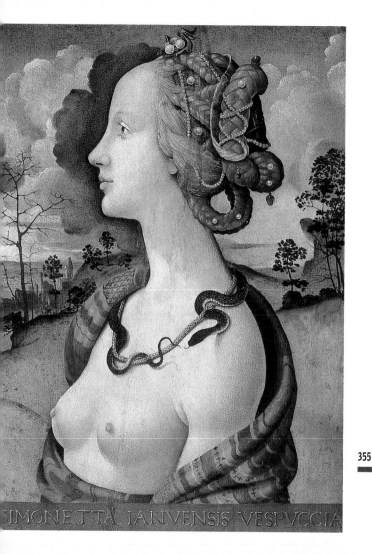

SIMONETTA IANVENSIS VESPVCCIA

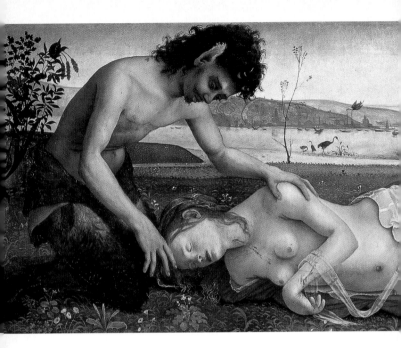

356

Piero di Cosimo
Florence, 1461–1521

The Death of Procris

c. 1492

Oil on panel
25 ³/₄ x 72 ¹/₂ in (65.4 x 184.2 cm)
National Gallery
London

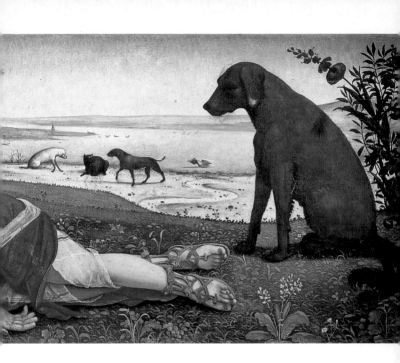

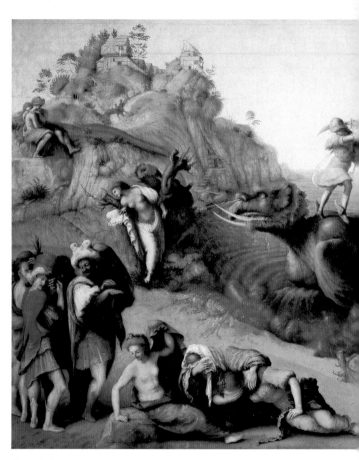

Piero di Cosimo
Florence, 1461–1521

The Freeing of Andromeda, c. 1515

Oil on panel, 28 x 48 1/2 in (71 x 123 cm)
Uffizi Gallery, Florence

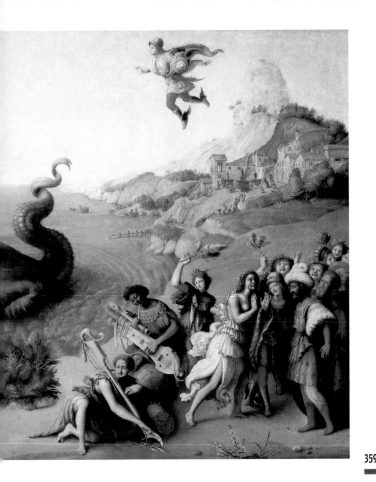

360

Raphael (Raffaello Sanzio)
Urbino, 1483–Rome, 1520

Marriage of the Virgin

1504

Oil on panel
67 x 46 ¹/₂ in (170.2 x 118.1 cm)
Pinacoteca di Brera
Milan

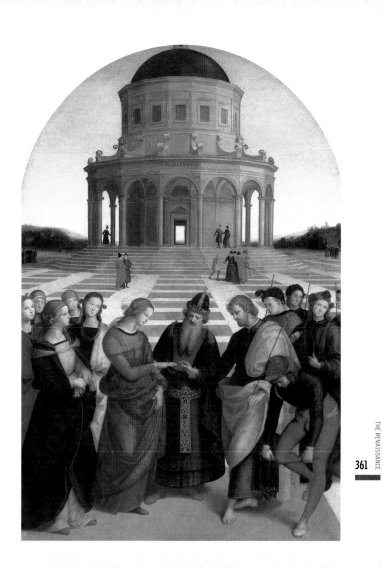

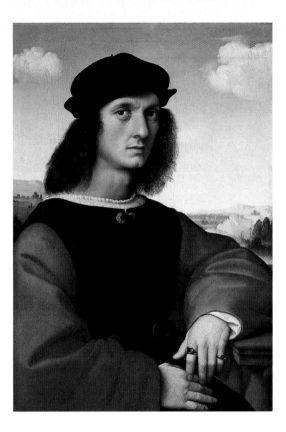

Raphael (Raffaello Sanzio)
Urbino, 1483–Rome, 1520

Portrait of Agnolo Doni

1506

Oil on panel
24 ³/₄ x 17 ³/₄ in (63 x 45 cm)
Palazzo Pitti, Galleria Palatina
Florence

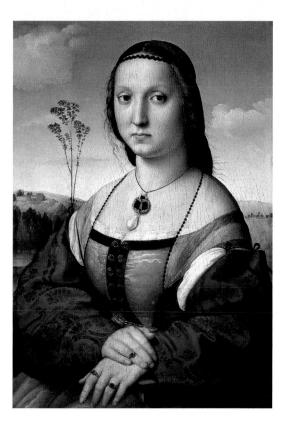

Raphael (Raffaello Sanzio)
Urbino, 1483–Rome, 1520

Portrait of Maddalena Doni

1505

Oil on panel
24 ¹/₄ x 17 ³/₄ in (63 x 45 cm)
Palazzo Pitti, Galleria Palatina
Florence

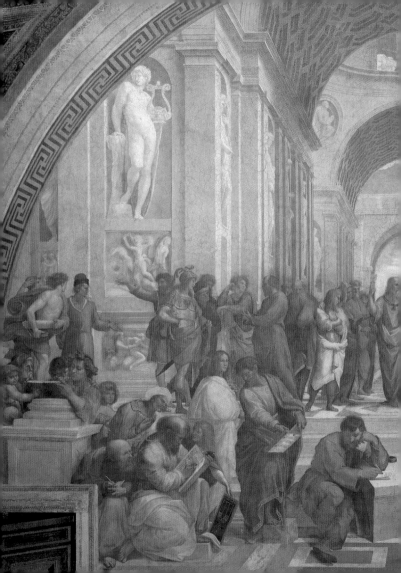

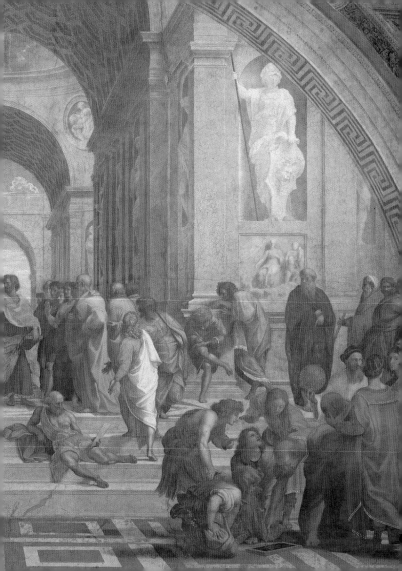

Raphael (Raffaello Sanzio)
Urbino, 1483–Rome, 1520

Portrait of Baldassare Castiglione

c. 1514–1515

Oil on canvas
32 $^1/_4$ x 26 $^1/_2$ in (82 x 67 cm)
Louvre
Paris

pp. 364–365

Raphael (Raffaello Sanzio)
Urbino, 1483–Rome, 1520

School of Athens

1509–1511

Fresco
Vatican Museums (Stanza della Segnatura)
Vatican City

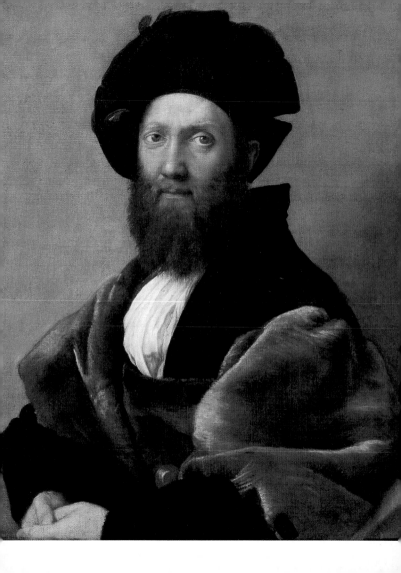

Raphael (Raffaello Sanzio)

Urbino, 1483–Rome, 1520

**The Transfiguration
of Christ**

1519–1520

Oil on panel
160 x 110 in (406.4 x 279.4 cm)
Vatican Museums
Vatican City

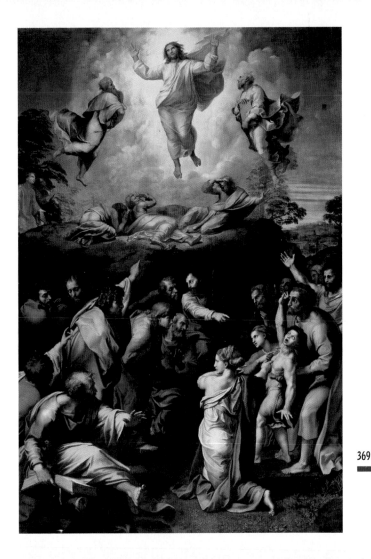

Michelangelo Buonarroti

Caprese, Arezzo, 1475-Rome, 1564

370

**The Holy Family with the Infant
Saint John the Baptist**
Doni Tondo

1503–1504

Tempera on panel
diam. 47 ¹/₄ in (120 cm)
Uffizi Gallery
Florence

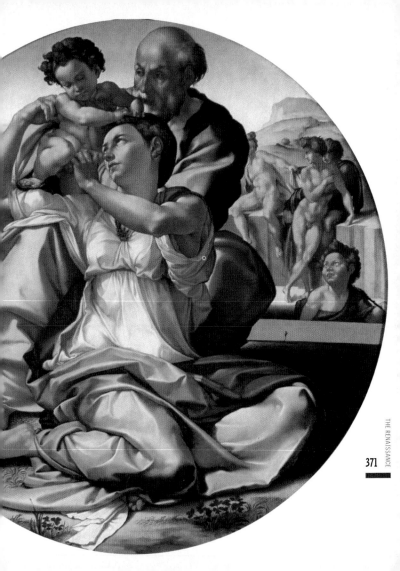

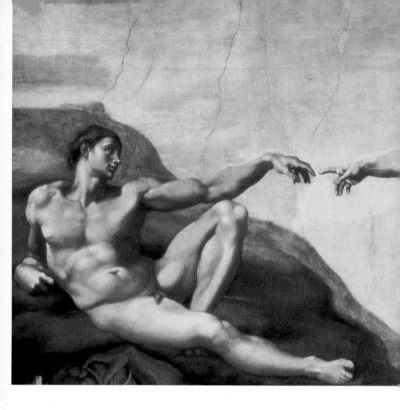

372 Michelangelo Buonarroti
Caprese, Arezzo, 1475–Rome, 1564

Creation of Adam

1510

Fresco
Sistine Chapel (ceiling)
Vatican City

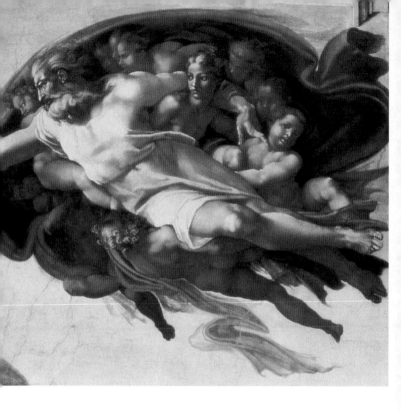

374

Michelangelo Buonarroti
Caprese, Arezzo, 1475–Rome, 1564

The Prophet Daniel

1508–1512

Fresco
Sistine Chapel (ceiling)
Vatican City

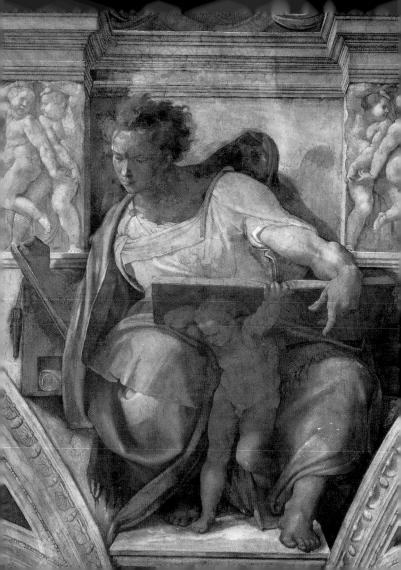

376

Michelangelo Buonarroti
Caprese, Arezzo, 1475–Rome, 1564

The Last Judgement
1536–1541

Fresco
Sistine Chapel
Vatican City

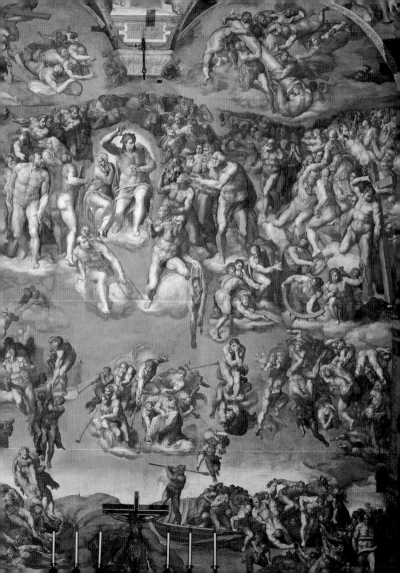

Michelangelo Buonarroti
Caprese, Arezzo, 1475–Rome, 1564

Condemned Man
The Last Judgement
(detail)

1536–1541

Fresco
Sistine Chapel
Vatican City

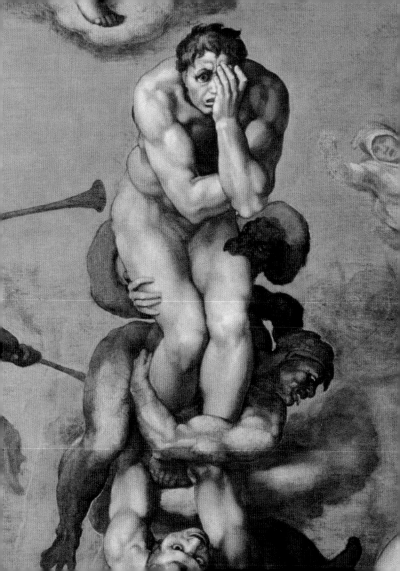

Correggio (Antonio Allegri)
Correggio, Reggio Emilia, 1489–1534

Assumption of the Virgin
(dome)

Saint Hilary
(pendentive)

1524–1530

Fresco
Cathedral
Parma

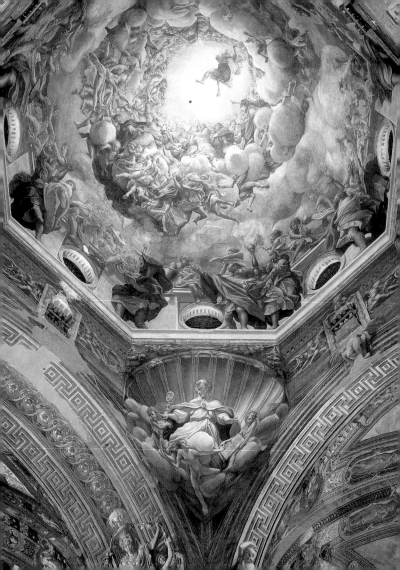

382

Correggio (Antonio Allegri)
Correggio, Reggio Emilia, 1489–1534

Adoration of the Child

c. 1524

Oil on canvas
32 x 26 ¹/₂ in (81 x 67 cm)
Uffizi Gallery
Florence

384

Correggio (Antonio Allegri)
Correggio, Reggio Emilia, 1489-1534

Danae

c. 1531

Oil on canvas
63 ¹/₂ x 76 in (161 x 193 cm)
Galleria Borghese
Rome

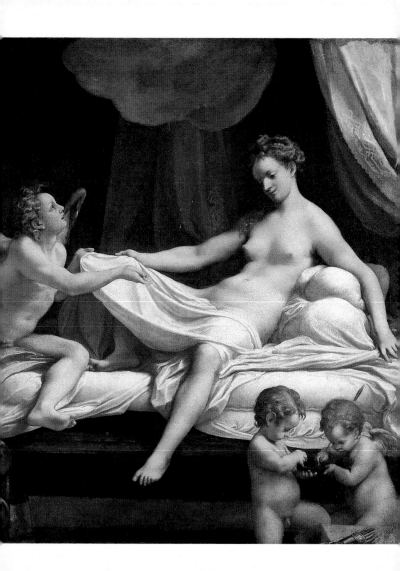

Giorgione (Giorgio da Castelfranco)
Castelfranco, Treviso, c. 1477–Venice, 1510

The Tempest

1506–1508

Oil on canvas
32 $\frac{1}{4}$ x 28 $\frac{3}{4}$ in (82 x 73 cm)
Accademia
Venice

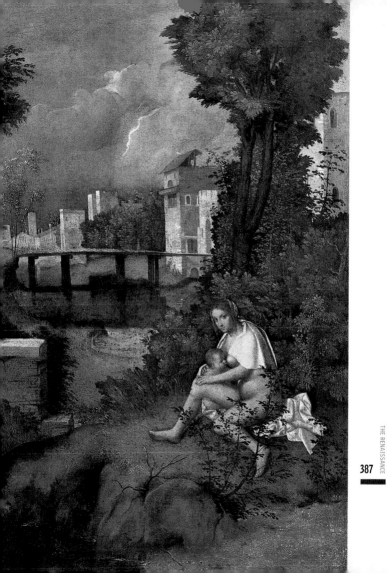

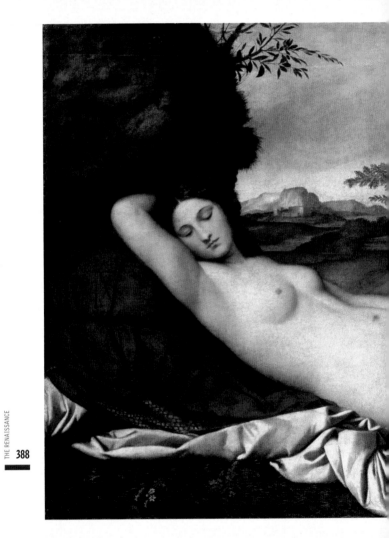

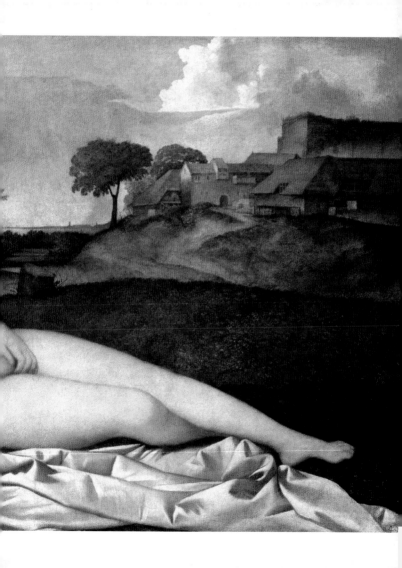

Giorgione (Giorgio da Castelfranco)

Castelfranco, Treviso, c. 1477–Venice, 1510

Portrait of a Man in Armor with a Shield

1505–1510

Oil on canvas
30 $1/2$ x 28 $3/4$ in (90 x 73 cm)
Uffizi Gallery
Florence

pp. 388–389

Giorgione (Giorgio da Castelfranco)

Castelfranco, Treviso, c. 1477–Venice, 1510

The Sleeping Venus

1509

Oil on canvas
42 $3/4$ x 69 in (108.5 x 175 cm)
Gemäeldegalerie Alte Meister
Dresden

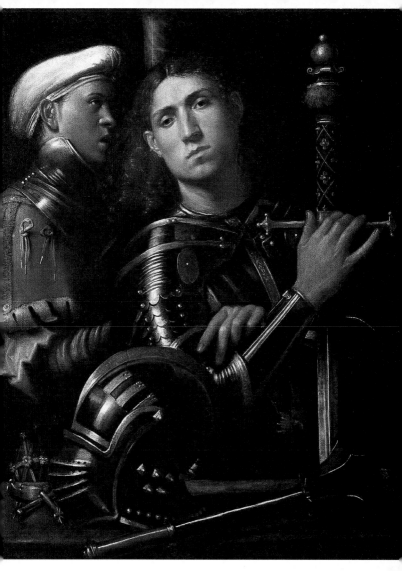

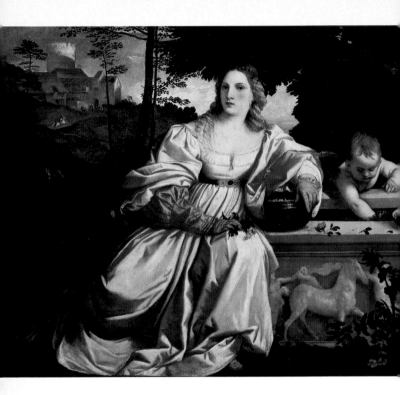

392

Titian (Tiziano Vecellio)
Pieve di Cadore, Belluno, c. 1490–Venice, 1576

Sacred and Profane Love

1515

Oil on canvas
46 ¹/₂ x 109 ¹/₄ in (118 x 279 cm)
Galleria Borghese
Rome

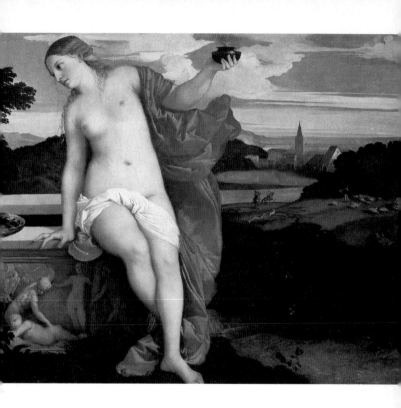

394

Titian (Tiziano Vecellio)
Pieve di Cadore, Belluno, c. 1490–Venice, 1576

Assumption

1516–1518

Oil on panel
271 1/4 x 141 3/4 in (690 x 360 cm)
Santa Maria Gloriosa dei Frari
Venice

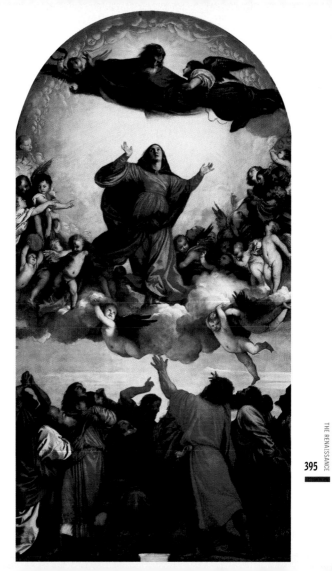

396

Titian (Tiziano Vecellio)
Pieve di Cadore, Belluno, c. 1490–Venice, 1576

Portrait of Charles V of France with his Dog

1532–1533

Oil on canvas
75 ½ x 43 ¾ in (192 x 111 cm)
Prado
Madrid

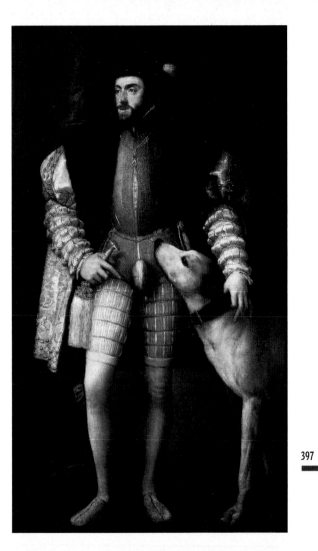

Titian (Tiziano Vecellio)
Pieve di Cadore, Belluno, c. 1490–Venice, 1576

The Pesaro Madonna

1519–1526

Oil on canvas
192 ¹/₄ x 106 ¹/₄ in (488 x 270 cm)
Santa Maria Gloriosa dei Frari
Venice

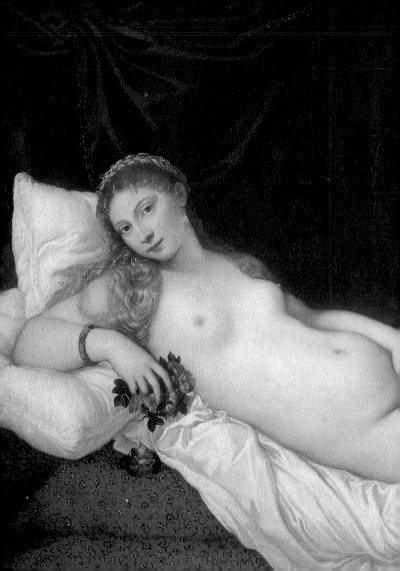

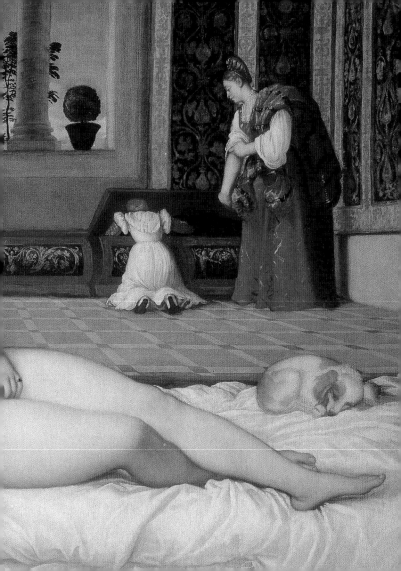

Titian (Tiziano Vecellio)

Pieve di Cadore c. 1490–Venice, 1576

Self-Portrait

1566

Oil on canvas
33 ³/₄ x 27 ¹/₄ in (86 x 69 cm)
Prado
Madrid

pp. 400–401

Titian (Tiziano Vecellio)

Pieve di Cadore, c. 1490–Venice, 1576

The Venus of Urbino

1538

Oil on canvas
46 ³/₄ x 65 in (119 x 165 cm)
Uffizi Gallery
Florence

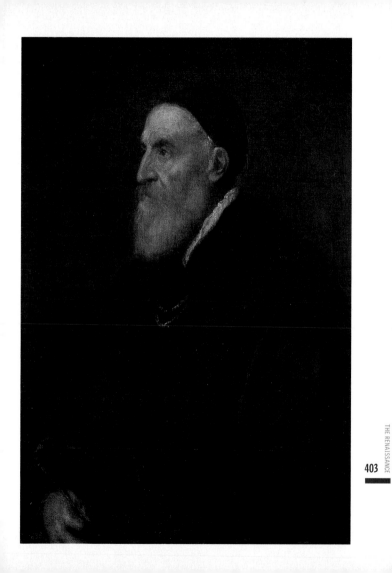

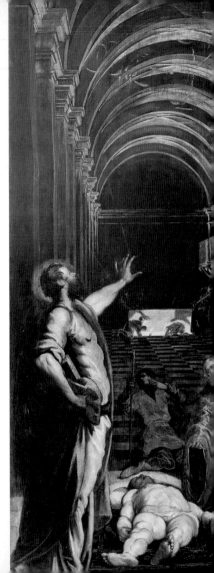

404

Tintoretto (Jacopo Robusti)

Venice, 1518–1594

The Discovery of the Body of Saint Mark

1562–1566

Oil on canvas
157 ¹/₂ x 157 ¹/₂ in (400 x 400 cm)
Pinacoteca di Brera
Milan

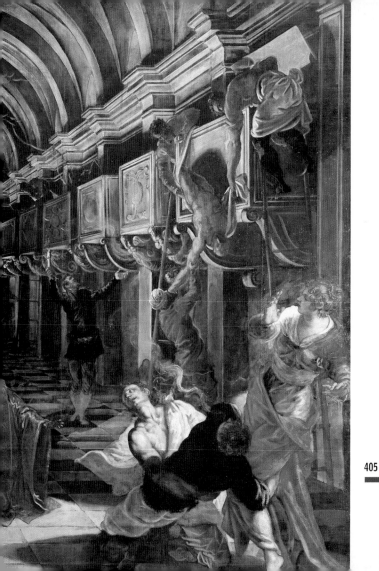

406

Tintoretto (Jacopo Robusti)

Venice, 1518–1594

**Portrait of the Procurator
Jacopo Soranzo**

1550

Oil on canvas
41 3/4 x 35 in (106 x 89 cm)
Accademia
Venice

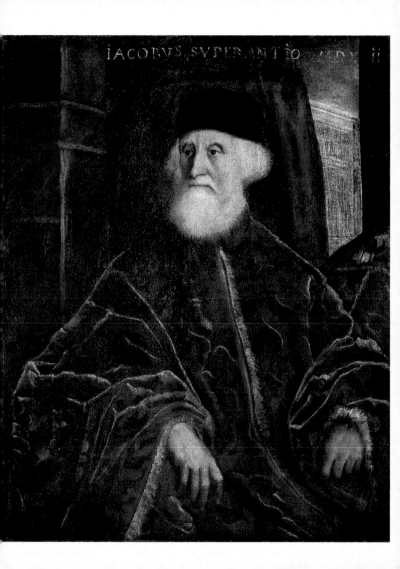
IACORVS·SVPERANTIO· ·ADV· ii

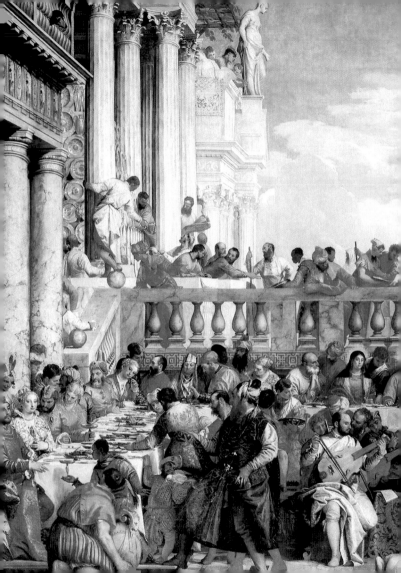

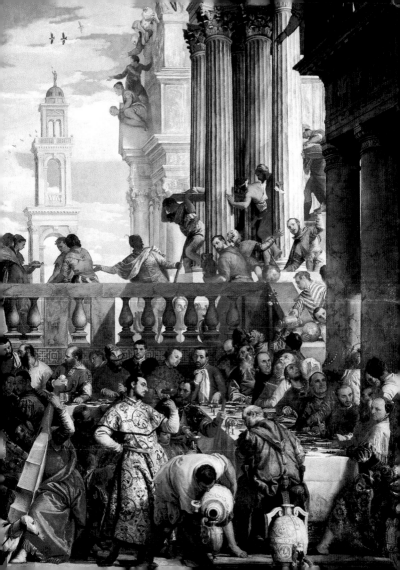

Veronese
(Paolo Caliari)
Verona, c. 1528-Venice, 1588

**Members of the
Barbaro Household**
Sala dell'Olimpo
(detail of the ceiling)

c. 1561

Fresco
Villa Barbaro, Maser
Treviso

pp. 408–409

Veronese
(Paolo Caliari)
Verona, c. 1528-Venice, 1588

Marriage at Cana

1562–1563

Oil on canvas
262 $^1/_4$ x 389 $^3/_4$ in
(666 x 990 cm)
Louvre
Paris

Albrecht Dürer

Nuremberg, 1471–1528

Self-Portrait with Fur Coat

1500

Oil on panel
26 ¹/₂ x 19 ¹/₄ in (67 x 49 cm)
Alte Pinakothek
Munich

pp. 412–413

Lorenzo Lotto

Venice, c. 1480–Loreto, 1556

The Bridal Couple

1523

Oil on canvas
28 x 33 in (71 x 84 cm)
Prado
Madrid

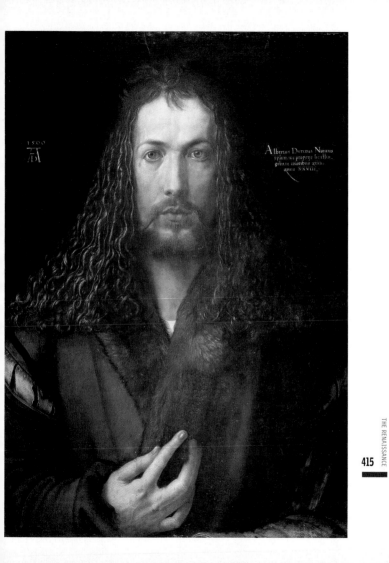

1500

Albertus Durerus Noricus
ipsum me proprijs sic effin-
gebam coloribus ætatis
anno XXVIII.

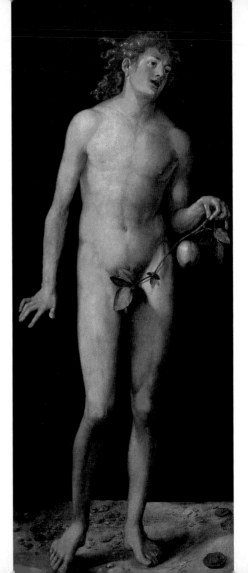

Albrecht Dürer
Nuremberg, 1471–1528

Adam

1507

Oil on panel
82 ¹/₄ x 32 in (209 x 81 cm)
Prado
Madrid

opposite

Albrecht Dürer
Nuremberg, 1471–1528

Eve

c. 1507

Oil on panel
82 ¹/₄ x 32 in (209 x 81 cm)
Prado
Madrid

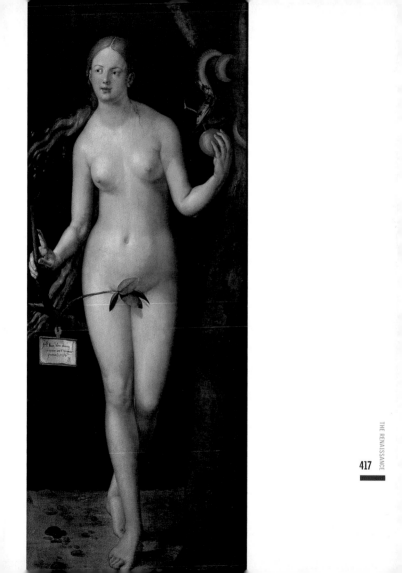

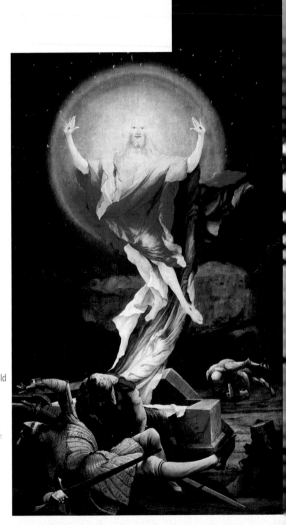

Matthias Grünewald

Würzburg, c. 1480–
Halle, 1528

**Resurrection
and Annunciation**
The Isenheim Altarpiece
(Diptych)

1512–1516

Oil on panel
106 x 112 ¹/₂ in
(269 x 286 cm)
Musée d'Unterlinden
Colmar

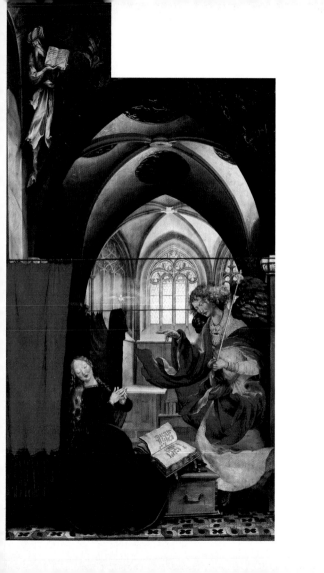

420

Lucas Cranach the Elder
Kronach, 1472–Weimar, 1553

Portrait of Martin Luther

c. 1523-1524

Parchment mounted on panel
17 ¹/₄ x 11 ³/₄ in (43.6 x 29.8 cm)
Germanisches Nationalmuseum
Nuremberg

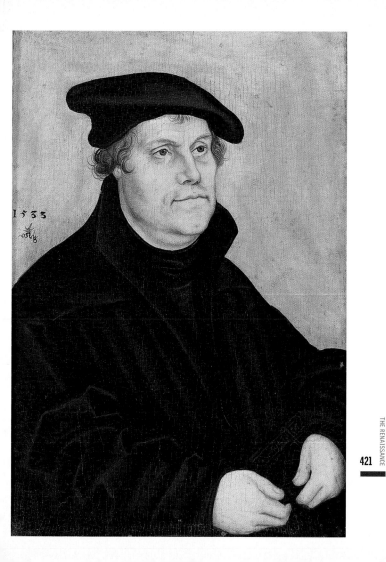

1 5 3 3

422

Lucas Cranach the Elder
Kronach, 1472–Weimar, 1553

Venus and Cupid

c. 1531

Oil on panel
66 1/2 x 26 1/2 in (169 x 67 cm)
Galleria Borghese
Rome

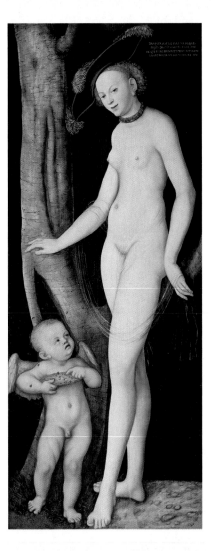

424

Albrecht Altdorfer
c. 1480–Regenburg, 1538

The Martyrdom of Saint Florian

c. 1518

Oil on panel
30 x 26 ¹/₂ in (76.4 x 67.2 cm)
Uffizi Gallery
Florence

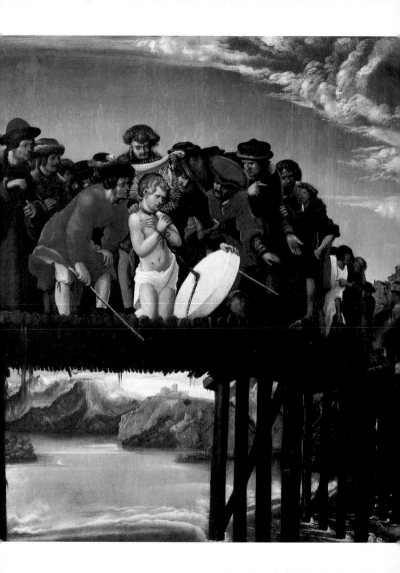

426

Albrecht Altdorfer
c. 1480–Regensburg, 1538

Susanna Bathing

c. 1526

Oil on panel
29 $\frac{1}{2}$ x 24 in (74.8 x 61.2 cm)
Alte Pinakothek
Munich

428

Hans Holbein the Younger
Augusta, 1497/8–London, 1543

The Astronomer Nikolaus Kratzer

c. 1528

Tempera on panel
32 ¹/₄ x 26 ¹/₂ in (83 x 67 cm)
Louvre
Paris

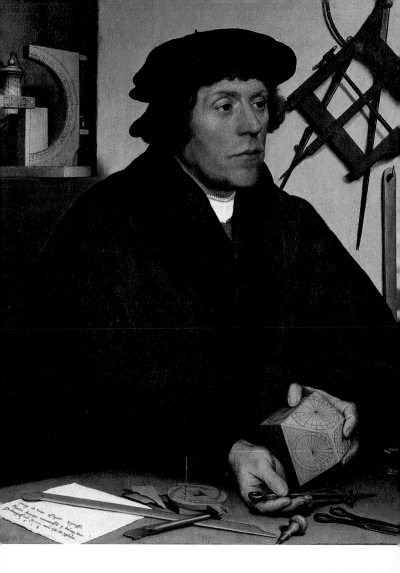

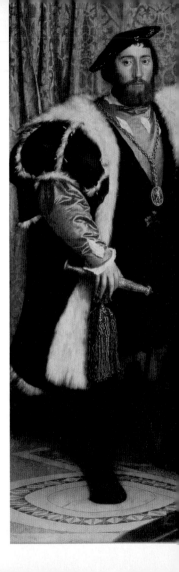

Hans Holbein the Younger
Augusta, 1497/8-London, 1543

The Ambassadors

c. 1533

Oil on panel
81 $^1/_2$ x 82 $^1/_2$ in (207 x 209.5 cm)
National Gallery
London

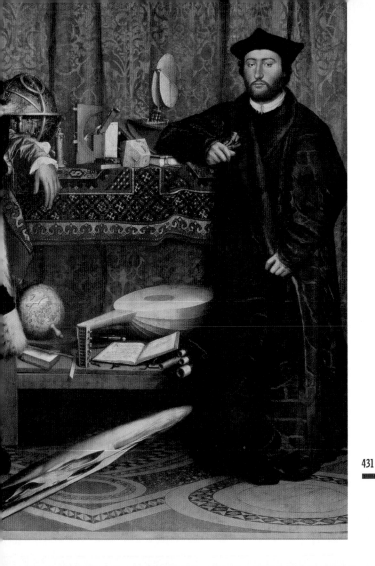

432

Andrea del Sarto
(Andrea d'Agnolo di Francesco)
Florence, 1486–1530
Madonna of the Harpies
1517

Oil on canvas
81 $\frac{1}{2}$ x 70 in (207 x 178 cm)
Uffizi Gallery
Florence

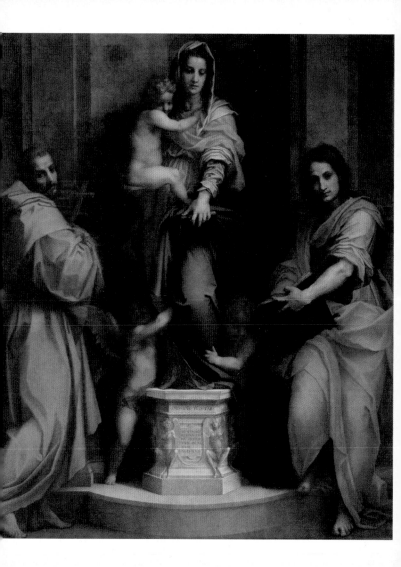

434

Pontormo (Jacopo Carrucci)

Empoli, 1494–Florence, between 1555 and 1557

Deposition

c. 1527

Oil on panel
123 x 76 in (312.4 x 193 cm)
Santa Felicita (Capponi Chapel)
Florence

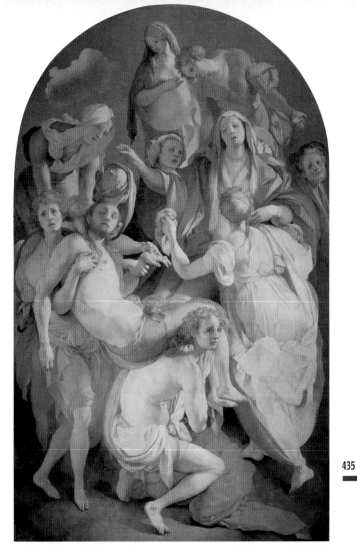

436

Rosso Fiorentino (Giovanni Battista di Jacopo)
Florence, 1494–Fontainebleau, 1540

Deposition

1521

Oil on panel
132 x 78 in (335.3 x 198 cm)
Pinacoteca
Volterra

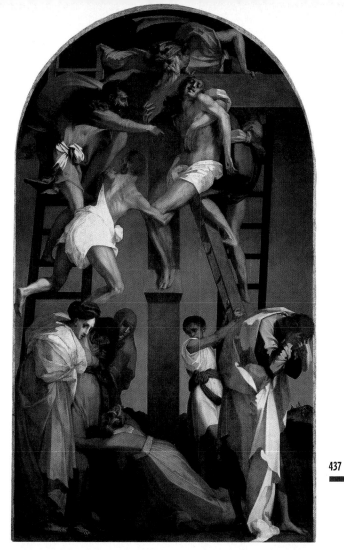

Parmigianino (Francesco Mazzola)

Parma, 1503–Casalmaggiore, Cremona, 1540

Madonna with the Long Neck

1534–1540

Oil on panel
85 x 52 in (216 x 132 cm)
Uffizi Gallery
Florence

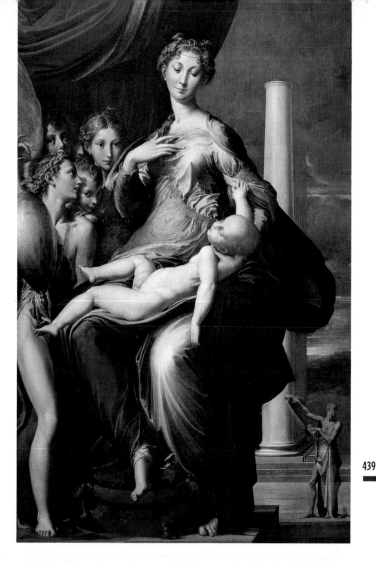

440

Agnolo Bronzino

Florence, 1503–1572

**Portrait of Eleanor of Toledo
and her Son, Giovanni de' Medici**

c. 1545

Oil on panel
45 $^{1}/_{4}$ x 37 $^{3}/_{4}$ in (115 x 96 cm)
Uffizi Gallery
Florence

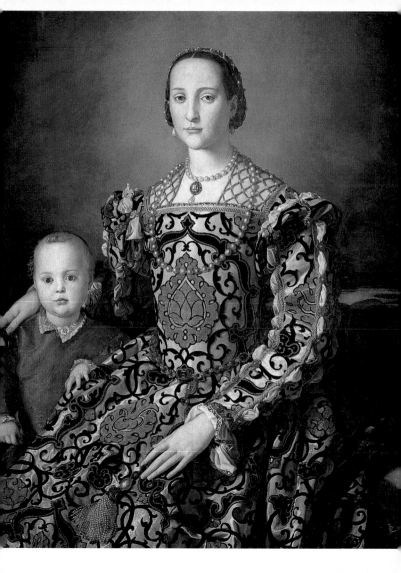

442

Jean Clouet
Brussels c. 1475/80–Paris, 1541

Francis I of France

1530–1535

Oil on panel
37 ³/₄ x 21 ¹/₄ in (96 x 74 cm)
Louvre
Paris

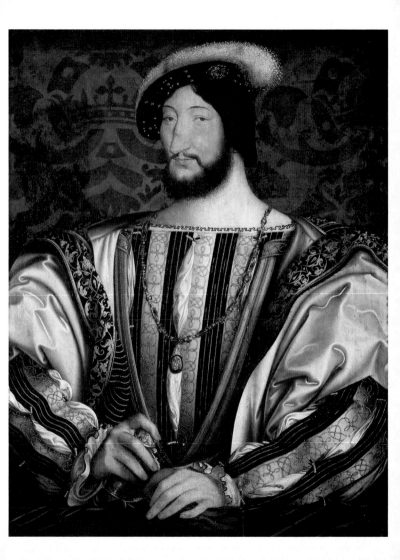

444

Jean Clouet
Brussels c. 1475/80–Paris, 1541

The Botanist Pierre Quthe

1562

Oil on panel
35 ¹/₄ x 27 ¹/₂ in (91 x 70 cm)
Louvre
Paris

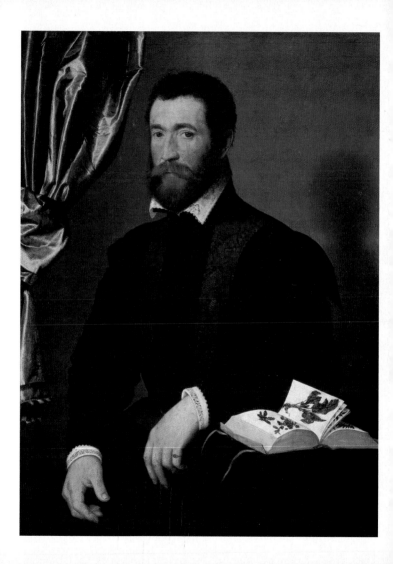

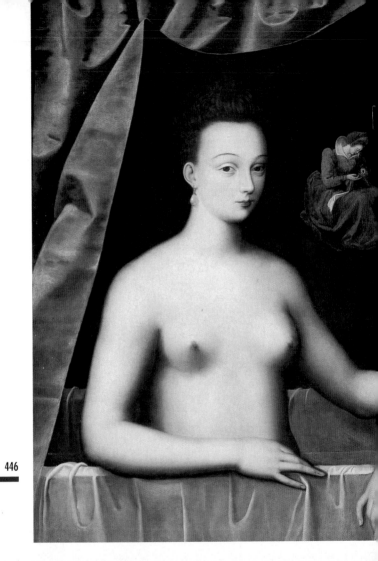

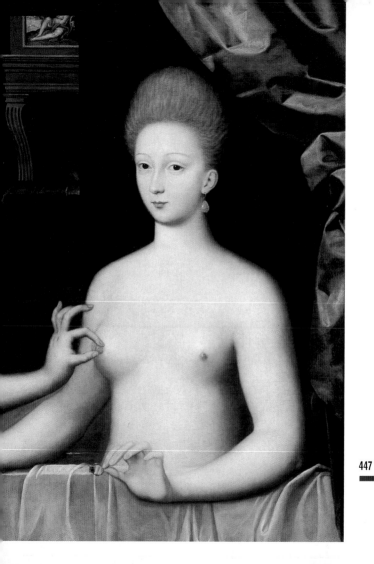

447

Alessandro Allori

Florence, 1535-1607

Christ and the Woman Taken in Adultery

1577

Oil on panel
148 ¹/₄ x 108 ¹/₄ in (378 x 275 cm)
Santo Spirito
Florence

pp. 446–447

School of Fontainebleau

**Gabrielle d'Estrées and One of Her Sisters
in the Bath**

c. 1594

Oil on panel
37 ¹/₄ x 49 ¹/₄ in (96 x 125 cm)
Louvre
Paris

450

Pieter Bruegel
the Elder

Breda, 1528–Brussels, 1569

Haymaking

1565

Oil on panel
46 x 63 ¹/₄ in (117 x 161 cm)
Národni Galerie
Prague

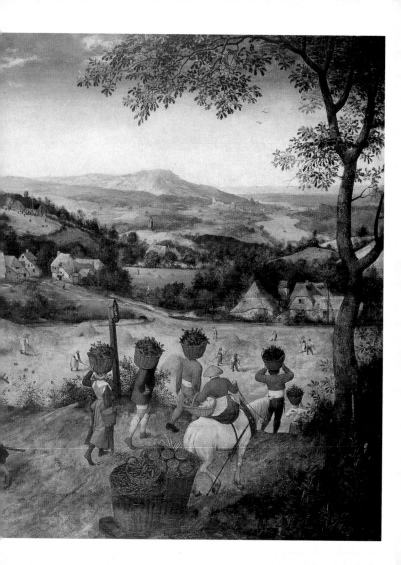

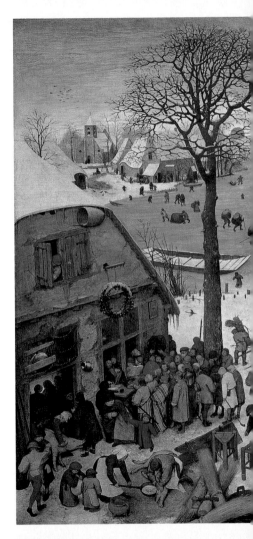

452

Pieter Bruegel the Elder
Breda, 1528-Brussels, 1569

The Census of Bethlehem

1566

Tempera on panel
45 ³/₄ x 64 ¹/₂ in (116 x 164 cm)
Musées Royaux des Beaux-Arts
Brussels

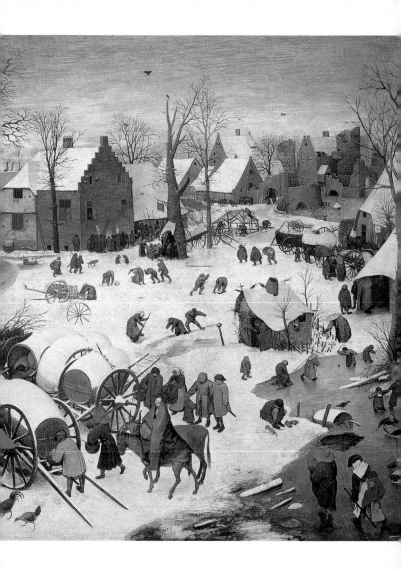

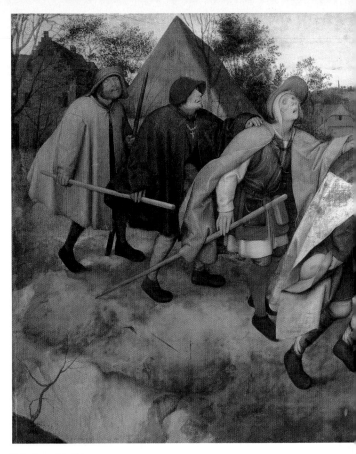

Pieter Bruegel the Elder

Breda, 1528–Brussels, 1569

The Parable of the Blind

1564

Oil on canvas, 33 $\frac{1}{4}$ x 60 $\frac{1}{4}$ in (86 x 154 cm)
Museo Nazionale di Capodimonte
Naples

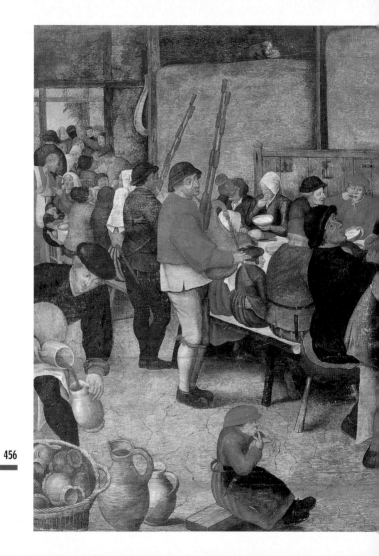

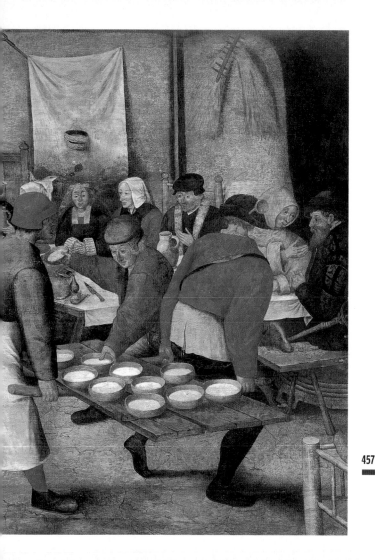

Giuseppe Arcimboldo
Milan, c. 1527–1593

Summer

1573

Oil on canvas
30 x 25 in (76 x 63.5 cm)
Louvre
Paris

pp. 456-457

Pieter Bruegel the Elder
Breda, 1528–Brussels, 1569

Wedding Banquet

c. 1568

Oil on panel
45 x 64 ½ in (114 x 164 cm)
Kunsthistorisches Museum
Vienna

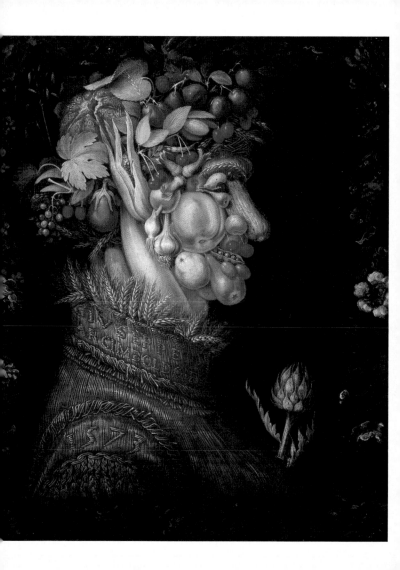

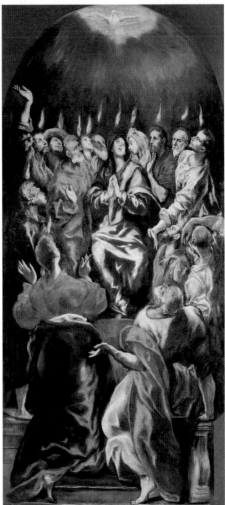

El Greco
(Domenikos Theotokopoulos)
Crete, 1541–Toledo, 1614

The Pentecost

1596–1600

Oil on canvas
108 ¹/₄ x 50 in (275 x 127 cm)
Prado
Madrid

opposite

El Greco
(Domenikos Theotokopoulos)
Crete, 1541–Toledo, 1614

**The Assumption of
the Virgin**

1607–1613

Oil on canvas
127 ¹/₄ x 65 ³/₄ in (323 x 167 cm)
Santa Cruz Museum
Toledo

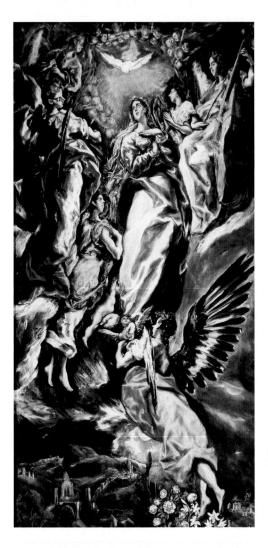

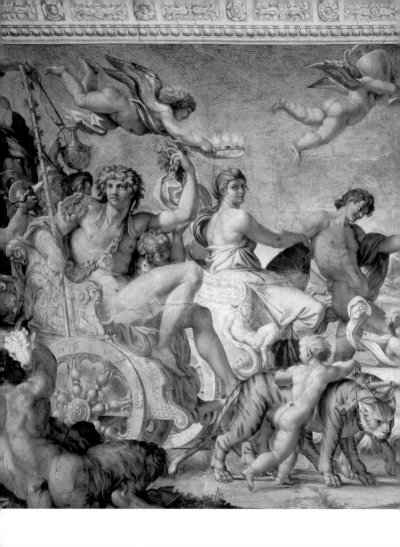

THE AGE OF BAROQUE

Although the seventeenth century may be known as the Baroque century, painting styles in this period were varied and at times contradictory. The century began with a remarkable painter, Michelangelo Merisi da Caravaggio, who, despite a brief life (born in 1573, he died in 1610), left his mark on the history of Western painting. In his paintings, Caravaggio emphasized the more human aspects of stories from the Bible, such as the poverty of saints and the settings in which they lived. This non-idealized humanity is portrayed with sharp contrasts of light and shadow, which accentuates the dramatic and at times violent nature of his canvases. This visual idiom is known by the name of "luminism."

At the beginning of the seventeenth century, Rome was a veritable magnet for painters, sculptors, and architects from all over Europe. The continent was riven by the Wars of Religion and the countries, such as Holland, that adhered to the Protestant Reformation were no longer interested in commissioning paintings to illustrate the teachings of the Bible. But if the Church stopped being a major client for artists in Protestant countries, Rome was more interested than ever in having their help to affirm the glory of the Catholic Church. A great many churches were decorated with frescoes and many altarpieces and sculptural groups were executed. Along with Italian painters, there was an enormous contingent of painters from France, Germany, the Netherlands, and Spain. The new visual idiom expressed by Caravaggio, who had lived in Rome from 1593 until about 1606, had a powerful influence upon some of them, and they went on to spread luminism in Italy and throughout Europe. This led to the birth of "Caravaggism."

In Spain, the great interpreters of Caravaggio's luminism were the young Velázquez (1599-1660) and Francisco de Zurbarán (1598-1664), and in the Iberian peninsula this style took on the name of "*tenebrismo.*" The Caravaggist style as applied to the subjects of everyday life was taken to

Holland by the painters Hendrick Terbrugghen (1588–1629) and Gerrit van Honthorst (1590–1656). Moreover, the impact of Caravaggesque luminism was very important in the development of Rembrandt's work. Although its spread was more limited in France, Caravaggism found a great interpreter there too in the person of Georges de La Tour (1593–1653).

At the same time, the visual language that was known as "Baroque" began to take form in Rome. Initially this consisted of a series of large decorations in which illusionism and movement were the prevailing elements. By further perfecting the perspective techniques that had been developed over the two previous centuries, the painters of the seventeenth century executed, among other things, large painted architectural structures intended to deceive the eye of the observer, drawing him or her into the painted space as if it were real. Well suited to expressing the glorification of the saints, the large perspective views of figures floating in the air, stretching out across the sky, were very popular with the Catholic church. From Rome, this approach spread throughout Italy and into Catholic Germany, Austria, Spain, and Portugal. This was also one of the first artistic trends to cross the Atlantic Ocean, where it spread, as early as the eighteenth century, through the Spanish and Portuguese colonies in the Americas.

One of the most important artists in the school of *trompe-l'oeil* painting (the depiction of false architecture on the walls and ceilings of churches and the villas of the wealthy) was the Jesuit priest Andrea Pozzo (1642–1709). Toward the end of the century he executed an immense fresco in the vault of the church of Saint Ignatius in Rome showing *The Glory of Saint Ignatius*. In this painting, a monumental *trompe-l'oeil* architectural structure stretches up toward the sky. Dozens of figures perch on it or float in mid-air. At the center, above the fake edifice, Saint Ignatius himself, supported by clouds and angels, ascends toward the divine light. The *trompe-l'oeil* painting expands the space

while the vanishing point reaching up toward the sky offers a sense of the infinite. All the figures are in movement. The entire scene is swept by a great sense of dynamism. We are witnessing not only the glory of a saint but also the triumph of artifice.

Dynamism is a key word for any understanding of Baroque art. Even when we are not dealing with monumental works such as the frescoes on the vaults of churches, Baroque paintings are filled with movement. This is true of the great Flemish painter Pieter Paul Rubens and his followers, and the Spanish painters Bartolomé Esteban Murillo (1618–1682) and Jusepe de Ribera (1591–1652), who, while emphasizing the dynamic aspects of a scene, preferred a more fluid rendering of images, based on the modulation of color rather than on linear design or the use of chiaroscuro.

This tendency was opposed, throughout the seventeenth century, by a classicist current that held the drawing of a figure with a perfectly rendered chiaroscuro enclosed within outlines to be the most important element of a painting. This school was tied to Renaissance painting and, more than ever before, was based on the models of classical Greek and Roman art. The classicism of the seventeenth century developed especially in France, and its leading figure was the painter Nicolas Poussin (1594–1665), who spent much of his life in Rome.

Finally, a special chapter in the history of painting in the seventeenth century is needed to deal with Dutch painters. Even though Holland converted to Protestantism—an iconoclastic religion—this took place in a general climate of tolerance. That explains, for instance, the fact that Rembrandt treated religious subjects in paintings intended for private devotion. The churches, however, no longer commissioned works from artists. The new clients were members of the wealthy bourgeoisie of Haarlem, Leyden, Amsterdam, Delft,

and so on. Painters like Vermeer, Pieter de Hooch (1629–1684), Jacob van Ruysdael (c.1628–1682), Adrien van Ostade (1610–1685), and Jan Steen (1626–1679), were no longer asked to paint religious scenes, but instead scenes of domestic life, landscapes, views of cities, and still lifes. Indeed, often it was the artists themselves who chose the subjects they offered to the purchaser. This led to a new view of the world, a more intimate style of painting, made up of small-scale canvases, featuring characters lost in thought or pursuing everyday activities. There were also famous commissions from the guilds of the militias of Haarlem and Amsterdam, done by Frans Hals (1582/3–1666) and Rembrandt, who painted, respectively, the *Banquet of the Officers of the Saint George Militia Company* and the *Night Watch*, which were group portraits of members of guilds in poses of self-celebration.

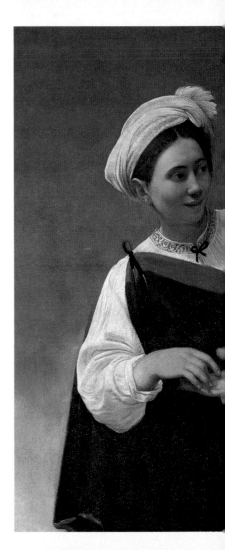

Michelangelo Merisi da Caravaggio

Caravaggio, Bergamo, 1573–Porto Ercole,
Grosseto, 1610

The Fortune Teller

c. 1594

Oil on canvas
59 ¹/₂ x 45 ¹/₃ in (151.2 x 116 cm)
Palazzo Conservatori, Pinacoteca Capitolina
Rome

pp. 462–463

Annibale Carracci

Bologna, 1560–Rome, 1609

**The Triumph of Bacchus
and Ariadne**

c. 1597–1604

Fresco
Palazzo Farnese, Galleria Farnese
Rome

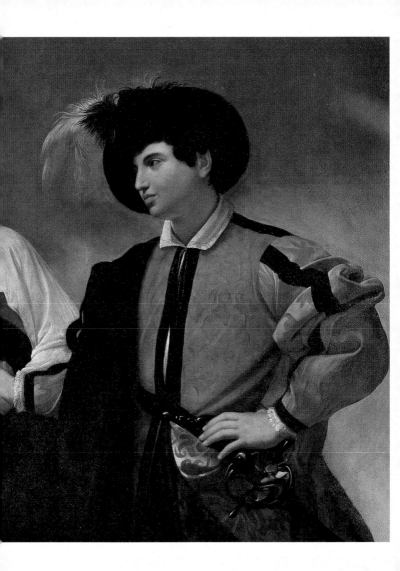

470

Michelangelo Merisi da Caravaggio
Caravaggio, Bergamo, 1573–Porto Ercole, Grosseto, 1610

The Young Bacchus

c. 1599

Oil on canvas
36 $^1/_2$ x 33 $^1/_2$ in (93 x 85 cm)
Uffizi Gallery
Florence

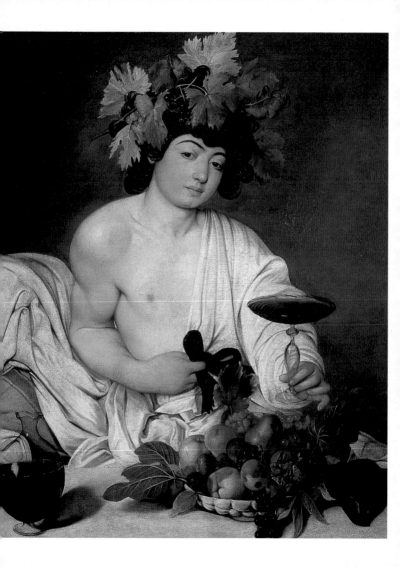

Michelangelo Merisi da Caravaggio
Caravaggio, Bergamo, 1573–Porto Ercole, Grosseto, 1610

The Head of Medusa

BETWEEN 1594 AND 1599

Oil on canvas transferred to panel
diam. 21 $\frac{1}{4}$ in (55 cm)
Uffizi Gallery
Florence

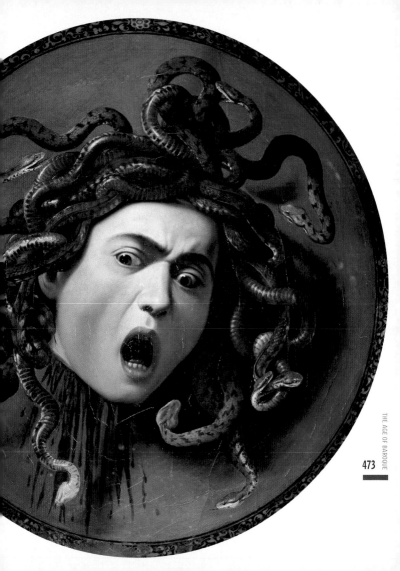

474

Michelangelo Merisi da Caravaggio

Caravaggio, Bergamo, 1573–Porto Ercole,
Grosseto, 1610

Supper at Emmaus

1601

Oil and tempera on canvas
55 ¹/₂ x 21 ³/₄ in (141 x 196.2 cm)
Pinacoteca di Brera
Milan

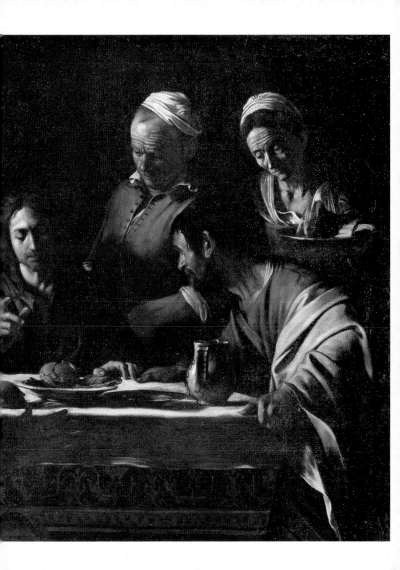

476

Michelangelo Merisi da Caravaggio
Caravaggio, Bergamo, 1573–Porto Ercole, Grosseto, 1610

The Conversion of Saint Paul

1601

Oil on canvas
90 ¹/₂ x 69 in (230 x 175 cm)
Santa Maria del Popolo (Cerasi Chapel)
Rome

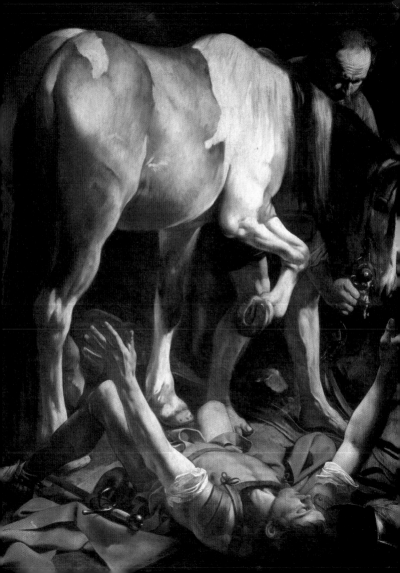

Orazio Gentileschi
Pisa, 1563–London, 1639

**Judith and her Maid with the
Head of Holofernes**

1611–12

Oil on canvas
48 ¹/₂ x 56 in (123 x 142.5 cm)
Vatican Museums
Vatican City

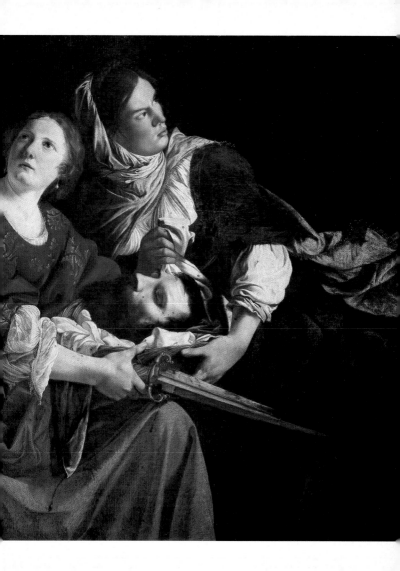

480

Artemisia Gentileschi
Rome, 1593–Naples, c. 1652

Judith Beheading Holofernes

c. 1620

Oil on canvas
78 1/4 x 63 3/4 in (199 x 162 cm)
Uffizi Gallery
Florence

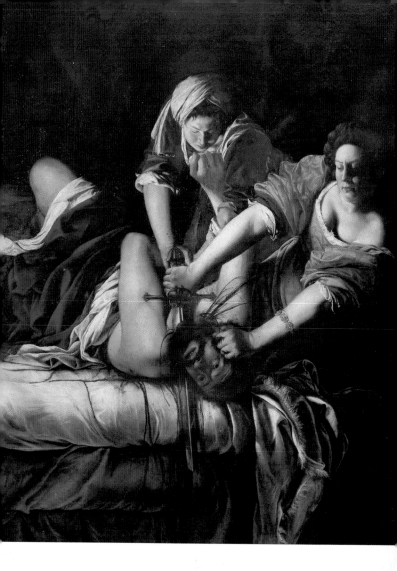

482

Artemisia Gentileschi

Rome, 1593–Naples, c. 1652

Judith and her Maid

c. 1614

Oil on canvas
45 x 36 ³/₄ in (114 x 93.5 cm)
Palazzo Pitti, Galleria Palatina
Florence

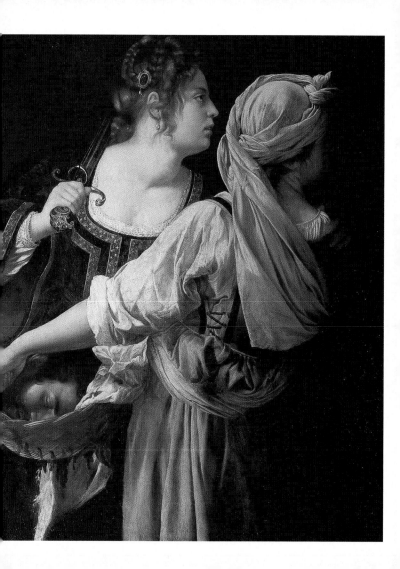

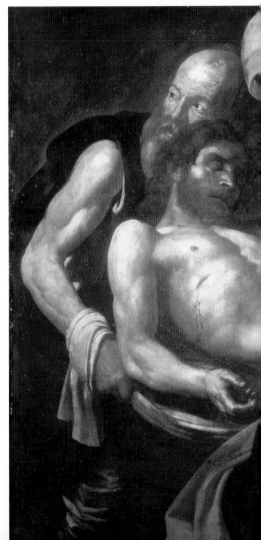

Battistello (Giovanni
Battista Caracciolo)

Naples, c. 1570–1637

484

**Christ Carried
to the Tomb**

c. 1618–1621

Oil on canvas
50 ¹/₂ x 64 ¹/₂ in (128 x 164 cm)
Fondazione Longhi
Florence

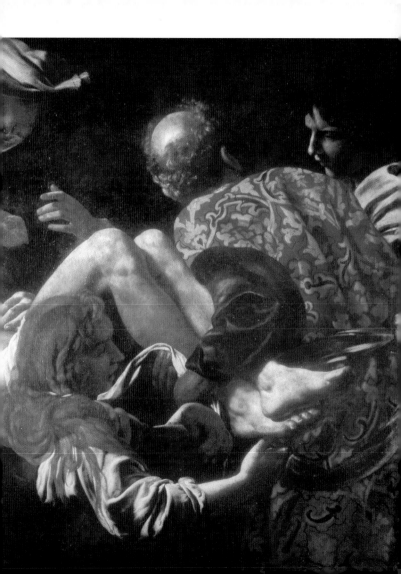

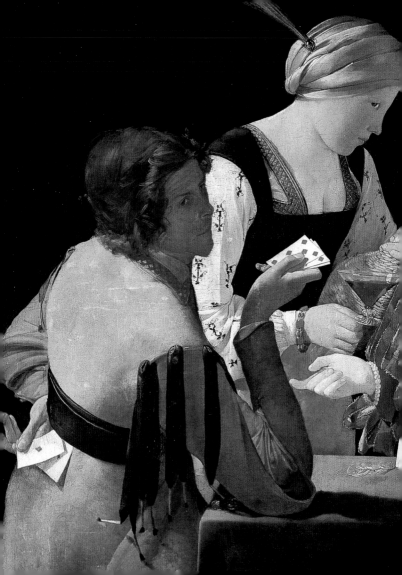

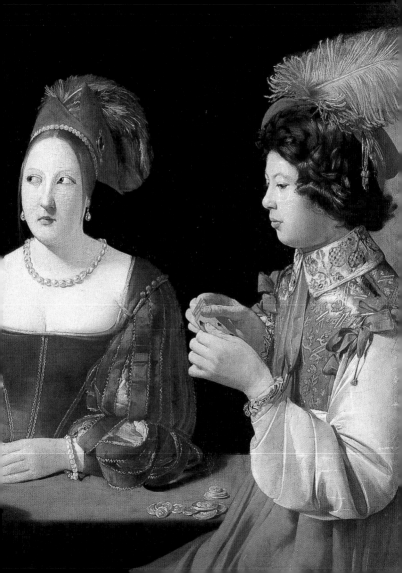

Georges de La Tour
Vic-sur-Seille, 1593–Lunéville, 1653

Nativity

c. 1640

Oil on canvas
30 x 35 ¹/₄ in (76 x 91 cm)
Musée des Beaux-Arts
Rennes

pp. 486–487

Georges de La Tour
Vic-sur-Seille, 1593–Lunéville, 1653

The Cheat

c. 1635–1640

Oil on canvas
41 ³/₄ x 57 ¹/₂ in (106 x 146 cm)
Louvre
Paris

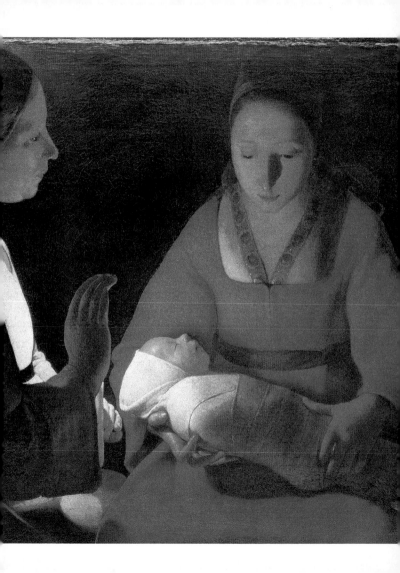

490

Georges de La Tour
Vic-sur-Seille, 1593–Lunéville, 1653

The Penitent Magdalen

1640–1645

Oil on canvas
50 $\frac{1}{2}$ x 37 in (128 x 94 cm)
Louvre
Paris

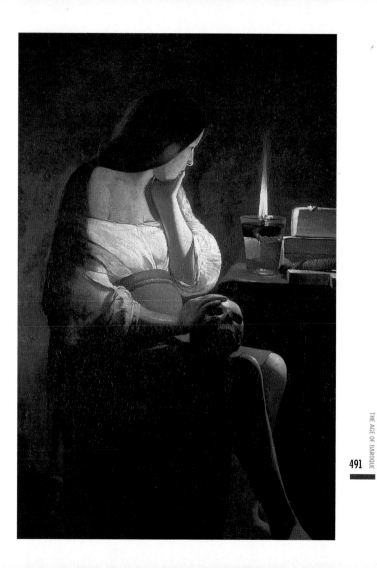

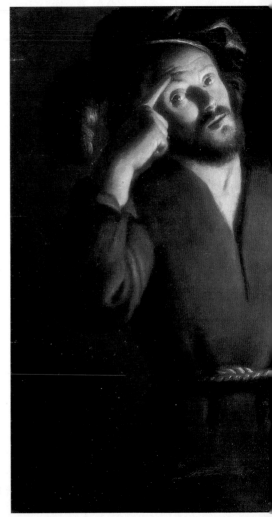

492

Trophime Bigot
Arles, 1579–Avignon, 1650

The Cellar

1620–1650

Oil on panel
10 x 14 ¹/₄ in (25.3 x 36.4 cm)
Uffizi Gallery
Florence

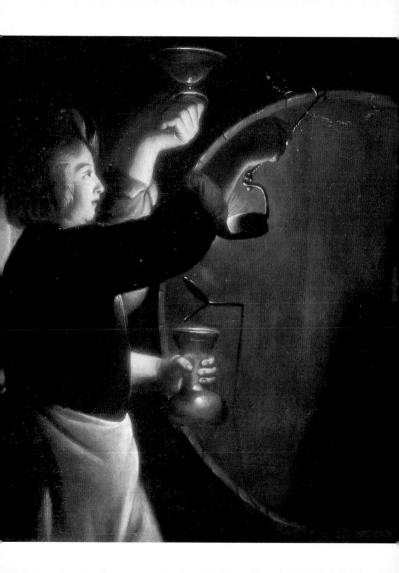

494

Follower of Theodor van Baburen
(Utrecht, 1595–1624)

The Denial of Saint Peter

c. 1625

Oil on canvas
34 ¹/₄ x 41 ³/₄ in (87 x 106 cm)
National Museum
Krakow

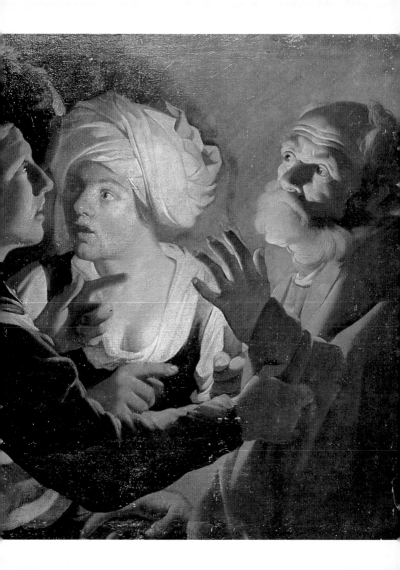

496

Hendrick Terbrugghen
Deventer, 1588–Utrecht, 1629

Duet

1628

Oil on canvas
39 $^3/_4$ x 32 in (101 x 81 cm)
Louvre
Paris

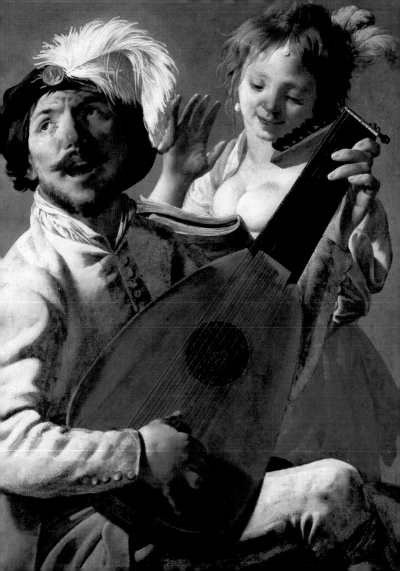

498

Gerrit van Honthorst
Utrecht, 1590–1656

Adoration of the Shepherds

1617

Oil on canvas
133 $^1/_4$ x 78 $^3/_4$ in (338.5 x 198.5 cm)
Uffizi Gallery
Florence

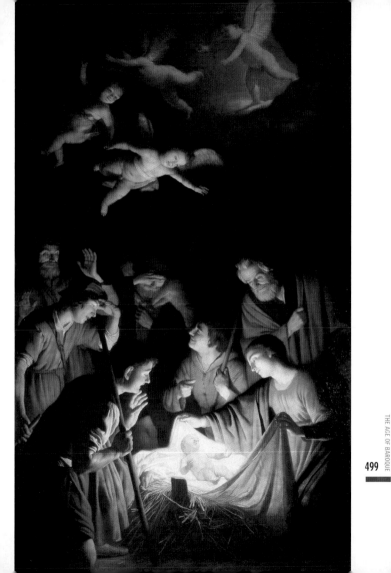

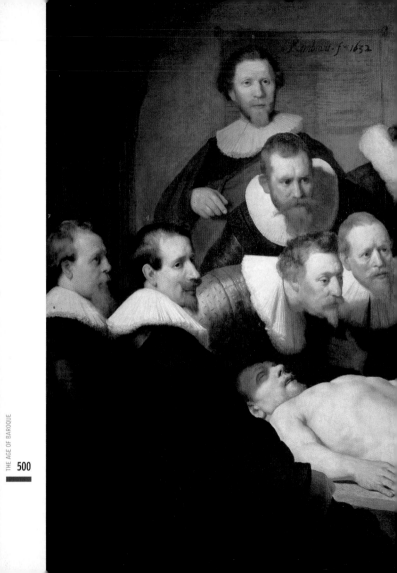

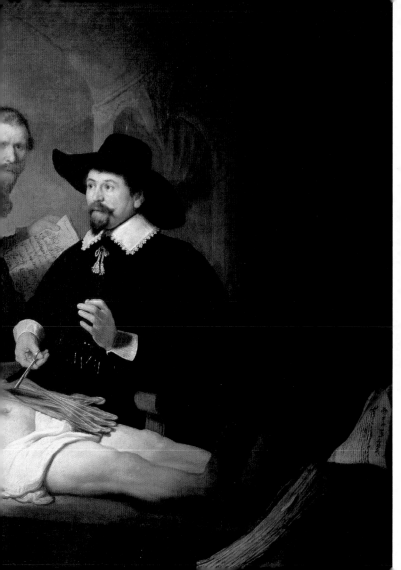

Rembrandt Harmenszoon van Rijn
Leiden, 1606–Amsterdam, 1669

Artemisia

1634

Oil on canvas
56 x 59 ¹/₁ in (142 x 152 cm)
Prado
Madrid

pp. 500–501

Rembrandt Harmenszoon van Rijn
Leiden, 1606–Amsterdam, 1669

The Anatomy Lesson of Doctor Tulp

1632

Oil on canvas
66 ¹/₁ x 85 in (169.5 x 216 cm)
Mauritshuis
The Hague

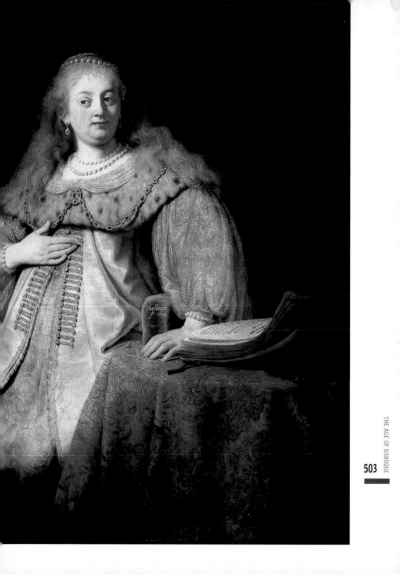

504

Rembrandt Harmenszoon van Rijn
Leiden, 1606–Amsterdam, 1669

The Deposition

1634

Oil on canvas
62 $^{1}/_{4}$ x 46 in (158 x 117 cm)
Hermitage
St. Petersburg

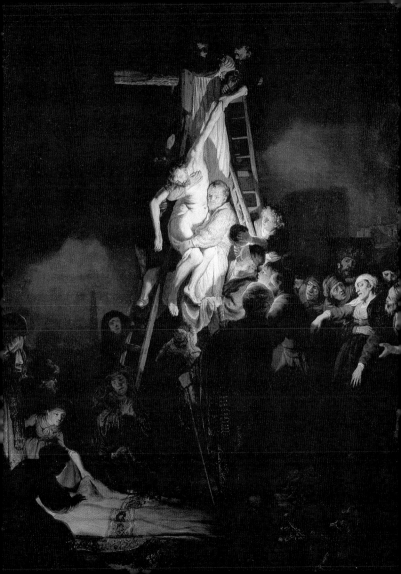

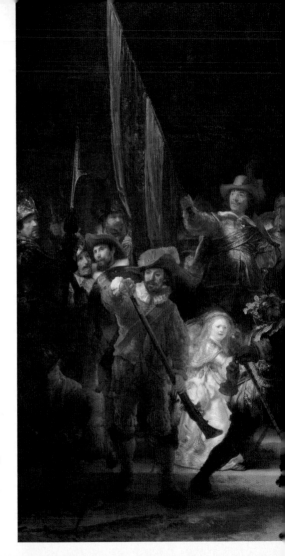

Rembrandt
Harmenszoon
van Rijn

Leiden, 1606–
Amsterdam, 1669

**The Night Watch
(The Company of
Captain Frans
Banning Cocq and
Lieutenant Willem
van Ruytenburch)**

1642

Oil on canvas
143 x 172 in
(363 x 437 cm)
Rijksmuseum
Amsterdam

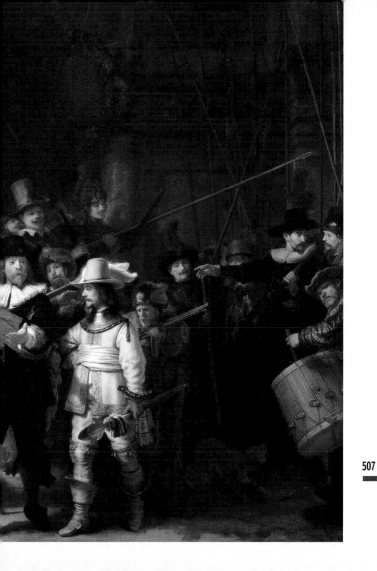

508

Rembrandt Harmenszoon van Rijn
Leiden, 1606–Amsterdam, 1669

Bathsheba at her Toilet

1654

Oil on canvas
56 x 56 in (142 x 142 cm)
Louvre
Paris

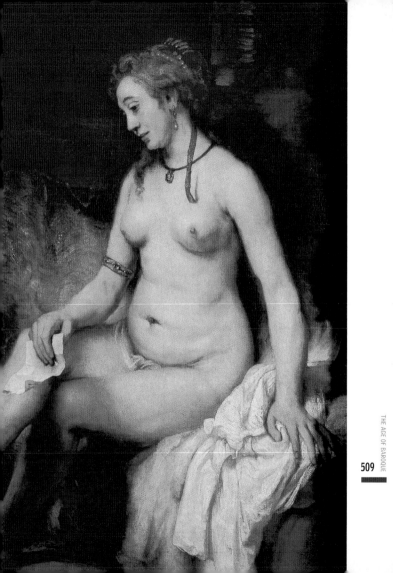

Rembrandt Harmenszoon van Rijn
Leiden, 1606–Amsterdam, 1669

Self-Portrait

1660

Oil on canvas
33 1/2 x 24 in (85 x 61 cm)
Uffizi Gallery
Florence

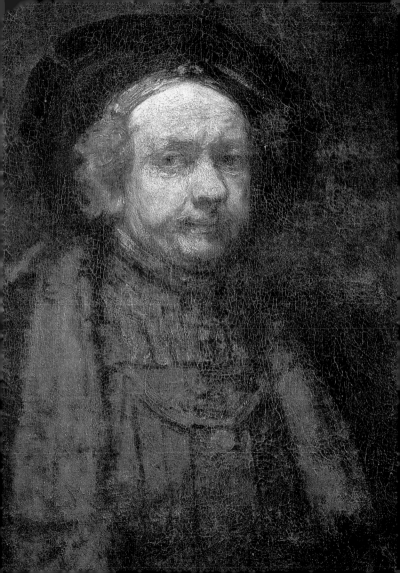

Rembrandt Harmenszoon van Rijn
Leiden, 1606–Amsterdam, 1669

Portrait of Jeremias de Decker

1666

Oil on canvas
28 x 22 in (71 x 56 cm)
Hermitage
St. Petersburg

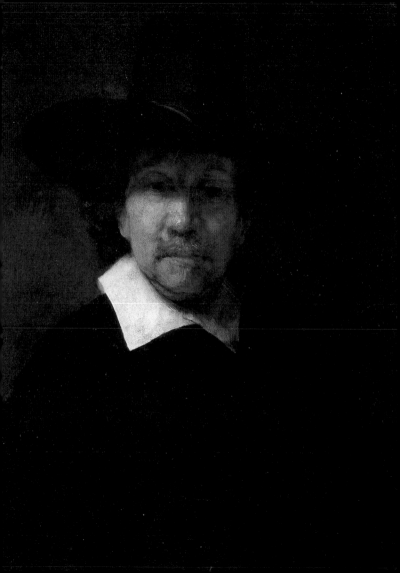

514

Gerrit Dou
Leiden, 1613–1675

The Dropsical Woman

c. 1663

Oil on canvas
33 ³/₄ x 26 ³/₄ in (86 x 67.8 cm)
Louvre
Paris

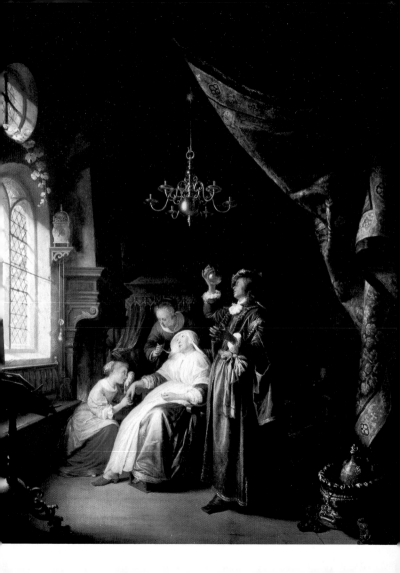

516

Gerrit Dou
Leiden, 1613–1675

Young Woman at a Window

1662

Oil on panel
15 x 11 ¹/₂ in (38 x 29 cm)
Sabauda Gallery
Turin

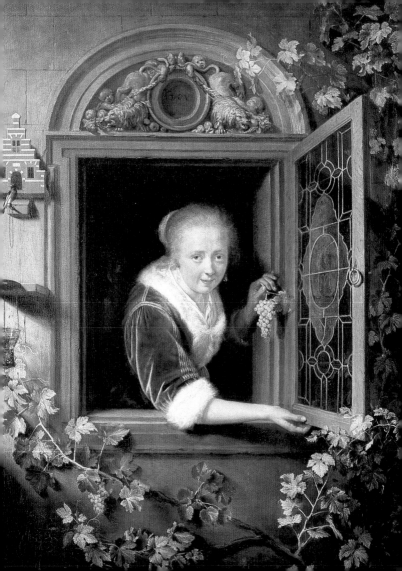

518

Jusepe de Ribera
Valencia, 1591–Naples, 1652

The Holy Trinity
c. 1635

Oil on canvas
89 x 71 ¼ in (226 x 181 cm)
Prado
Madrid

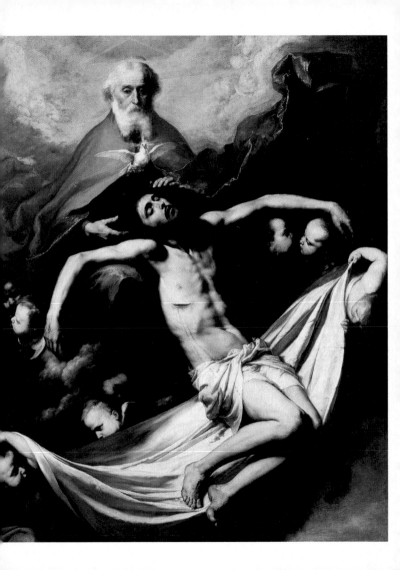

Jusepe de Ribera
Valencia, 1591–Naples, 1652

Jacob Among the Sheep

1632

Oil on canvas
68 ¹/₂ x 86 ¹/₄ in (174 x 219 cm)
San Lorenzo de El Escorial
Madrid

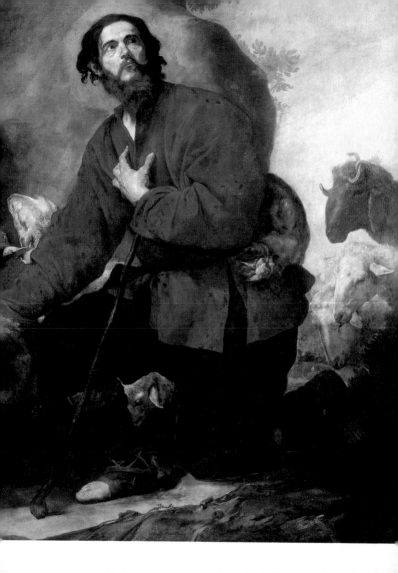

522

Francisco de Zurbarán
Fuente de Cantos, 1598–Madrid, 1664

**The Appearance of the Crucified
Saint Peter to Saint Peter Nolasco**

1629

Oil on canvas
70 ¹/₂ x 87 ³/₄ in (179 x 223 cm)
Prado
Madrid

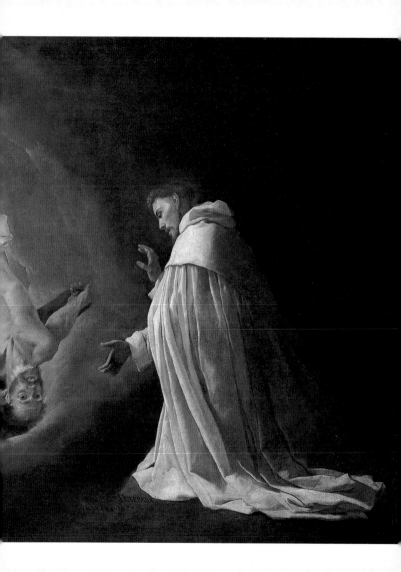

524

Francisco de Zurbarán
Fuente de Cantos, 1598–Madrid, 1664

Birth of the Virgin

c. 1627

Oil on canvas
55 $^1/_2$ x 42 $^3/_4$ in (141 x 108.6 cm)
The Norton Simons Foundation
Pasadena

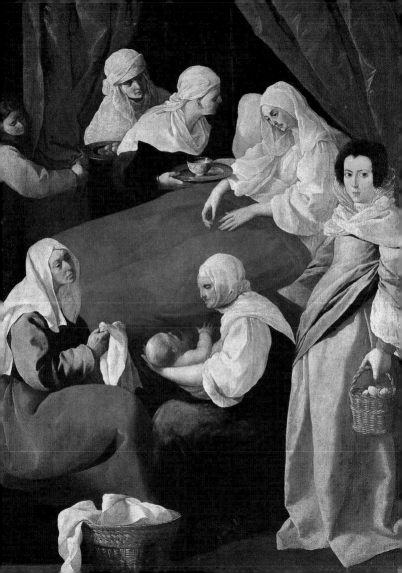

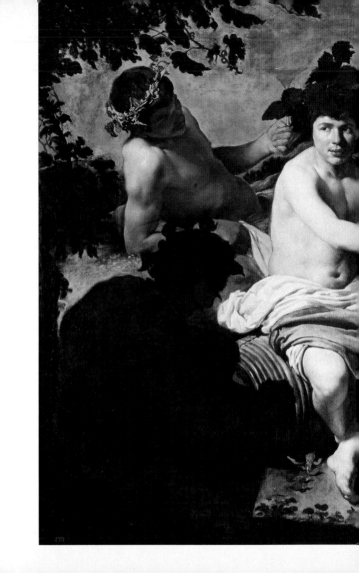

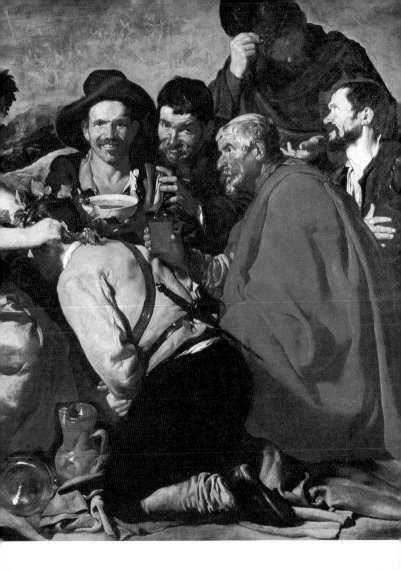

Diego Velázquez
Seville, 1599–Madrid, 1660

Apollo in the Forge of Vulcan

1629

Oil on canvas
87 ³/₄ x 114 ¹/₄ in (223 x 290 cm)
Prado
Madrid

pp. 526–527

Diego Velázquez
Seville, 1599–Madrid, 1660

The Triumph of Bacchus

c.1628

Oil on canvas
65 x 88 ¹/₂ in (165 x 225 cm)
Prado
Madrid

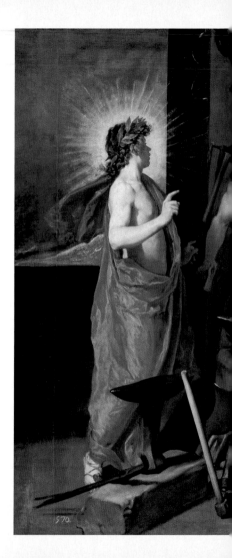

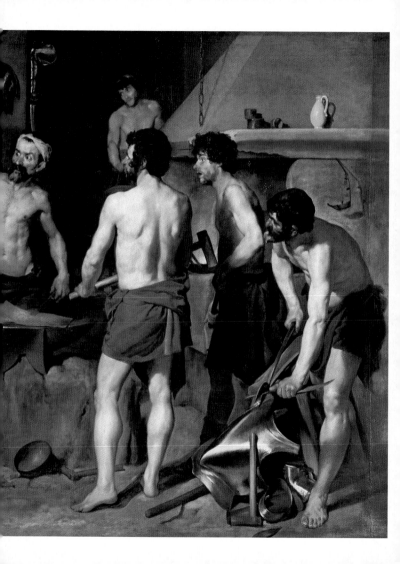

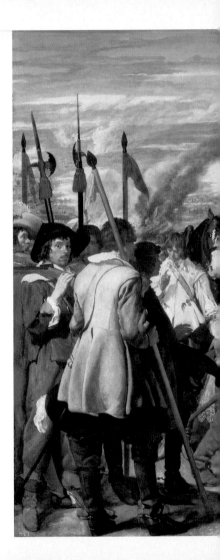

Diego Velázquez
Seville, 1599–Madrid, 1660

The Surrender of Breda

c. 1635

Oil on canvas
120 ³/₄ x 144 ¹/₂ in (307 x 367 cm)
Prado
Madrid

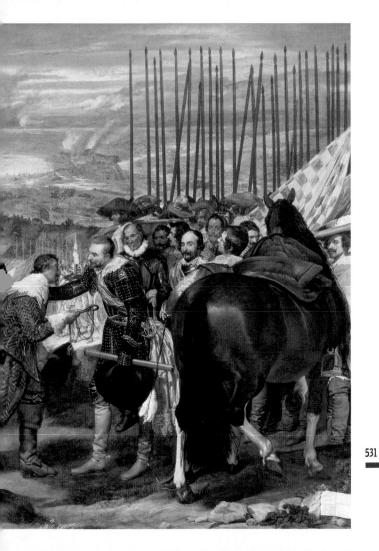

532

Diego Velázquez
Seville, 1599–Madrid, 1660

Las Meninas

c. 1656

Oil on canvas
124 ¹/₂ x 108 ³/₄ in (316 x 276 cm)
Prado
Madrid

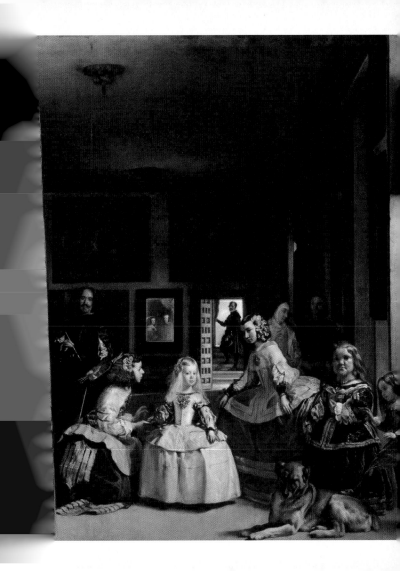

534

Diego Velázquez
Seville, 1599–Madrid, 1660

Portrait of the Infanta Dona Margherita of Austria

c. 1660

Oil on canvas
83 ¹/₂ x 57 ³/₄ in (212 x 147 cm)
Prado
Madrid

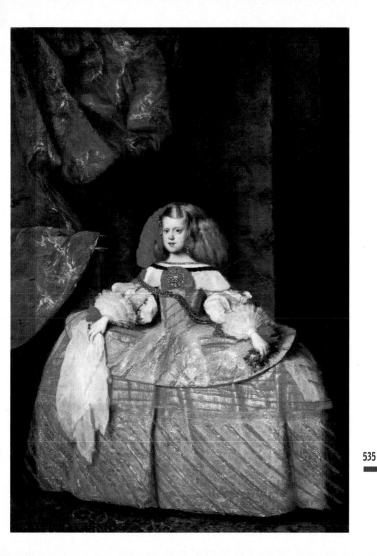

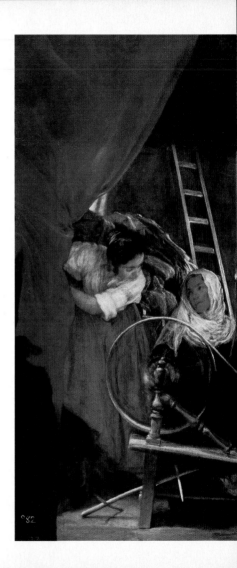

536

Diego Velázquez
Seville, 1599–Madrid, 1660

The Fable of Arachne

c. 1659

Oil on canvas
86 ½ x 113 ¾ in (220 x 289 cm)
Prado
Madrid

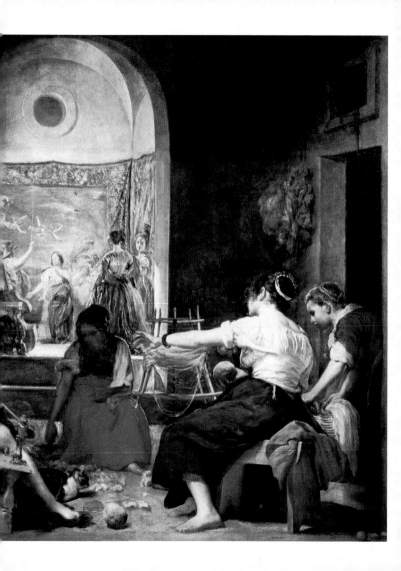

538

Bartolomé Esteban Murillo

Seville, 1618-1682

Children Eating Grapes and a Melon

c. 1645–1646

Oil on canvas
57 ¹/₂ x 40 ³/₄ in (145.9 x 103.6 cm)
Alte Pinakothek
Munich

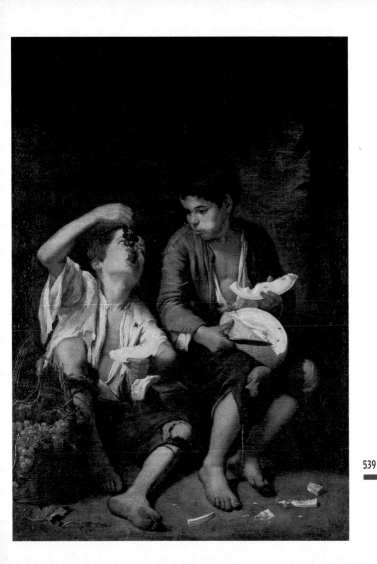

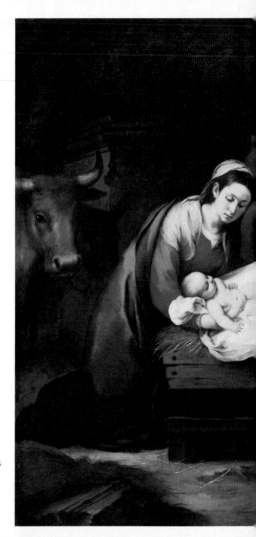

540

Bartolomé Esteban Murillo
Seville, 1618–1682

Adoration of the Shepherds

c. 1650

Oil on canvas
73 ¹/₂ x 89 ³/₄ in (187 x 228 cm)
Prado
Madrid

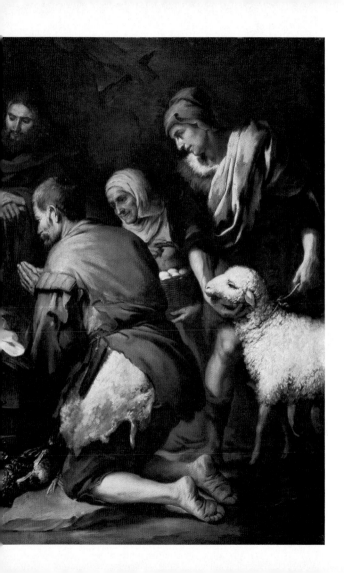

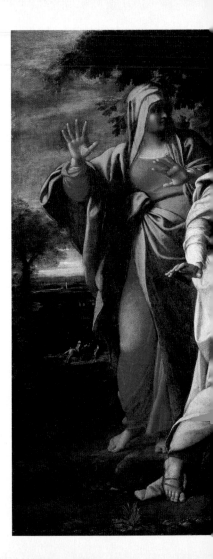

542

Annibale Carracci
Bologna, 1560–Rome, 1609

The Three Marys at Christ's Tomb

LATE 16ᵗʰ CENTURY

Oil on canvas
47 ³/₄ x 57 ³/₄ in (121 x 145.5 cm)
Hermitage
St. Petersburg

544

Guercino
(Giovanni Francesco Barbieri)
Cento, Ferrara 1591–Bologna, 1666

The Incredulity of Saint Thomas

1623

Oil on canvas
45 ¹/₄ x 56 in (115 x 142 cm)
Vatican Museums
Vatican City

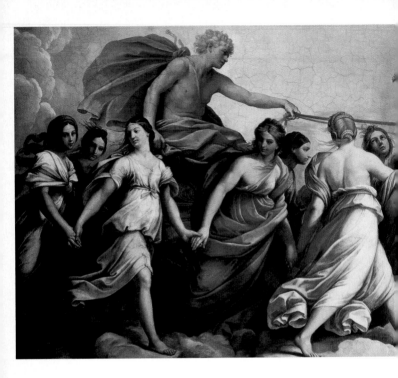

546

Guido Reni
Bologna, 1575–1642

Aurora

1613–1614

Fresco
110 1/4 x 275 1/2 in (280 x 700 cm)
Casino Rospigliosi-Pallavicini
Rome

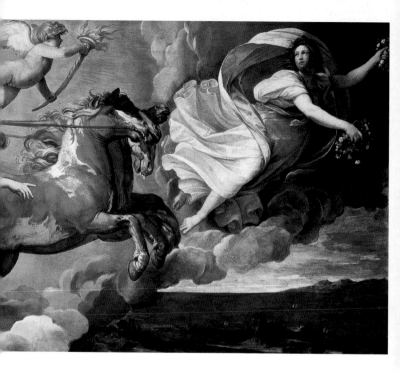

Guido Reni

Bologna, 1575–1642

The Abduction of Helen

1626–1629

Oil on canvas
99 $\frac{1}{4}$ x 104 $\frac{1}{2}$ in (253 x 265 cm)
Louvre
Paris

548

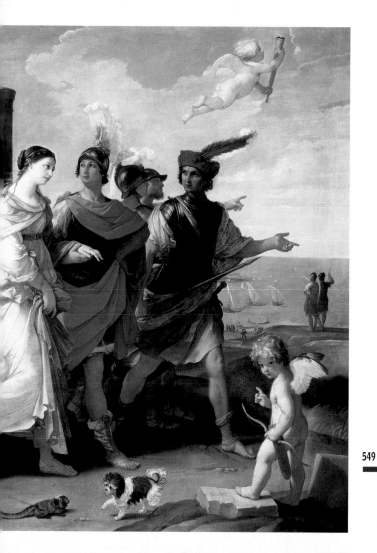

550

Domenico Fetti
Rome, 1589-1624

The Lost Drachma

c. 1617

Oil on canvas
29 $\frac{1}{2}$ x 17 $\frac{1}{4}$ in (75 x 44 cm)
Palazzo Pitti, Galleria Palatina
Florence

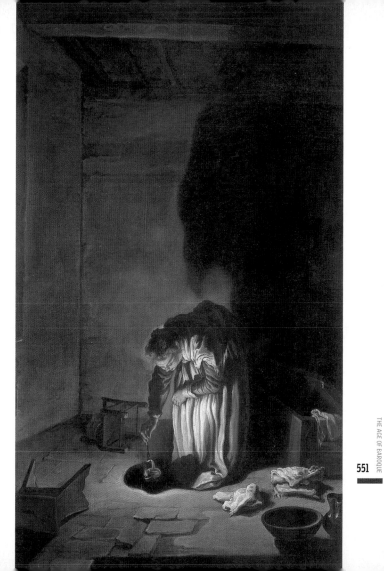

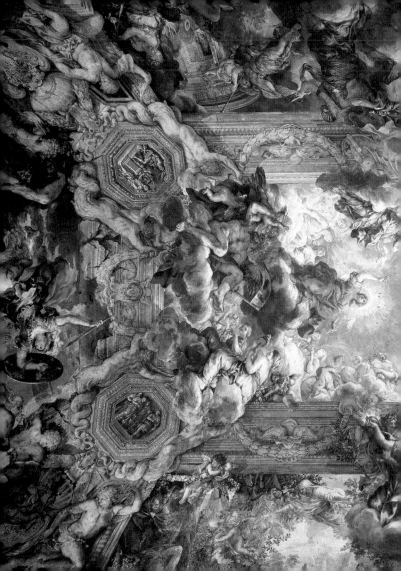

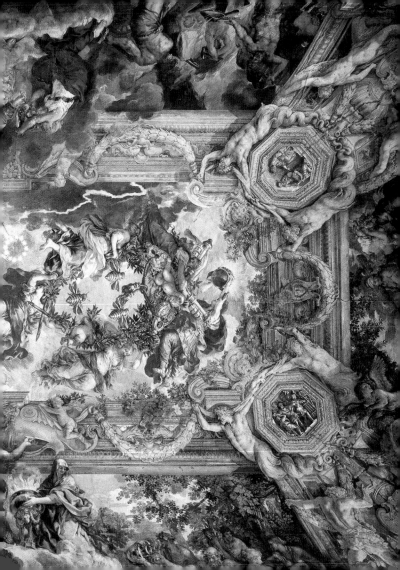

Baciccia (Giovanni Battista Gaulli)
Genoa, 1639–Rome, 1709

Triumph of the Name of Jesus

1674–1679

Fresco
Chiesa del Gesù
Rome

pp. 552–553

Pietro da Cortona
Cortona, 1596–Rome, 1669

Triumph of Divine Providence

1633–1639

Fresco
Palazzo Barberini
Rome

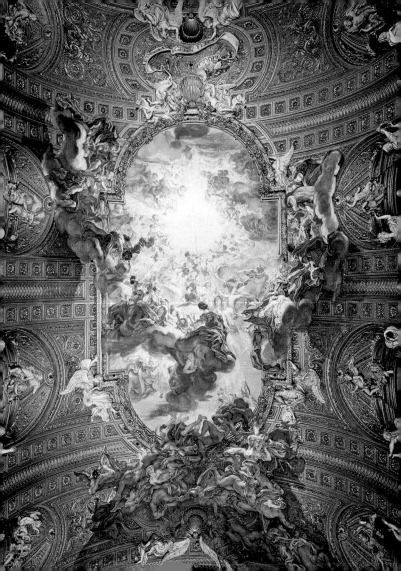

Andrea Pozzo
Trento, 1642–Vienna, 1709
Allegory of Europe
The Glory of Saint Ignatius
(detail of the ceiling)

1691-1694

Fresco
Sant'Ignazio
Rome

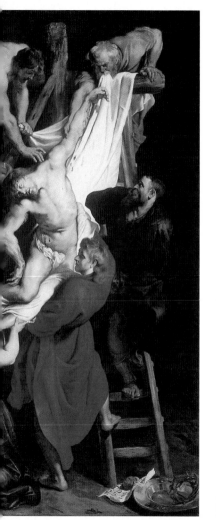
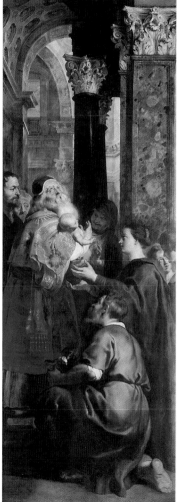

Peter Paul Rubens
Siegen, 1577–Antwerp, 1640

The Four Philosophers

1611–1612

Oil on panel
64 ¹/₄ x 54 ³/₄ in (164 x 139 cm)
Palazzo Pitti, Galleria Palatina
Florence

pp. 558–559

Peter Paul Rubens
Siegen, 1577–Antwerp, 1640

The Descent from the Cross
Triptych

1608–1612

Oil on panel
165 ¹/₄ x 181 in (420 x 460 cm)
Onze Lieve Vrouve Kerk
Antwerp

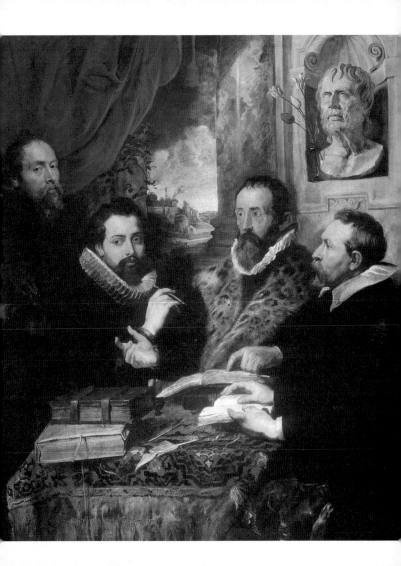

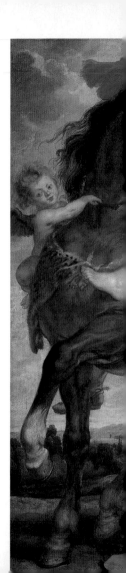

562

Peter Paul Rubens
Siegen, 1577–Antwerp, 1640

**The Rape of the Daughters
of Leucippus**

c. 1618

Oil on canvas
87 ¹/₂ x 82 ³/₄ in (222 x 210 cm)
Alte Pinakothek
Munich

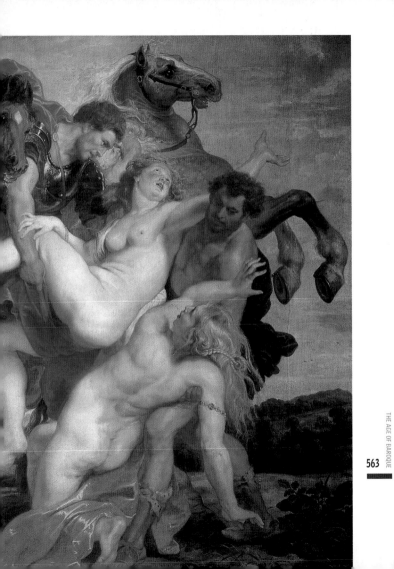

564

Peter Paul Rubens
Siegen, 1577–Antwerp, 1640

**Marie de Medicis Disembarking
at Marseilles**

1621–1625

Oil on canvas
155 x 116 ¹/₄ in (394 x 295 cm)
Louvre
Paris

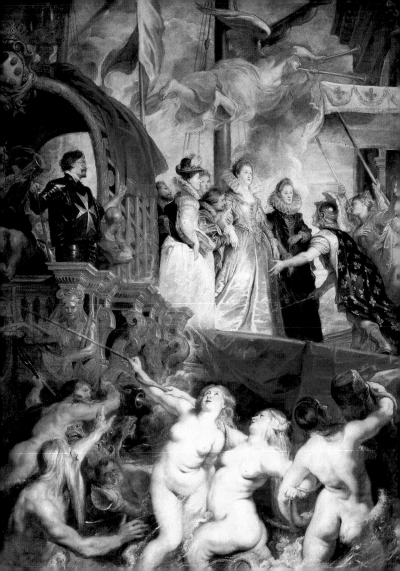

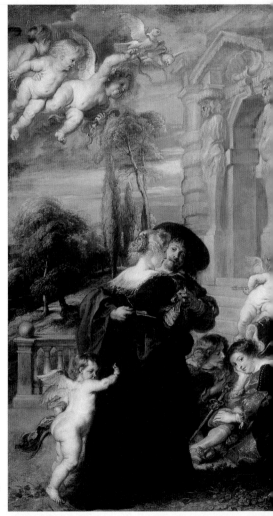

Peter Paul Rubens
Siegen, 1577-Antwerp, 1640

The Garden of Love

c. 1633

Oil on canvas
78 x 111 ¹/₂ in (198 x 283 cm)
Prado
Madrid

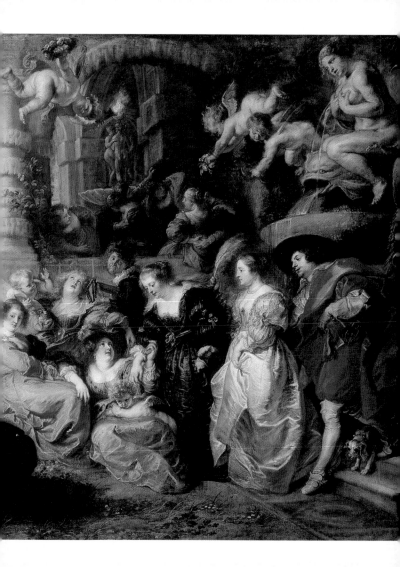

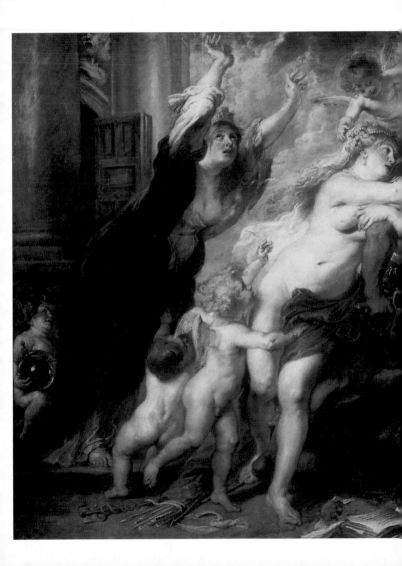

Jacob Jordaens
Antwerp, 1593–1678

The King Drinks

c. 1640

Oil on canvas
64 ¹/₂ x 82 ³/₄ in (156 x 210 cm)
Musées Royaux des Beaux-Arts
Brussels

pp. 568–569

Peter Paul Rubens

570 Siegen, 1577–Antwerp, 1640

The Consequences of War

1637–1638

Oil on canvas
81 x 134 ¹/₄ in (206 x 342 cm)
Palazzo Pitti, Galleria Palatina
Florence

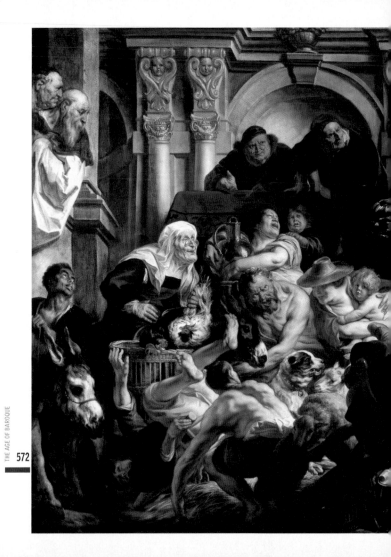

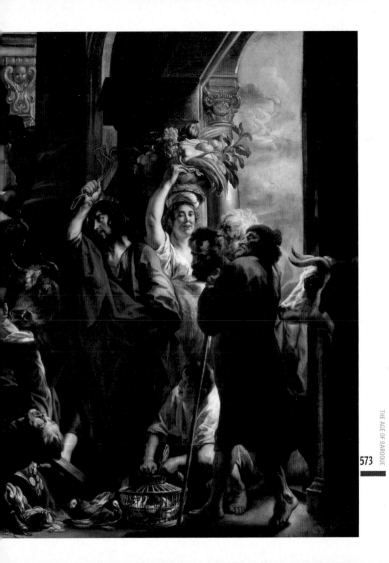

Anthony van Dyck

Antwerp, 1599–London, 1641

**Portrait of Charles I of England
in Hunting Costume**

c. 1633

Oil on canvas
104 ¹/₄ x 81 ¹/₂ in (266 x 207 cm)
Louvre
Paris

pp. 572–573

Jacob Jordaens

Antwerp, 1593–1678

**Christ Expelling the Merchants
from the Temple**

c. 1650

Oil on canvas
113 ¹/₂ x 171 ³/₄ in (288 x 436 cm)
Louvre
Paris

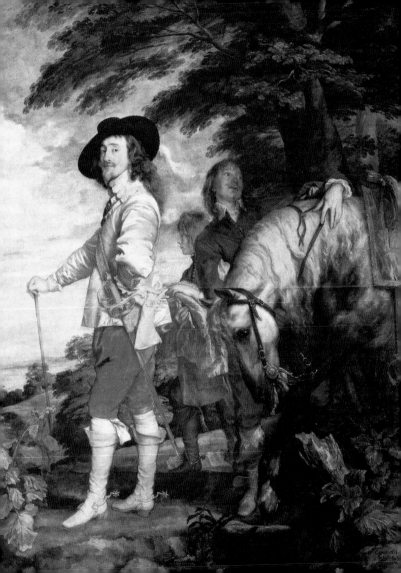

576

Anthony van Dyck
Antwerp, 1599–London, 1641

**Portrait of Charles I of England
on Horseback**

1635–1640

Oil on canvas
48 $\frac{1}{2}$ x 33 $\frac{1}{2}$ in (123 x 85 cm)
Prado
Madrid

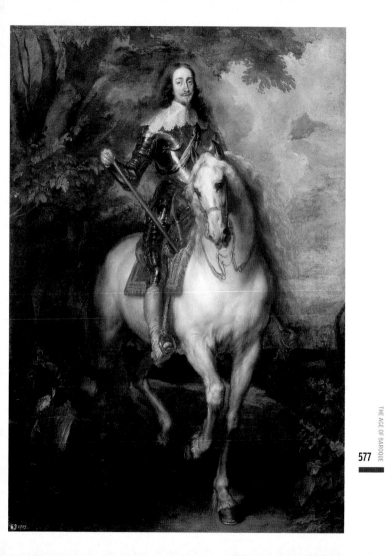

578

Anthony van Dyck
Antwerp, 1599–London, 1641

Portrait of Margherita of Lorraine

c. 1634

Oil on canvas
80 $\frac{1}{4}$ x 46 in (204 x 117 cm)
Uffizi Gallery
Florence

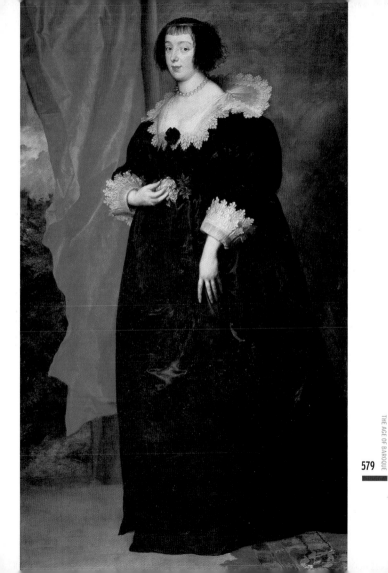

Nicolas Poussin
Les Andelys, 1594–Rome, 1665

The Rape of the Sabines

c. 1637

Oil on canvas
62 ¹/₂ x 81 in (159 x 206 cm)
Louvre
Paris

582

Nicolas Poussin
Les Andelys, 1594–Rome, 1665

The Arcadian Shepherds
c. 1638–1640

Oil on canvas
33 ¹/₂ x 47 ¹/₄ in (85 x 121 cm)
Louvre
Paris

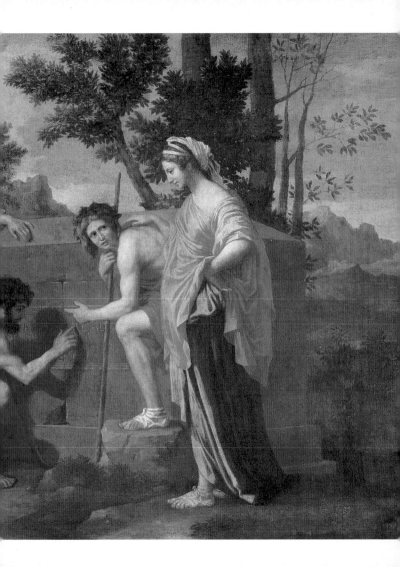

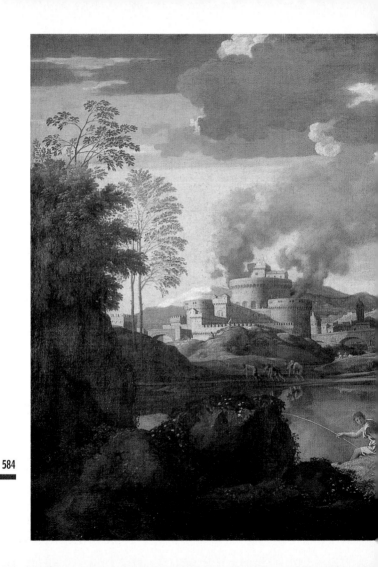

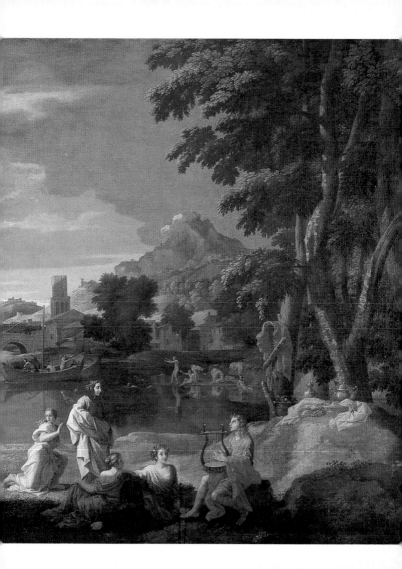

Claude Lorrain (Claude Gellée)
Chamagne, Nancy, 1600–Rome, 1682

**Cleopatra Disembarking
at Tarsus**

1642

Oil on canvas
46 ³/₄ x 66 ¹/₄ in (119 x 168 cm)
Louvre
Paris

pp. 584–585

Nicolas Poussin
Les Andelys, 1594–Rome, 1665

**Landscape with Orpheus
and Eurydice**

c. 1650

Oil on canvas
48 ³/₄ x 78 ³/₄ in (124 x 200 cm)
Louvre
Paris

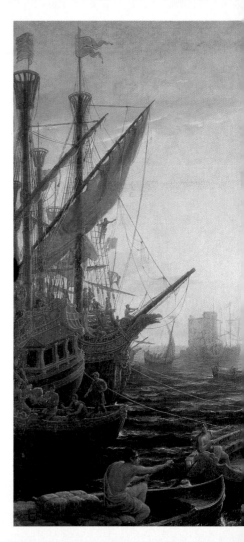

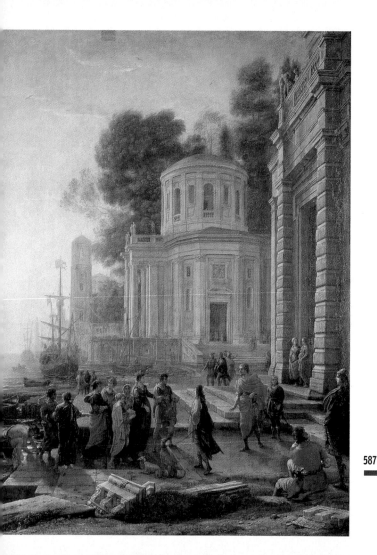

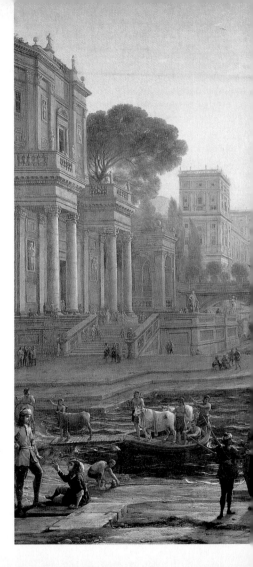

588

Claude Lorrain (Claude Gellée)
Chamagne, Nancy, 1600–Rome, 1682

Ulysses and Cressida
1646

Oil on canvas
46 ¾ x 59 in (119 x 150 cm)
Louvre
Paris

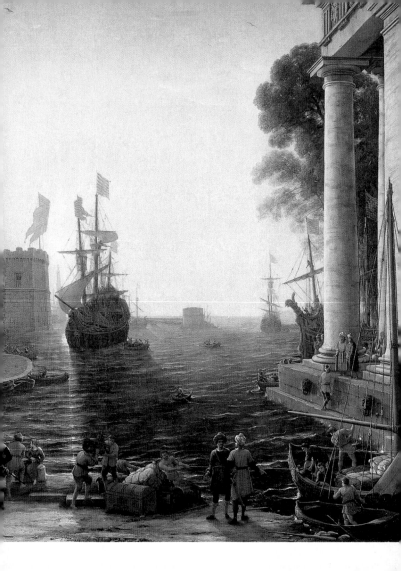

Louis Le Nain
Laon, 1593–Paris, 1648

Peasant Family

c. 1643

Oil on canvas
44 ¹/₂ x 62 ¹/₂ in (113 x 159 cm)
Louvre
Paris

590

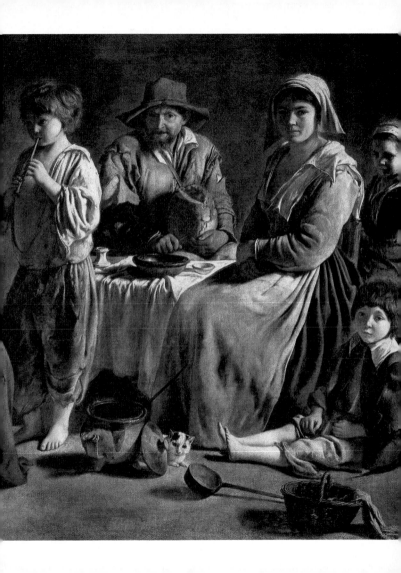

592

Louis Le Nain
Laon, 1593–Paris, 1648

Group of Smokers

c. 1643

Oil on canvas
46 x 54 in (117 x 137 cm)
Louvre
Paris

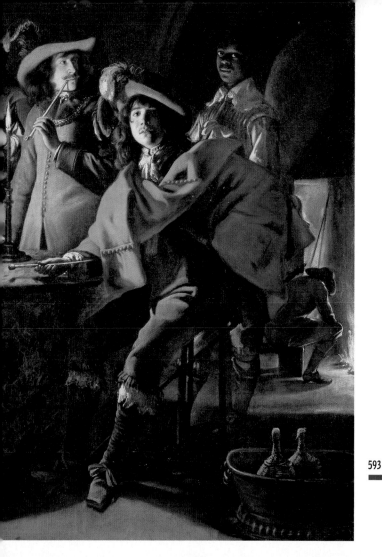

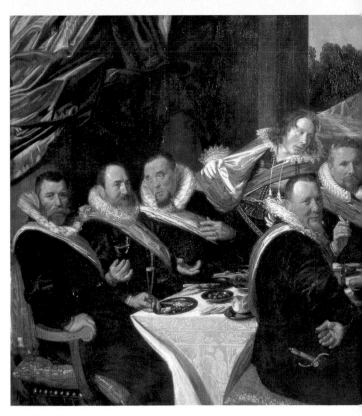

594

Frans Hals
Antwerp, 1582/3–Haarlem, 1666

**Banquet of the Officers of the
Saint George Militia Company**

1616

Oil on canvas
69 x 127 ¹/₂ in (175 x 324 cm)
Frans Hals Museum
Haarlem

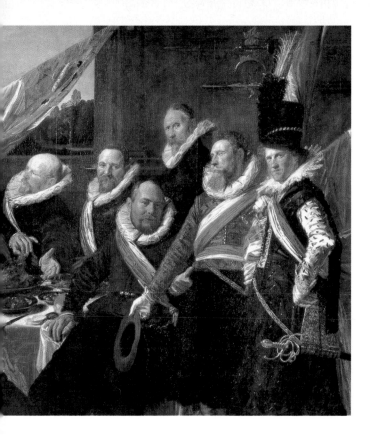

Frans Hals
Antwerp, 1582/3–Haarlem, 1666

Clown Playing the Lute

c. 1623

Oil on panel
28 x 24 $\frac{1}{2}$ in (71 x 62 cm)
Louvre
Paris

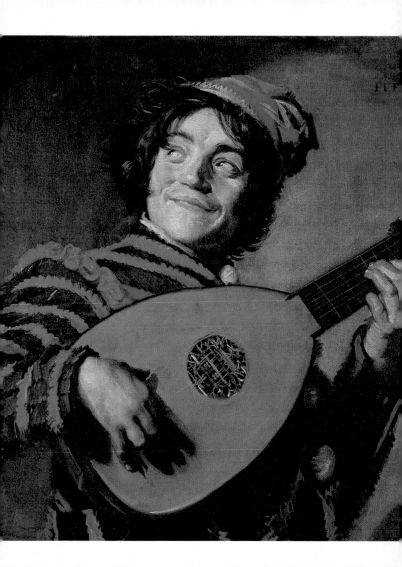

598

Frans Hals

Antwerp, 1582/3–Haarlem, 1666

Portrait of Willem van Heythuysen

c. 1650

Oil on panel
18 1/$_4$ x 14 3/$_4$ in (46.5 x 37.5 cm)
Musées Royaux des Beaux–Arts
Brussels

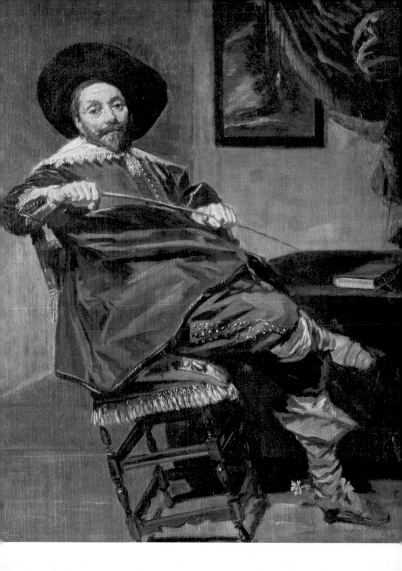

Carel Fabritius
Middenbeemster, 1622–Delft, 1654

The Goldfinch

c. 1654

Oil on panel
13 $^1/_4$ x 9 in (33.5 x 22.8 cm)
Mauritshuis
The Hague

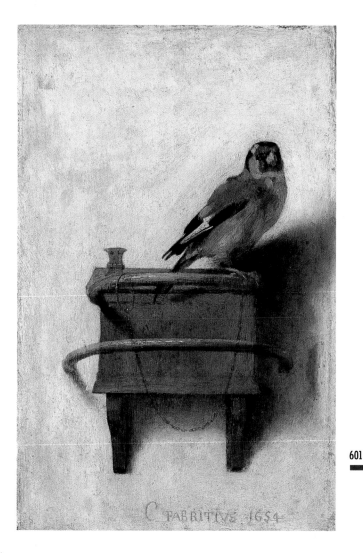

602

Jan Steen
Leiden, 1626–1679

The Lovesick Girl

1660

Oil on canvas
24 x 20 ¹/₄ in (61 x 52.1 cm)
Alte pinakothek
Munich

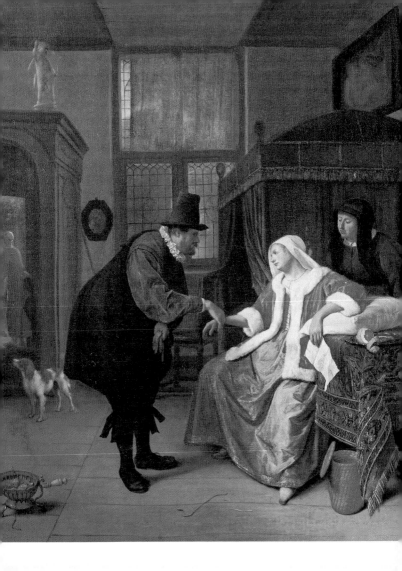

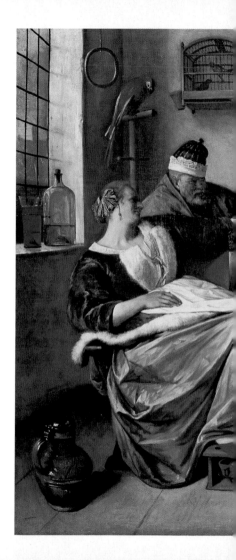

604

Jan Steen
Leiden, 1626–1679

The Merry Company

c. 1663–1665

Oil on canvas
52 ¹/₄ x 64 ¹/₄ in (134 x 163 cm)
Mauritshuis
The Hague

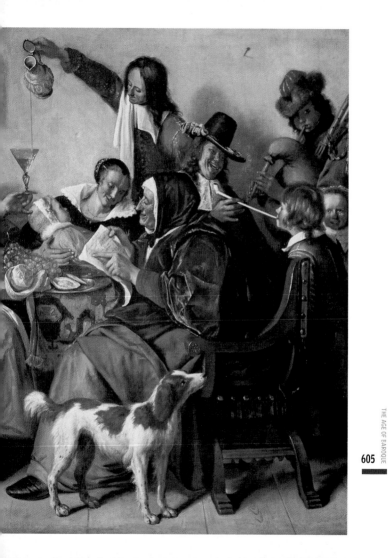

606

Pieter de Hooch
Rotterdam, 1629-Amsterdam, after 1684

A Woman Drinking

1658

Oil on canvas
27 1/$_4$ x 23 1/$_2$ in (69 x 60 cm)
Louvre
Paris

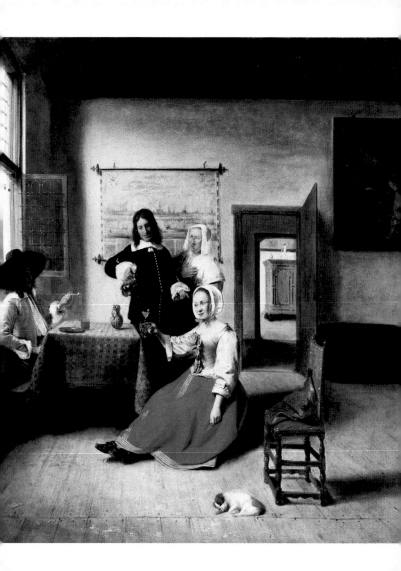

608

Pieter de Hooch
Rotterdam, 1629–Amsterdam, 1684

A Dutch Courtyard

1658–1660

Oil on canvas
30 1/4 x 25 1/2 in (78 x 65 cm)
Mauritshuis
The Hague

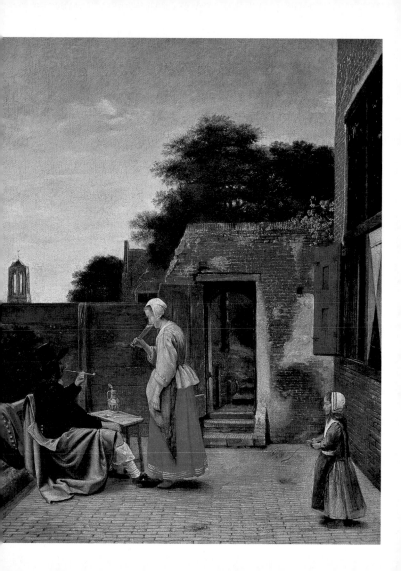

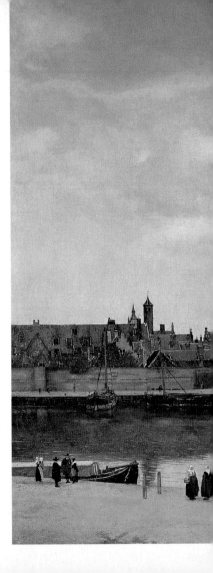

610

Jan Vermeer
Delft, 1632–1675

View of Delft

c. 1660–1661

Oil on canvas
38 ¹/₂ x 46 ¹/₄ in (98 x 117.5 cm)
Mauritshuis
The Hague

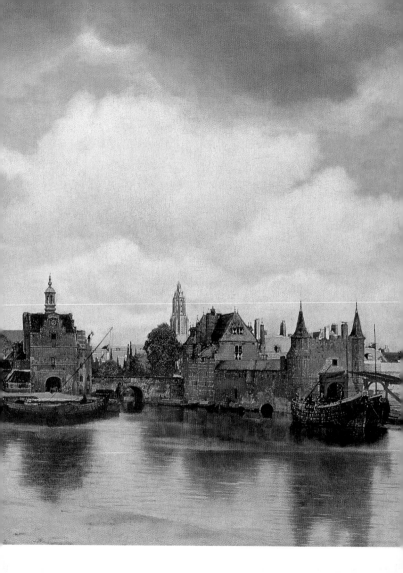

612

Jan Vermeer
Delft, 1632–1675

Head of a Girl with a Pearl Earring

c. 1665–1666

Oil on canvas
17 ¹/₂ x 15 ¹/₄ in (44.5 x 39 cm)
Mauritshuis
The Hague

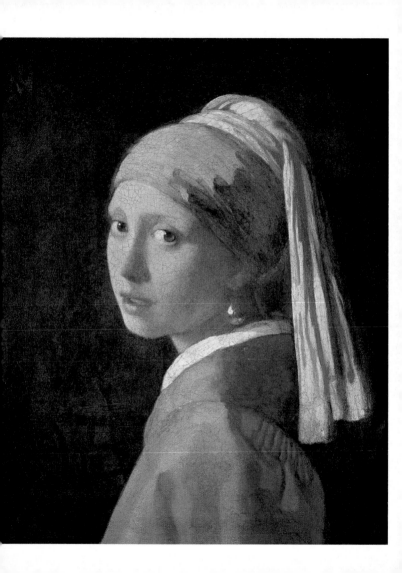

614

Jan Vermeer
Delft, 1632–1675

The Astronomer

1668

Oil on canvas
20 ½ x 18 in (51.5 x 45.5 cm)
Louvre
Paris

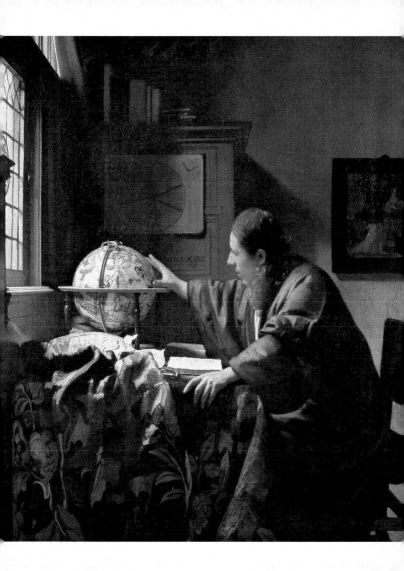

Jan Vermeer
Delft, 1632–1675

The Lacemaker

1669–1670

Oil on panel transferred to canvas
9 ¹/₂ x 8 in (24 x 20.5 cm)
Louvre
Paris

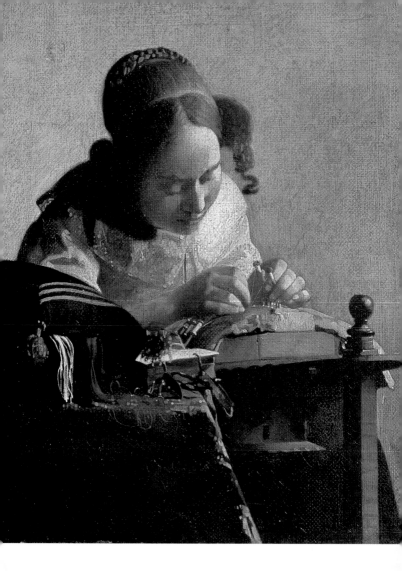

618

Willem Kalf
Rotterdam, 1619–Amsterdam, 1693

Still Life

1661

Oil on canvas
30 x 24 ¹/₂ in (76 x 62 cm)
Pushkin Museum
Moscow

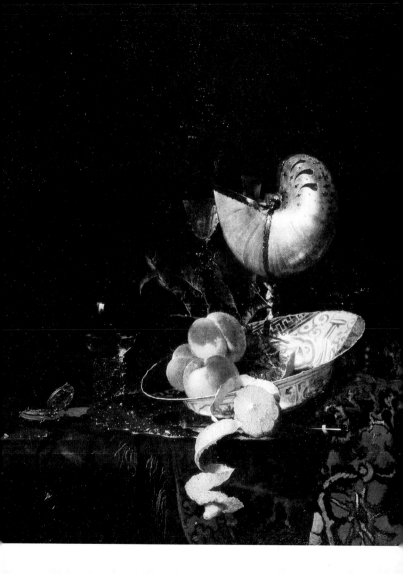

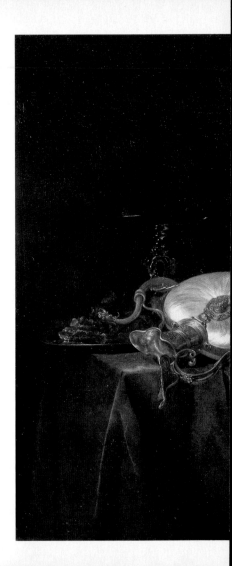

Willem van Aelst
Delft, 1626–Amsterdam, 1683

Still Life with Fruit

1653

Oil on canvas
30 1/4 x 40 1/4 in (77 x 102 cm)
Palazzo Pitti, Galleria Palatina
Florence

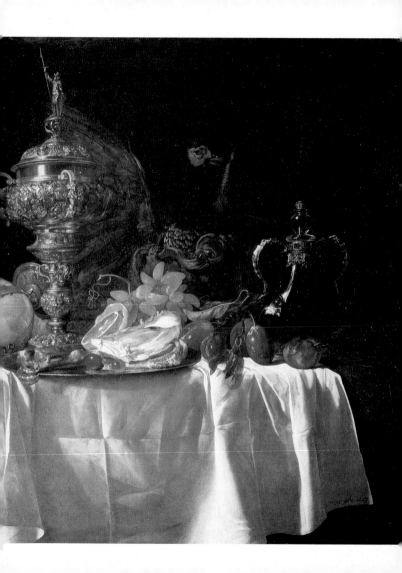

ROCOCO

AND VEDUTISM

The term "Rococo" refers to a style that developed in France in the first few years of the eighteenth century. It mainly concerned architecture, interior decoration, and the applied arts, and continued to flourish throughout the first half of the century. In brief, Rococo is a derivative of Baroque, and it preserves all of that style's formal dynamism, while transferring it to more slender and delicate decorative elements. Although it is easy to isolate its expressions in architecture, furniture, and interior decoration, it is almost contrived to speak of a Rococo style of painting; or at the very least, to claim that there is a single style in the painting of the first half of the eighteenth century.

Created as a worldly form of art in the court of the French king Louis XIV, Rococo in painting is distinguished, perhaps, by the prurient and frivolous themes of courtly life associated with the playfulness of love, and the mythological figures of Venus, Pan, and Cupid. In terms of style, the works of painters such as Jean-Antoine Watteau (1684–1721), François Boucher (1703–1770), and Jean-Honoré Fragonard (1765–1770) are characterized by their diagonal compositions, dynamism, gleaming colors, soft textures, and by an intentional, self-conscious degree of awareness and refinement. There are idealized shepherd boys and shepherdesses involved in the games of love, in a natural setting that is also the fruit of artifice, where everything refers to the pleasures of the senses.

At the same time as Rococo decorativism spread throughout the architecture and applied arts of Europe and many French painters devoted themselves to the sophisticated subjects of courtly life, a new style of painting began to establish itself in Italy, especially in Rome and Venice, where it was known as "*vedutismo*," or view painting. In reality, vedutism had its beginnings in northern Europe, especially in Holland. One of its exponents, Gaspard van Wittel (1655–1736), took up residence in Rome in 1675. Gaspare Vanvitelli—as

he came to be known in his adopted land—executed a long series of views of Italian cities, which are now priceless documents for what they show of daily life at the time. Thus, van Witell opened the way for the vedutism of the eighteenth century. In Rome, the chief exponents of vedutism were Giovanni Paolo Pannini (1691/2–1765) and Giovanni Battista Piranesi (1720–1778)—the latter was an engraver and etcher as well as an architect—and their work served as an inspiration, in the second half of the century, for the French painter Hubert Robert (1733–1808). In Venice, Giovanni Antonio Canal, known as Canaletto (1697–1768), and Francesco Guardi (1712–1793), were active, and their work constituted the high point of Italian vedutism.

If, on the one hand, vedutism seems to be quite specific to Italian art, on the other, it was non-Italian collectors and clients who showed the greatest interest in art of this sort. Canaletto's most important clients lived in England, and his nephew, Bernardo Bellotto (1720–1780), himself a view painter, left Venice and went to work in Dresden, Munich, Vienna, and, finally, Warsaw, where he painted memorable views.

Rosalba Carriera
Venice, 1675-1757

Enrichetta Anna Sofia of Modena

1723

Pastel on paper
23 ¹/₂ x 18 ¹/₄ in (59.5 x 46.5 cm)
Uffizi Gallery
Florence

pp. 622-623

Jean-Antoine Watteau
Valenciennes, 1684-Paris, 1721

Embarking for Cythere

1717

Oil on canvas
50 ³/₄ x 76 ¹/₂ in (129 x 194 cm)
Louvre
Paris

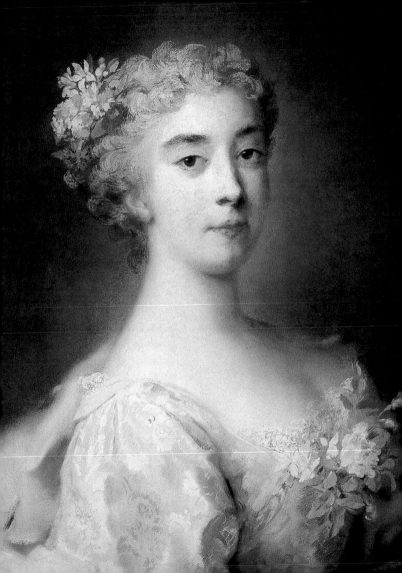

628

Jean-Antoine Watteau
Valenciennes 1684–Paris, 1721

The Guitar Player

1715

Oil on panel
9 $\frac{1}{2}$ x 6 $\frac{3}{4}$ in (24 x 17 cm)
Musée Condé
Chantilly

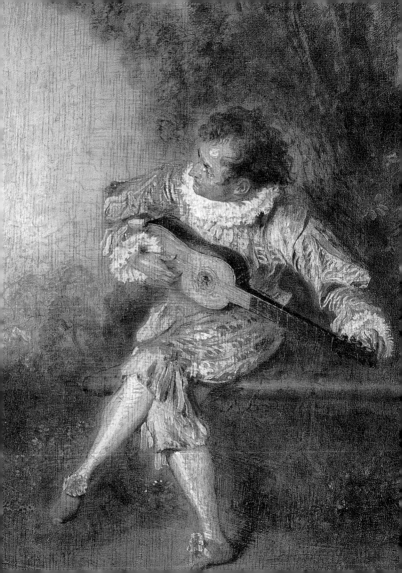

630

Jean-Antoine Watteau
Valenciennes, 1684–Paris, 1721

Gilles

c. 1719

Oil on canvas
72 ³/₄ x 58 ¹/₄ in (185 x 148 cm)
Louvre
Paris

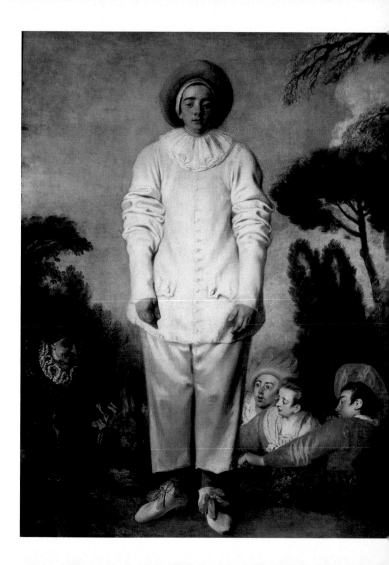

632

Jean-Marc Nattier
Paris, 1685–1766

Portrait of Catherine I of Russia

1717

Oil on canvas
56 x 43 ¹/₄ in (142.5 x 110 cm)
Hermitage
St. Petersburg

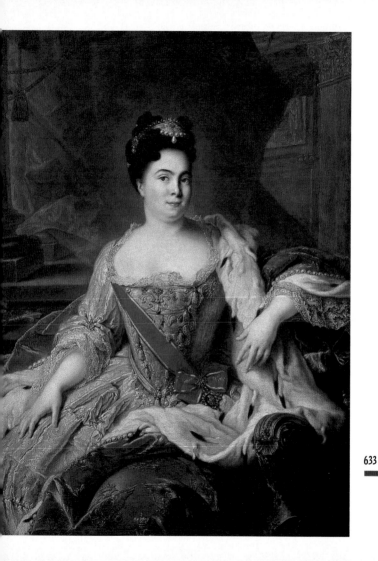

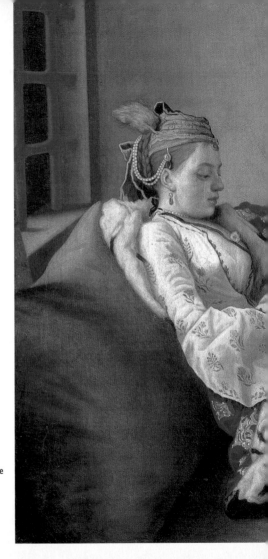

Jean-Etienne Liotard
Geneva, 1702-1789

634

**Marie Adelaide of France
in Turkish Costume**

1753

Oil on canvas
19 ³/₄ x 22 in (50 x 56 cm)
Uffizi Gallery
Florence

636

François Boucher
Paris, 1703-1770

The Luncheon

1739

Oil on canvas
32 x 25 ¹/₄ in (81.5 x 65.5 cm)
Louvre
Paris

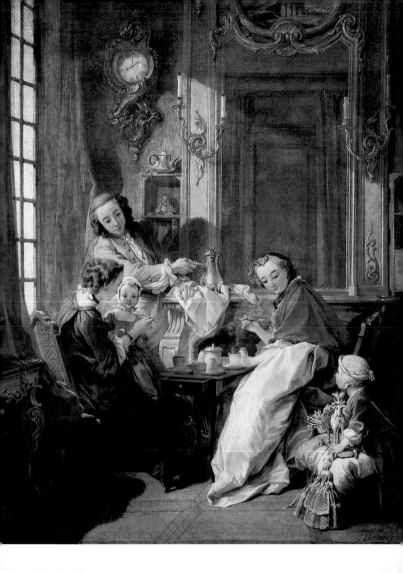

638

Jean-Honoré Fragonard
Grasse, 1732–Paris, 1806

Bathers

1765

Oil on canvas
25 1/4 x 31 1/2 in (64 x 80 cm)
Louvre
Paris

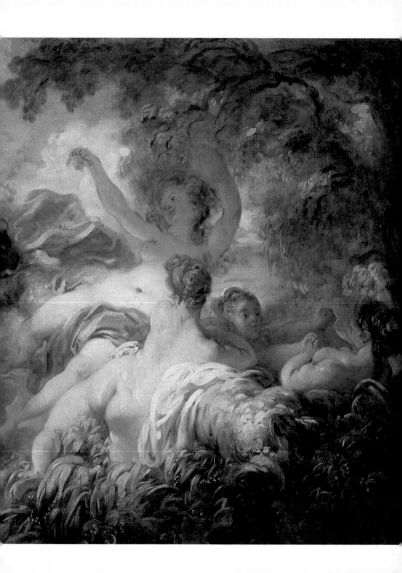

640

Jean-Honoré Fragonard
Grasse, 1732–Paris, 1806

The Swing

1767

Oil on canvas
32 x 25 ¼ in (81 x 64.2 cm)
Wallace Collection
London

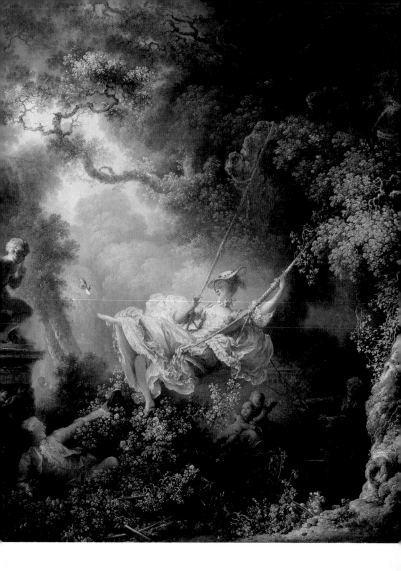

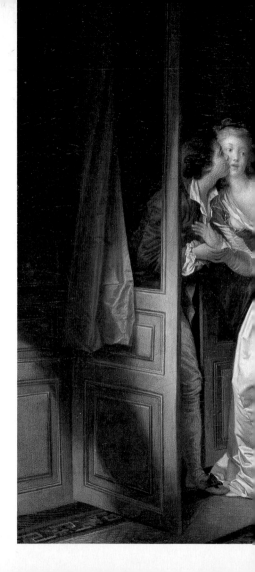

ROCOCO AND VEDUTISM

642

Jean-Honoré Fragonard
Grasse, 1732–Paris, 1806

The Furtive Kiss
1765–1770

Oil on canvas
17 ¾ x 21 ¾ in (45 x 55 cm)
Hermitage
St. Petersburg

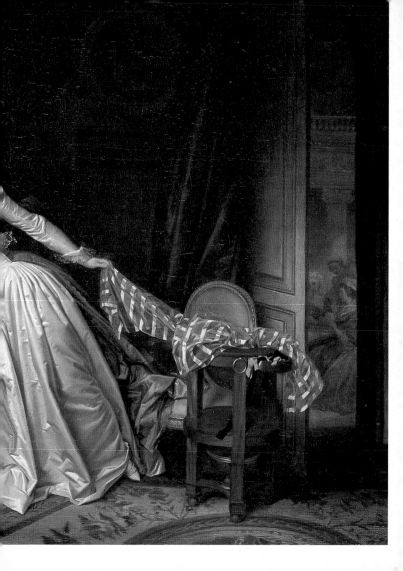

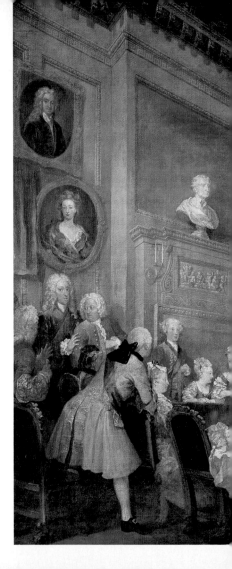

644

William Hogarth
London, 1697-1764

**Recitation of the
Empress of the Indies**

1732

Oil on canvas
51 $^1/_2$ x 57 $^3/_4$ in (131 x 146.5 cm)
Galway College
Dorset

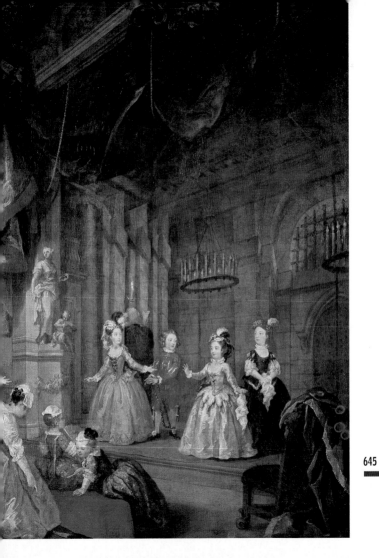

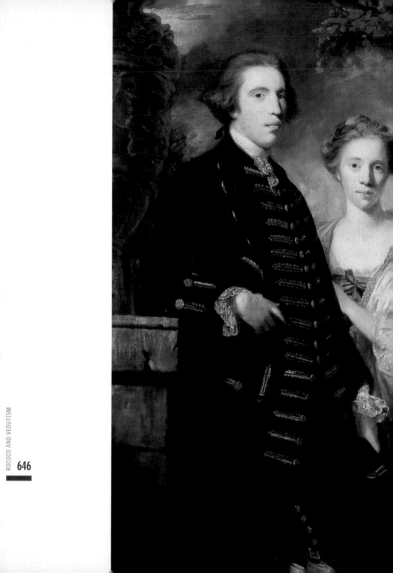

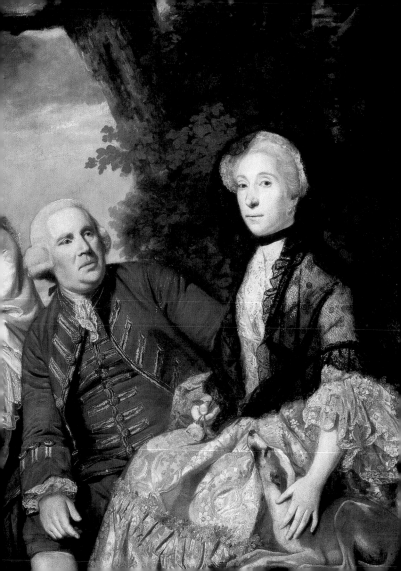

Thomas Gainsborough
Sudbury, 1727–London, 1788

Conversation in the Park

1746

Oil on canvas
28 ³/₄ x 26 ³/₄ in (73 x 68 cm)
Louvre
Paris

pp. 646–647

Joshua Reynolds
Plympton, 1723–London, 1792

The Roffey Family

1765

Oil on canvas
58 x 73 ¹/₂ in (147.3 x 186.7 cm)
Birmingham Art Gallery
Birmingham

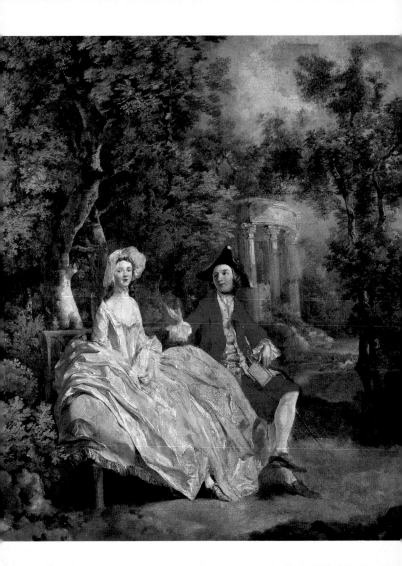

650

Thomas Gainsborough
Sudbury, 1727–London, 1788

**Portrait of a Woman in Blue
(The Duchess of Beaufort)**

1770–1780

Oil on canvas
30 x 25 ¼ in (76 x 64 cm)
Hermitage
St. Petersburg

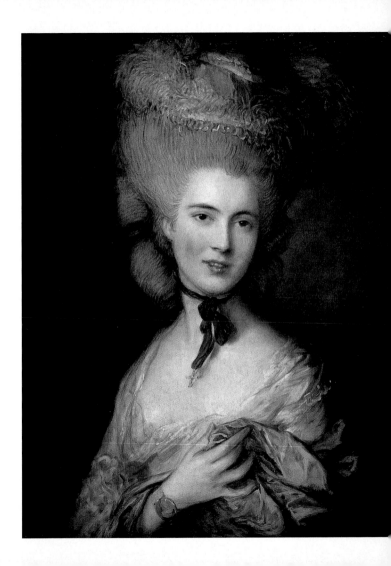

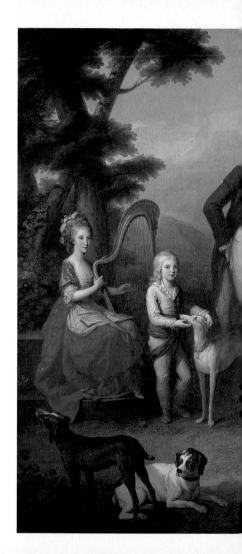

652

Angelica Kauffmann
Coire, 1741-Rome, 1807

The Royal Family of Naples
1783

Oil on canvas
122 x 167 ¹/₄ in (310 x 426 cm)
Museo Nazionale di Capodimonte
Naples

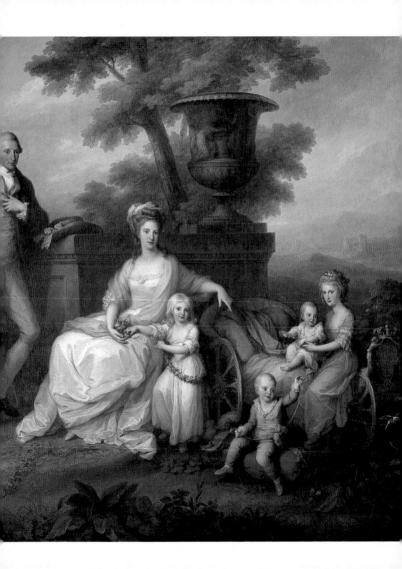

654

Angelica Kauffmann
Coire, 1741–Rome, 1807

Portrait of a Young Baccante

1801

Oil on canvas
50 ¾ x 40 ½ in (129 x 102 cm)
Palazzo Barberini,
Galleria Nazionale d'Arte Antica
Rome

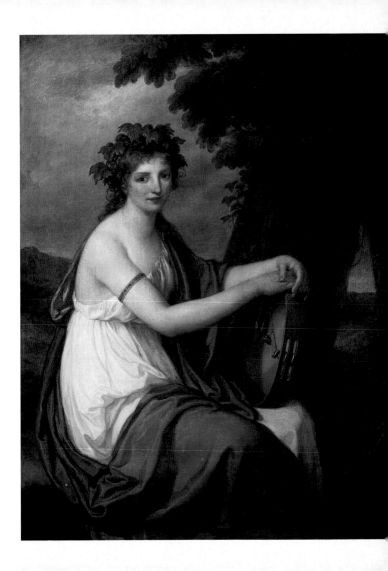

656

Elisabeth Vigée-Lebrun
Paris, 1755–1842

Self-Portrait

1790

Oil on canvas
39 ¹/₄ x 32 in (100 x 81 cm)
Uffizi Gallery
Florence

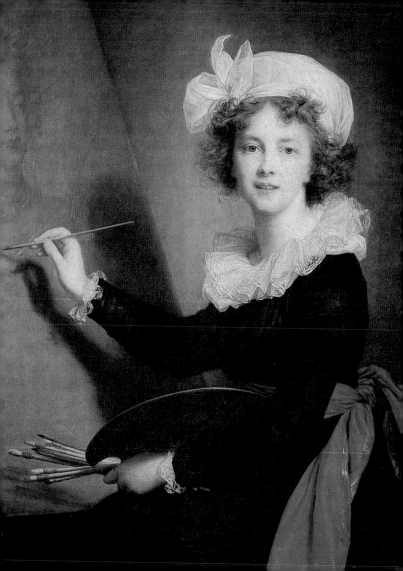

Giovanni Battista Tiepolo
Venice, 1696–Madrid, 1770

658

Rachel Hiding the Idols Stolen from her Father

1726–1729

Fresco
157 ¹/₂ x 196 ¹/₄ in (400 x 500 cm)
Palazzo Arcivescovile
Udine

660

Sebastiano Ricci
Belluno, 1659–Venice, 1734

Madonna and Child with Saints

1708

Oil on canvas
159 ³/₄ x 82 in (406 x 208 cm)
San Giorgio Maggiore
Venice

Jean-Baptiste-Siméon Chardin
Paris, 1699–1779

Child with a Spinning Top

1738

Oil on canvas
26 ¹/₂ x 30 in (67 x 76 cm)
Louvre
Paris

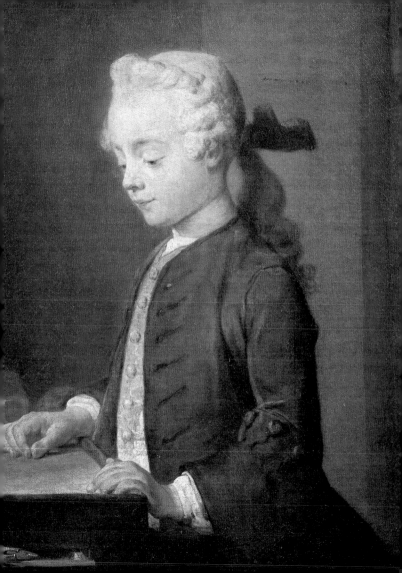

Jean-Baptiste-Siméon Chardin
Paris, 1699–1779

664

Girl with a Shuttlecock

1740

Oil on canvas
32 ¹/₄ x 26 in (82 x 66 cm)
Uffizi Gallery
Florence

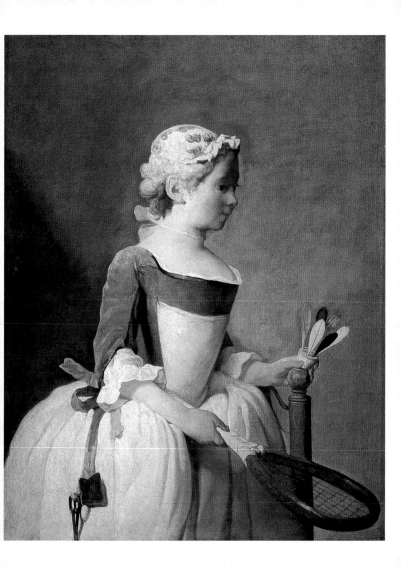

ROCOCO AND VEDUTISM

666

Jean-Baptiste-Siméon Chardin
Paris, 1699–1779

Still Life

1763

Oil on canvas
18 ½ x 22 ½ in (47 x 57 cm)
Louvre
Paris

668

Jean-Baptiste-Siméon Chardin
Paris, 1699–1779

Return from the Market

1739

Oil on canvas
18 ¹/₂ x 15 in (47x 38 cm)
Louvre
Paris

Jean-Baptiste-Siméon Chardin
Paris, 1699-1779

670

**Still Life with the Attributes
of the Arts**

1766

Oil on canvas
44 x 55 ¼ in (112 x 140.5 cm)
Hermitage
St. Petersburg

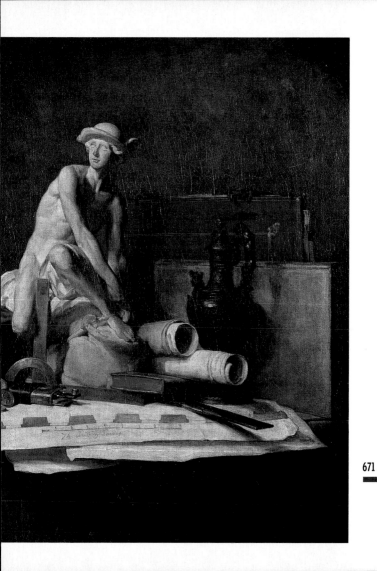

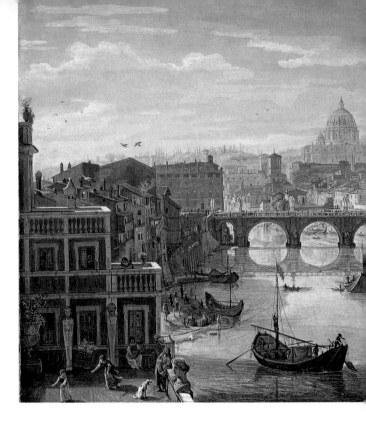

672

Gaspard van Wittel
(Gaspare Vanvitelli)
Amersfoort, 1655–Rome, 1736

The Tiber at Castel Sant'Angelo

1683

Oil on canvas
19 x 38 ³/₄ in (48.5 x 98.5 cm)
Palazzo Barberini,
Galleria Nazionale d'Arte Antica
Rome

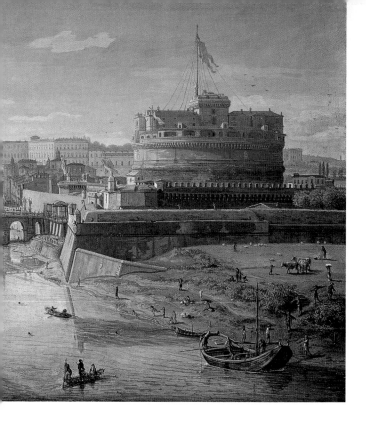

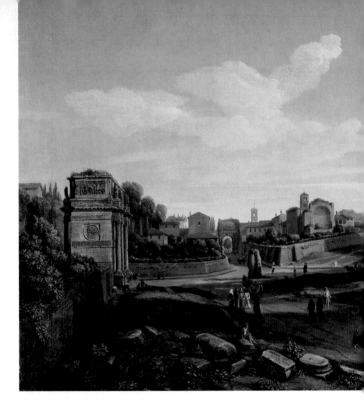

674

Gaspard van Wittel
(Gaspare Vanvitelli)
Amersfoort, 1655–Rome, 1736

**The Colosseum and the
Roman Forum**

1711

Oil on canvas
20 ¹/₄ x 42 ¹/₄ in (53 x 107 cm)
Sabauda Gallery
Turin

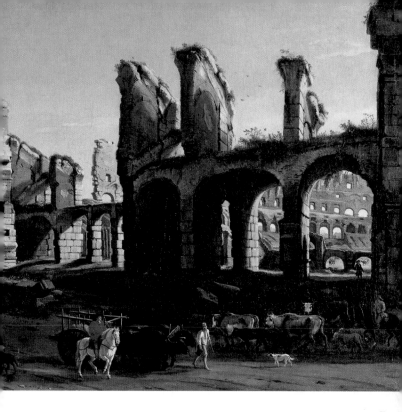

Giovanni Paolo Pannini
Piacenza, 1691/2–Rome, 1765

Interior of Saint Peter's Basilica

c. 1754

Oil on canvas
61 x 78 ³/₄ in (155 x 200 cm)
Ca' Rezzonico
Venice

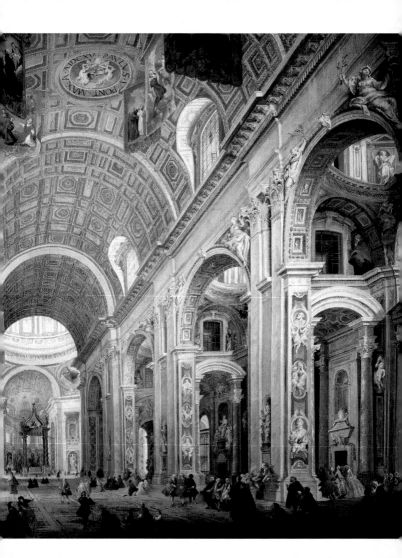

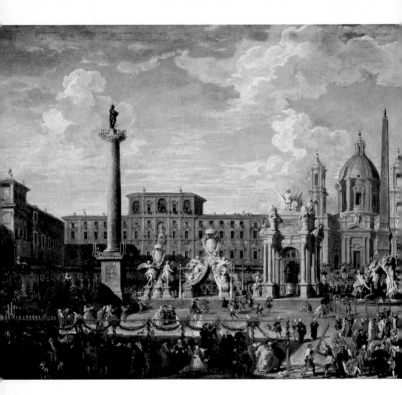

678

Giovanni Paolo Pannini

Piacenza, 1691/2-Rome, 1765

**Preparations in Piazza Navona
to Celebrate the Birth of the
Dauphin of France**

1729

Oil on canvas
43 ¼ x 99 ¼ in (110 x 252 cm)
Louvre
Paris

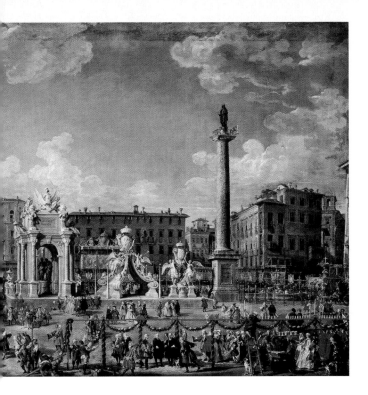

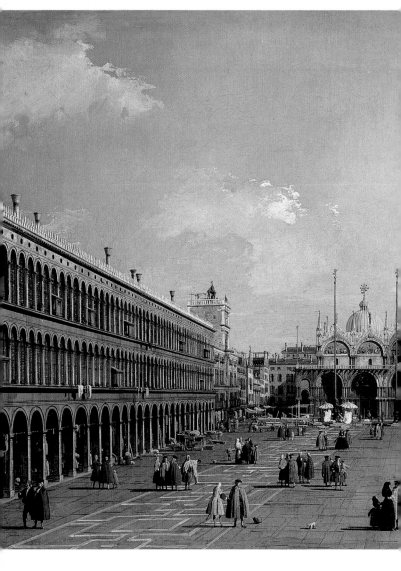

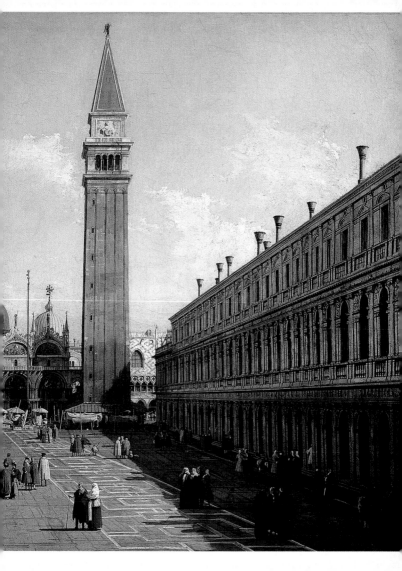

Canaletto
(Giovanni Antonio Canal)
Venice, 1697–1768

**The Return of the
Bucentaur to the Molo
on Ascension Day**

1729

Oil on canvas
71 ³/₄ x 102 in (182 x 259 cm)
Pushkin Museum
Moscow

pp. 680–681

Canaletto
(Giovanni Antonio Canal)
Venice, 1697–1768

Saint Mark's Square

1744

Oil on canvas
71 ³/₄ x 102 in (182 x 259 cm)
Musée Jacquemart–André
Paris

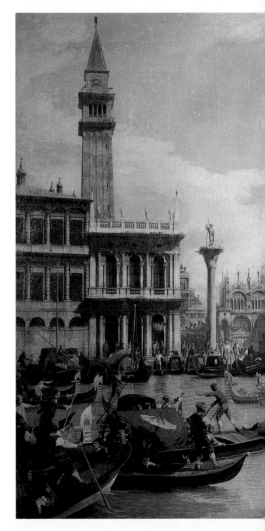

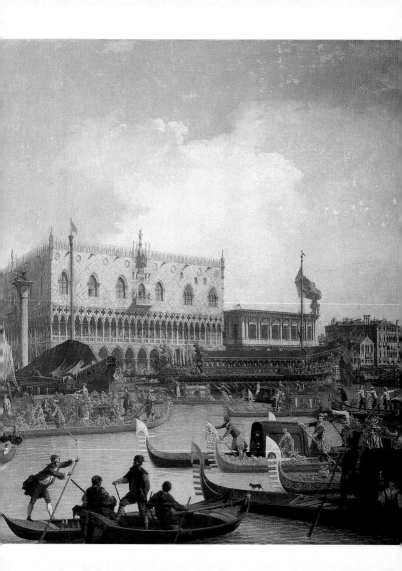

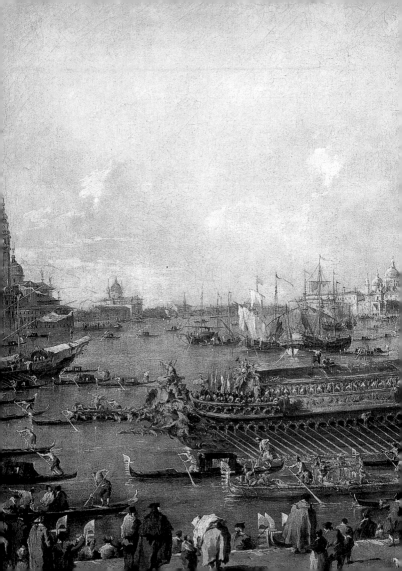

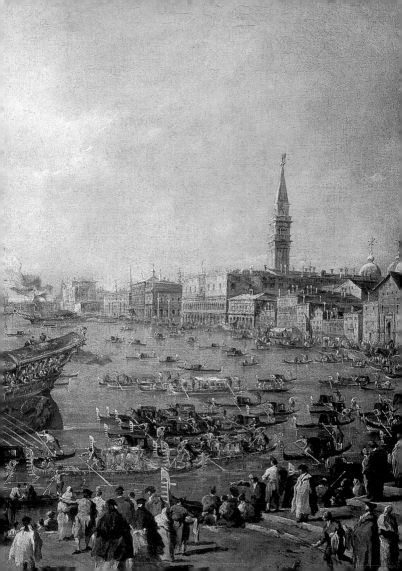

Francesco Guardi
Venice, 1712-1793

**The Doge Carried
by Gondoliers after
his Election**

1770

Oil on canvas
26 ½ x 39 ½ in
(67 x 100 cm)
Musée des Beaux-Arts
Grenoble

pp. 684-685

Francesco Guardi
Venice, 1712-1793

**Departure of the
Bucentaur on
Ascension Day**

1766-1770

Oil on canvas
26 x 39 ¾ in
(66 x 101 cm)
Louvre
Paris

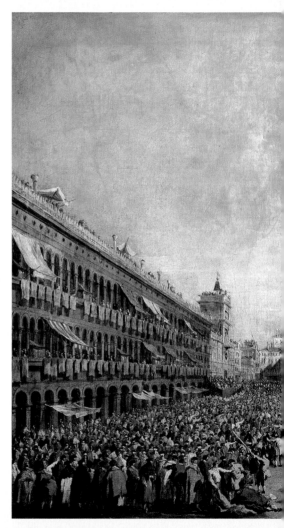

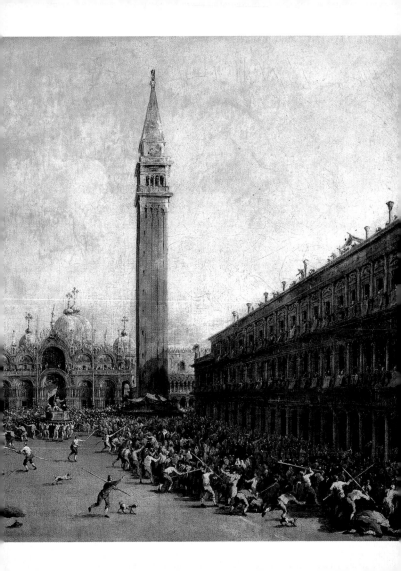

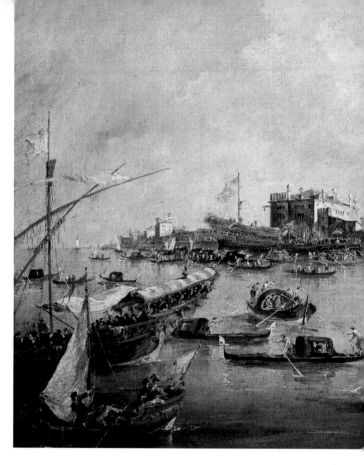

Francesco Guardi
Venice, 1712-1793

The Bucentaur at San Niccolò

c. 1768

Oil on canvas, 26 ¹/₂ x 39 ¹/₂ in (67 x 100 cm)
Louvre, Paris

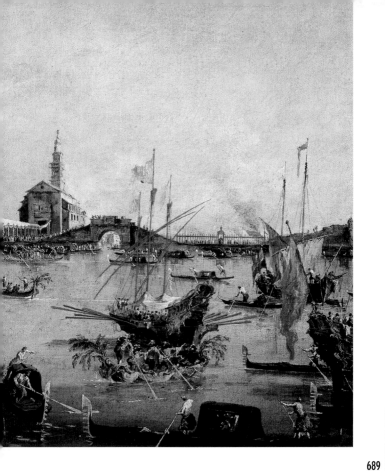

690

Bernardo Bellotto
Venice, 1720–Warsaw, 1780

Capriccio with the Colosseum

1743–1744

Oil on canvas
52 $^7/_4$ x 46 $^1/_2$ in (134 x 118 cm)
National Gallery
Parma

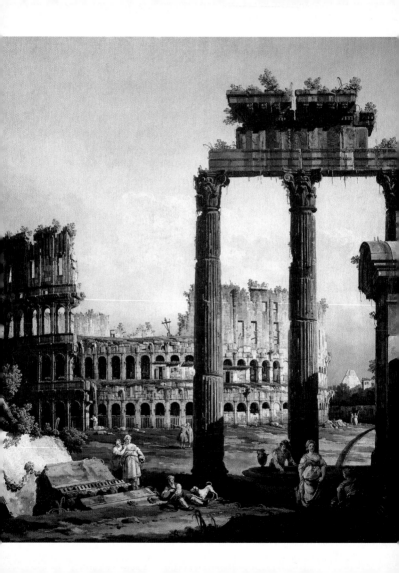

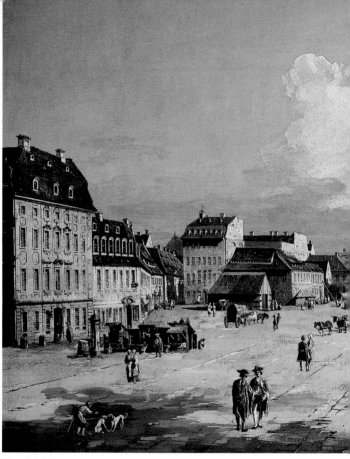

692

Bernardo Bellotto
Venice, 1720–Warsaw, 1780

View of the Market Place, Dresden

AFTER 1761

Oil on canvas, 33 x 20 ½ in (84 x 52 cm)
Palazzo Barberini, Galleria Nazionale d'Arte Antica
Rome

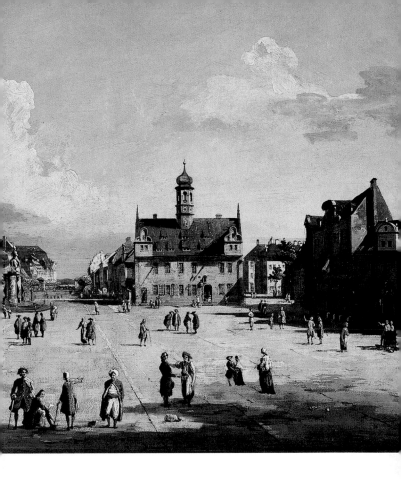

694

Hubert Robert
Paris, 1733–1808

**Interior of the Main Gallery
of the Louvre**

1796

Oil on canvas
44 ¹/₂ x 56 ¹/₄ in (112.5 x 143 cm)
Louvre
Paris

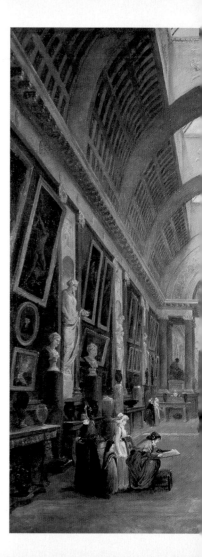

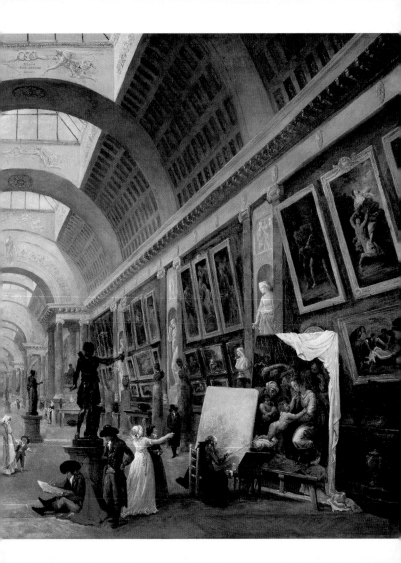

696

Hubert Robert
Paris, 1733–1808

Architectural Capriccio
1768

Oil on canvas
51 ¹/₂ x 65 ¹/₄ in (139.1 x 106 cm)
Barnard Castle, The Bowes Museum
County Durham

NEOCLASSICISM

AND ROMANTICISM

Neoclassical painting had roots reaching back to the eighteenth century, and it extended at least through the middle of the nineteenth century. One reason for its growth was the increase in archeological research. In 1738, excavations began at Herculaneum, followed, ten years later, by digs on the site of the lost city of Pompeii. Interest in the Graeco-Roman world thus became systematic, and in various parts of Europe compendiums were published, allowing the reading public to become familiar with the monuments of ancient Greece. One example is *Les ruines des plus beaux monuments de la Grece* (*The Ruins of the Most Beautiful Monuments of Greece*), by the French author Julien-David Leroy (1724–1803), published in 1758, or *The Antiquities of Athens*, 1762, by the Englishmen James Stuart (1713–1788) and Nicholas Revett (1720–1804). In 1755, the German art historian Johann Joachim Winckelmann (1717–1768) published the volume *Gedanken über die Nachahmung der griechischen Werke in der Malerei und Bildhauerkunst* (*Reflections on the Imitation of Greek Works in Painting and Sculpture*), in Dresden. He also published *Geschichte der Kunst des Altertums* (*History of Ancient Art*) in 1764. In his writings, Winckelmann argued that art must emulate the "noble simplicity" and the "calm greatness" that marked Greek art, condemning excess in expression, considered an error by the Greeks themselves. He called for an ideal beauty, an expression of the divine, in contrast with natural beauty which, in his view, represented humanity.

One of the earliest expressions in painting of this ideal is found in the work of another German, Anton Raphael Mengs (1728–1779), who shared Winckelmann's ideas and, like him, had gone to live in Rome out of a love of classical antiquity. In 1761, Mengs did a fresco entitled *Parnassus*, on a ceiling in the Villa Aldobrandini, in Rome. This work served as a benchmark for followers of the new Neoclassical ideas. The nascent school of art developed in the complex cultural context of the eighteenth century in

reaction to the excesses of the Baroque and the worldly and erotic character of the Rococo style. Themes of gallantry were replaced by themes of ancient history. To bring their classical subjects to life, the artists made use, first and foremost, of design as a basic element in their paintings. The interplay of color and the dizzying compositions found in Baroque and Rococo art were replaced by stern compositions based on line, chiaroscuro, and the classic proportions of the human body. Artists turned, once again, not only to classical subjects, but also to Renaissance pictorial techniques in the execution of their art. In order to attain a scrupulous rendering of the architecture, the costumes, and the artworks of antiquity, Neoclassical painters turned to the style of Raphael, Correggio or, even, the Carraccis, as can be seen in work of the previously mentioned Mengs or in that of the French artist Jean-Auguste-Dominique Ingres (1780–1867).

One of the high points in Neoclassical painting is the work of Jacques-Louis David (1748–1825), who painted The *Oath of the Horatii* in 1784. The classical theme is rendered with a composition in which the architecture, the figures arranged as if in a frieze, and the clothing all posit a rigorous return to classical forms. This formal rigor—the frieze-like composition, the symmetry and plasticity in the figures—would later be transferred by David to scenes of contemporary history, such as *The Coronation of Napoleon I and Empress Josephine* (1808).

With Neoclassicism, design, chiaroscuro, classical proportions, and exact perspective all became the fundamental elements of painting. Even when the subjects treated were neither mythological nor historical, these were the rules that, from this point forward, a painter was obliged to obey, according to official art education. Even if the subject belonged to the domain of Orientalism, the figures should comply with the canonical proportions and the plastic renderings typical of the traditional use of

chiaroscuro. A number of painters quickly began to feel uncomfortable with these Neoclassical rules. Among them, Eugène Delacroix (1798–1863), considered to be Romantic painter, not only tried to distance himself from classical subjects, but also began to use a method of modelling his figures directly with the pigment, without relying on the more traditional chiaroscuro, and to infuse his works with a sense of drama and dynamism. At first, however, the Romantic painters, considered to be in opposition with Neoclassical artists, differed from the latter primarily in terms of their choice of subject; they often relied on the same painting technique, based on design, chiaroscuro, and a plastic rendering of figures.

By and large, it is possible to distinguish between two distinct phases in the course of Romantic painting. The first phase, termed the pre-Romantic phase, runs from about 1770 until 1800. Prominent artists of this period included the painter Johann Heinrich Füssli (1741–1825), the Frenchman Girodet (1767–1824), a pupil of David, and the German painter Caspar David Friedrich (1774–1840). Although their paintings featured subjects quite different from those found in classical art, they were still indebted to academic painting. The new aspect of their work was primarily in their choice of subject: unsettling, as in the case of *The Nightmare*, by the Swiss-born artist Füssli, naturalized as an Englishman, or contemplative, as in Friedrich's dramatic landscapes.

Subsequently, Romantic ideas about freedom, their interest in medieval history and in other contemporary civilizations, as well as in modern history, led to the development of new modes of composition, as well as original subjects. This took place during the first few decades of the nineteenth century. Among the works that strode confidently onto the stage of European art were the huge canvas, *The Raft of the Medusa* (1819), by Théodore Géricault (1791–1824), depicting the dramatic story of

a shipwreck in the Indian Ocean; *The Third of May 1808 in Madrid, The Executions on Principe Pio Hill* (1814), by Francisco Goya (1746–1828), with the scene of an execution; *Dante and Virgil in Hell* (1822) and *The Massacre of Chios* (1824), by Eugène Delacroix. In the latter painting, an episode of contemporary history was shown, from the war between Greeks and Turks. In the foreground, Greek families await death or slavery.

Aside from their powerful political content, what these paintings have in common is the freedom from academic precepts with which they were executed. Harking back to such Italian models as Tintoretto, Géricault created a dynamic and intensely dramatic composition—that is, the opposite of Neoclassical ideals. For his part, Goya created a brutal, expressionistic, also caricatural description of an episode from Napoleon's invasion of Spain. Lastly, Delacroix, with his fluid hand and his new way of constructing figures through the modulation of pigments, reminiscent of Rubens, established color as the fundamental element of the image.

From then on, the idea of art as an individual vision of the world, as the expression of internal rebellion, and not so much as compliance with abstract canons imposed from without, was increasingly powerful. In this sense, the art of the Englishman William Turner (1775–1851) is a remarkable example of individual vision and creativity.

Anton Raphael Mengs
Aussig, Bohemia, 1728-
Rome, 1779

The Judgment of Paris

c. 1757

Oil on canvas
89 x 116 ¼ in
(226 x 295.5 cm)
Hermitage
St. Petersburg

pp. 698–699

Jacques-Louis David
Paris, 1748-Brussels, 1825

Madame Récamier

1800

Oil on canvas
68 ½ x 96 in (174 x 244 cm)
Louvre
Paris

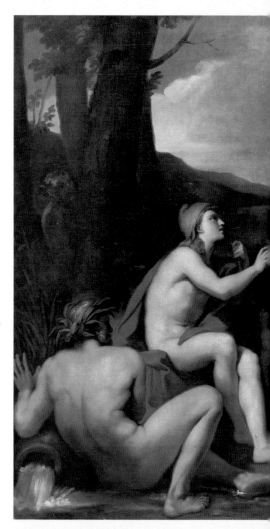

NEOCLASSICISM AND ROMANTICISM

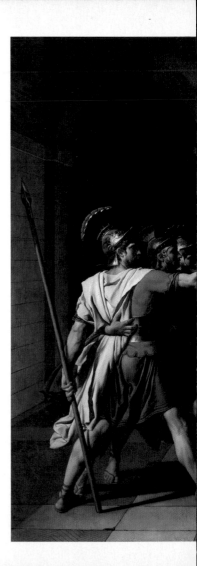

706

Jacques-Louis David
Paris, 1748–Brussels, 1825

The Oath of the Horatii

1784

Oil on canvas
130 x 167 ¼ in (330 x 425 cm)
Louvre
Paris

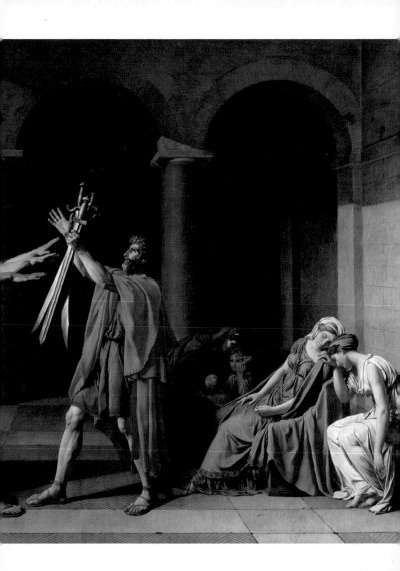

Jacques-Louis David
Paris, 1748–Brussels, 1825

708

**The Sabine Women Halt
the Fight Between the Romans
and the Sabines**

1799

Oil on canvas
151 $\frac{1}{2}$ x 205 $\frac{1}{2}$ in (385 x 522 cm)
Louvre
Paris

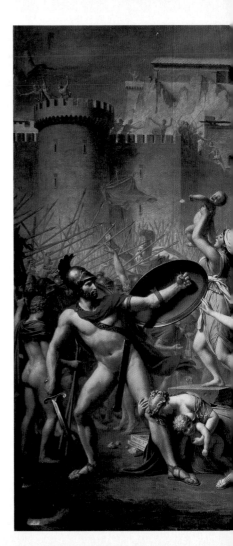

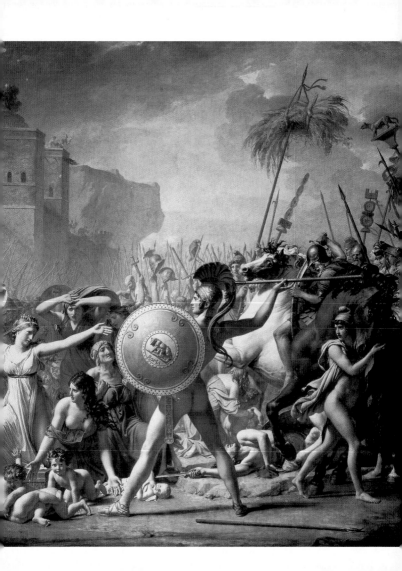

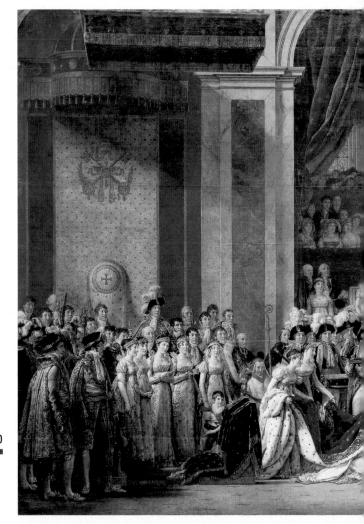

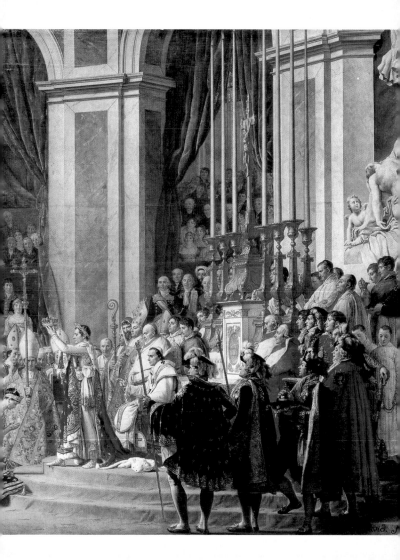

Girodet-Trioson
(Anne-Louis Girodet de Roucy)
Montargis, 1767–Paris, 1824

Portrait of Napoleon I

1804

Oil on canvas
99 ½ x 47 ¼ in (253 x 120 cm)
Musée Girodet
Montargis

pp. 710–711

Jacques-Louis David
Paris, 1748–Brussels, 1825

**The Coronation of Napoleon I
and Empress Josephine**

1806–1807

Oil on canvas
244 ½ x 385 ½ in (621 x 979 cm)
Louvre
Paris

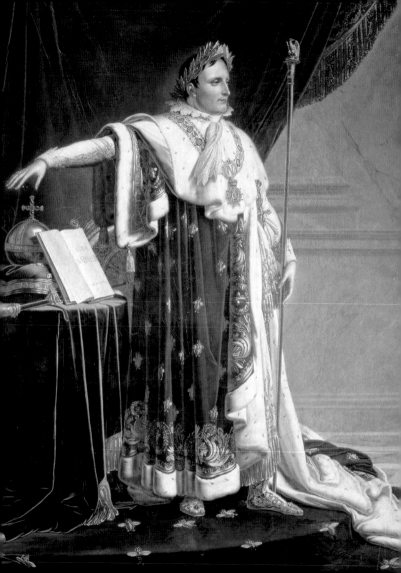

Girodet-Trioson (Anne-
Louis Girodet de Roucy)

Montargis, 1767–Paris, 1824

714

**The Entombment
of Atala**

1808

Oil on canvas
81 ½ x 105 in (207 x 267 cm)
Louvre
Paris

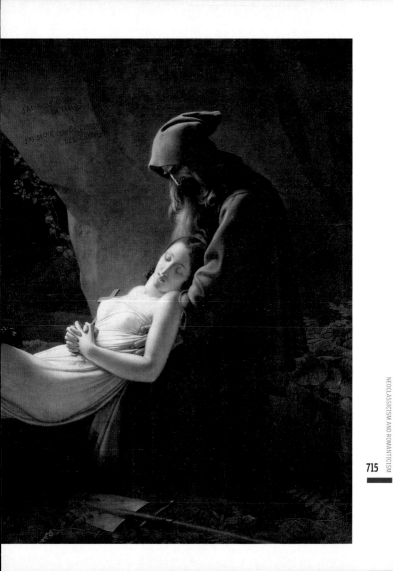

NEOCLASSICISM AND ROMANTICISM

716

Jean-Auguste-Dominique Ingres
Montauban, 1780–Paris, 1867

Oedipus and the Sphinx

1808

Oil on canvas
74 $\frac{1}{2}$ x 56 $\frac{3}{4}$ in (189 x 144 cm)
Louvre
Paris

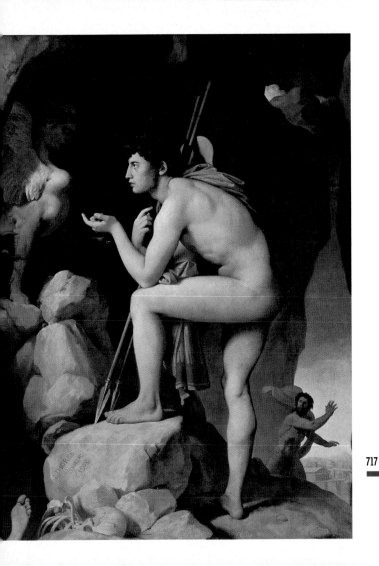

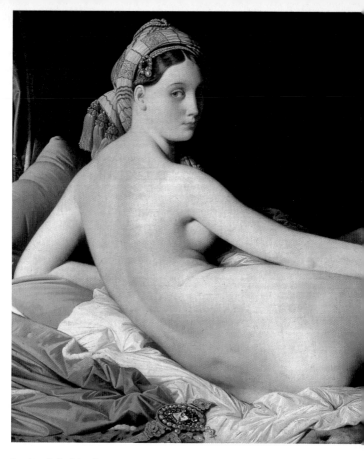

718

Jean-Auguste-Dominique Ingres
Montauban, 1780–Paris, 1867

The Grand Odalisque

1814

Oil on canvas, 35 ¹/₄ x 63 ³/₄ in (91 x 162 cm)
Louvre
Paris

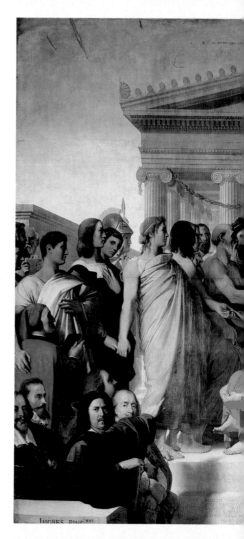

720

Jean-Auguste-Dominique Ingres
Montauban, 1780–Paris, 1867

Apotheosis of Homer

1827

Oil on canvas
152 x 201 ½ in (386 x 512 cm)
Louvre
Paris

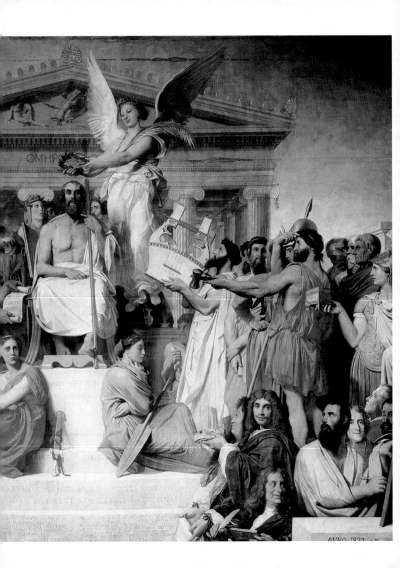

722

Jean-Auguste-Dominique Ingres
Montauban, 1780–Paris, 1867

The Turkish Bath

1862

Oil on canvas
diam. 42 $^1/_2$ in (108 cm)
Louvre
Paris

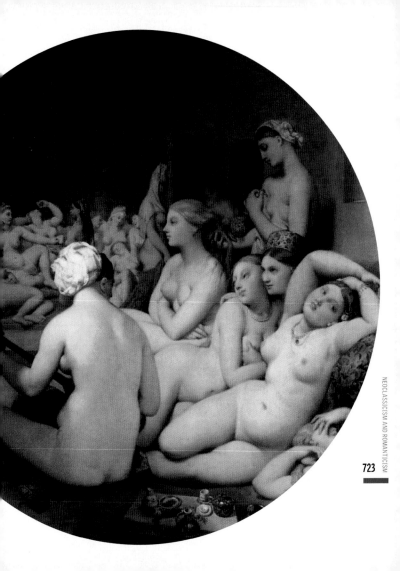

Francesco Hayez
Venice, 1791-Milan, 1882

The Sicilian Vespers

1846

Oil on canvas
88 ¹/₂ x 121 ¹/₄ in (225 x 308 cm)
Galleria d'Arte Moderna
Rome

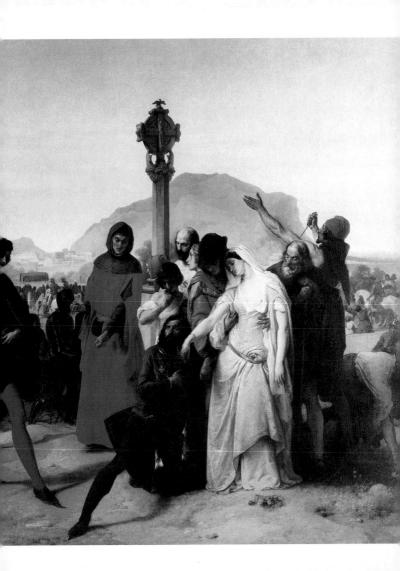

Francesco Hayez
Venice, 1791–Milan, 1882

726

The Kiss

1859–1867

Oil on canvas
21 $^3/_4$ x 15 $^3/_4$ in (55 x 40 cm)
Pinacoteca di Brera
Milan

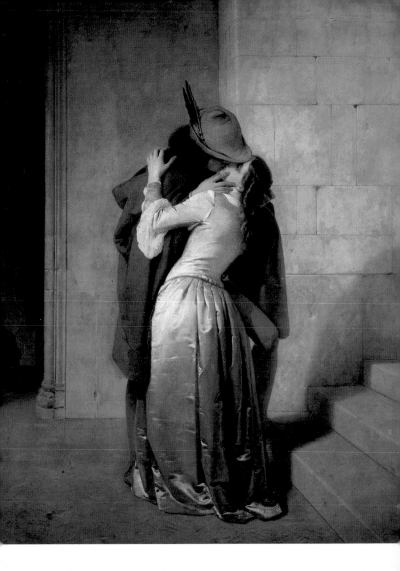

Jean-Baptiste Greuze
Tournus, 1725–Paris, 1805

728

The Broken Jug

1785

Oil on canvas
42 ¹/₂ x 33 ³/₄ in (108 x 86 cm)
Louvre
Paris

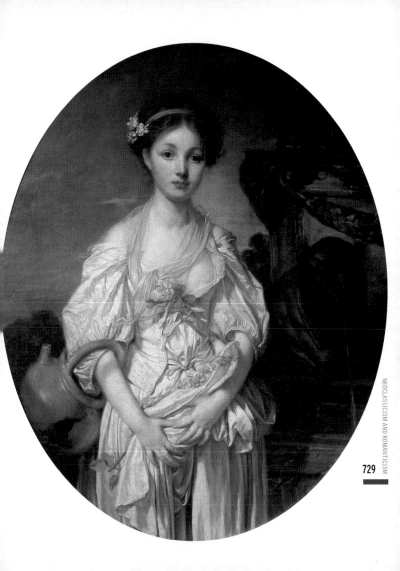

729

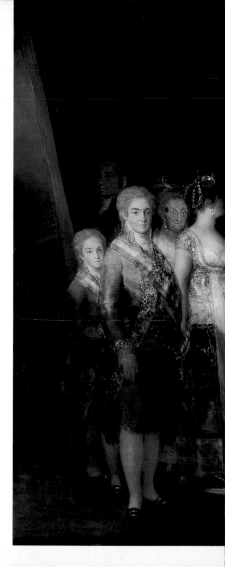

Francisco Goya y Lucientes
Fuendetodos, Saragozza, 1746–Bordeaux, 1828

The Family of Charles IV of Spain

1800

Oil on canvas
110 ¹/₄ x 132 ¹/₄ in (280 x 336 cm)
Prado
Madrid

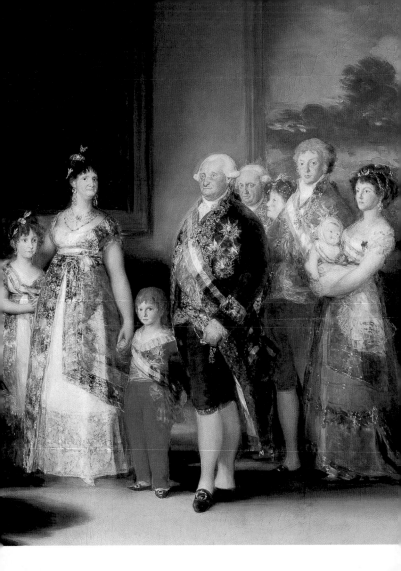

732

Francisco Goya y Lucientes
Fuendetodos, Saragozza, 1746–Bordeaux, 1828

The Colossus

c. 1808

Oil on canvas
45 ³/₄ x 41 ¹/₄ in (116 x 105 cm)
Prado
Madrid

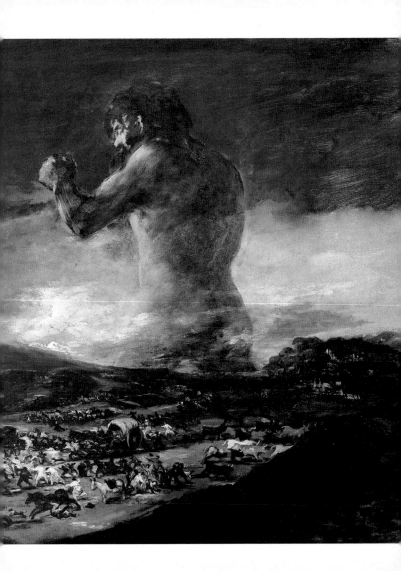

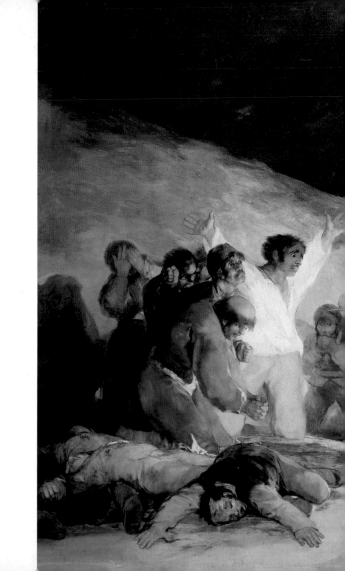

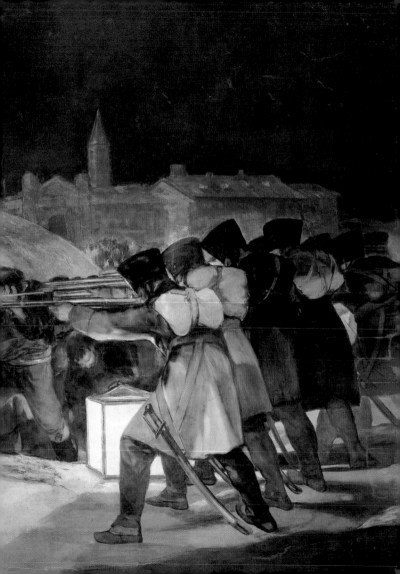

Francisco Goya y Lucientes

Fuendetodos, Saragozza, 1746–
Bordeaux, 1828

**Saturn Devouring one of
his Children**

1820–1823

Mural transferred to canvas
57 $\frac{1}{2}$ x 32 $\frac{1}{4}$ in (146 x 83 cm)
Prado
Madrid

pp. 734–735

Francisco Goya y Lucientes

Fuendetodos, Saragozza, 1746–
Bordeaux, 1828

**The Third of May 1808 in Madrid,
The Executions on Principe Pio Hill**

1814

Oil on canvas
104 $\frac{3}{4}$ x 135 $\frac{3}{4}$ in (266 x 345 cm)
Prado
Madrid

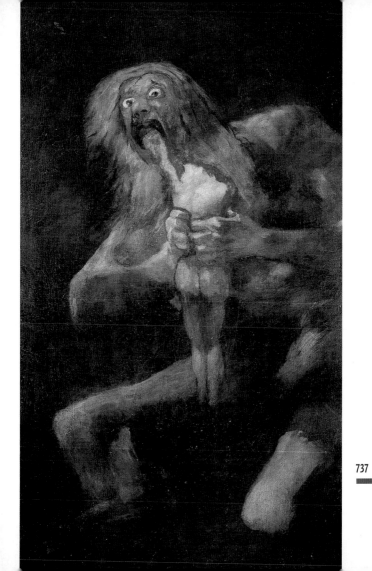

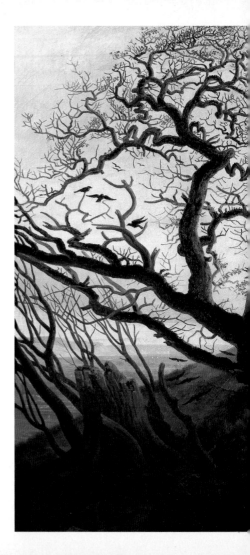

738

Caspar David Friedrich
Greifswald, 1774–Dresden, 1840

Tree with Crows

c. 1822

Oil on canvas
23 ¹/₄ x 29 in (59 x 74 cm)
Louvre
Paris

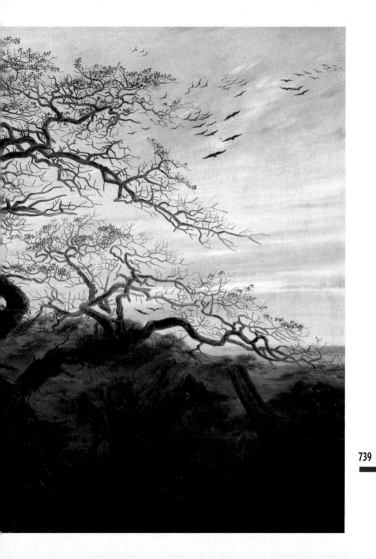

740

Caspar David Friedrich
Greifswald, 1774–Dresden, 1840

The Sea of Ice

1822

Oil on canvas
38 ¹/₄ x 50 in (97 x 127 cm)
Kunsthalle
Hamburg

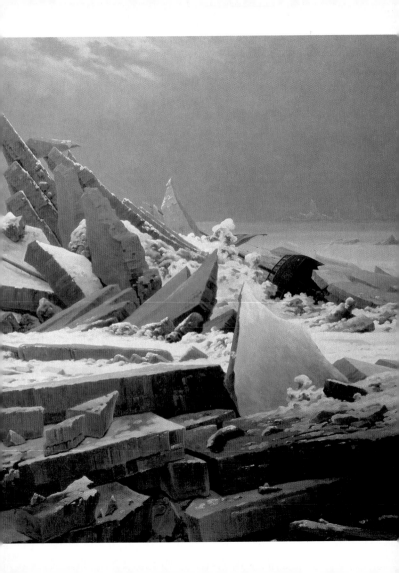

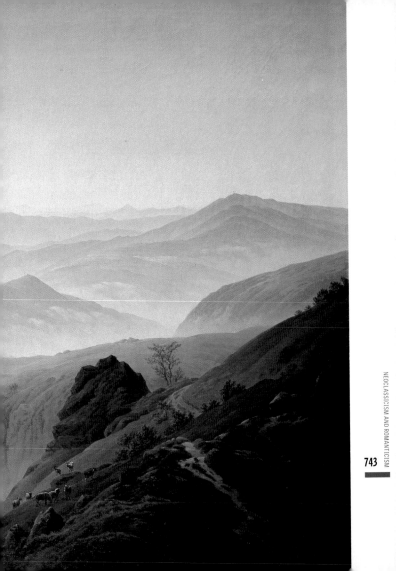

Marie-Guilhelmine Benoist
Paris, 1768–1826

Portrait of a Woman

1800

Oil on canvas
32 x 25 ¹/₂ in (81 x 65 cm)
Louvre
Paris

pp. 734–735

Caspar David Friedrich
Greifswald, 1774–Dresden, 1840

Morning in the Mountains

c. 1823

Oil on canvas
53 ¹/₄ x 67 in (135 x 170 cm)
Hermitage
St. Petersburg

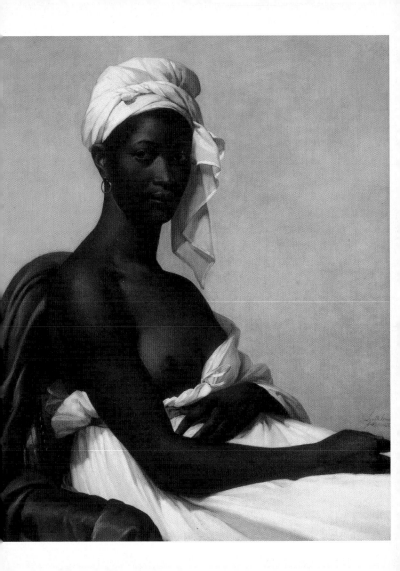

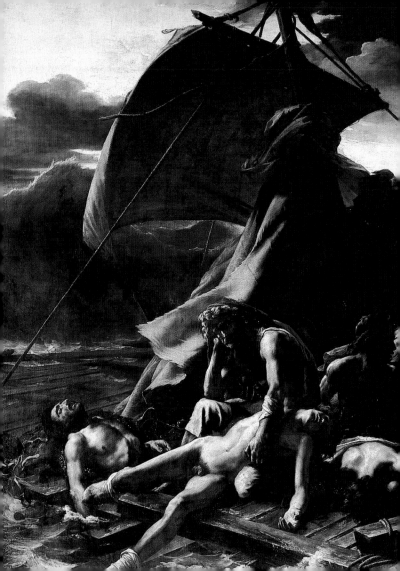

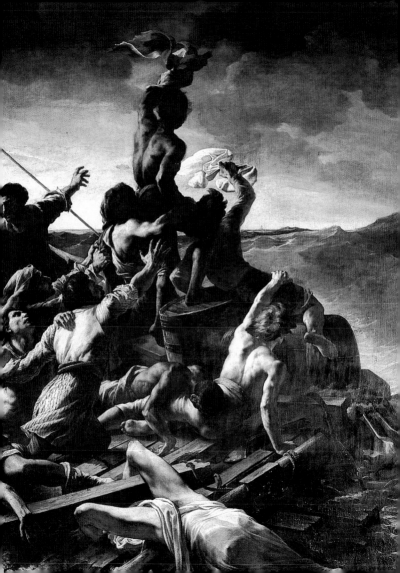

Eugène Delacroix
Charenton-Saint-Maurice, 1798–Paris, 1863

The Massacre of Chios

1824

Oil on canvas
185 $^1/_2$ x 139 $^1/_4$ in (471 x 354 cm)
Louvre
Paris

pp. 746–747

Théodore Géricault
Rouen, 1791–Paris, 1824

The Raft of the Medusa

1819

Oil on canvas
193 $^1/_4$ x 282 in (491 x 716 cm)
Louvre
Paris

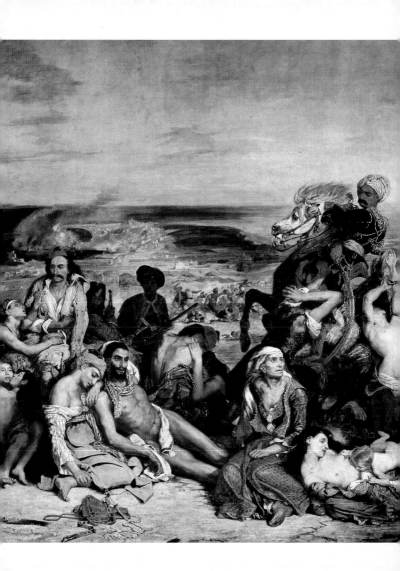

Eugène Delacroix

Charenton-Saint-Maurice,
1798–Paris, 1863

750

**The Death of
Sardanapalus**

1827

Oil on canvas
115 ½ x 195 in (395 x 495 cm)
Louvre
Paris

752

Eugène Delacroix
Charenton-Saint-Maurice, 1798–Paris, 1863

Liberty Leading the People

1830

Oil on canvas
102 ¹/₄ x 128 in (260 x 325 cm)
Louvre
Paris

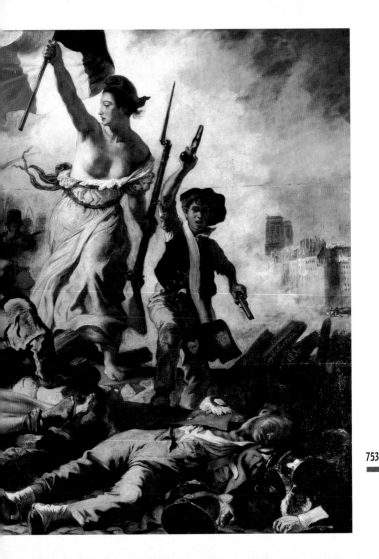

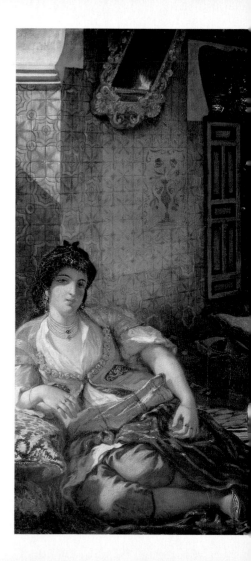

Eugène Delacroix
Charenton-Saint-Maurice,
1798–Paris, 1863

Women of Algiers

1834

Oil on canvas
42 $\frac{1}{2}$ x 90 $\frac{1}{4}$ in (180 x 229 cm)
Louvre
Paris

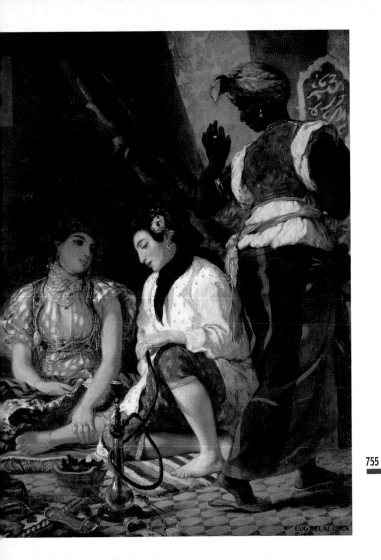

Eugène Delacroix
Charenton-Saint-Maurice, 1798–Paris, 1863

Frédéric Chopin

1838

Oil on canvas
17 1/$_4$ x 15 in (45 x 38 cm)
Louvre
Paris

756

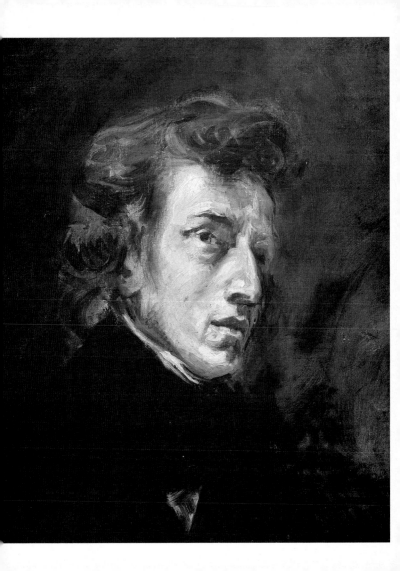

Johann Heinrich Füssli
Zurich, 1741–London, 1825

758

Lady Macbeth Sleepwalking

1784

Oil on canvas
87 x 63 in (221 x 160 cm)
Louvre
Paris

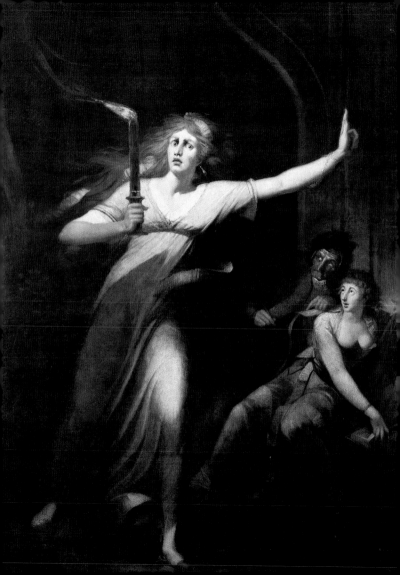

NEOCLASSICISM AND ROMANTICISM

William Blake
London, 1757-1827

760

Frontispiece from "Europe: a Prophecy"

1794

Etching
9 $\frac{1}{4}$ x 6 $\frac{1}{2}$ in (23.5 x 16.5 cm)
Pierpont Morgan Library
New York

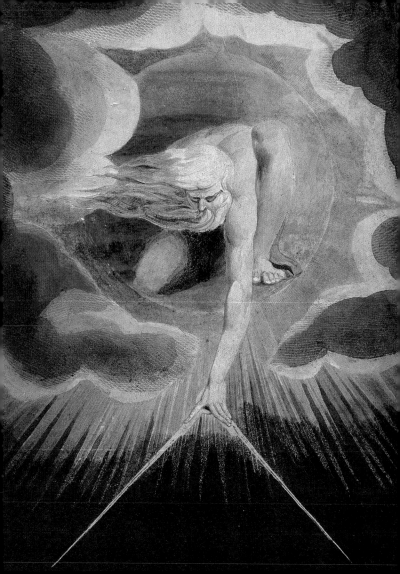

Joseph Mallord
William Turner
London, 1775–1851

**Landscape with
Distant River
and Bay**

762

c. 1813

Oil on canvas
48 ¹/₂ x 36 ¹/₂ in
(123 x 93 cm)
Louvre
Paris

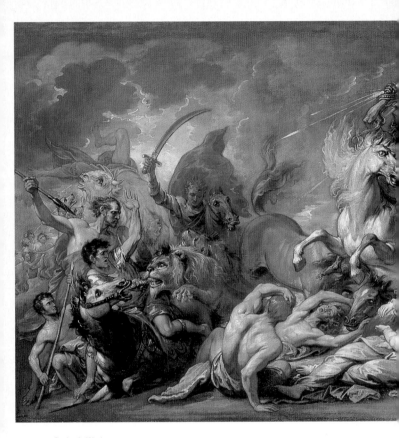

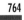

Benjamin West

Springfield, Pennsylvania, 1738–
London, 1820

Death on a Pale Horse

1796

Oil on canvas
23 ¹/₂ x 50 ¹/₂ in (59.5 x 128.5 cm)
The Detroit Institute of Arts, Detroit

764

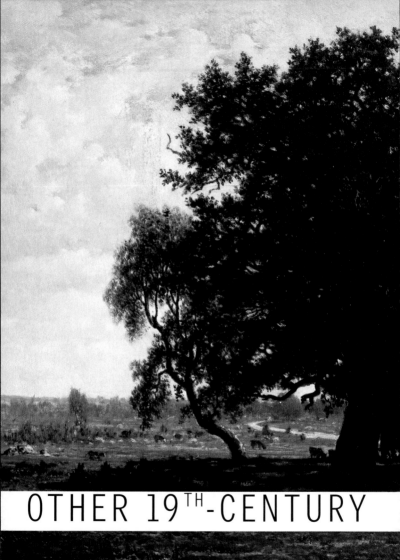

OTHER 19ᵀᴴ-CENTURY

ART MOVEMENTS

t was certainly the rebellious spirit of Romanticism that encouraged a group of German artists living in Rome to found a brotherhood of painters in 1809—the first such confraternity in modern times. They named it the Brotherhood of Saint Luke. They were students from the Academy of Vienna, where the teaching was influenced by Neoclassical art. The confraternity was intended as a reaction to the art being taught in the Academy. They condemned that art as devoid of spirituality and purity. The chief movers behind the Brotherhood of Saint Luke, Friedrich Overbeck (1789–1869), Franz Pforr (1788–1812), and Peter von Cornelius (1783–1867), considered art to be similar to prayer, like a priesthood. They wished to regain the religious ideals of the Middle Ages which, in their opinion, classicism was incapable of expressing. When they first began to work together as a group, the painters of the Brotherhood of Saint Luke went so far as to live in an abandoned monastery, San Isidoro sul Pincio, or Saint Isidore on the Pincian Hill. In the monastery each of them lived in a monk's cell, providing for themselves as well as tending to the needs of the group, just like monks, and dedicating themselves to painting. Overbeck went so far as to convert to Catholicism. The monastic life lasted for a couple of years, coming to an end with Pforr's death in 1812. Their attraction for monkish ways and Catholicism, and their long hair, won the members of the Brotherhood of Saint Luke the nickname of "Nazarenes," which, at first, was clearly a term of ridicule.

To put art back on the "way of truth," which they believed was the path of Christian feeling, these painters turned to the art of the past, especially the painters of fifteenth-century Italy, such as Fra' Angelico, Pietro Perugino, Fra' Filippo Lippi, and Luca Signorelli, in whom they thought they detected the simplicity and spiritual purity that art had lost. Comparable to the treatises on archaeology for Neoclassical artists, the Nazarenes took their inspiration from the *History of Painting in Italy* by the Riepenhausen brothers, who were also living in Rome, and whose book introduced the German-speaking public to the

painting of fourteenth- and fifteenth-century Italy. Some members of the group, however, sought inspiration in early German painting, and especially in the work of Albrecht Dürer. The Nazarenes came to the attention of Ludwig of Bavaria during his stay in Rome, and several members of the group returned to Germany at the invitation of the crown prince of Bavaria. They were highly influential on nineteenth-century German painting. Their influence can be seen in some Italian painting as well, especially in the school of "purismo," guided by Tommaso Minardi (1787–1871).

In 1848, the Pre-Raphaelite Brotherhood of painters was founded in London. It was formed by young students of the Royal Academy in London, who, like the turn-of-the-century Nazarenes, wanted to restore painting to a more naive and spiritual form of expression. They therefore turned to the styles of painting from the years prior to the fifteenth-century Italian painter Raphael, which they considered to be models for a more spontaneous and natural approach. The ideas of the Nazarenes, which could be considered one of the earliest inspirations for the Pre-Raphaelites, were well known in England where a painter named William Dyce (1806–1864) was applying their principles. Like the Nazarenes, the Pre-Raphaelites no longer wanted to obey the rules of the academy, which subjected art to theoretical choices, fixed compositional schemes, and ways of depicting light. All the same, in contrast with the Nazarenes, the Pre-Raphaelites, in their paintings of edifying subjects, tended to attain a more realistic portrayal of the human figure and the detailed rendition of the natural elements and the architectural and environmental settings of the scenes, as in early Flemish painting.

Among the leading members of the Pre-Raphaelite Brotherhood in its first years were the painters William Holman Hunt (1827–1910), John Everett Millais (1829–1896), and Dante Charles Gabriel Rossetti (1828–1882). In

1850, the Pre-Raphaelites were the targets of fierce attacks from art critics, but the following year the critic John Ruskin (1819-1900), who was calling for the historic rehabilitation of the so-called "Italian primitive artists," among others, came out in the their defense. Later, Edward Burne-Jones (1833-1898) and William Morris (1834-1896) took up the ideas of Rossetti, and originated the current of Neo-Pre-Raphaelitism.

Outside of the rules of the official schools of painting, many landscape painters such as the painters of the Barbizon School, were also hard at work. As early as 1822, Barbizon, a small French village at the edge of the forest of Fontainebleau, was a popular destination for a certain number of artists who wished to escape the traditional model of landscape painting based primarily on the ideal formulas of the classical landscape, the historic landscape, or the impetuous visions of Romantic painters. Even if they later painted their works in the seclusion of their studio, they wanted to take inspiration from a direct contact with nature. They did not constitute a full-fledged movement, but they shared an admiration for Dutch landscape painting of the seventeenth century and more recent English landscape painting, especially the work of John Constable (1776-1837). The list of painters who lived in Barbizon or spent time there, including many non-French artists, is quite lengthy. Among the names, we should mention Théodore Rousseau (1812-1867), Jean-François Millet (1814-1875)—famous for his pictures of life and work in the fields—and Camille Corot (1796-1875).

Gustave Courbet (1819-1877), the painter who was destined to become the founding father of the school of "realist" painting, discovered Barbizon in 1841. He shared with the painters of the Barbizon School a fondness for nature studies and everyday themes, as well as a strong interest in Dutch painting. In that sense, his painting too was a form of reaction against

Neoclassicism and Romanticism. The new landscape painting on the one hand and Courbet on the other prepared the ground for the true great artistic revolution of the nineteenth century: Impressionism.

Peter von Cornelius
Düsseldorf, 1783–Berlin, 1867

Joseph Recognized by his Brothers

c. 1815

Detached fresco
95 ³/₄ x 119 ³/₄ in (243 x 304 cm)
Staatliche Museen
Berlin

pp. 766-767

Théodore Rousseau
Paris, 1812–Barbizon, 1867

Oak Trees, Aspromonte

1850-1852

Oil on canvas
25 x 39 ¹/₄ in (63.5 x 99.5 cm)
Louvre
Paris

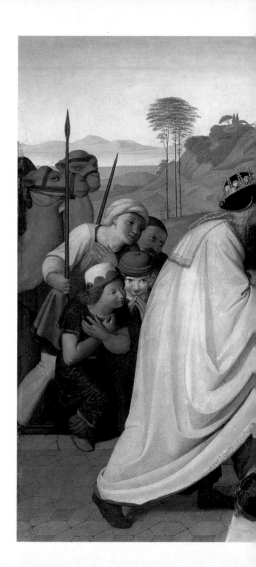

774

Friedrich Overbeck
Lübeck, 1789–Rome, 1869

Adoration of the Magi

1813

Oil on panel
19 ¹/₂ x 26 in (49.7 x 66 cm)
Kunsthalle
Hamburg

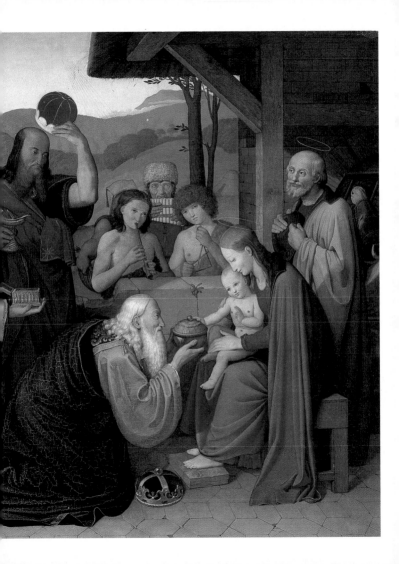

William Holman Hunt
London, 1827-1910

776 **The Finding of the Savior in the Temple**

1854–1860

Oil on canvas
33 ¼ x 55 ½ in (85.7 x 141 cm)
Birmingham Art Gallery
Birmingham

778

Dante Charles Gabriel Rossetti
London, 1828–Birchington-on-Sea, 1882

Astarte Siriaca

1877

Oil on canvas
72 ³/₄ x 43 in (185 x 109 cm)
Manchester Art Gallery
Manchester

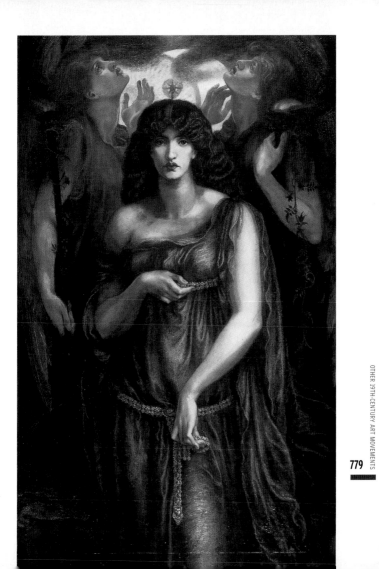

Edward Burne-Jones

Birmingham, 1833–Fulham, 1898

The Prioress's Tale

1865–1898

Gouache on paper
40 ³/₄ x 24 ³/₄ in (103.5 x 62.8 cm)
Delaware Art Museum
Wilmington

pp. 780–781

John Everett Millais

Southampton, 1829–London, 1896

782

Lorenzo and Isabella

1849

Oil on panel
8 ³/₄ x 11 ¹/₂ in (22 x 29.3 cm)
The Makins Collection
Washington

784

Ford Madox Brown
Calais, 1821–London, 1893

The Last of England
1852–1855

Oil on panel
32 $\frac{1}{2}$ x 29 $\frac{1}{2}$ in (82.5 x 75 cm)
Birmingham Art Gallery
Birmingham

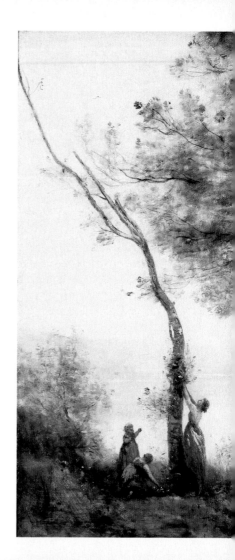

786

Jean-Baptiste-Camille Corot
Paris, 1796–Ville-d'Avray, 1875

Memory of Mortefontaine
1864

Oil on canvas
25 ¹/₂ x 35 in (65 x 89 cm)
Louvre
Paris

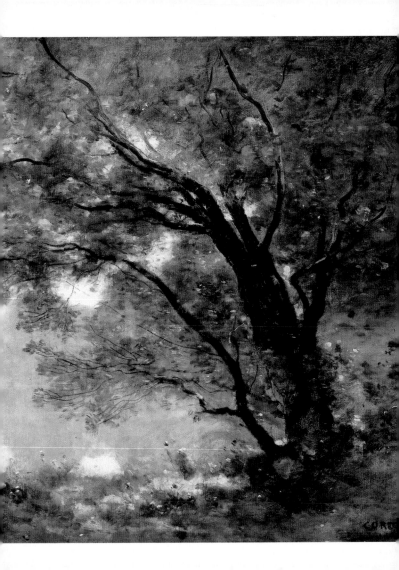

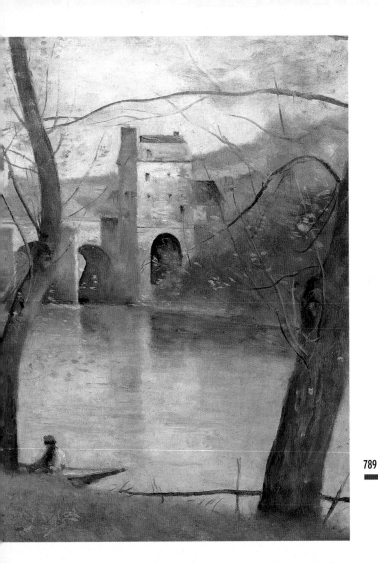

Jean-Baptiste-Camille Corot
Paris, 1796–Ville-d'Avray, 1875

Girl in Blue

1874

Oil on canvas
31 $\frac{1}{2}$ x 20 in (80 x 50.5 cm)
Louvre
Paris

pp. 788–789

Jean-Baptiste-Camille Corot
Paris, 1796–Ville-d'Avray, 1875

790

The Bridge at Mantes

1868–1870

Oil on canvas
15 $\frac{1}{4}$ x 21 $\frac{3}{4}$ in (38.5 x 55.5 cm)
Louvre
Paris

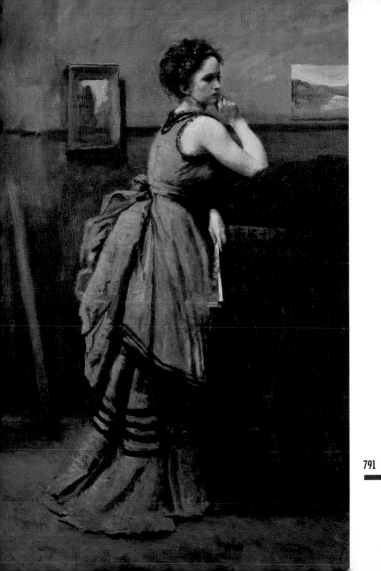

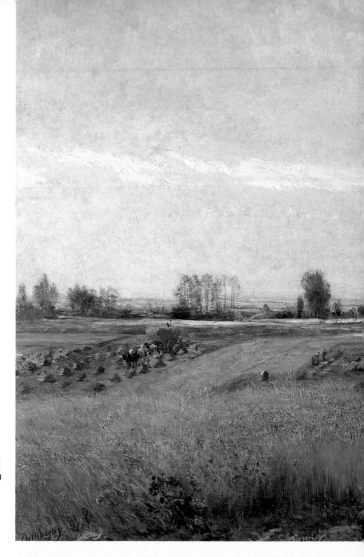

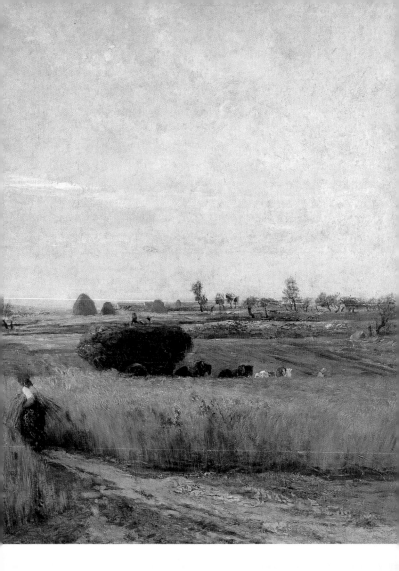

Jean-François Millet
Gruchy, 1814–Barbizon, 1875

The Gleaners

1857

Oil on canvas
32 ¹/₄ x 43 ³/₄ in (83.5 x 111 cm)
Musée d'Orsay
Paris

pp. 792-793

Charles-François Daubigny
Paris, 1817–1878

The Harvest

1851

Oil on canvas
53 ¹/₄ x 77 ¹/₄ in (135 x 196 cm)
Musée d'Orsay
Paris

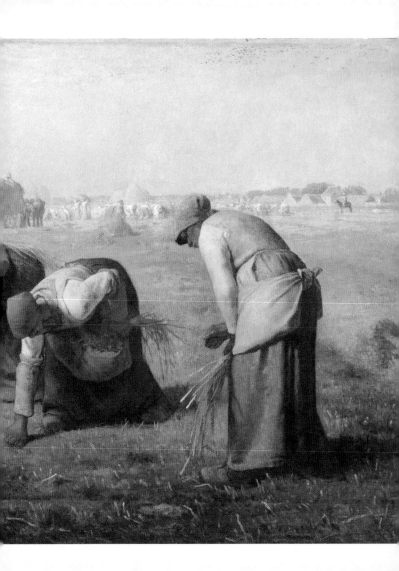

796

Jean-François Millet
Gruchy, 1814–Barbizon, 1875

The Angelus
1857–1859

Oil on canvas
21 ¹/₄ x 26 in (55.5 x 66 cm)
Musée d'Orsay
Paris

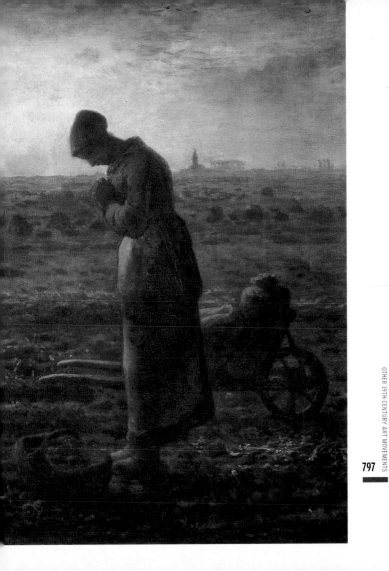

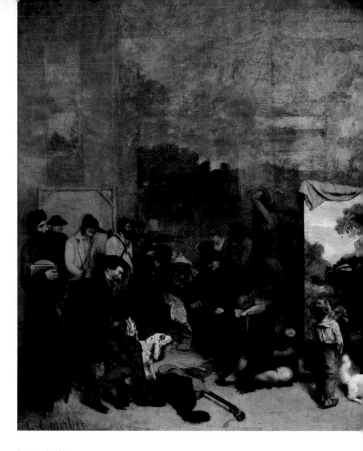

Gustave Courbet
Ornans, 1819–La Tour-de-Peilz, 1877

The Artist's Studio

1855

Oil on canvas
141 $\frac{1}{4}$ x 235 $\frac{1}{2}$ in (359 x 598 cm)
Musée d'Orsay
Paris

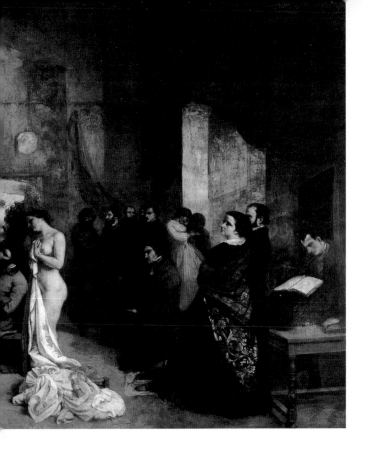

Winslow Homer
Boston, 1836–Scarboro,
Maine, 1910

800

Summer Night

1890

Oil on canvas
30 ¹/₄ x 40 ¹/₄ in
(76.7 x 102 cm)
Musée d'Orsay
Paris

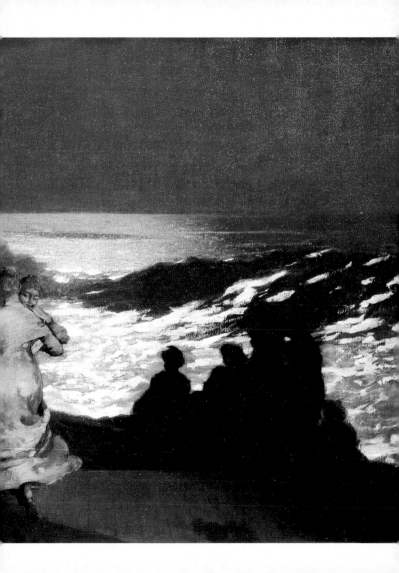

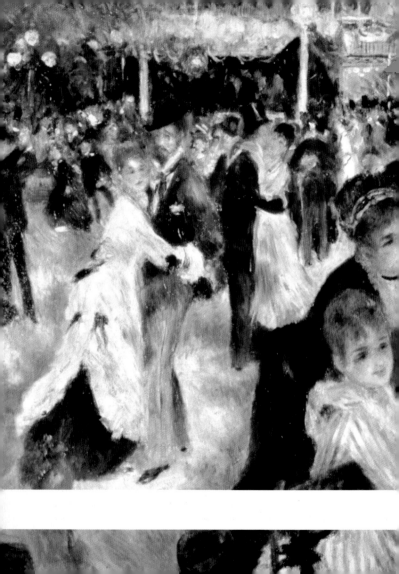

IMPRESSIONISM

Impressionism was one of the most intense and creative movements in the entire history of art. At the beginning of the 1870s, a group of painters who were opposed to the artistic conventions taught at the École des Beaux-Arts in Paris and in French institutes of art in general, decided to found an association that would show their artwork freely, without being obliged to submit them to the jury of the annual official Parisian art show. The jury was primarily made up of teachers from the schools in question, and artists who failed to comply with their strictures were rejected.

According to the academic tradition, training for a painter required, first of all, extensive practice at drawing from etchings or plaster casts, followed by drawing from living models, and only then was it possible to graduate to the use of canvas and brushes. Even then, according to the precepts of the official schools, it was necessary to rely upon preliminary sketches and designs. This practice, advocated by Neoclassical painters, had been handed down by centuries of tradition dating back to the Renaissance and applied especially to the painting of mythological, historic, and religious subjects as well as portraits, rigorously and slowly executed within the four walls of the studio. Some of the most successful French "academic" painters included Horace Vernet (1789–1863), William-Adolphe Bouguereau (1825–1905), and Jean-Léon Gérôme (1824–1904). The academic tradition was also well-established in Britain where artists like the Dutch-born Lawrence Alma-Tadema (1836–1912) gained official recognition—even knighthood. (The reproductions at the beginning of this chapter are of works by these official or "academic" painters.) By the late nineteenth century this academic conservatism had become for many artists an obstacle to the creative process.

The young painters who founded the *Société anonyme des artistes peintres, sculpteurs, graveurs, etc.*, including Claude Monet (1840–1926), Auguste Renoir (1841–1919), and Camille Pissarro (1830–1903), were eager to express

a new idea of art and the world. They had already developed by the end of the 1860s, each in his own manner, a new pictorial idiom, which met with fierce opposition from the official arbiters of culture. In order to capture the fleeting visions of the world and to express the vitality of nature and the dizzy whirl of city life, they no longer relied on plaster casts, and they no longer tried to match their figures to the canons of proportions and beauty inherited from antiquity. The no longer did preliminary drawings for their compositions; instead they executed them directly with paint, which was applied to the canvas with rapid brushstrokes, like colorful patches. In this way, not only could they capture a subject in an instantaneous manner, before it escaped their view, but the young painters also managed to infuse their paintings with a great vitality.

Among the first paintings to express these new ideas were the canvases dedicated to *La Grenouillère*, a restaurant on the banks of the Seine outside of Paris, where there were also facilities for swimming. *La Grenouillère* was very popular with Parisians in search of weekend amusements. In 1869 Monet and Renoir set up their easels in the open air and worked elbow to elbow, with rapid brushstrokes, discontinuous lines, and patches of color. They depicted the restaurant, the little islet known as the "Camembert," the swimming facilities, the boats, and the throngs of weekenders. Their work, at least as it appeared to the ordinary viewer, were just a series of sketches. Details had vanished, there was no minute description of figures. But their paintings were bursting with life! The canvases were filled with a tireless sense of movement; they quivered with light and color in a way that had never been seen. All this irritated the masters of academic painting no end. Not only did the young painters fail to respect the methods of the École des Beaux-arts, they did not even respect the traditional choice of subjects. This led to a new artistic vocabulary, which would produce a great turning point in the history of Western culture, comparable to the influence of the artists of the

Renaissance, opening the way to the variegated and complex world of modern art.

The young painters, however, had some very important points of reference. One of these was the work of the artist Édouard Manet (1832–1883). A few years earlier Manet, though he was hardly a proponent of open-air painting, had introduced rapid and fragmentary brushstrokes and an abbreviated rendering of figures into the painterly idiom, taking inspiration from such old masters as Diego Velázquez and Frans Hals. This contributed to the vivacity and dynamism of his compositions. Moreover, Manet had painted subjects that were decidedly contemporary in character.

The first showing of the work of this group assembled by these rebellious painters took place in 1874. Among other participants, we should mention Monet, Renoir, Pissarro, Paul Cézanne (1839–1906), Edgar Degas (1834–1917), Alfred Sisley (1839–1899), Berthe Morisot (1841–1895), and Monet's first art teacher, Eugène Boudin (1824–1898). They were all artists that possessed strong personalities, and they did not always agree. At the group's first exhibition, Claude Monet's painting *Impression. Sunrise* was shown. The canvas, done in 1872, depicted the Seine estuary at Le Havre at dawn. It was almost impossible to recognize the city's port structures. The orange sun cut through a heavy mist, depositing orange highlights on the choppy river water. As in the rest of the picture, two or perhaps three small watercraft were moving through the water, rendered with broad, rapid brushstrokes. In short, the painting showed a great indifference to detailed description and, in contrast, a surprising capacity, through a summary technique, to infuse a marked atmospheric sense into an image. What was seen was no longer a subject with all its details, but rather the atmosphere, the expression of a sensation.

The painting was the target of sarcastic barbs from a critic named Louis Leroy (1812-1885). In an article for the journal *Charivari*, taking advantage of the title of Monet's painting, speared all the painters who took part in the show with the name of "Impressionists." This is the origin of the present-day definition of "Impressionism," which may seem like a vague term that fails to describe adequately the wealth of creation that was about to be added to the history of painting.

This first exhibition was followed by seven more, which did not always feature works by the same artists. The only artist who participated in all eight shows was Pissarro. Even though the painters who were grouped under the heading of Impressionists remained friends for life, their careers went in separate directions, and each of them worked in a largely individual way. Their painting continued to develop. Monet and Pissarro originated the "series," which were groups of paintings with the same subject, and with the same point of view, but depicting different times of day, showing how the appearance of a subject or a place varies according to the circumstances and the time at which they are seen. Monet's longevity allowed him to pursue his interests to a considerable degree. Toward the end of his career, the painter had attained a style in which the act of making a brushstroke, especially in his water lily paintings, seems to be the true protagonist of the canvas.

Impressionist painters can take credit for having liberated painting from the idea that art is made according to predetermined rules and formulas imposed from outside sources—that tend to crush both personality and culture. Impressionist painting expressed the changing appearance of the world beneath the glittering atmospheric light. It affirmed nature as a source of knowledge and discovery, bringing new themes to the attention of artists and the public. Furthermore, it was, first and foremost, a powerful cry for freedom in the face of conformity, in both art and in life.

Horace Vernet
Paris, 1789-1863

Defense of the Barrier at Clichy
1820

Oil on canvas
38 ¹/₂ x 51 ¹/₂ in (97.5 x 130.5 cm)
Louvre
Paris

Pierre-Auguste Renoir
Limoges, 1841-Cagnes, 1919

**The Dance at the Moulin
de la Galette**
1876

Oil on canvas
51 ¹/₄ x 69 in (130 x 175 cm)
Musée d'Orsay
Paris

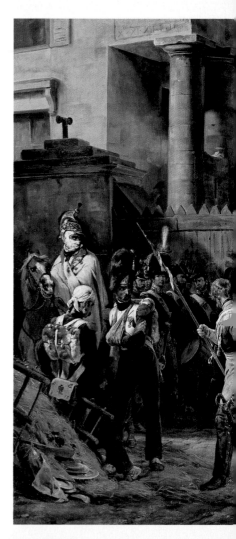

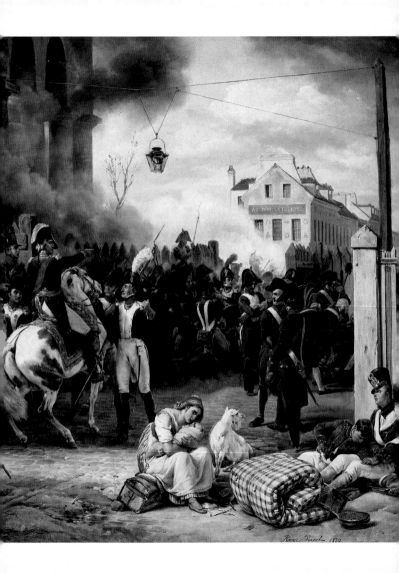

810

Charles Gleyre
Chevilly, 1808–Paris, 1874

Daphne and Chloe

1862

Oil on panel
9 ¹/₄ x 7 ¹/₄ in (23.5 x 18.5 cm)
Musée Cantonal des Beaux-Arts
Lausanne

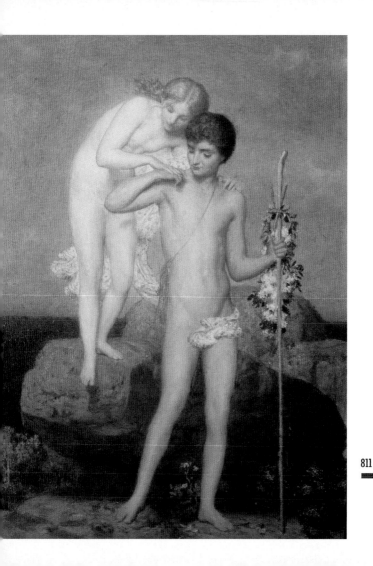

Alexandre Cabanel
Montpellier, 1823–Paris, 1889

The Birth of Venus

1863

Oil on canvas, 51 ¹/₄ x 88 ¹/₂ in (130 x 225 cm)
Musée d'Orsay, Paris

William-Adolphe Bouguereau

La Rochelle, 1825-1905

Tobias Taking Leave of his Father

1860

Oil on canvas
60 ¹/₄ x 46 ³/₄ in (153 x 119 cm)
Hermitage
St. Petersburg

pp. 814-815

Jean-Léon Gérôme

Vesoul, 1824-Paris, 1904

Cockfight

1846

Oil on canvas
56 ¹/₄ x 80 ¹/₄ in (143 x 204 cm)
Musée d'Orsay
Paris

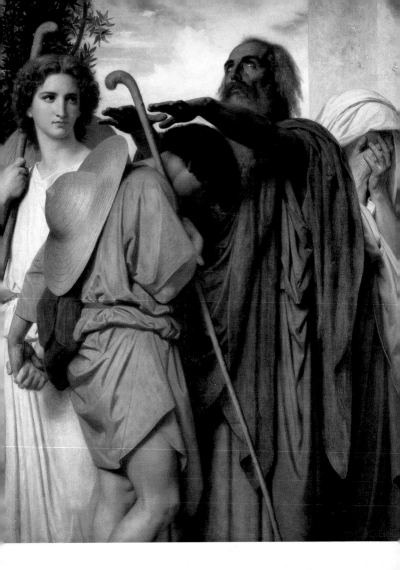

IMPRESSIONISM

818

William-Adolphe Bouguereau
La Rochelle, 1825–1905

The Birth of Venus

1879

Oil on canvas
118 x 84 ³/₄ in (300 x 215 cm)
Musée d'Orsay
Paris

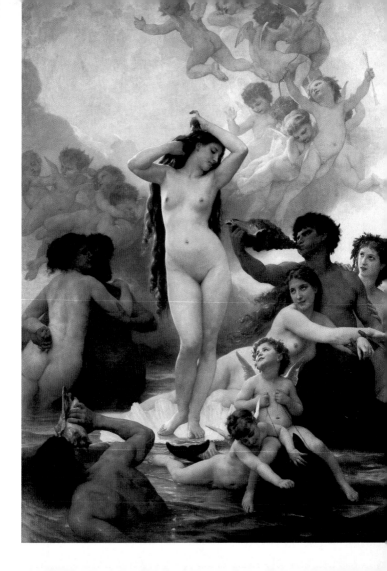

Lawrence Alma-Tadema
Dronrijp, Frisia, 1836-Wiesbaden, 1912

The Finding of Moses by the Pharaoh's Daughter
1904

Oil on canvas, 51 ¹/₄ x 84 in (137.7 x 213.4 cm)
Private Collection

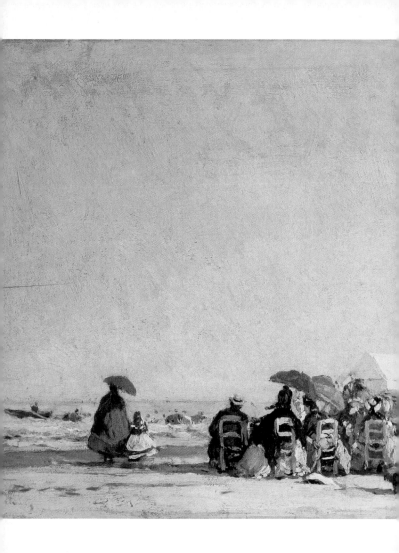

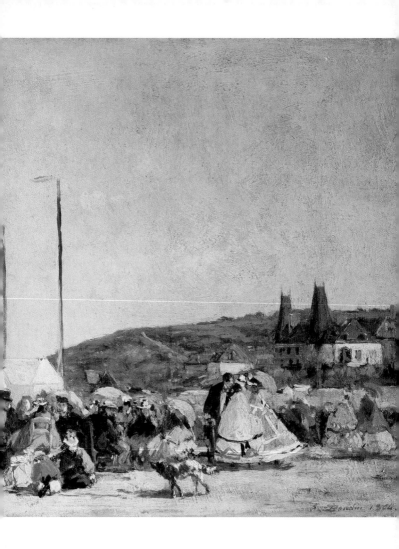

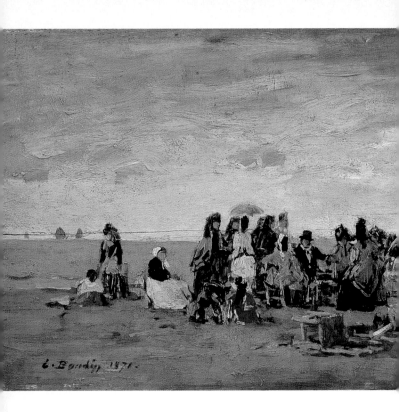

Eugène Boudin
Honfleur, 1824–Deauville, 1898

The Beach at Trouville
1871

Oil on panel
7 $\frac{1}{2}$ x 18 in (19 x 46 cm)
Pushkin Museum
Moscow

pp. 822–823

Eugène Boudin
Honfleur, 1824–Deauville, 1898

The Beach at Trouville
1864

Oil on canvas
10 $\frac{1}{2}$ x 19 in (26 x 48 cm)
Musée d'Orsay
Paris

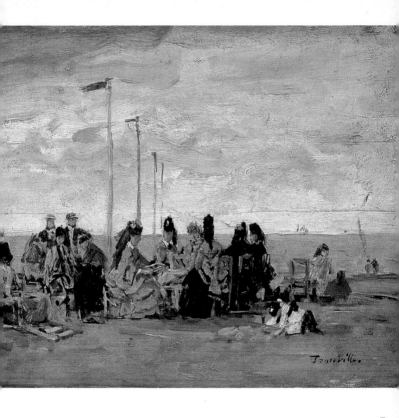

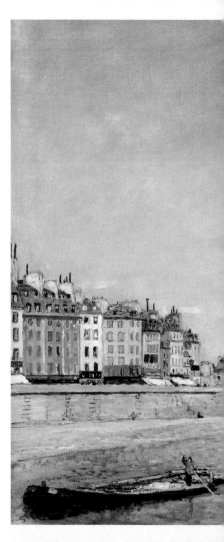

Johan–Barthold Jongkind
Latrop, 1819–Saint-Égrève, 1891

The Seine and Notre-Dame, Paris
1864

Oil on canvas
16 ¹/₂ x 22 ¹/₄ in (42 x 56.5 cm)
Musée d'Orsay
Paris

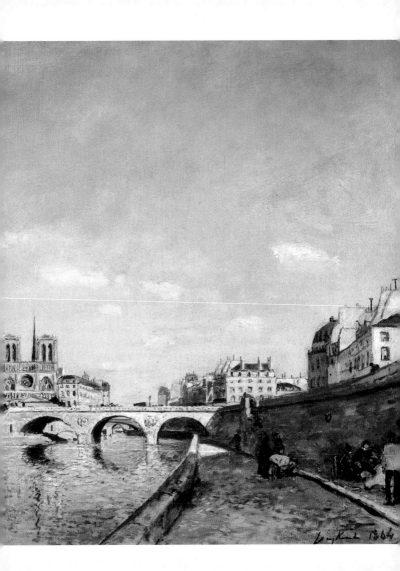

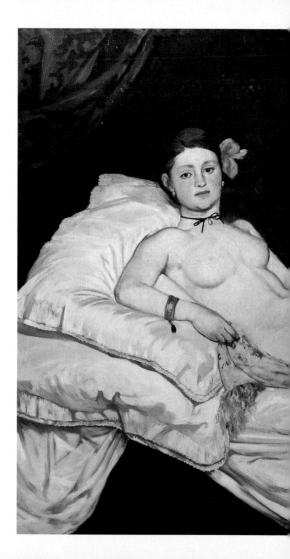

IMPRESSIONISM

828

Édouard Manet
Paris, 1832-1883

Olympia

1863

Oil on canvas
40 ¹/₂ x 74 ³/₄ in
(103 x 190 cm)
Musée d'Orsay
Paris

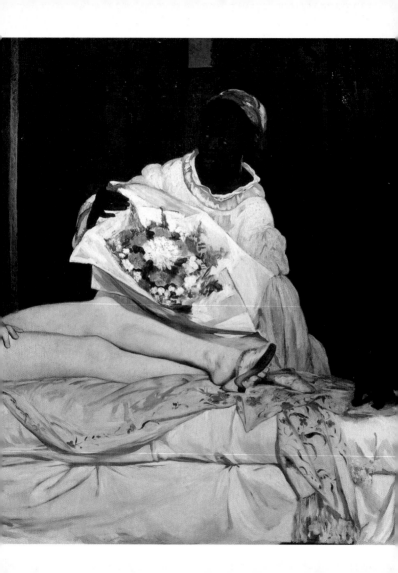

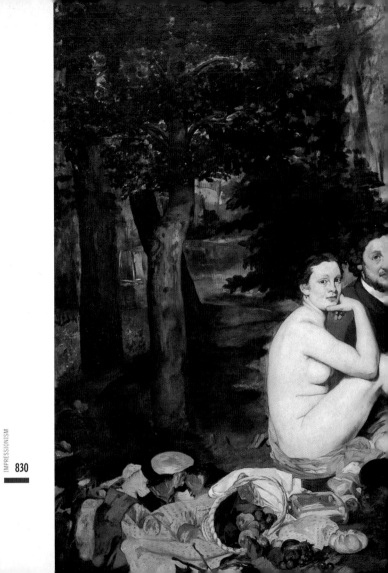

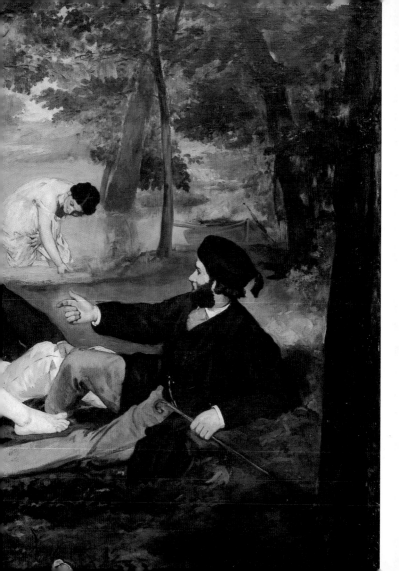

Édouard Manet
Paris, 1832-1883

The Balcony

1868–1869

Oil on canvas
67 x 48 ¹/₄ in (170 x 124 cm)
Musée d'Orsay
Paris

pp. 830–831

Édouard Manet
Paris, 1832-1883

Luncheon on the Grass

1863

Oil on canvas
82 x 104 in (208 x 264 cm)
Musée d'Orsay
Paris

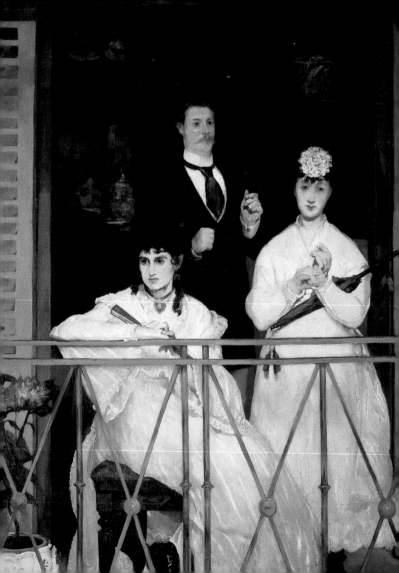

834

Édouard Manet
Paris, 1832-1883

**Monet Working on his Studio-Boat
in Argenteuil**

1874

Oil on canvas
32 ¹/₂ x 39 ¹/₂ in (82.5 x 100.5 cm)
Neue Pinakothek
Munich

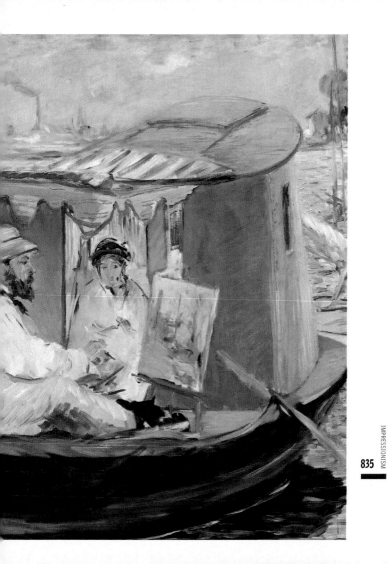

836

Édouard Manet
Paris, 1832-1883

Bar at the Folies-Bergère

1881-1882

Oil on canvas
37 ³/₄ x 51 ¹/₄ in (96 x 130 cm)
Courtauld Institute Galleries
London

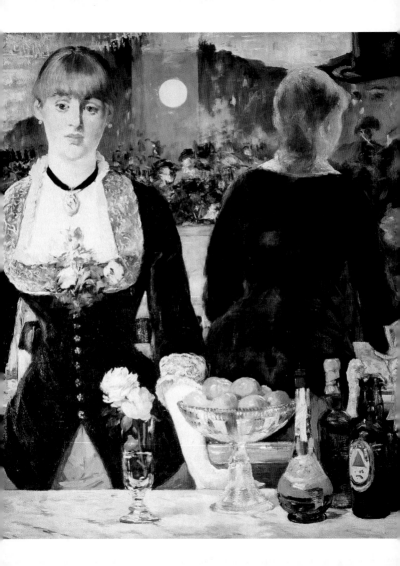

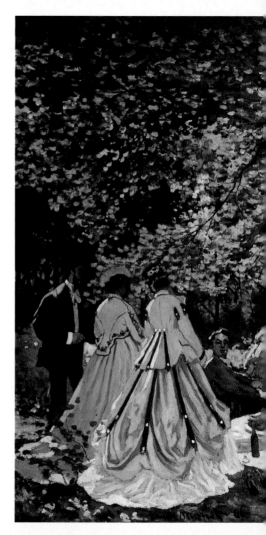

Claude Monet

Paris, 1840–Giverny, 1926

838

Luncheon on the Grass
(study)

1866

Oil on canvas
51 ¹/₄ x 71 ¹/₄ in (130 x 181 cm)
Pushkin Museum
Moscow

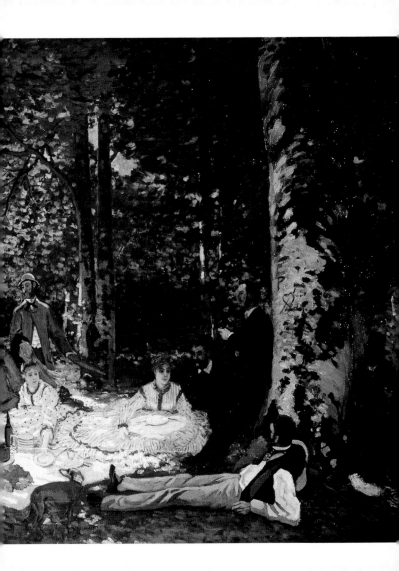

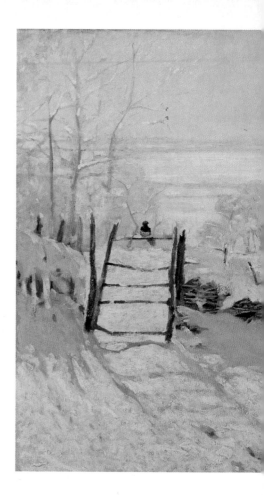

840

Claude Monet
Paris, 1840– Giverny, 1926

The Magpie

1869

Oil on canvas
35 x 51 ¹/₄ in (89 x 130 cm)
Musée d'Orsay
Paris

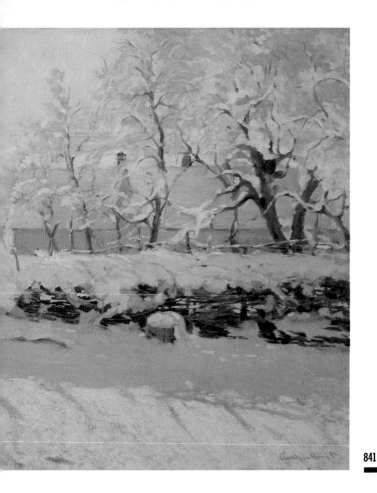

Claude Monet

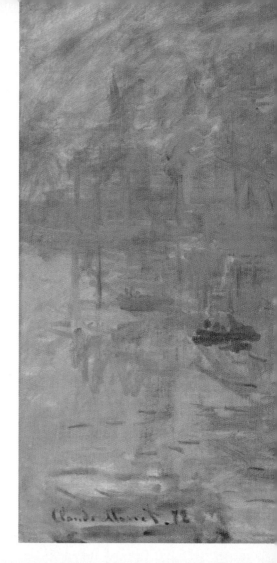

Claude Monet
Paris, 1840–Giverny, 1926

Impression: Sunrise
1872

Oil on canvas
19 x 24 ³/₄ in (48 x 63 cm)
Musée Marmottan
Paris

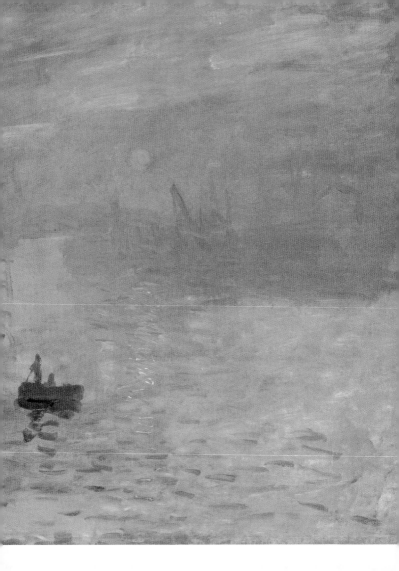

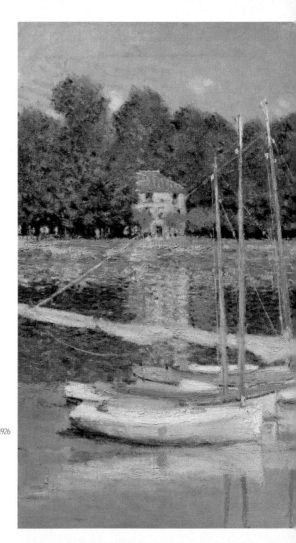

Claude Monet
Paris, 1840–Giverny, 1926

844

**The Bridge
at Argenteuil**
1874

Oil on canvas
23 $^1/_4$ x 31 $^1/_2$ in
(60.5 x 80 cm)
Musée d'Orsay
Paris

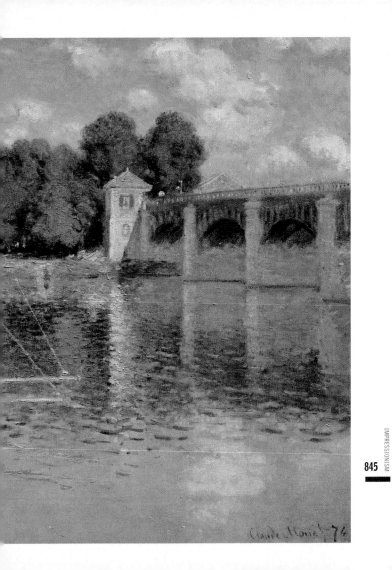

Claude Monet

Paris, 1840–Giverny, 1926

**Rouen Cathedral: The Portal and
Tour d'Albane, Full Sunlight**

1894

Oil on canvas
42 $^1/_4$ x 28 $^3/_4$ in (107 x 73 cm)
Musée d'Orsay
Paris

pp. 846–847

Claude Monet

Paris, 1840–Giverny, 1926

Saint-Lazare Station

1877

Oil on canvas
29 $^3/_4$ x 41 in (75.5 x 104 cm)
Musée d'Orsay
Paris

850

Claude Monet
Paris, 1840–Giverny, 1926

White Water Lilies

1899

Oil on canvas
35 x 36 ¹/₂ in (89 x 93 cm)
Pushkin Museum
Moscow

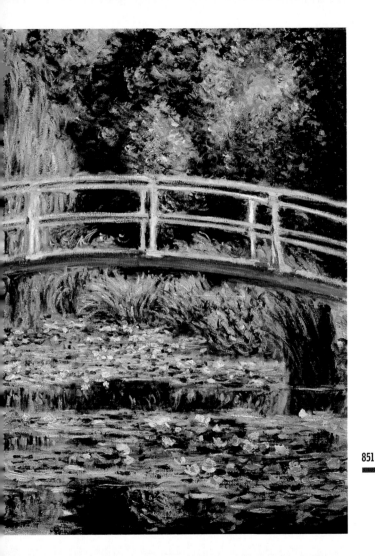

IMPRESSIONISM

852

Claude Monet
Paris, 1840–Giverny, 1926

The Houses of Parliament, Sunset

1904

Oil on canvas
32 x 36 ¹/₄ in (81 x 92 cm)
Musée d'Orsay
Paris

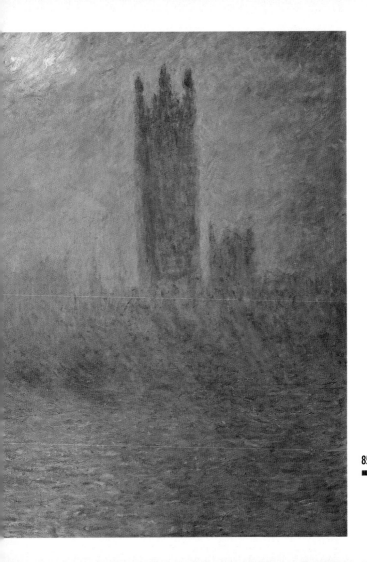

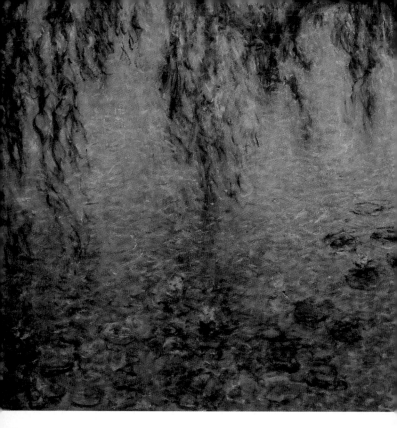

854

Claude Monet
Paris, 1840–Giverny, 1926

Water Lilies: The Willow
(central panel)

1920

Oil on canvas
Orangerie Museum
Paris

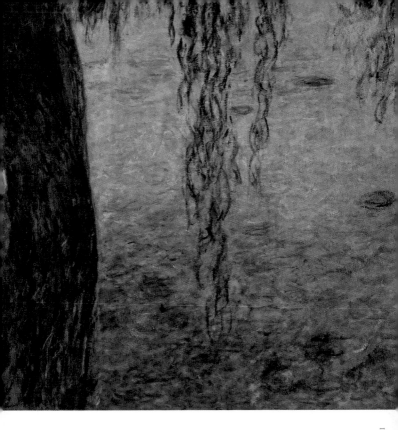

856

Pierre-Auguste Renoir
Limoges, 1841–Cagnes, 1919

La Grenouillère
1869

Oil on canvas
23 ¼ x 31 ½ in (59 x 80 cm)
Pushkin Museum
Moscow

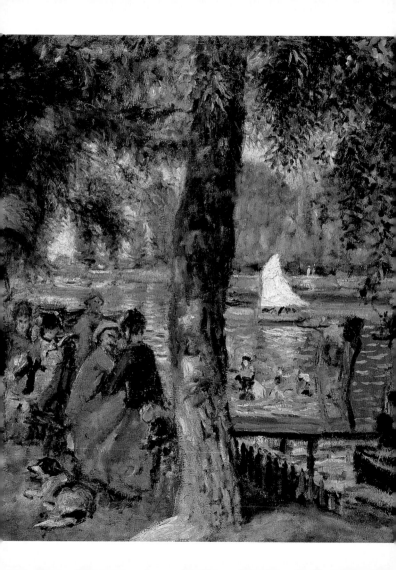

858

Pierre-Auguste Renoir
Limoges, 1841–Cagnes, 1919

The Theater Box

1874

Oil on canvas
31 ½ x 24 ¾ in (80 x 63 cm)
Courtauld Institute Galleries
London

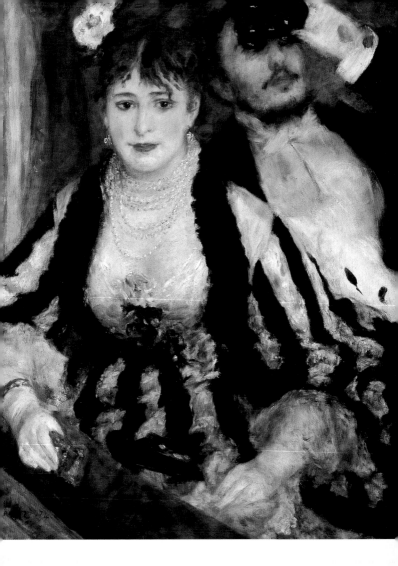

860

Pierre-Auguste Renoir
Limoges, 1841-Cagnes, 1919

The Swing

1876

Oil on canvas
36 $\frac{1}{4}$ x 28 $\frac{3}{4}$ in (92 x 73 cm)
Musée d'Orsay
Paris

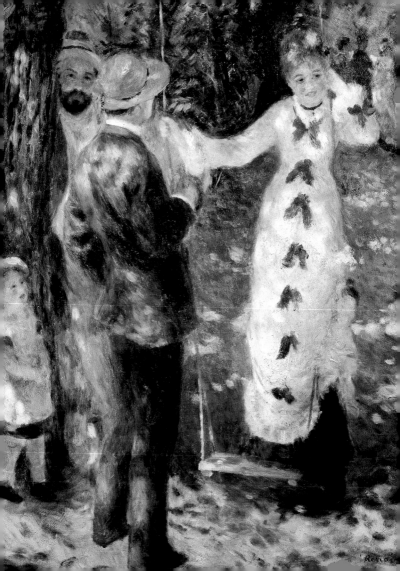

862

Pierre-Auguste Renoir
Limoges, 1841–Cagnes, 1919

Portrait of Jeanne Samary

1877

Oil on canvas
22 x 18 ¹/₂ (56 x 47 cm)
Pushkin Museum
Moscow

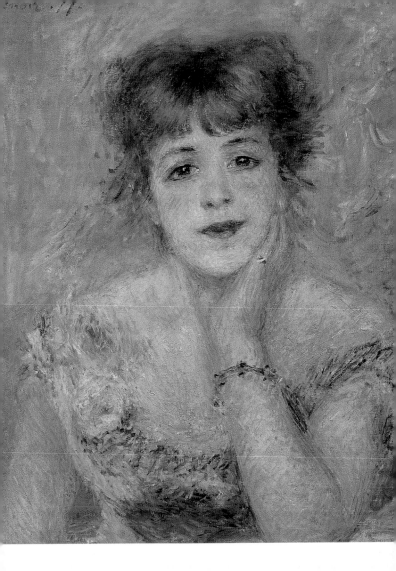

Camille Pissarro
Saint-Thomas, Antille Danesi, 1830–
Paris, 1903

Red Roofs

1877

Oil on canvas
21 ½ x 25 ¾ in (54.5 x 65.5 cm)
Musée d'Orsay
Paris

Camille Pissarro
Saint-Thomas, Antille Danesi, 1830–
Paris, 1903

The Entrance to the Village of Voisins

1872

Oil on canvas
18 x 21 ³/₄ in (46 x 55.5 cm)
Musée d'Orsay
Paris

pp. 866–867

Camille Pissarro
Saint-Thomas, Antille Danesi, 1830–
Paris, 1903

Hoar Frost, The Old Road to Ennery

1873

Oil on canvas
25 ¹/₂ x 36 ¹/₂ in (65 x 93 cm)
Musée d'Orsay
Paris

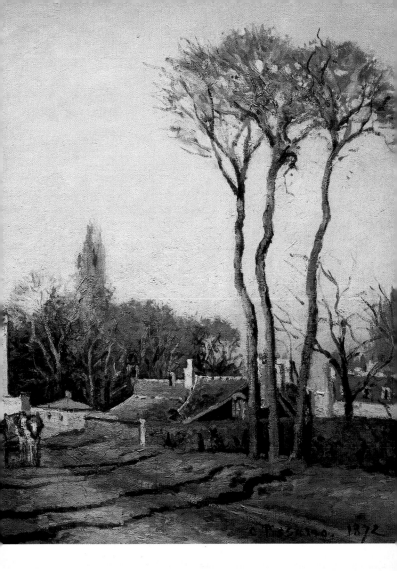

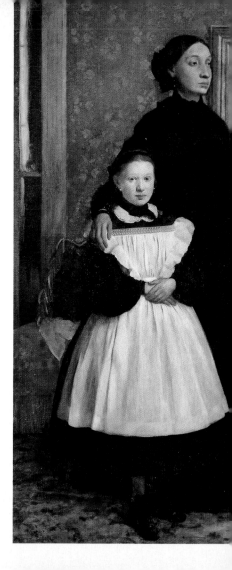

870

Edgar Degas
Paris, 1834–1917

The Bellelli Family

1858–1867

Oil on canvas
78 ³/₄ x 98 ¹/₂ in (200 x 250 cm)
Musée d'Orsay
Paris

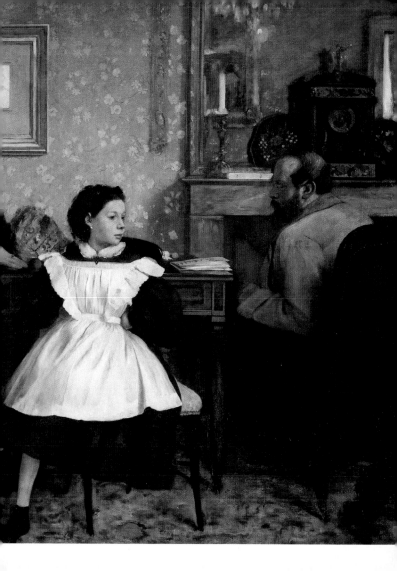

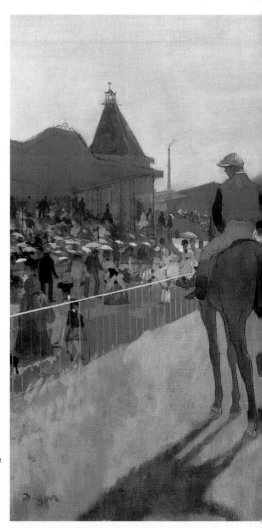

872

Edgar Degas
Paris, 1834–1917

Jockeys Before the Race
1866–1868

Oil on card on canvas
11 x 24 in (46 x 61 cm)
Musée d'Orsay
Paris

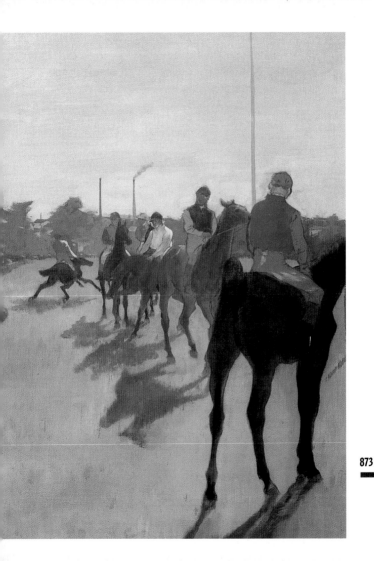

874

Edgar Degas
Paris, 1834–1917

Absinthe

1875–1876

Oil on canvas
36 $^1/_4$ x 26 $^3/_4$ in (92 x 68 cm)
Musée d'Orsay
Paris

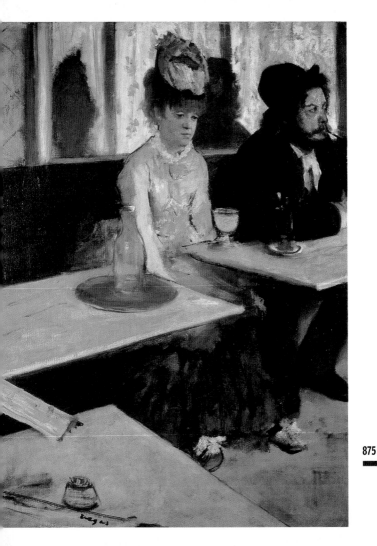

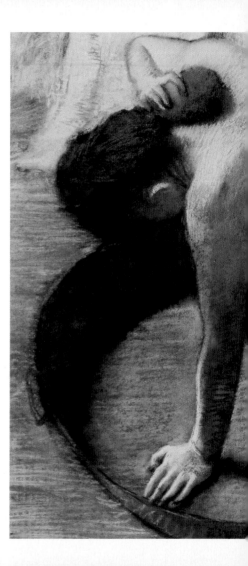

876

Edgar Degas
Paris, 1834-1917

The Tin Bath
1886

Pastel on card
23 $^1/_2$ x 32 $^1/_4$ in (60 x 83 cm)
Musée d'Orsay
Paris

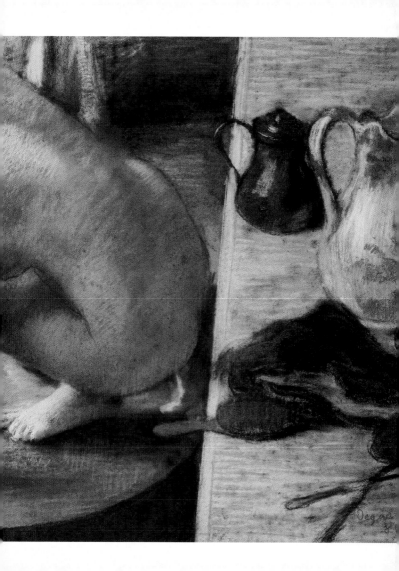

878

Alfred Sisley
Paris, 1839–Moret-sur-Loing, 1899

The Flood at Port-Marly

1876

Oil on canvas
23 ¹/₂ x 32 in (60 x 81 cm)
Musée d'Orsay
Paris

880

Alfred Sisley
Paris, 1839–Moret-sur-Loing, 1899

Snow at Louveciennes

1878

Oi on canvas
24 x 20 in (61 x 50.5 cm)
Musée d'Orsay
Paris

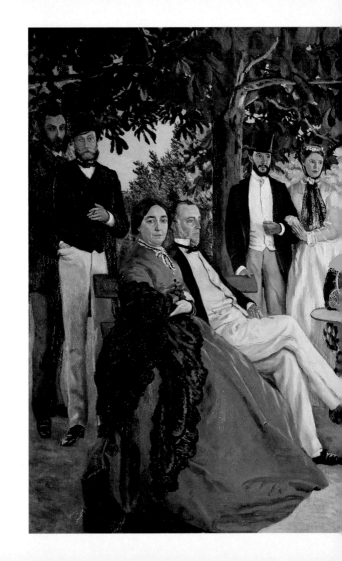

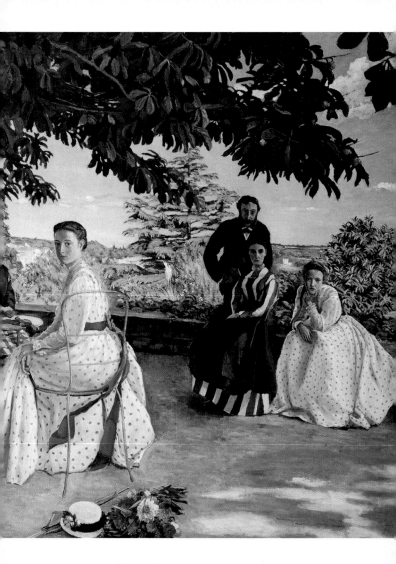

Frédéric Bazille
Montpellier, 1841–Beaune-la-Rolande, 1870

**The Artist's Studio, Rue de
la Condamine**

1870

Oil on canvas
38 ¹/₂ x 50 ¹/₂ in (98 x 128.5 cm)
Musée d'Orsay
Paris

pp. 882–883

Frédéric Bazille
Montpellier, 1841–Beaune-la-Rolande, 1870

**The Artist's Family on a Terrace
near Montpellier**

1867

Oil on canvas
59 ¹/₄ x 90 ¹/₂ in (152 x 230 cm)
Musée d'Orsay
Paris

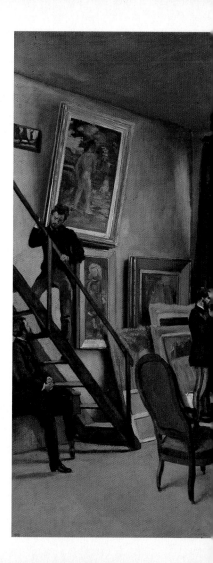

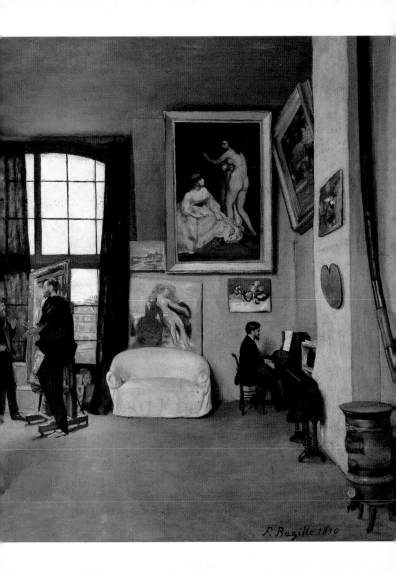

F. Bazille 1870

886

Berthe Morisot
Bourges, 1841-Paris, 1895

The Cradle

1873

Oil on canvas
22 x 18 in (56 x 46 cm)
Musée d'Orsay
Paris

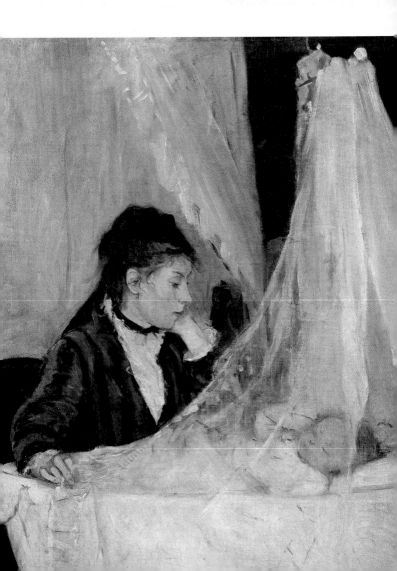

888

Berthe Morisot
Bourges, 1841-Paris, 1895

Chasing Butterflies
1874

Oil on canvas
18 x 22 in (46 x 56 cm)
Musée d'Orsay
Paris

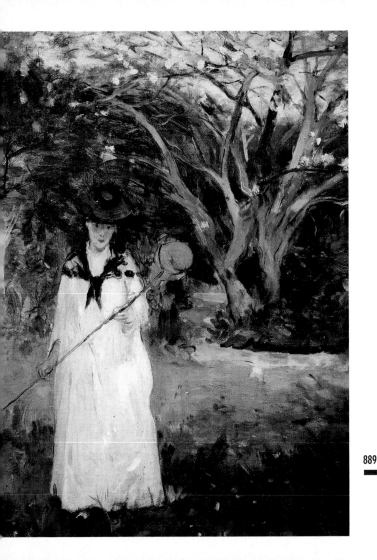

890

Gustave Caillebotte
Paris, 1848–
Gennevilliers, 1894

Parquet Planers

1875

Oil on canvas
40 ¹/₄ x 57 ³/₄ in
(102 x 146.5 cm)
Musée d'Orsay
Paris

Henri Fantin-Latour
Grenoble, 1836–Buré, 1904

The Studio at Batignolles
1870

Oil on canvas
80 ¹/₄ x 107 ¹/₄ in (204 x 273.5 cm)
Musée d'Orsay
Paris

894

Giovanni Boldini
Ferarra, 1842–Paris, 1931

Portrait of Giuseppe Verdi

1886

Pastel on paper
25 ¹/₂ x 21 ¹/₄ in (65 x 54 cm)
Galleria d'Arte Moderna
Rome

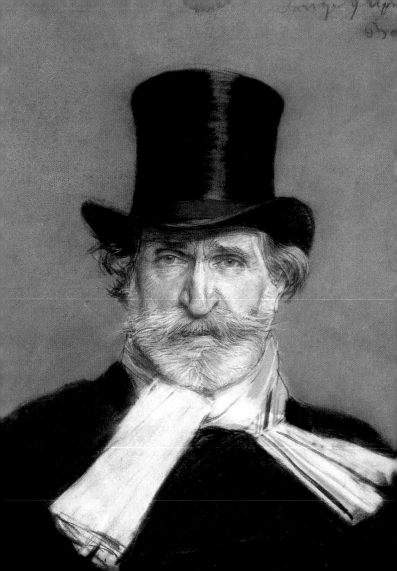

896

Giovanni Boldini
Ferarra, 1842-Paris, 1931

Portrait of Madame Charles Max

1896

Oil on canvas
80 $^1/_4$ x 39 $^1/_4$ in (205 x 100 cm)
Musée d'Orsay
Paris

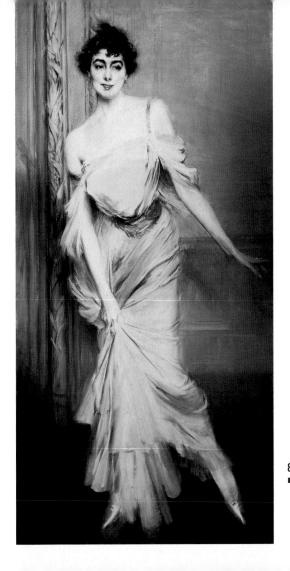

Mary Stevenson Cassatt
Pittsburgh, 1844–Le Mesnil-Théribus,
Oise, 1926

Girl in the Garden

c. 1880–1882

Oil on canvas
36 $^{1}/_{4}$ x 24 $^{3}/_{4}$ in (92 x 63 cm)
Musée d'Orsay
Paris

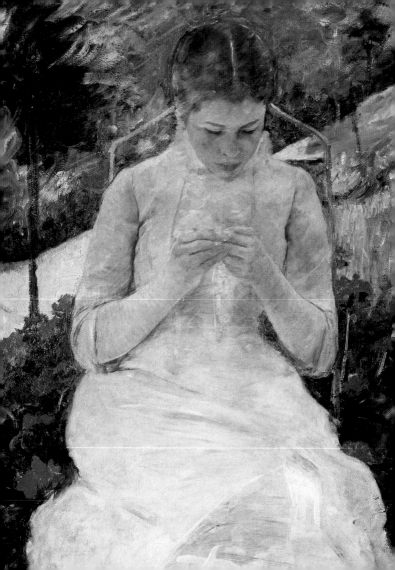

900

Mary Stevenson Cassatt

Pittsburgh, 1844–Le Mesnil-Théribus,
Oise, 1926

The Bath

1893

Oil on canvas
39 1/2 x 26 in (100.3 x 66 cm)
The Art Institute of Chicago
Chicago

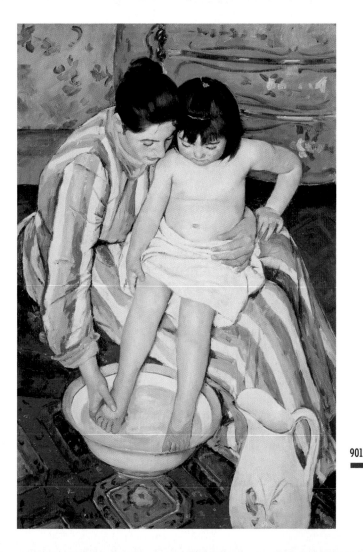

902

James Abbott McNeill Whistler
Lowell, Massachusetts, 1834–London, 1903

Arrangement in Grey and Black: Portriat of the Artist's Mother

1871

Oil on canvas
56 ³/₄ x 64 in (144.3 x 162.5 cm)
Musée d'Orsay
Paris

904

John Singer Sargent

Florence, 1856–London, 1925

Portrait of Elizabeth Winthrop Chanler

1893

Oil on canvas
49 ¹/₂ x 40 ¹/₂ in (125.7 x 102.9 cm)
Smithsonian Institution, American Art Museum
Washington D.C.

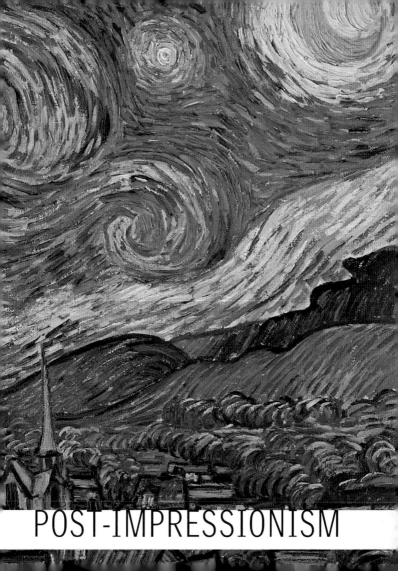

POST-IMPRESSIONISM

The term "Post-Impressionism" is used to indicate the many different styles of painting that followed Impressionism, beginning with the last group exhibition, held in 1886. The painters encompassed by this term shared, above all else, the fact that they had begun their careers in close contact with the Impressionists, whose painting was executed using rapid brushstrokes placed directly on the canvas, without the intermediation of a preparatory drawing. All the same, even if they did preserve some aspects of their early experiences, these painters developed new ideas, independent from those of their predecessors and often quite distant from the ideas of their contemporaries. This was a period of enormous creative ferment, which paved the way for the avant-gardes of the twentieth century.

Cézanne (1839–1906), after his frequent exchanges—we might even speak of an apprenticeship—with Camille Pissarro, began his own highly personal research into the structure of painting, beginning with fairly definite sections of colors, composed in some cases of parallel sections in the same color, or in others with broad patches of a single hue. This produced images with a strong geometric appearance. Both his landscapes and his still lifes tend to highlight, more than the ephemeral aspect of things, a quality that is more certain: solidity, volumes, planes. His unusual visual language made quite an impression upon the younger artists Pablo Picasso (1881–1973) and Georges Braque (1882–1963), who took considerable inspiration for the creation of their first Cubist works.

The name of Georges Seurat (1859–1891) is identified with "pointillism," a style that he created and that also derives from Impressionist painting. The "pointillist" technique entails the creation of an image with an array of tiny dots of pure color. Seen close up, the paintings resemble a constellation of colored points. From a distance, the colored dots mix in the retina and, thus,

give life to shapes. Seurat died quite young and his followers, including Paul Signac (1863–1935), soon came to realize that this "scientific" method left little or no room for individual expression. Pointillism, however, survived in works by Fauvists, Cubists, and Futurists.

The path followed by Van Gogh (1853–1890), on the other hand, is entirely different. When he arrived in Paris from Holland, in 1886, his painting consisted of earth tones, tending toward the shadowy. His contact with Impressionism had as its immediate effect the lightening of his palate and the use of rapid, colorful brushstrokes, even though, in his case, those brushstrokes were particularly dense from the outset. Van Gogh was not seeking beauty, but rather, expression, as he himself stated. Impressionism was, to him, nothing more than a springboard that could take him into the world of colors and the infinite possiblities of different brushstrokes. He studied the theories of colors, exchanging ideas with his friend who invented Pointillism, Georges Seurat, and with Paul Gauguin (1848–1903). He wound up developing an idiom based upon the explosive contrasts of colors and upon a variety of brushstrokes—comma-like brushstrokes, dot-like brushstrokes, wavy brushstrokes that were so dense with color that they left an array of textures on the canvas. Van Gogh thus attained his ambition to use painting "to say something comforting in the way that music is comforting," and to paint "men and women with that element of the eternal that was formerly symbolised by the halo, and that we try to express by the actual radiance and vibration of our colors." Van Gogh became a point of reference for the Fauvists (André Derain, Henri Matisse, the early Braque) and for the Expressionists (Ernest Ludwig Kirchner, Emil Nolde, Edvard Munch). The power of his work, however, continued to exert its influence long after the early twentieth century, and served as an inspiration ever for such recent painters as the British artist Francis Bacon.

For his part, Paul Gauguin, along with his young friend Émile Bernard (1868–1941), developed a new type of painting that the pair dubbed "Syntethism." In search of a form of spirituality that they considered long lost, they worked to create a simpler, more "naive," form of painting, closer to the soul, at least in the opinion of the two artists. Taking inspiration from stained glass, from Japanese prints, and from folk art, Gauguin developed a very simplified style that featured a bold black outline, which he then filled with flat colors. This style developed from 1889. One of the most significant examples is the canvas *The Vision after the Sermon*. Gauguin's quest for the naive led him first to Brittany, and later to Tahiti, where he felt that he had found a more primitive, and thus purer, society.

Paul Gauguin's ideas also served as inspiration for the movement of the Nabis ("prophets" in Hebrew). Although their results were quite different, the Nabis, among whom we should mention Paul Sérusier (1864–1927), Maurice Denis (1870–1943), Édouard Vuillard (1868–1940), Pierre Bonnard (1867–1947), and the Swiss artist Félix Edouard Vallotton (1865–1925), shared Syntethism's guiding spirit, that is, they sought to attain—through simplification of imagery, flat zones of pure color, inspired by medieval stained glass windows, Japanese prints, and ancient Egyptian art—"the flavor of primitive sensations."

Paris, as during the time of the Impressionists, was once again the capital of Western art, the dynamo creating new ideas. All the same, something quite important was taking place in Vienna as well. In the capital of Austria, in 1897, the Viennese Secession was founded, an association of artists guided by Gustav Klimt (1862–1918). Sensitive to the new schools of art that were developing primarily in France, the Viennese Secession was a movement devoted to experimentation and innovation, both in painting and in sculpture, architecture and the graphic arts. Keenly attuned to Impressionist

above

Paul Cézanne

Aix-en-Provence, 1839–1906

The House of the Hanged Man

1873

Oil on canvas
21 ³/₄ x 26 in (55 x 66 cm)
Musée d'Orsay
Paris

Vincent van Gogh

Groot-Zundert, 1853–Auvers-sur-Oise, 1890

The Starry Night

JUNE 1889

Oil on panel
29 x 36 ¹/₄ in (73.7 x 92.1 cm)
Museum of Modern Art
New York

912

Paul Cézanne
Aix-en-Provence, 1839–1906

L'Estaque

c. 1878–1879

Oil on canvas
21 ³/₄ x 28 ³/₄ in (55.5 x 73 cm)
Musée d'Orsay
Paris

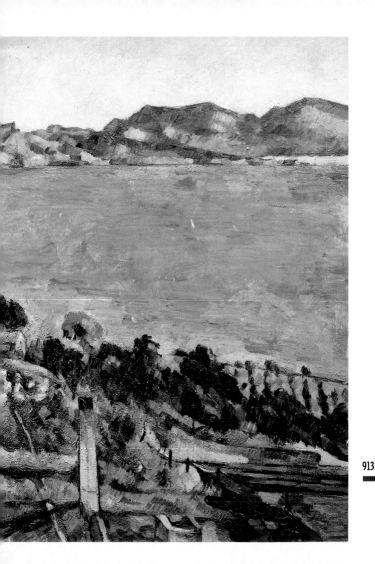

914

Paul Cézanne
Aix-en-Provence, 1839–1906

The Kitchen Table
1888–1890

Oil on canvas
25 $^1/_2$ x 31 $^1/_2$ in (65 x 80 cm)
Musée d'Orsay
Paris

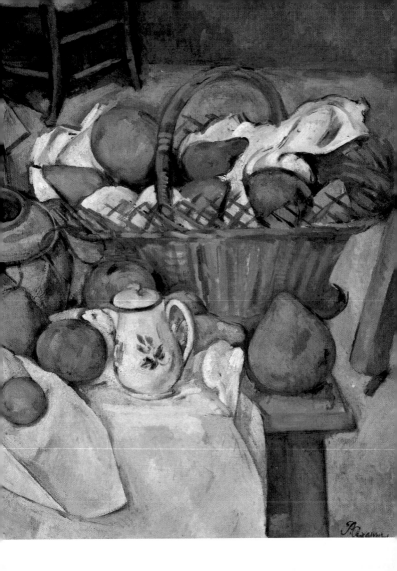

916

Paul Cézanne
Aix-en-Provence, 1839–1906

The Blue Vase

1889–1890

Oil on canvas
24 ¹/₂ x 20 in (62 x 51 cm)
Musée d'Orsay
Paris

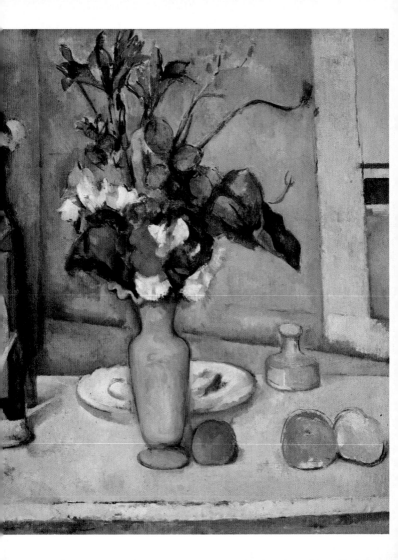

918

Paul Cézanne
Aix-en-Provence, 1839-1906

Large Pine and Red Fields
1890-1895

Oil on canvas
28 ¹/₄ x 35 ³/₄ in (72 x 91 cm)
Hermitage
St. Petersburg

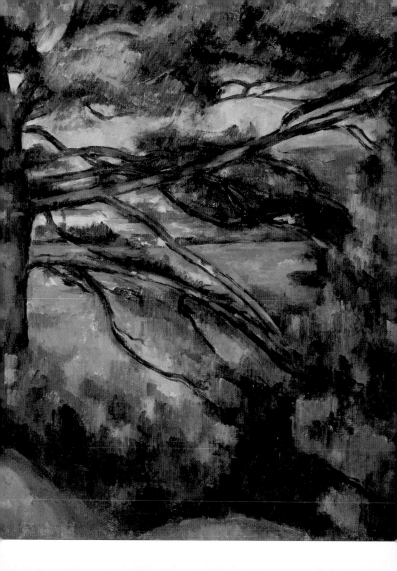

920

Paul Cézanne
Aix-en-Provence, 1839–1906

Woman with a Coffeepot

c. 1895

Oil on canvas
50 ½ x 38 in (130.5 x 96.5 cm)
Musée d'Orsay
Paris

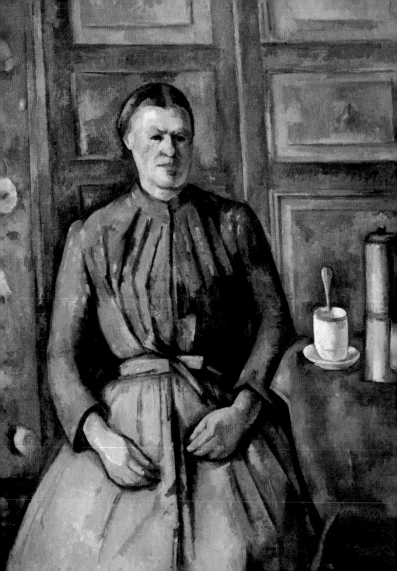

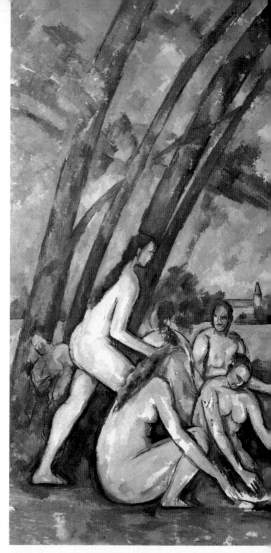

922

Paul Cézanne
Aix-en-Provence, 1839–1906

The Large Bathers
1906

Oil on canvas
82 x 99 in (208.3 x 251.5 cm)
Philadelphia Museum of Art
Philadelphia

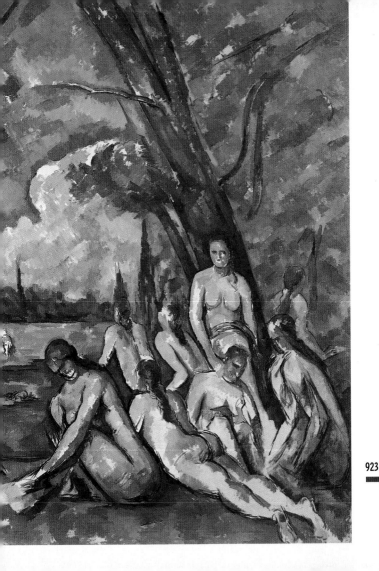

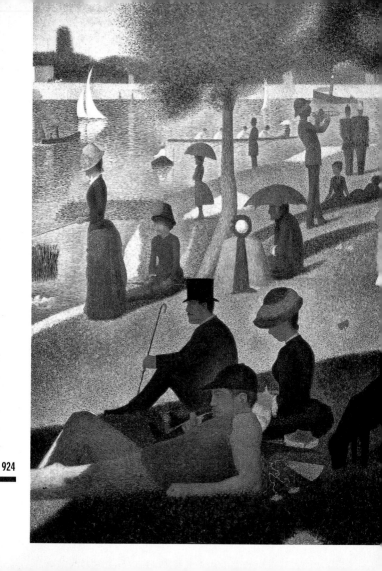

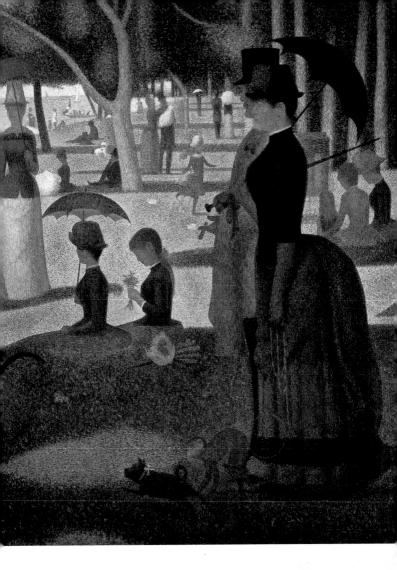

Georges Seurat
Paris, 1859–1891

The Circus

1884–1886

Oil on canvas
73 x 60 in (185.5 x 152.5 cm)
Musée d'Orsay
Paris

pp. 924-925

Georges Seurat
Paris, 1859–1891

**Sunday Afternoon on the Island of
La Grande-Jatte**

1884–1886

Oil on canvas
81 3/4 x 121 1/4 in (207.6 x 308 cm)
Art Institute of Chicago
Chicago

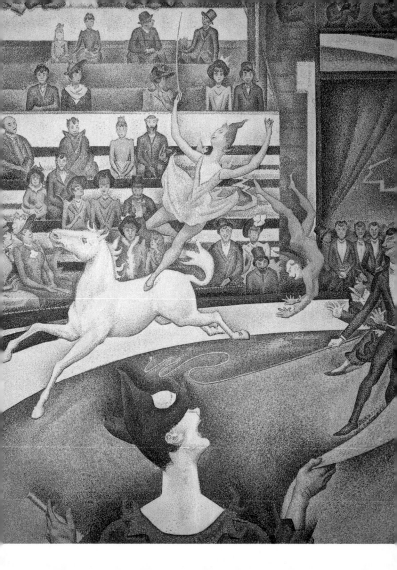

928

Vincent van Gogh
Groot-Zundert, 1853–Auvers-sur-Oise, 1890

Self-Portrait with a Grey Felt Hat

Winter 1887–1888

Oil on canvas
17 1/4 x 14 3/4 in (44 x 37.5 cm)
Rijksmuseum Vincent Van Gogh
Amsterdam

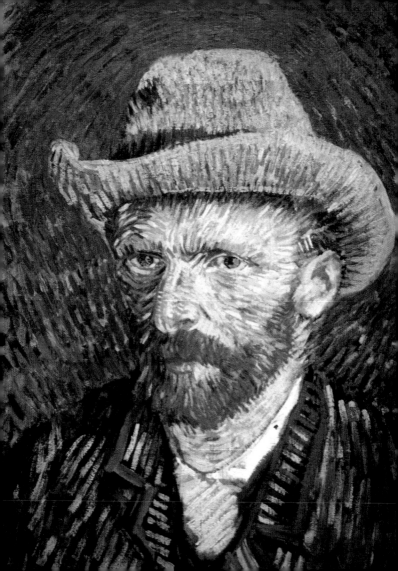

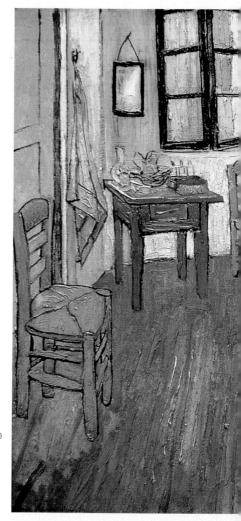

Vincent van Gogh
Groot-Zundert, 1853–Auvers-sur-Oise, 1890

930

Vincent's Bedroom at Arles

OCTOBER 1888

Oil on canvas
28 ¼ x 35 ½ in (72 x 90 cm)
Rijksmuseum Vincent van Gogh
Amsterdam

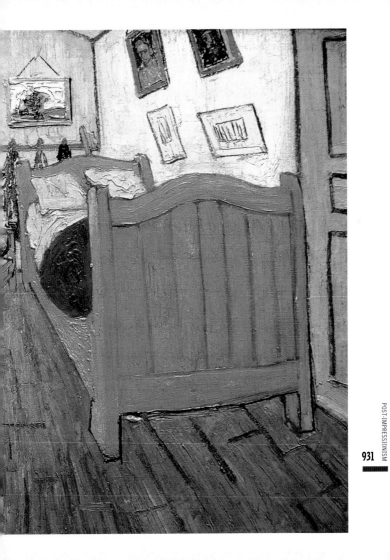

932

Vincent van Gogh
Groot-Zundert, 1853–Auvers-sur-Oise, 1890

Vase with Twelve Sunflowers

AUGUST 1888

Oil on canvas
35 ³/₄ x 28 in (91 x 71 cm)
Neue Pinakothek
Munich

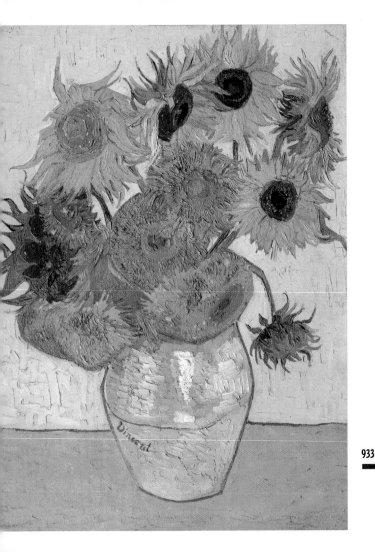

Vincent

934

Vincent van Gogh
Groot-Zundert, 1853–Auvers-sur-Oise, 1890

Portrait of Doctor Paul Gachet

June 1890

Oil on canvas
26 ³/₄ x 22 ¹/₂ in (68 x 57 cm)
Musée d'Orsay
Paris

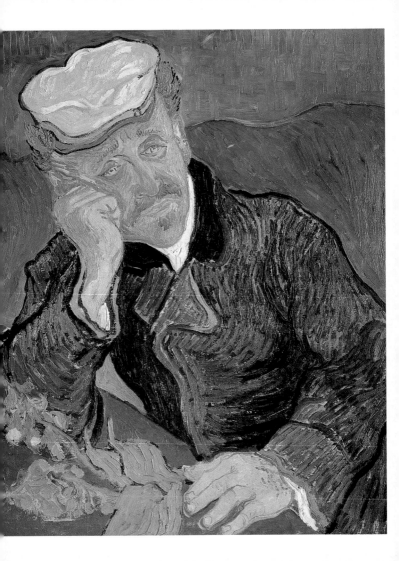

POST-IMPRESSIONISM

936

Vincent van Gogh
Groot-Zundert, 1853–Auvers-sur-Oise, 1890

The Church at Auvers

c. 1890

Oil on canvas
37 x 29 ¹/₂ in (94 x 74 cm)
Musée d'Orsay
Paris

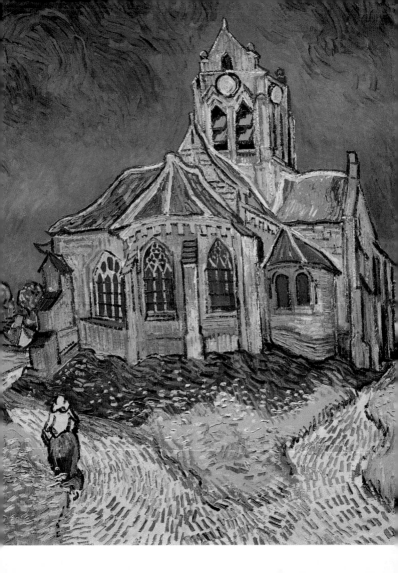

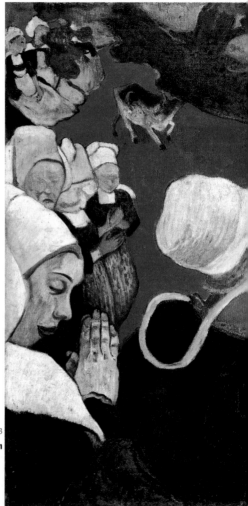

938

Paul Gauguin
Paris, 1848–Marquesas Islands, 1903

The Vision after the Sermon

1888

Oil on canvas
28 ³/₄ x 36 ¹/₄ in (73 x 92 cm)
National Gallery of Scotland
Edinburgh

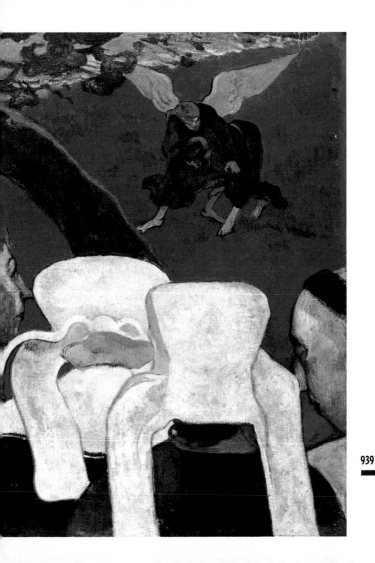

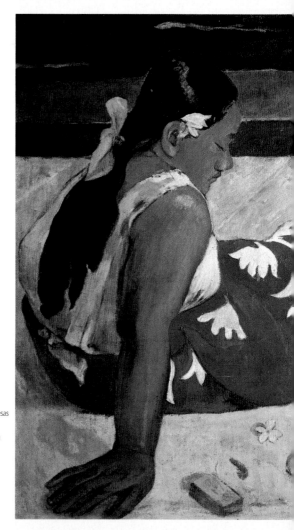

Paul Gauguin
Paris, 1848–Marquesas
Islands, 1903

940

**Two Women on
the Beach**

1891

Oil on canvas
27 ¹/₄ x 36 in
(69 x 91.5 cm)
Musée d'Orsay
Paris

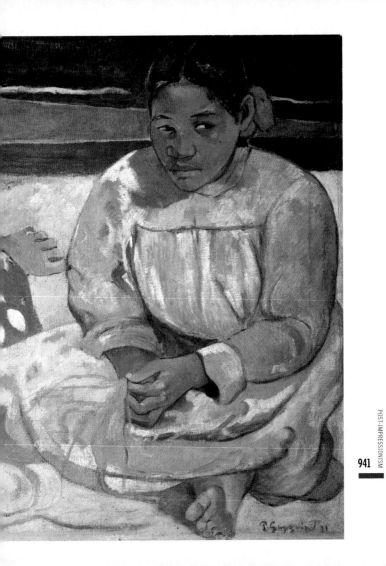

942

Paul Gauguin
Paris, 1848–Marquesas Islands, 1903

The White Horse

1898

Oil on canvas
55 x 36 in (140 x 91.5 cm)
Musée d'Orsay
Paris

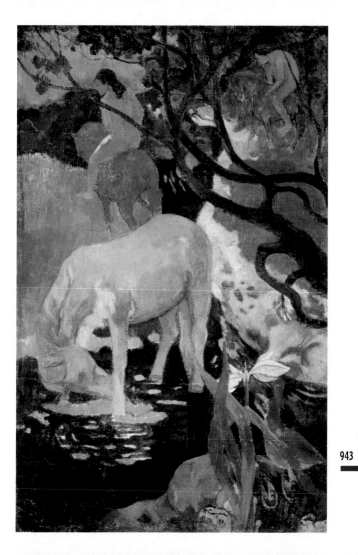

944

Émile Bernard
Lille, 1868–Paris, 1941

Breton Women with Parasols

1892

Oil on canvas
32 x 41 ¼ in (81 x 105 cm)
Musée d'Orsay
Paris

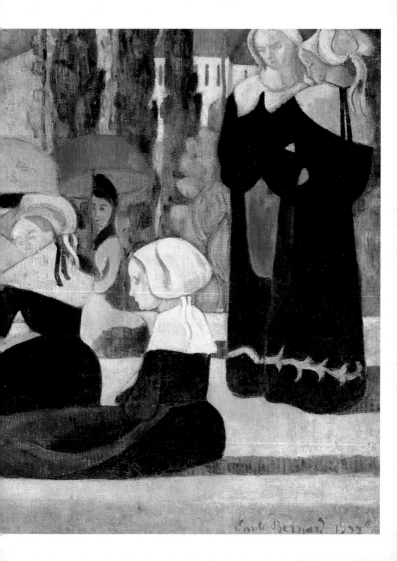

946

Paul Sérusier
Paris, 1864–Morlaix, 1927

The Talisman

1888

Oil on panel
10 $\frac{1}{2}$ x 8 $\frac{1}{4}$ in (27 x 21 cm)
Musée d'Orsay
Paris

948

Paul Sérusier
Paris, 1864–Morlaix, 1927

The Flowering Hedge

1889

Oil on canvas
28 ³/₄ x 23 ³/₄ in (73 x 60.5 cm)
Musée d'Orsay
Paris

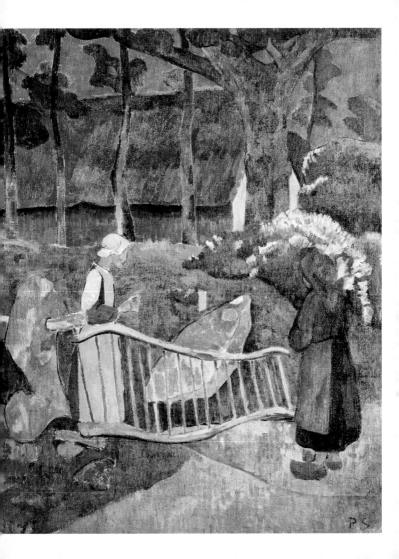

950

Félix Edouard Vallotton
Lausanne, 1865–Paris, 1925

Child Playing with a Ball
1899

Oil on paper pasted on board
19 x 24 in (48 x 61 cm)
Musée d'Orsay
Paris

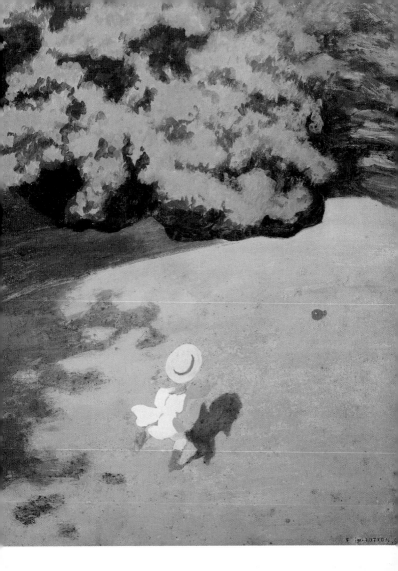

952

Henri de Toulouse-Lautrec
Albi, 1864-Malromé, 1901

Dance at the Moulin Rouge
1890

Oil on canvas
45 ¹/₂ x 59 in (115.5 x 150 cm)
Philadelphia Museum of Art
Philadelphia

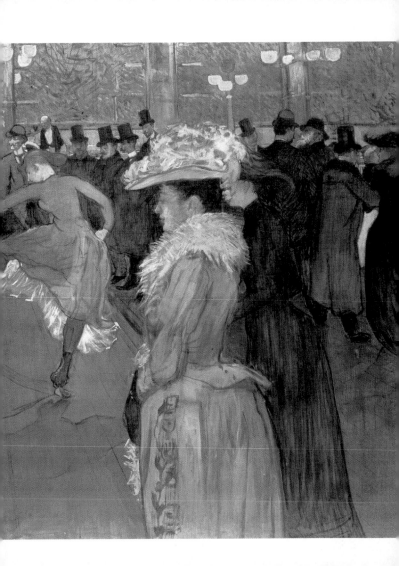

954

Henri de Toulouse-Lautrec
Albi, 1864–Malromé, 1901
**Study for Loïe Fuller at the
Folies-Bergère**
1893

Oil on card
25 x 17 $^3/_4$ in (63.2 x 45.3 cm)
Musée Toulouse-Lautrec
Albi

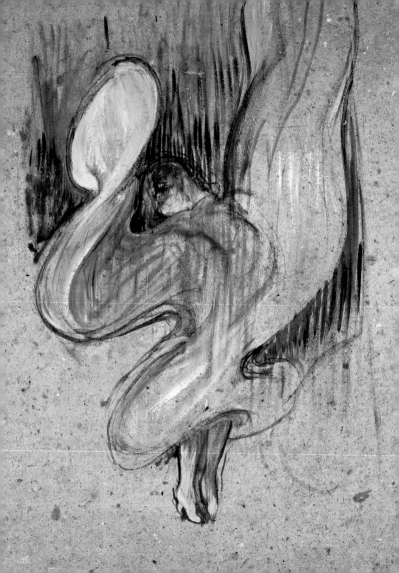

956

Henri de Toulouse-Lautrec
Albi, 1864–Malromé, 1901

Madame Poupoule at her Toilette

1898

Oil on panel
24 x 19 ¹/₂ in (60.8 x 49.6 cm)
Musée Toulouse-Lautrec
Albi

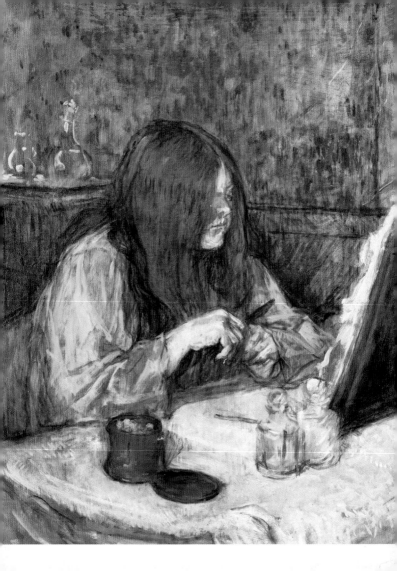

Gustav Klimt
Vienna, 1862-1918

Judith I

1901

Oil on canvas in an embossed copper frame
made by Georg Klimt
33 x 16 $^1/_2$ in (84 x 42 cm)
Österreichische Galerie
Vienna

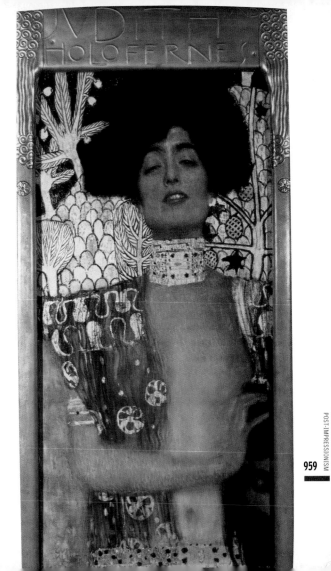

960

Gustav Klimt
Vienna, 1862-1918

The Kiss

1907-1908

Oil on canvas
70 ³/₄ x 70 ³/₄ in (180 x 180 cm)
Österreichische Galerie
Vienna

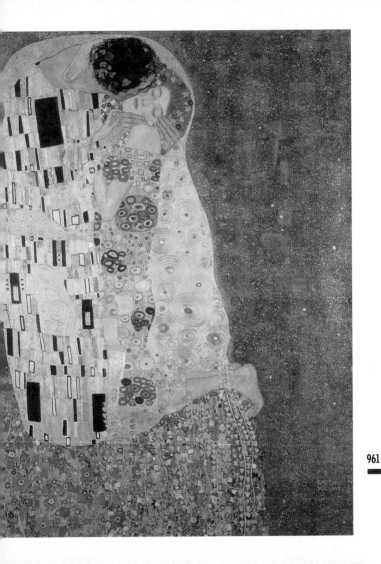

962

Gustave Moreau
Paris, 1826–1898

Orpheus

1865

Oil on canvas
60 ¹/₄ x 39 ¹/₄ in (154 x 99.5 cm)
Musée d'Orsay
Paris

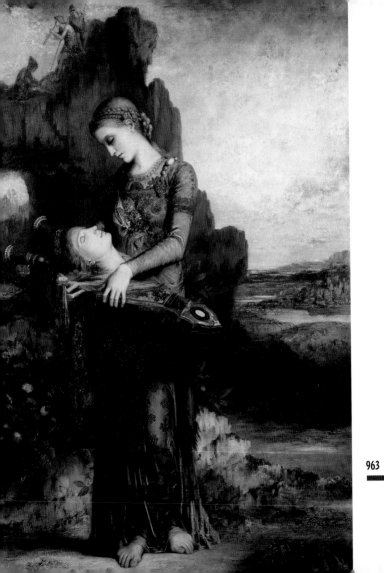

964

Gustave Moreau
Paris, 1826–1898

The Unicorns

c. 1885

Oil on canvas
45 $\frac{1}{4}$ x 35 $\frac{1}{2}$ in (115 x 90 cm)
Musée Gustave Moreau
Paris

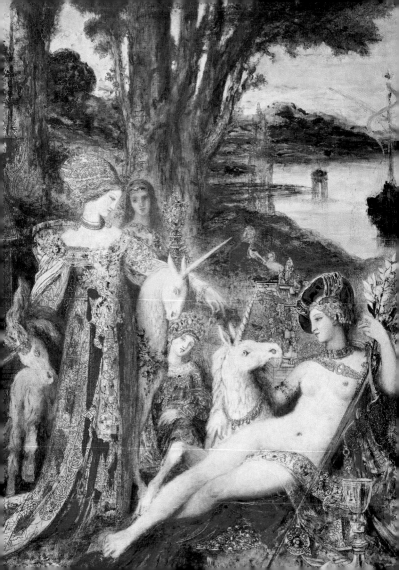

966

Odilon Redon
Bordeaux, 1840–Paris, 1916

Flight into Egypt

c. 1903

Oil on canvas
17 $^3/_4$ x 15 in (45 x 38 cm)
Musée d'Orsay
Paris

968

Odilon Redon
Bordeaux, 1840–Paris, 1916

Vase with Flowers

c. 1912

Pastel on paper
22 $^1/_2$ x 13 $^3/_4$ in (57 x 35 cm)
Louvre
Paris

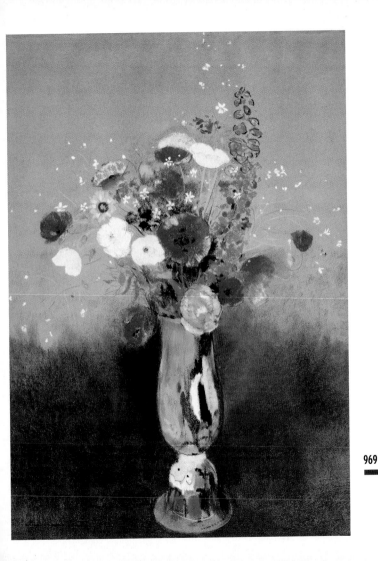

970

Henri Rousseau (Le Douanier)
Laval, 1844–Paris, 1910

The Snake Charmer
1907

Oil on canvas
65 x 70 ¹/₄ in (165 x 180 cm)
Musée d'Orsay
Paris

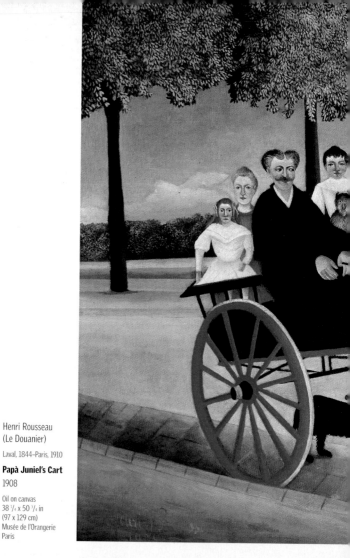

972

Henri Rousseau
(Le Douanier)

Laval, 1844–Paris, 1910

Papà Juniel's Cart

1908

Oil on canvas
38 ¹/₄ x 50 ³/₄ in
(97 x 129 cm)
Musée de l'Orangerie
Paris

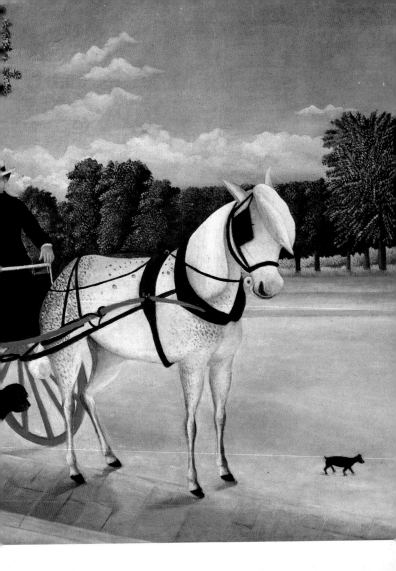

INDEX

The publishers would like to thank the following archives, museums, and institutions who have authorized the reproduction of the works in this book:

Scala Group, Firenze, who provided the majority of the reproductions of the works of art in this book; and:

Bridgeman Art Library, London/**Farabola Foto**, Milan: 18–19, 49, 53, 78–79, 100, 184–185, 186–187, 224, 225, 231, 232, 241, 258–259, 279, 281, 301, 309, 356–357, 388–389, 430–431, 433, 435, 598–599, 641, 646–647, 696–697, 713, 764–765, 772–773, 774–775, 776–777, 778–779, 780–781, 782–783, 784–785, 794–795, 811, 820–821, 826–827, 836–837, 922–923, 924–925, 929, 938–939, 952–953, 957, 960;

Corbis/Contrasto, Milan: 20–21;

Digital Image ©2004, The Museum of Modern Art, New York/Scala, Florence: 906–907

Photoservice Electa, Milan — with the permission of Ministero per i Beni Artistici e Storici: 348–349;

Ministère Français de la Culture et de la Communication, DRAC Rhône-Alpes, Service Régional de l'Archéologie: 16–17;

Rijksmuseum, Amsterdam: 506–507;

Photo RMN, Paris: 854–855;

©**The National Gallery**, London: cover, 273;

Vatican Museums, Vatican City: 372–373, 375, 377, 379